THE WARS OF THE ROSES

OSPREY
PUBLISHING

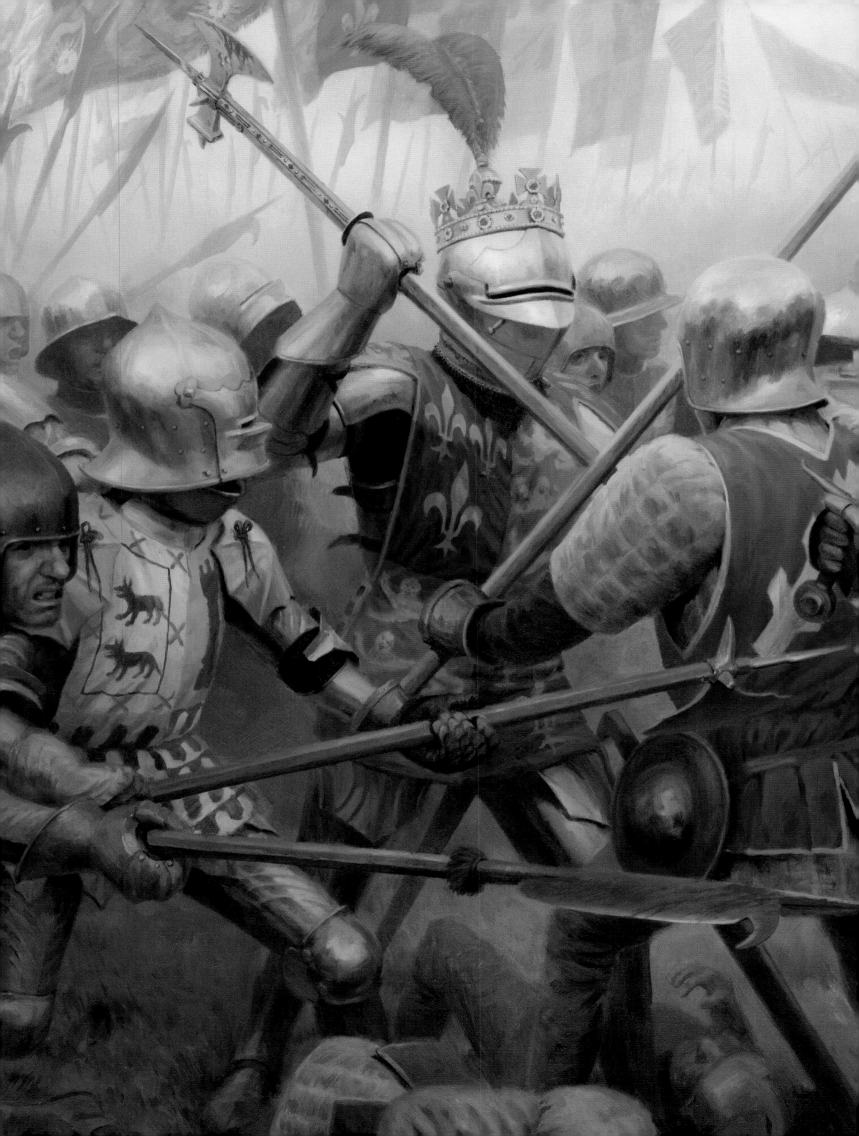

THE WARS OF THE ROSES

THE MEDIEVAL ART OF GRAHAM TURNER

To Anita

OSPREY PUBLISHING
Bloomsbury Publishing Plc
Kemp House, Chawley Park, Cumnor Hill, Oxford, OX2 9PH, UK
29 Earlsfort Terrace, Dublin 2, Ireland
1385 Broadway, 5th Floor, New York, NY 10018, USA
E-mail: info@ospreypublishing.com
www.ospreypublishing.com

OSPREY is a trademark of Osprey Publishing Ltd

First published in Great Britain in 2024

A catalogue record for this book is available from the British Library.

ISBN: HB 9781472847287; eBook 9781472847270; ePDF 9781472847263; XML 9781472847294

24 25 26 27 28 10 9 8 7 6 5 4 3 2 1

Index by Alan Rutter
Cover and layout design by Stewart Larking
Printed and bound in India by Replika Press Private Ltd.

Front cover: The Battle of Barnet.
Back cover: The Sun in Splendour; Duchess Cecily's Supplication; John Neville, Lord Montagu; Disturbing the Peace.
Front flap: English armour c.1434 and c.1461–65.
Back flap: Richard III at Bosworth.

Unless otherwise indicated, all the images in this book come from the author's collection.

Osprey Publishing supports the Woodland Trust, the UK's leading woodland conservation charity.

To find out more about our authors and books visit **www.ospreypublishing.com**. Here you will find extracts, author interviews, details of forthcoming events and the option to sign up for our newsletter.

CONTENTS

ACKNOWLEDGEMENTS

I consider myself extremely fortunate to have been able to follow a career as an artist, something that wouldn't be possible without the support of those who buy my paintings and prints; I am most grateful to you all – without you I would have had to get a 'proper job'.

Soon after painting my first Battle of Bosworth I wrote and introduced myself to Osprey Publishing, receiving a very encouraging reply and beginning a relationship that has seen me illustrate 90 of their iconic books to date. It was natural that I should approach Osprey with my ideas for this book, and I am most grateful for their support and enthusiasm in making it become a reality. Thanks to Marcus Cowper, whom I have worked with for a quarter of a century, and the rest of the team at Osprey.

My paintings are underpinned by considerable research, with each of them asking new questions that need investigating. I am acutely aware that I am reliant on countless historians, authors, researchers, curators and archaeologists, the museums and galleries that care for surviving artifacts and the organisations and individuals who work to preserve our historic buildings, battlefields and other sites, along with living historians, re-enactors, armourers and many other specialists who all contribute to the vast body of knowledge and information that I am able to refer to and draw on. Some of you have assisted me more directly, and your help and advice, and the opportunity to discuss various ideas and questions with you, is much appreciated. You are too numerous to name, but I thank you all.

Thank you also to those who have generously provided photos and other images to supplement my paintings and own photos in this book.

The most important people to thank here are of course my family. Anita, who married me just before my interest in the Wars of the Roses manifested itself, and who has gamely put up with all that has followed and given me the love and support that's allowed me to flourish. To our children, Alexander and Georgina, whose childhoods were a little out of the ordinary as I pursued my jousting ambitions, but who appear to have grown up without too many scars! And, of course, my parents, Helen and Michael; having an artist for a father must have had something to do with what I became, and my decision to move away from the subject matter he's been so successful painting set me on a fascinating path that has ultimately led to this book.

PREFACE

History is part of us all. An interest in history, no matter how cursory, shows an appreciation that countless generations of people not unlike ourselves have walked this earth before us, and that we are adding our own small chapter to the story of humanity before passing it on to future generations. As we look at and assess what has gone before us, we should also try to ensure that our contribution will be judged positively by those who follow.

History surrounds us, and not just in the lovingly preserved historic sites and museums that we are fortunate to be able to visit. A well-trodden

footpath bears the footprints of countless generations, while an old wall contains the fingerprints of those who have maintained it over the centuries. Remove the scars of the modern world, and the underlying hills and valleys are essentially the same ones on which our forebears lived out their lives, under the same skies, watching the same seasons pass, experiencing similar weather.

Of course, history becomes much more vivid and exciting when it involves times of trouble, plots, rebellions and war. In the grand scheme of world history, the squabbles that so violently divided the ruling classes in England nearly six centuries ago are probably fairly insignificant, not dissimilar to many other troubles occurring around the globe, but to many of us who live on these shores, surrounded by the shadows of these events – the buildings, battlefields and institutions – these stories and the people they engulfed have a particular resonance, a fascination shared with many beyond the small island they took place on. With a compelling cast of varied, recognisable characters populating a narrative of such twists and turns that could challenge the most outrageous Hollywood script, the Wars of the

ABOVE Unveiling my first painting of the Battle of Bosworth at the Bosworth Battlefield Visitor Centre on 22 August 1995.

RIGHT Jousting on my horse Magic in 2010, a momentous year that would see us crowned champions at the prestigious Queen's Golden Jubilee Trophy at the Royal Armouries.

FAR RIGHT Portraying the duke of Clarence at a joust held at the Tower of London in 2007.

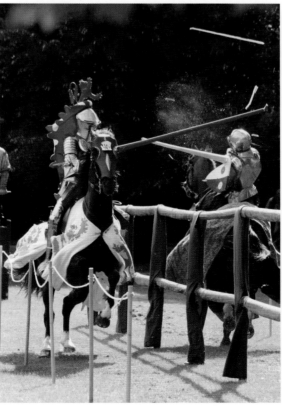

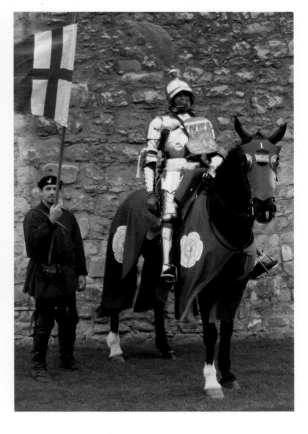

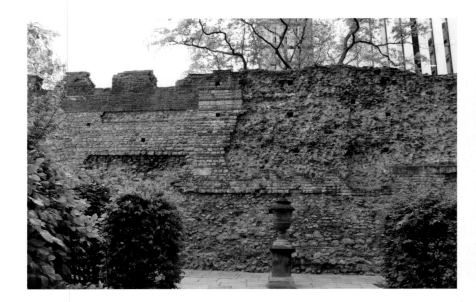

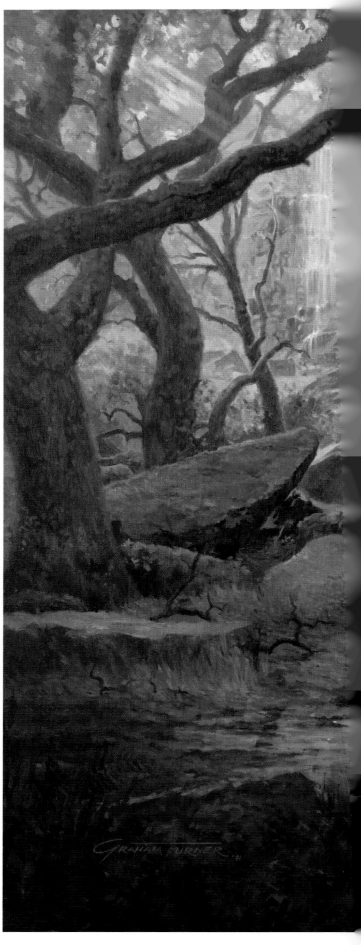

Roses has it all. By trying to understand these people and their beliefs, fears and motivations, we can learn a considerable amount about ourselves and our place in this continuing story.

I grew up with a fascination with castles and 'knights in armour', but it wasn't until I'd become established as a professional artist that this boyhood interest inspired my first foray into painting something 'medieval', leading to a few canvases of Arthurian knights errant that were encouragingly received. It was while trying to learn something about armour for these first efforts that I started reading about the Wars of the Roses, and soon discovered that real history was so much more interesting than anything you could make up. A trip to Bosworth battlefield provided my epiphany; in my mind's eye I could clearly see Richard III leading his knights in their thunderous charge across the landscape, and this inspired my first Wars of the Roses canvas, unveiled at the Battlefield Visitor Centre on 22 August 1995, the anniversary of the battle.

That painting was the start of my fascination – obsession perhaps – with the Wars of the Roses, and this book is the culmination of more than a quarter of a century's research and painting. Over this time there have been discoveries that have added to and altered our collective knowledge and interpretation of the past, as my own knowledge and understanding has continued to grow and evolve. Each painting throws up new questions and challenges, requiring me to gather information about many diverse subjects and to visit sites across the country. My passion even led me into the world of jousting for several years – taking research to the extreme perhaps – and the incredible experiences I gained and will always treasure also helped provide a considerably deeper appreciation of what I'm painting.

ABOVE One of the few fragments of London's medieval wall to survive, built on a Roman base with brick parapet added in 1477, after the siege six years earlier.

RIGHT
FEARING NO FOE

A knight errant rides through an ancient forest.

Oil on canvas, 30" x 24" (76cm x 61cm), 1991.

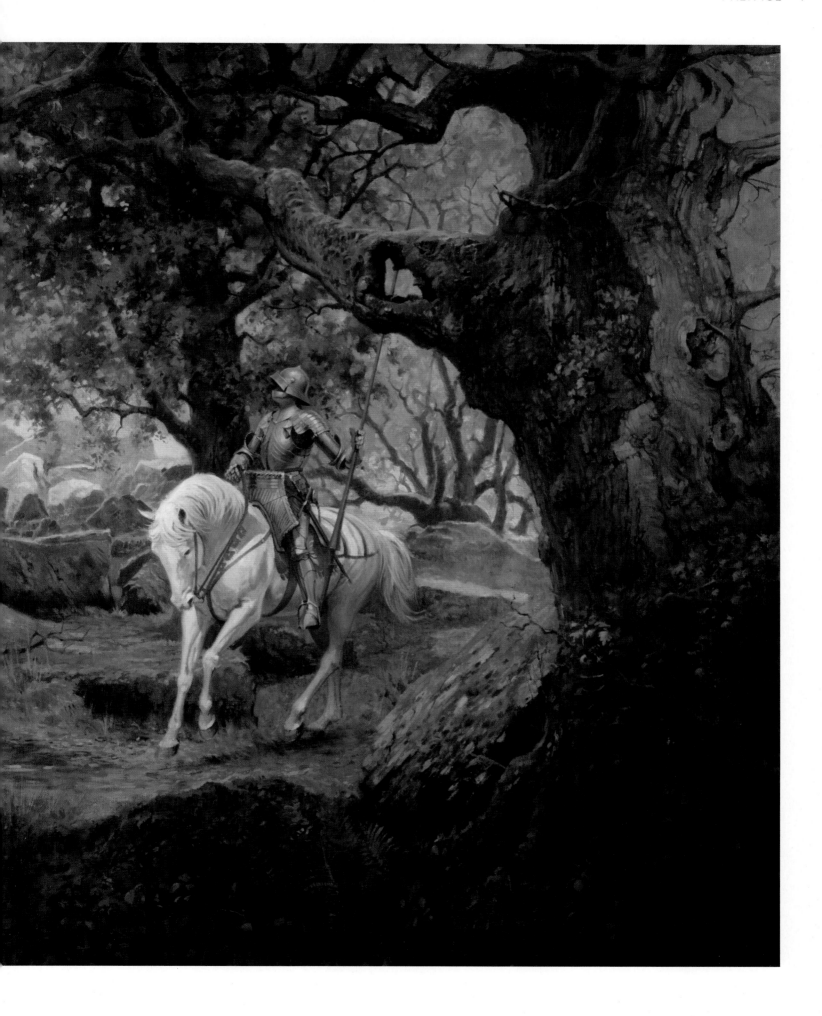

The idea that I should collect my Wars of the Roses paintings together in a book had been suggested many times before I finally agreed that maybe what I had created could form the basis for such a volume. I never anticipated it could become so all-consuming and take over my life for so long, but I am delighted to have had the reason and opportunity to paint some of the subjects I'd neglected, including lesser-known events that add so much additional interest and depth to the period. There is subject matter to keep me painting for several lifetimes, and some subjects I'd like to revisit with a fresh and better-informed eye, so it's an ongoing journey that will never be finished; this book represents where I've got to now, but there's so much more I want to create, and my excitement for the next painting remains undimmed.

I didn't originally envisage writing the text myself, but was persuaded that after so many years of immersing myself in the subject and researching it for my paintings, I was best placed to write about the events and people in those paintings. Although my work is primarily visual, the written words our ancestors left to us are a vital source of information – and inspiration. Where possible I've kept to the original spelling and grammar of the letters and other sources I've quoted from; written English was rapidly evolving, and these are the words that came from the writers' pens, the voices of our predecessors writing about the events that were happening around them.

My hope is that the combination of my paintings and text will help to bring to life the people who lived through the Wars of the Roses, to relate and connect them to us and the world we now live in, while explaining the complex course of events that make their experiences of life appear so different from our own, and yet in some respects quite familiar.

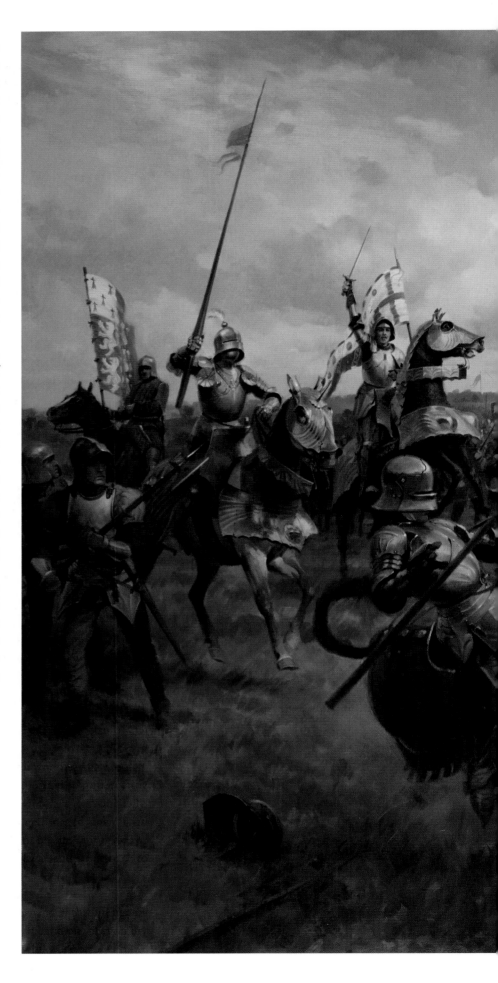

THE BATTLE OF BOSWORTH
22 August 1485

King Richard III leads his household knights and retainers in their thunderous charge towards Henry Tudor, seeking to end the battle with one decisive stroke.

Oil on canvas, 48" x 32" (122cm x 81cm), 1995.

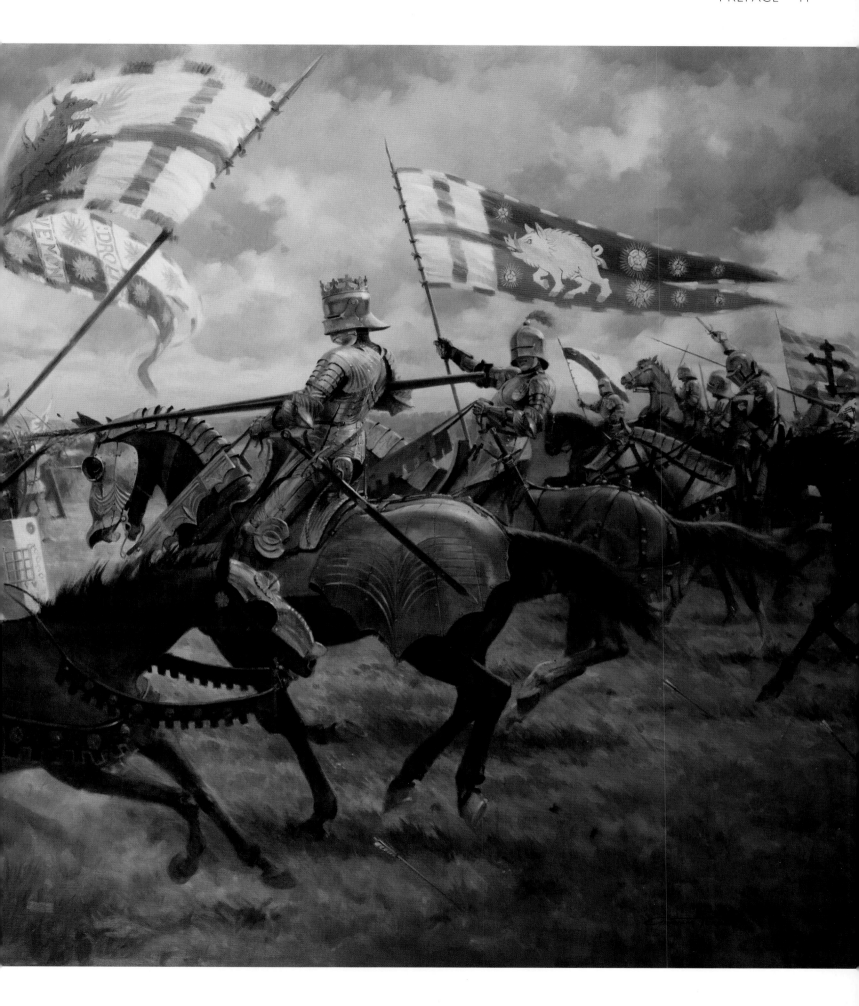

INTRODUCTION

The period of strife in England between 1455 and 1485 is known to us now as the Wars of the Roses, but that title came into use long after the tumultuous events of that 30-year period, applied by historians keen to categorise and simplify what was really a succession of violent blood-lettings interspersed with relative periods of peace. Because wars need two sides, here we have the Lancastrians and Yorkists, the red rose and white rose, fighting for the throne, neatly ended by Henry Tudor's victory at Bosworth and his adoption of the Tudor rose, a combination of both badges in symbolic unity.

The reality was far more nuanced than this simplification, and at first acquaintance can appear fiendishly complex.

Firstly, the use of the two roses to define the period is rather misleading, for while the white rose was indeed one of the badges used by the duke of York and his family, there were many others, and the red rose appears very rarely as a distinctive badge of the house of Lancaster. It was later that the two roses would be used to identify the opposing factions, an idea immortalised by Shakespeare's fictional scene in *Henry VI: Part I*, where the rivals pluck roses; (York) 'If he suppose that I have pleaded truth, From off this brier pluck a white rose with me.' (Somerset) 'Let him that is no coward nor no flatterer, But dare maintain the party of the truth, Pluck a red rose off this thorn with me... Here in my scabbard; meditating that, Shall dye your white rose in a bloody red.'[1]

Rather than two defined sides, we actually see a fascinating series of shifting allegiances, often with self-interested motives at heart, with the objective evolving from a struggle to influence and control the king to one where the throne itself is the prize, sub-plots involving private disputes over land and inheritance that boil over into bloodshed, and a cast of main characters that changes as their fortunes reverse and those who have gambled badly find their heads on the block.

Nor was there a defined beginning and end, but rather a gradual slide into civil war over a number of years, then a few aftershocks and one more pitched battle before history moved on to the next chapter.

The events were written about at the time by chroniclers, letter writers and poets, in newsletters, petitions and reports. While a few are eyewitness accounts, many are based around hearsay or have a definite bias, so need to be treated with that in mind. Government, civic, and legal records provide additional information, and purchases are recorded in a few surviving account books, which, despite their seemingly mundane purpose, help throw light on the lives of our ancestors. Paintings, sculptures, artifacts, buildings, battlefields and archaeology all add to a patchwork of information that helps us in our efforts to understand and visualise the past.

The 'histories' written in the 16th century by the likes of Polydore Vergil, Edward Hall and Raphael Holinshed would provide the stories that would be further embellished by Shakespeare to create his dramatic interpretation of the events of over a century earlier, and his plays have exerted their considerable influence over our perception of the Wars of the Roses ever since.

Artists painted images to illustrate some of the contemporary chronicles, and their work can shed valuable light on the armour and clothing of the time. Shakespeare's influence would however colour the work of later writers and artists, with many of the often otherwise fabulous works of art created in the nineteenth and early twentieth centuries, when history painting was fashionable, being paintings of Shakespeare's plays rather than attempts to recreate actual history.

No event has probably been more affected by Shakespeare's writings, or exploited for various agendas, than the Battle of Agincourt – 'We few, we happy few, we band of brothers'[2] – and it is with Henry V, and his father before him, that the story of the Wars of the Roses should probably begin...

ABOVE **Red and white roses decorate the border of a book produced in 1487, along with them combined to form the Tudor rose.** (The British Library, Royal MS 20 E III f.30v)

LEFT **Tomb effigies provide valuable information about the armour worn during the Wars of the Roses. Here I am photographing Nicholas Fitzherbert at Norbury in Derbyshire.**

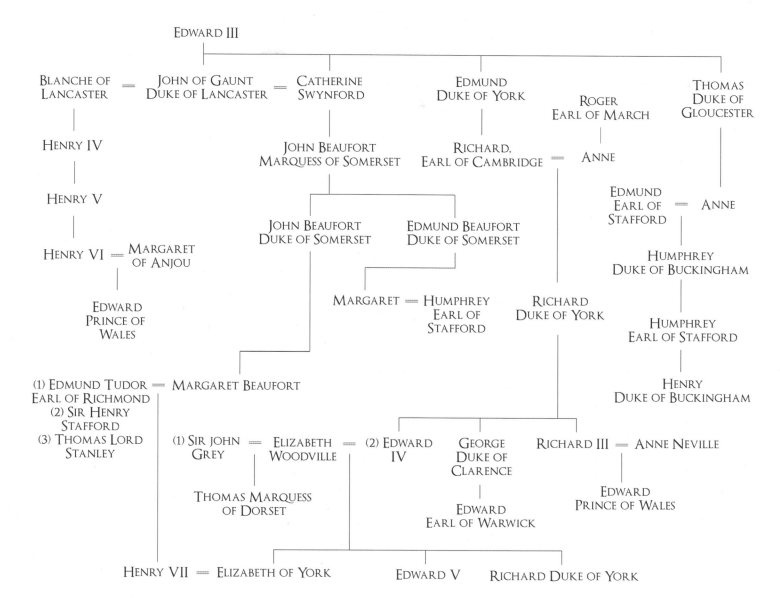

EDWARD III

BLANCHE OF LANCASTER = JOHN OF GAUNT DUKE OF LANCASTER = CATHERINE SWYNFORD EDMUND DUKE OF YORK ROGER EARL OF MARCH THOMAS DUKE OF GLOUCESTER

HENRY IV

HENRY V

JOHN BEAUFORT MARQUESS OF SOMERSET RICHARD, EARL OF CAMBRIDGE = ANNE

EDMUND EARL OF STAFFORD = ANNE

HENRY VI = MARGARET OF ANJOU

JOHN BEAUFORT DUKE OF SOMERSET EDMUND BEAUFORT DUKE OF SOMERSET

HUMPHREY DUKE OF BUCKINGHAM

EDWARD PRINCE OF WALES

MARGARET = HUMPHREY EARL OF STAFFORD RICHARD DUKE OF YORK

HUMPHREY EARL OF STAFFORD

(1) EDMUND TUDOR EARL OF RICHMOND (2) SIR HENRY STAFFORD (3) THOMAS LORD STANLEY = MARGARET BEAUFORT

HENRY DUKE OF BUCKINGHAM

(1) SIR JOHN GREY = ELIZABETH WOODVILLE = (2) EDWARD IV GEORGE DUKE OF CLARENCE RICHARD III = ANNE NEVILLE

THOMAS MARQUESS OF DORSET

EDWARD PRINCE OF WALES

EDWARD EARL OF WARWICK

HENRY VII = ELIZABETH OF YORK EDWARD V RICHARD DUKE OF YORK

ABOVE **A genealogical table showing the connections between the houses of York and Lancaster, the names by which the opposing sides have become known referring to their titles, with nothing to do with the English towns or counties.** (Christopher Gravett)

RIGHT Among those commemorated in the armorial and genealogical Rous Roll of *c.*1483 are (from left to right) the Yorkist kings, Edward IV and Richard III, both brothers wearing armour and holding swords and charters, Edward with the lion of the earldom of March at his feet and Richard his famous boar, along with Warwick Castle in his left hand. In the second image is Anne Neville (who possibly commissioned the roll), at her feet the bear badge of her father, the Earl of Warwick, alongside a second depiction of her husband, Richard III, and their son, Edward, Prince of Wales. (The British Library, Add MS 48976 f.2 & f.8)

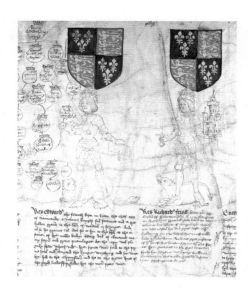

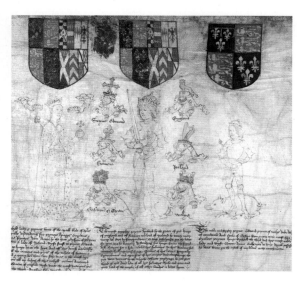

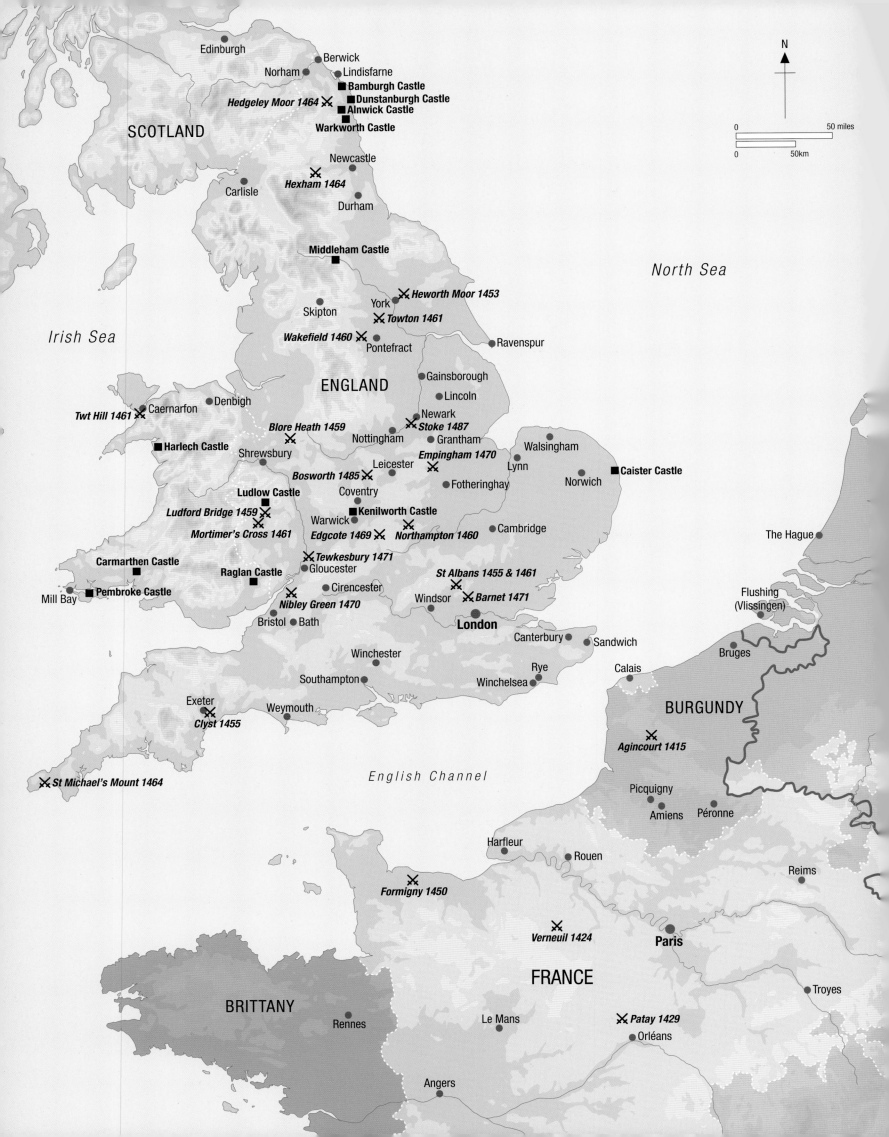

N

SCOTLAND

Edinburgh
Berwick
Norham
Lindisfarne
■ Bamburgh Castle
Hedgeley Moor 1464 ✕ ■ Dunstanburgh Castle
■ Alnwick Castle
Warkworth Castle

Newcastle
Carlisle
Hexham 1464 ✕

Durham

North Sea

0 50 miles
0 50km

Middleham Castle

Irish Sea

Skipton
York ✕ Heworth Moor 1453
Towton 1461 ✕
Wakefield 1460 ✕
Pontefract
Ravenspur

ENGLAND
Gainsborough
Lincoln

Denbigh
Twt Hill 1461 ✕ Caernarfon
Blore Heath 1459
Newark
✕ Stoke 1487
Nottingham Grantham
Walsingham
Harlech Castle
Shrewsbury
Empingham 1470 ✕
Leicester
Bosworth 1485 ✕ Lynn
Caister Castle
Coventry Fotheringhay Norwich
Ludlow Castle
Ludford Bridge 1459 ✕
Mortimer's Cross 1461 ✕
Kenilworth Castle
Warwick
Edgcote 1469 ✕ Northampton 1460 ✕
Cambridge

The Hague

Carmarthen Castle
Raglan Castle
Tewkesbury 1471 ✕
Gloucester
St Albans 1455 & 1461
Flushing
(Vlissingen)
Mill Bay
Pembroke Castle
Nibley Green 1470 ✕
Cirencester
Windsor ✕ Barnet 1471
Bristol ● Bath
London
Canterbury Sandwich
Bruges
Winchester
Rye
Calais
Southampton
Winchelsea
BURGUNDY

Exeter ✕
Clyst 1455
Weymouth

English Channel

Agincourt 1415 ✕

St Michael's Mount 1464 ✕

Picquigny ✕
Amiens Péronne

Harfleur
Rouen

Formigny 1450 ✕

Reims

Verneuil 1424 ✕ Paris

BRITTANY FRANCE

Rennes Le Mans Patay 1429 ✕
Orléans

Troyes

Angers

CHRONOLOGY

1422

31 August, Henry V dies and his nine-month-old son becomes Henry VI (1422–61, 1470).

1444

24 May, Henry VI betrothed to Margaret of Anjou.

1450

Jack Cade Rebellion.

1452

Duke of York's failed Dartford *coup d'état*.

1453

17 July, French victory at the Battle of Castillon.

Henry VI suffers mental collapse.

24 August, Percy/Neville confrontation at Heworth Moor.

1455

22 May, First Battle of St Albans.

York's Second Protectorate.

15 December, Battle of Clyst.

1457

28 January, Henry Tudor born in Pembroke Castle.

1459

23 September, Battle of Blore Heath.

12–13 October, Ludford Bridge; Yorkist leaders flee to Ireland and Calais.

1460

10 July, Battle of Northampton.

York recognised as heir to Henry VI.

30 December, Battle of Wakefield; York killed.

1461

2 or 3 February, Battle of Mortimer's Cross.

17 February, Second Battle of St Albans.

4 March, Edward IV's reign commences (1461–83).

29 March, Battle of Towton.

1461–64

Campaign in north-east – sieges of Alnwick, Bamburgh and Dunstanburgh castles.

1464

25 April, Battle of Hedgeley Moor.

1 May, Edward IV secretly marries Elizabeth Woodville.

15 May, Battle of Hexham.

1465

July, Henry VI captured.

1468

3 July, Marriage of Charles the Bold, Duke of Burgundy, and Margaret of York.

1469

Robin of Redesdale's Rebellion.

24 July, Battle of Edgcote; Edward IV taken into custody by Earl of Warwick.

August–September, Siege of Caister Castle.

1470

12 March, Battle of Empingham (Losecoat Field).

20 March, Battle of Nibley Green.

April, Warwick and Clarence flee to France.

July, Treaty of Angers between Warwick and Queen Margaret.

September, Warwick invades and Edward IV flees into exile in Burgundy.

Restoration (Readeption) of Henry VI.

1471

14 March, Edward IV lands at Ravenspur in Yorkshire.

11 April, Edward IV enters London.

14 April, Battle of Barnet; Warwick killed.

4 May, Battle of Tewkesbury.

12–14 May, Bastard of Fauconberg attacks London.

21 May, Henry VI dies in the Tower of London.

1473

September, Jasper and Henry Tudor leave Wales for exile in Brittany.

Earl of Oxford takes St Michael's Mount.

1475

French campaign.

1483

9 April, death of Edward IV; succession of his son as Edward V.

6 July, Richard III crowned (1483–85).

October–December, Buckingham's rebellion.

1485

7 August, Henry Tudor lands at Mill Bay, Pembrokeshire.

22 August, Battle of Bosworth; Richard III killed; Henry Tudor succeeds as Henry VII (1485–1509).

1487

16 June, Battle of Stoke.

CHAPTER 1
HENRY V – A FORMIDABLE LEGACY

King Henry V died unexpectedly on 31 August 1422, probably from dysentery contracted while besieging the town of Meaux as he pressed home further conquests in France. He was 35 years old. He left behind a formidable reputation as the epitome of medieval warrior kingship, victor of Agincourt, conqueror of large areas of northern France and, as a result, heir to the French throne.

Studies have now presented Henry V as a more believable – albeit flawed – man than the traditional heroic portrayal, more human because of sometimes less palatable aspects to his character, but he still leaves a giant imprint on the pages of history, in England at least.

His father, Henry Bolingbroke, took the throne by force in 1399 to become the first of the Lancastrian kings (so-called because of their descent from John of Gaunt, Duke of Lancaster, son of Edward III), and his troubled reign as Henry IV saw his son emerge as a formidable character. The 1403 rebellion by Henry 'Hotspur' Percy and his father, the earl of Northumberland, saw the young prince Henry, then 16 years old, command part of his father's army at the battle of Shrewsbury, where he was shot in the face with an arrow while leading an attack on the rebels. A contemporary account of the battle describes the scene: 'Meanwhile the destruction dealt by the arrows, which were flying like a hailstorm

BELOW
THE BATTLE OF SHREWSBURY
21 July 1403

The hand-to-hand fighting around King Henry IV was the fiercest across the whole battlefield, the king becoming a clear target of the rebels. Here, the earl of Douglas cuts down the royal banner-bearer, while Sir Walter Blount reaches out to try to stop the banner falling to the ground. Behind, George Dunbar warns the king of the perilous situation he is in and urges him to withdraw.

Gouache, 19" x 13" (48cm x 33cm), 2017.

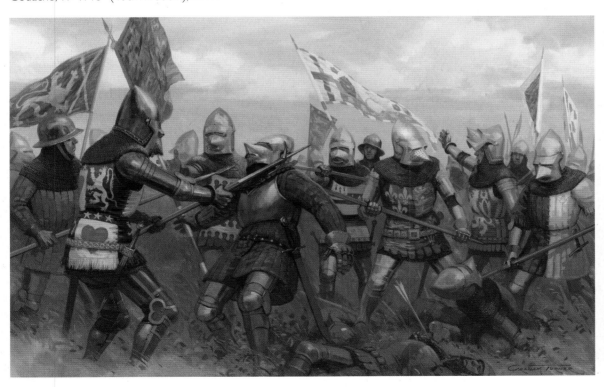

THE BATTLE OF SHREWSBURY
21 July 1403

Sixteen-year-old Henry, Prince of Wales, is shot in the face with an arrow while leading an attack on the rebel vanguard.

Gouache, 19" x 13" (48cm x 33cm), 2017.

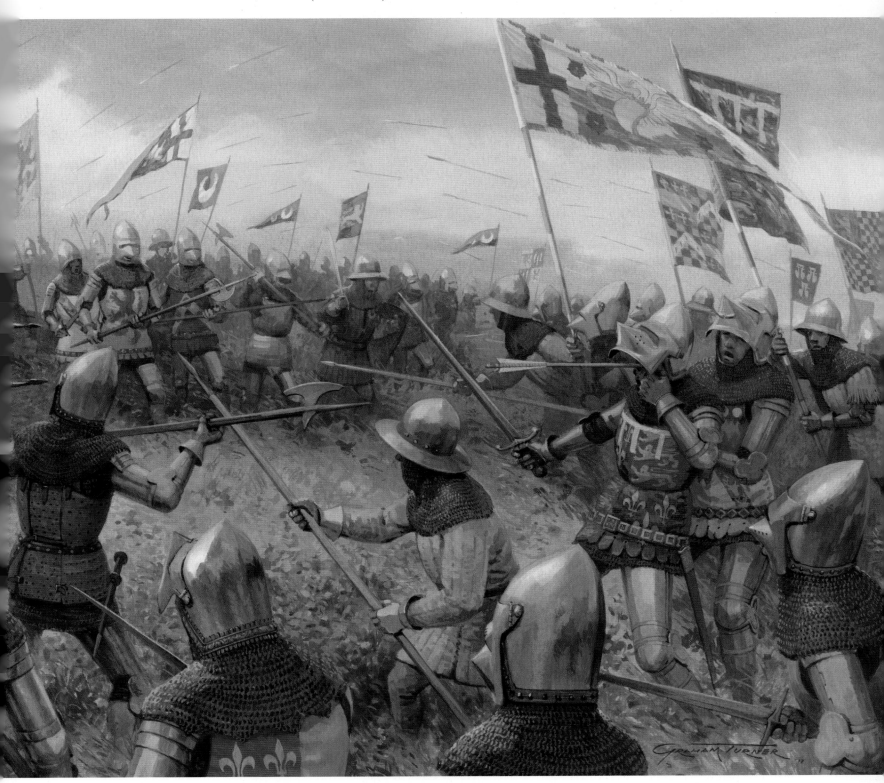

from both sides, was very great. Prince Henry, then fighting his first battle, was shot in the face by an arrow; boy though he was, he did not falter, but with courage beyond his years, disregarding his wounds, cheered on his troops to vengeance.'[1] His survival of this horrific wound was in no small part due to a remarkable feat of surgery, a detailed account of which was left by the physician.

Ten years after his brutal lesson in the dangers of the battlefield, Henry succeeded his father as king of England, having already taken over much of the governing of the country due to Henry IV's worsening health.

The throne Henry V inherited was not particularly secure, but his decision to renew the war with France, later to become known as the Hundred Years War, gave him the military success that would help cement his power. His 1415 campaign in France began – and could have ended – with the siege of Harfleur, but his gamble to defiantly march his army across northern France to the English-held port of Calais would result in his reign-defining victory against the odds at the Battle of Agincourt.

Henry returned to France again in 1417, and over the next three years his army took much of northern France, including Paris, leading to the divided French ruling class recognizing him as heir to the French throne in 1420 with the Treaty of Troyes, an agreement sealed with his marriage to the French king's daughter, Katherine of Valois. Their son, another Henry, who was just nine months old at the time of his father's death in August 1422, would grow to be quite a different character from his illustrious father, ill-suited to the demands of medieval kingship. The third Lancastrian king to occupy the English throne, Henry VI's tumultuous reign would see the eventual loss of English France and his countrymen turn against themselves in a 30-year period of self-destruction now known as the Wars of the Roses.

OPPOSITE
THE BATTLE OF AGINCOURT
25 October 1415

Archers of Henry V's exhausted army shoot their deadly arrows at the first wave of French cavalry, repulsing their attack and sending the survivors back into the path of the main French army.

Oil on canvas, 24" × 30" (61cm × 76cm), 2008.

NEXT PAGES
THE BATTLE OF AGINCOURT
25 October 1415

Henry V is in the thick of the fighting, surrounded by his bodyguard and with his banners flying above him, as they desperately fight off the French knights and men-at-arms who have struggled through the mud and a barrage of arrows to reach them.

Oil on canvas, 54" × 30" (137cm × 36cm), 2015.

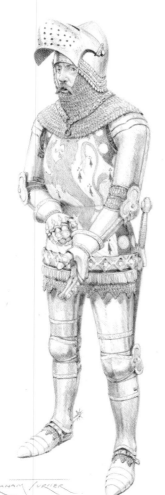

LEFT
SIR JOHN CORNWALL

Sir John Cornwall (1364–1443) was one of the most respected knights of his period and a leading figure in the Agincourt campaign. He is shown wearing armour of the late 14th/ early 15th century, still retaining the bascinet with mail aventail, but with the later rounded visor.

Pencil, 12" × 16.5" (30cm × 42cm), 2012.

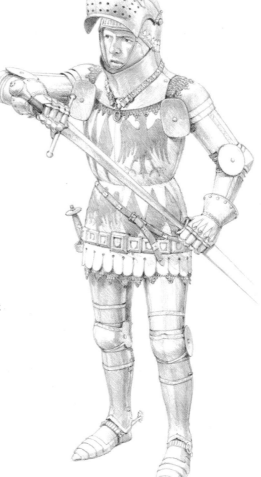

LEFT
THOMAS MONTAGU, EARL OF SALISBURY

Thomas Montagu, Earl of Salisbury, wearing armour from the time of the Battle of Agincourt featuring the latest style of great bascinet, with plate defences for the throat and neck rather than the mail aventail of the 14th century bascinet seen in the drawing of Sir John Cornwall. While offering greater protection, the great bascinet restricted movement of the head.

Pencil, 12" × 16.5" (30cm × 42cm), 2012.

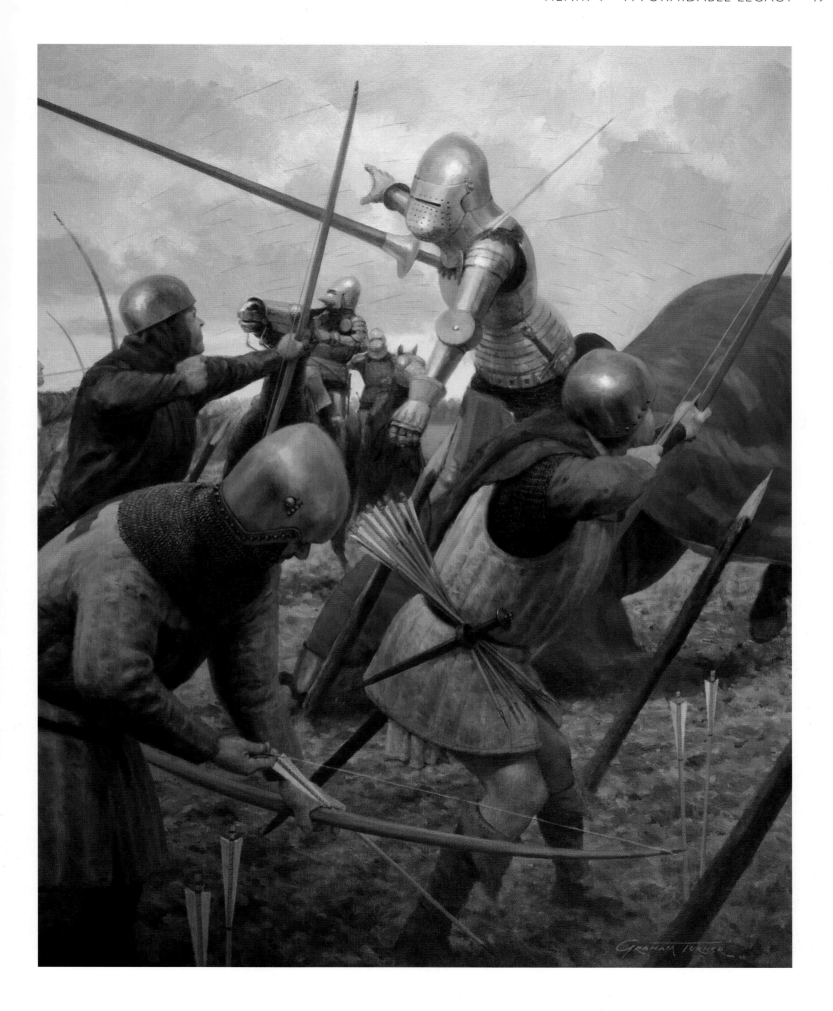

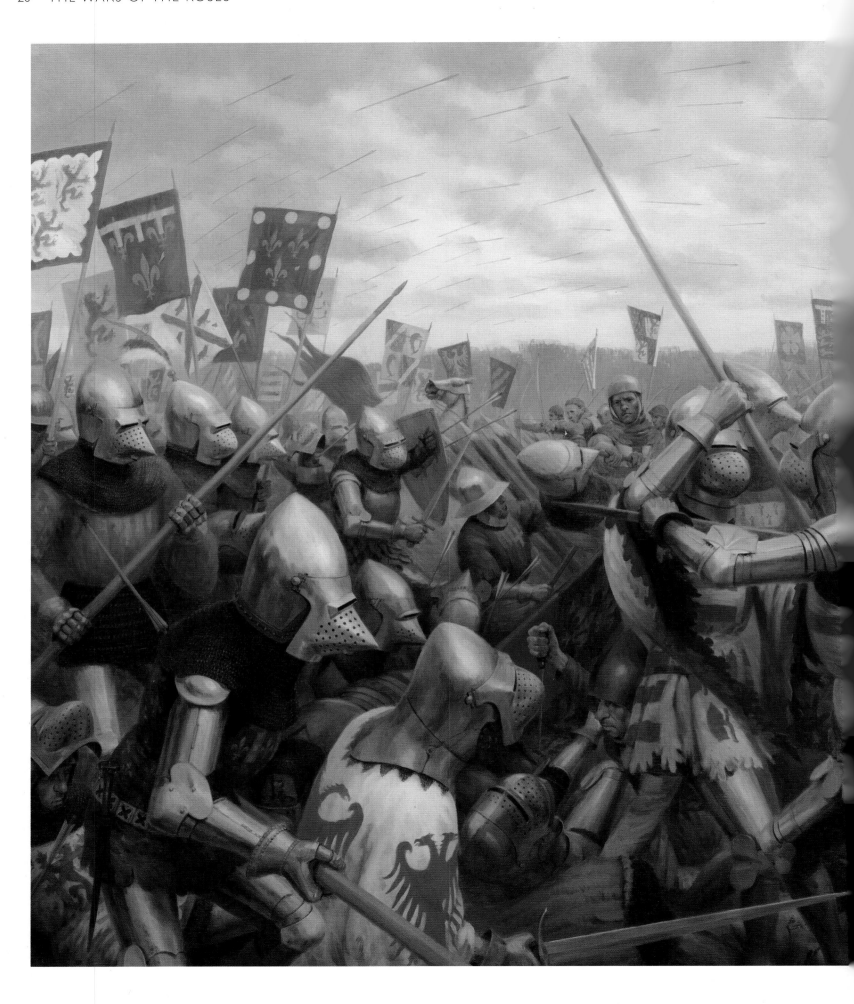

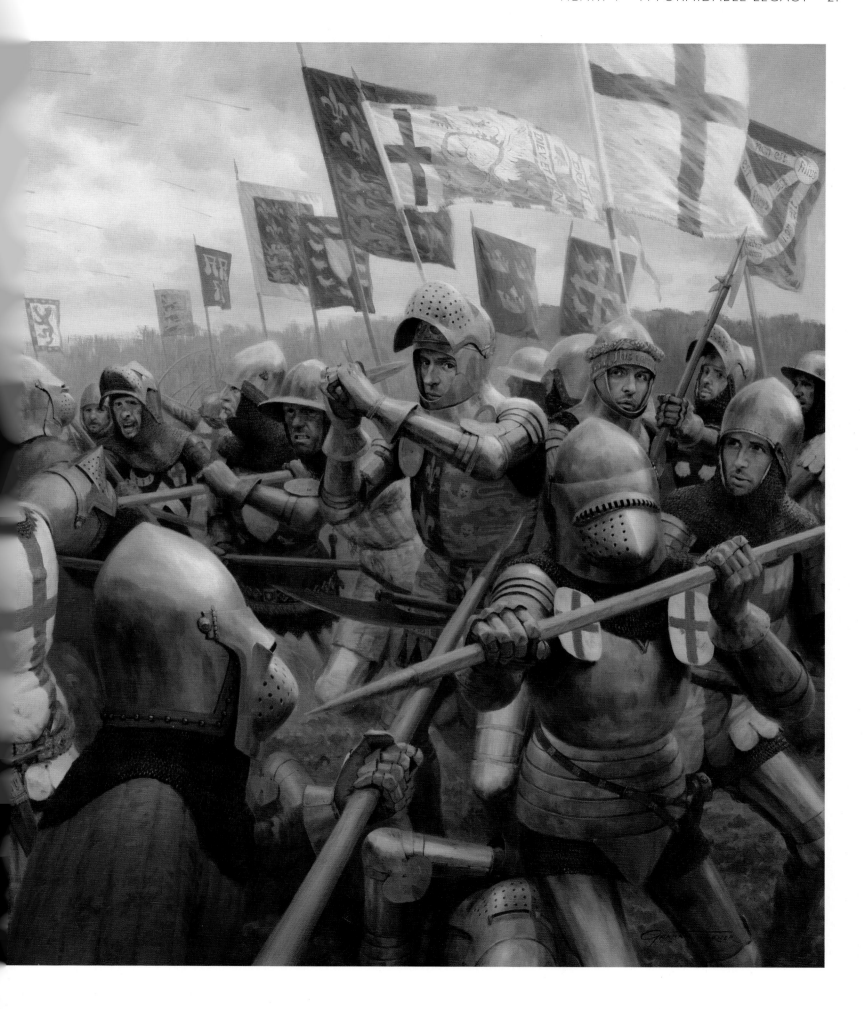

CHAPTER 2
HENRY VI – KING OF ENGLAND AND FRANCE

While history remembers Henry V as a great medieval warrior king, his son's epitaph is rather less flattering. Even the more rounded and less critical accounts of his reign agree that he was unsuited to kingship, and he is usually described as weak, ineffectual, easily led, and disinterested in the responsibilities of government – 'one of the least able and least successful kings ever to rule England'.[1]

Henry VI was born at Windsor Castle on 6 December 1421, and at nine months old became the youngest monarch ever to accede to the English throne. Little is known about Henry's young life, but he would clearly have had no memories of a time when he wasn't king, nor did he have the benefit of observing his father fulfilling the role he had been born into.

When the French King Charles VI died soon after Henry V in October 1422, according to the terms of the Treaty of Troyes the infant Henry VI also inherited the throne of France, but with large parts of the country still under the control of the French Dauphin (Charles VI's son) it would take many more years of warfare if the two kingdoms were ever going to be united under Henry's rule.

Until he came of age, a council was appointed to rule on Henry's behalf, headed – as protector and defender of England – by his uncles, John, Duke of Bedford, also appointed regent of France, and Humphrey, Duke of Gloucester. While Bedford looked after matters in France, his brother Gloucester proved a more contentious figure, his attempts to grasp more than the already considerable powers he had been granted leading to friction, most notably with his uncle, Henry Beaufort, Bishop of Winchester, with whom he fought for dominance over the coming years, climaxing in 1425 with armed confrontation and a dangerous stand-off in London.

Henry Beaufort was an immensely wealthy, ambitious and influential man, loaning considerable sums to finance his nephew Henry V's campaigns in France, and continuing to provide substantial loans to Henry VI. Appointed chancellor on three occasions, lastly in 1424, he was made a cardinal in 1426 by the Pope. Like the king, the Beaufort family was also descended from Edward III through his son John of Gaunt, but from his mistress Catherine Swynford rather than his wife. Gaunt would later marry Swynford, and their offspring were declared legitimate, but the Beauforts were excluded from any claim to the throne itself.

In 1426 the four-year-old King Henry was knighted by his uncle, the duke of Bedford, and the young king in turn dubbed several others, including Richard, Duke of York, then 14, who would have a huge part to play in the years to come.

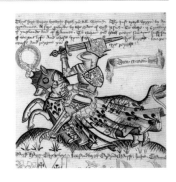

ABOVE **Henry VI depicted in the traditional role of warrior-king. However, unlike his father, he showed none of the martial instinct expected of him.** (The British Library, Harleian MS 2169 f.3)

THE BATTLE OF BAUGÉ

Henry V's brother, Thomas, Duke of Clarence, impetuously attacked a combined French and Scottish force at Baugé on 22 March 1421 without waiting for all his army to arrive – it cost him his life.

Gouache, 17" x 12.5" (43cm x 33cm), 1997.

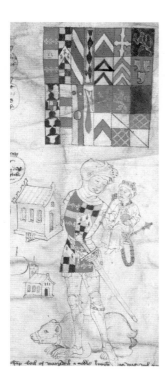

ABOVE **Richard Beauchamp, Earl of Warwick, holding the young King Henry VI,** from the Rous Roll, possibly commissioned c.1483 by Beauchamp's granddaughter, Anne Neville, Richard III's queen. Beauchamp's heraldry displays his pedigree, and he holds a Lancastrian livery collar to indicate his allegiance, while at his feet lies a muzzled bear, the instantly recognisable badge of the earls of Warwick. (The British Library, Add MS 48976 f.6)

RIGHT **The magnificent tomb of Richard Beauchamp, Earl of Warwick (1382–1439)** at St Mary's, Warwick. The earl wears an Italianate style of armour of the early 1450s, dating from the time the tomb was commissioned rather than the earl's lifetime.

Two years later the distinguished Richard Beauchamp, Earl of Warwick, was appointed as Henry's guardian, to educate him in 'good manners, letters, languages, nurture and courtesy'.[2] When he was seven years old, the young king was given two 'lytill cote armurs', and he also possessed several training swords of various sizes 'for to lerne the king to play in his tendre age', along with 'a litel harneys [armour] that the earle of Warwyk made for the kyng… garnysshed with gold'[3] – clearly an interest in martial skills was being cultivated.

With many years of experience in France, the duke of Bedford continued to successfully pursue English interests against the French, scoring a notable victory at Verneuil in 1424. However, by the late 1420s the tables began to turn, with the emergence of Jeanne d'Arc providing the necessary inspiration to see the siege of Orléans lifted and the English army defeated at the Battle of Patay, these successes allowing the Dauphin to be crowned King Charles VII at Reims on 17 July 1429.

Later the same year, on 6 November, Henry VI was formally crowned as king of England at Westminster Abbey and, to enforce his claim to the dual monarchy – and counter Charles VII's rival coronation – his coronation as French king followed at Notre Dame in English-held Paris on 16 December 1431, during a lengthy visit to France.

At around this time Henry's mother, Queen Katherine, widowed at just 21, secretly married Owain ap Maredudd ap Tudur – later to anglicise his name to Owen Tudor – a Welsh gentleman who had possibly been part of her household, although how they met remains unknown, lost amongst later

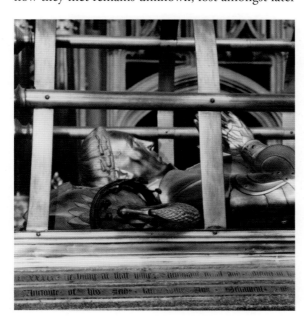

propaganda and romantic myth. The marriage was apparently kept from public knowledge until after Katherine's early death in 1437 – 'the whiche Oweyn hadde prevyly wedded the quene Katerine, and hadde iij or iiij chyldren be here [by her], unwetyng the comoun peple tyl that sche were ded and beryed.'[4] Shorn of the protection of his late wife, Owen's life became rather precarious for a time – marrying a dowager queen without consent was against the statutes, and there were those who feared what role he might now play in the life of his stepson the king. On leaving the safety of sanctuary in Westminster he was incarcerated in Newgate gaol, from where he briefly escaped only to be recaptured and soon after moved to Windsor Castle, where he remained for a year, finally gaining a pardon from the king in November 1439 and regaining an honourable position and generous pension. Katherine and Owen's sons Edmund and Jasper were recognised by the king as his half-brothers, and he took an interest in their upbringing and in time accepted them into the heart of his court, ennobling them as earls of Richmond and Pembroke respectively and providing them with the means to support their lofty titles.

The English position in France was severely weakened when Bedford passed away in 1435. His widow Jacquetta of Luxembourg controversially married Sir Richard Woodville, son of her late husband's chamberlain, less than two years later, and their daughter Elizabeth would become another key figure in the coming Wars of the Roses when she married the Yorkist King Edward IV in 1464.

In November 1437, as his 16th birthday approached, Henry VI declared his minority was over and his personal rule began. While his council would still advise him and take care of routine matters, he assumed powers that had previously been delegated to them. However, his rule faced several challenges: alongside the deteriorating military situation in France, the economy was in serious trouble, but as his reign progressed, rather than step up and tackle these issues, Henry increasingly left the administration of government to others while he dabbled with things that interested him.

The young Henry tends to come across as a sensitive, overgenerous and perhaps rather prudish character, but while he is usually portrayed as particularly pious, he was likely not a great deal more than conventionally so, with later attempts to sanctify him probably owing more to his tragic latter

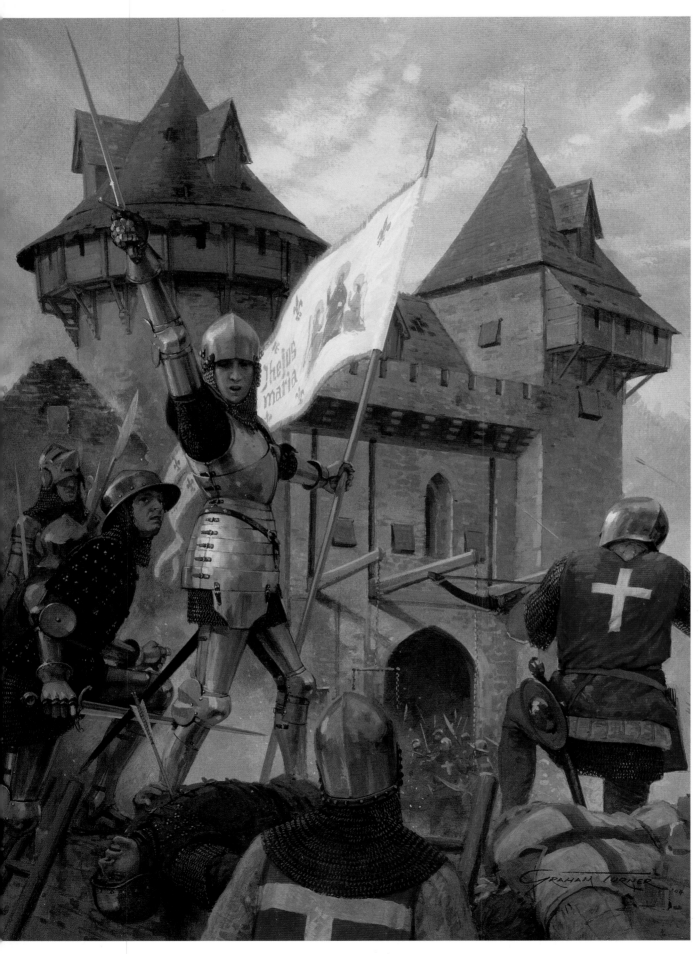

JEANNE D'ARC

Jeanne d'Arc leads the attack on Les Tourelles during the siege of Orléans in 1429. Guided by heavenly voices, 'La Pucelle' provided the charismatic inspiration to lift the demoralised spirits of the French and turn the course of the Hundred Years War.

Gouache, 12.5" × 16" (32cm × 41cm), 2004.

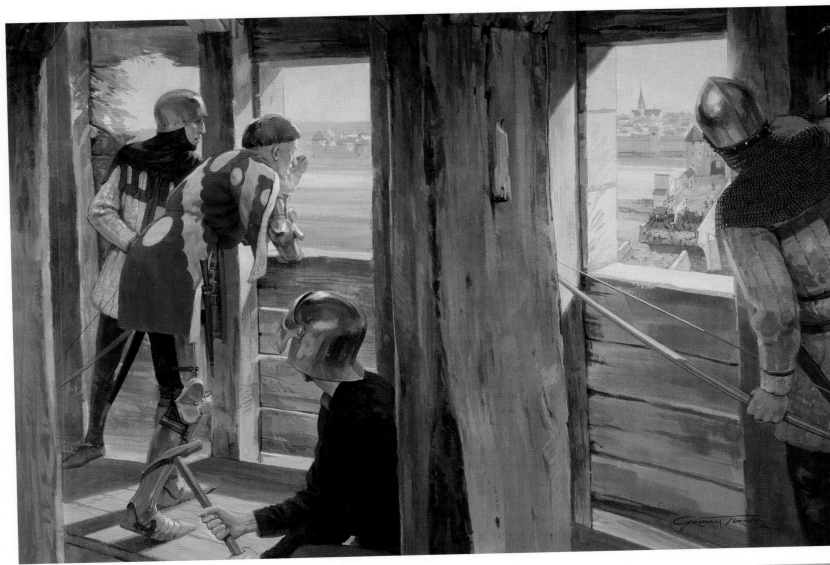

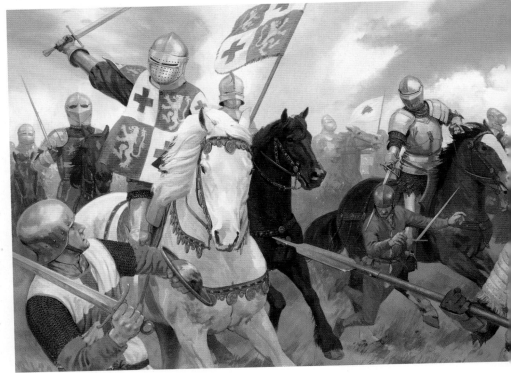

ABOVE

THE SIEGE OF ORLÉANS

William Glasdale, commander of the English besieging force at Orléans, shouts insults to Jeanne d'Arc and the defenders of the city from the top of Les Tourelles.

Gouache, 21.5" x 14.5" (55cm x 37cm), 2001.

RIGHT

THE BATTLE OF PATAY
18 June 1429

Following the successful lifting of the siege of Orléans, the French army, led by Jeanne d'Arc and her two loyal supporters La Hire and Pothon de Xaintraille, scored an important victory over the English at Patay, resulting in the capture of John Talbot, Earl of Shrewsbury. Less than a year later Jeanne was captured by the Burgundians and sold to the English, who subjected her to humiliating examinations and a long trial, before burning her at the stake in the market square at Rouen on 30 May 1431.

Gouache, 21.5" x 14.5" (55cm x 37cm), 2001.

years and the political needs of others. His devotion to the improvement of education facilities can be seen today in the buildings of Eton College and King's College Cambridge, both of which he founded and committed vast sums of money to the construction of. He envisaged a grammar school at Eton for poor scholars to be taught free of charge, along with an almshouse for homeless men, the foundation charter of 1440 stating 'it has become a fixed purpose in our heart to found a college, in honour and in support of that our Mother [the church], who is so great and so holy, in the parochial church of Eton near Windsor, not far from our birthplace.'[5] His intentions were often worthy, but he demonstrated a lack of sound judgement or a sense of proportion and balance, veering from leniency to extreme over-reaction.

With the war in France stalled and the English goal to unite the two countries under one king appearing out of reach, the duke of Gloucester argued for the continuation of war while Cardinal Beaufort and the emerging influential voice of the duke of Suffolk campaigned for a policy of peace, a policy that appealed to Henry's natural inclinations and which he would wholeheartedly pursue regardless of cost. William de la Pole, Duke of Suffolk, had served in France for many years and been a commander at the great English victory at Verneuil. Ransomed following his capture after the defeat at Orléans, he allied himself with Cardinal Beaufort on his return home and became a powerful figure at court, holding many high offices and exerting considerable power and influence.

After initial negotiations failed, the war continued, and in 1441 Richard, Duke of York – appointed lieutenant-general and governor of France and Normandy the previous year – was sent to France with a considerable force. However, two years later Cardinal Beaufort's nephew John, Earl of Somerset, was raised to a dukedom and given significant powers in France along with funds to raise an army, undermining York's position. He ultimately achieved nothing but disgrace after his ineffectual campaign and died soon after his return home, some rumours suggesting by his own hand. He was succeeded as duke of Somerset by his brother Edmund, who replaced York as lieutenant-general in December 1446. When Cardinal Beaufort passed away in 1447, Edmund would take his place as the family's senior representative at court and the king's favourite, leading to an enmity between him and York that would be a major factor in the outbreak of civil war.

Peace talks with France reconvened in 1444, with the duke of Suffolk leading the English negotiators, despite his pleas to the king questioning his suitability and asking to be excused from the appointment. Among his concerns was how his involvement was already being negatively viewed in England, due partly to the French requesting his participation, as well as his relationships with the likes of the duke of Orléans, his former prisoner, and those who had held Suffolk himself captive in France. He knew well the pitfalls of such an appointment, pointing out how others involved in previous peace-seeking embassies had suffered, despite their best-intentioned efforts.

The result of the negotiations was a temporary truce, sealed with a marriage agreement between King Henry and a niece of King Charles VII of France, Margaret of Anjou. Margaret was the daughter of René, Duke of Anjou, and Isabelle of Lorraine, but much of her early life had been spent with her grandmother, Yolande of Aragon, while both her parents struggled to hold onto other titles her father had inherited. These included the duchies of Bar and Lorraine, and the kingdoms of Naples, Sicily and even Jerusalem, but René's spirited efforts to fight for his disputed titles eventually resulted in military defeat and imprisonment, and an enormous ransom debt owed to the duke of Burgundy.

Margaret and Henry were betrothed on 24 May 1444 – with Suffolk standing in at the altar for the absent king. The couple would not meet for another year. She remained with her family, moving to Nancy in her father's duchy of Lorraine, where he and King Charles were campaigning against the Burgundians. Despite his problems, René remained an idealist, devoted to the ideals of chivalry, a poet, painter and enthusiastic promoter of pageantry and tournaments, and while at Nancy, he organised a spectacular tournament in which King Charles took part.

Fifteen-year-old Margaret finally arrived in her new country on 9 April 1445, having been escorted in

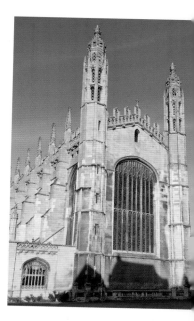

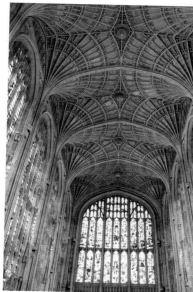

ABOVE **The soaring chapel of King's College, Cambridge, along with Eton College, remain as monuments to Henry VI's reign.** (Interior photo by the author, exterior by Julian Humphrys)

LEFT **The tomb of Cardinal Henry Beaufort (c.1375–1447) in Winchester Cathedral.**

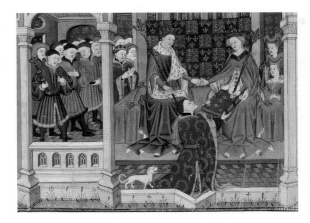

RIGHT **Painting from within the surviving book presented to Margaret of Anjou by John Talbot, Earl of Shrewsbury, as a gift on her betrothal to Henry VI, showing the earl kneeling before the royal couple. The border contains daisies, or 'marguerites', in reference to the queen.** (The British Library, Royal MS 15 E VI f.2v)

BELOW RIGHT **Shrewsbury's book contains a genealogical table showing Henry VI's descent from English kings on the right (supported by the figure of Richard, Duke of York), and French kings on the left (supported by Humphrey, Duke of Gloucester).** (The British Library, Royal MS 15 E VI f.3)

spectacular, and expensive, style on her journey by a huge English entourage – in which the duke of York played an important part. Adding to her upset at leaving her family and friends, the young queen was unwell at her ceremonial entry into Rouen, the capital of English France – the duchess of Suffolk stood in for her – and a rough Channel crossing left 'oure moost dere and best beloved wyf the Quene… seke of the labour and indisposicion of the see',[6] which further delayed her introduction to her husband. The couple were finally united and undertook a quiet marriage ceremony at Titchfield Abbey near Southampton on 22 April 1445, officiated by Henry's confessor, William Aiscough, Bishop of Salisbury.

Margaret was welcomed into London for her coronation at Westminster Abbey with a sumptuous display of pageantry, her route marked with theatrical set pieces, some reminding her of her duty to provide an heir, while others highlighted the desire for peace between England and France – 'Desired pees [peace] betwixt Englande and Fraunce/This tyme of Grace by mene of Margarete/We triste to God to liven in quiete'.[7]

The earl of Shrewsbury presented the queen with a magnificent book to commemorate her

marriage, containing chivalric romances, chronicles and texts such as Christine de Pizan's *Book of Deeds of Arms and Chivalry*. Christine was a remarkable figure, the first known professional female writer in Europe; respected and influential, and an early champion of women with her *Book of the City of Ladies*, written in 1405. In it she praises Margaret's great-grandmother, Duchess Marie of Anjou; 'One cannot praise highly enough this lady to whom all virtues abounded', adding, 'This lady certainly ruled her lands and territories, both in Provence and elsewhere, with the strictest justice, keeping them intact for her noble children until they came of age'.[8] Margaret's later actions were doubtless influenced by the examples set by three generations of illustrious female forebears.

Pizan's sequel, *The Treasure of the City of Ladies*, provided advice to women of differing social positions in society, including this for princesses on how they can be a calming influence over men's warlike nature: 'men are by nature more courageous and more hot-headed, and the great desire they have to avenge themselves prevents their considering either the perils or the evils that can result from war. But women are by nature more timid and also of a sweeter disposition, and for this reason, if they are wise and if they wish to, they can be the best means of pacifying men'.[9]

In the years before the crisis that would threaten her husband's throne, and her son's inheritance, Margaret generally seems to have behaved in the manner expected of a queen, maintaining her household, mediating on behalf of her subjects, and conducting other everyday activities. Like her husband she developed an interest in education, and in 1448 he permitted her to found Queens' College, Cambridge. Later, Edward IV would grant a new licence replacing Margaret with his queen as the 'vera fundatrix' (true foundress).[10]

CHAPTER 3
DESCENT TOWARDS CIVIL WAR

Following the royal wedding, further negotiations ceded English lands in Anjou and Maine to King Henry's new father-in-law, a move that would prove deeply unpopular in England. Gloucester's opposition to the negotiations with France and the handing over of territory had put him in direct conflict with his powerful rivals, and in 1447 he was arrested and charged with treason. Five days later Gloucester was found dead. The duke of Suffolk's involvement was widely suspected, although a collapse triggered by the shock of his arrest on fabricated charges would appear more likely.

Reluctance by English commanders delayed the transfer of Maine and its capital at Le Mans to the French until March 1448, after which the truce the handover was supposed to ensure would prove short-lived. French military successes followed, and at the end of October 1449 Edmund Beaufort, Duke of Somerset, surrendered Rouen, heralding the beginning of the collapse of English Normandy.

On top of these humiliating defeats, the worsening financial crisis and problems with Henry's rule at home also caused unrest. The huge cost of his marriage and increased household and military expenditure came at a time of falling income, due in part to an economic slump, but also to his unchecked distribution of royal assets and patronage to his favoured servants and courtiers. His seemingly unquestioning generosity to petitioners and haphazard interference in legal matters also called his judgement into question.

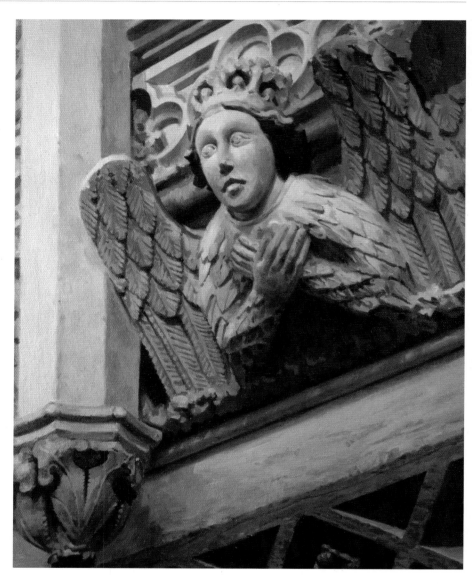

ANGEL AT EWELME

Angel from the tomb of Alice Chaucer, Duchess of Suffolk (d.1475), at St Mary's church, Ewelme, Oxfordshire. Alice was the granddaughter of the poet Geoffrey Chaucer and wife of William de la Pole, Duke of Suffolk.

Oil on canvas, 12" x 16" (30cm x 40cm), 2002.

> *'So there was noo good rule nor stablenes at that tyme to greet discomfort and hevynes of the peple.'*
> Bale's Chronicle

As he had been at the forefront of the unpopular negotiations with the French, William de la Pole, Duke of Suffolk, was widely blamed for the losses that followed. As popular unrest grew, on 9 January 1450, angry unpaid soldiers mustered in Portsmouth hacked to death one of Suffolk's affinity, Adam Moleyns, Bishop of Chichester and keeper of the Privy Seal. Suffolk's fall soon followed. Impeached by the Commons, he was charged with treason and corruption but never came to trial as

the king banished him for five years. Not that this saved him; the ship that was taking him to Calais and exile was intercepted by another vessel in the Channel, the *Nicholas of the Tower*. He was seized, subjected to a mock trial and beheaded 'withyn halfe a doseyn strokes'[1] with a rusty sword on the gunwale of a small boat, his body being dumped on the Kent coast.

The news from France continued to worsen, and on 15 April the French won a decisive victory against

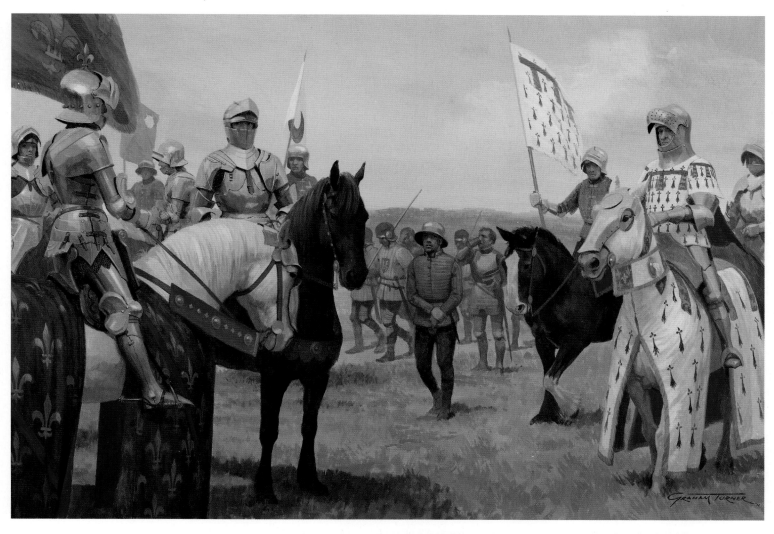

THE BATTLE OF FORMIGNY

The Count of Clermont and Constable de Richemont meet on the battlefield of Formigny, 15 April 1450. Clermont's small unit of artillerymen, protected by *francs-archeres* and men-at-arms, has just been defeated, but Richemont's arrival with his army would reverse the situation and result in a resounding French victory.

Gouache, 21.5" × 14.5" (55cm × 37cm), 2011.

FAR RIGHT The tomb of Alice Chaucer, Duchess of Suffolk, at St Mary's church, Ewelme.

RIGHT Garter stall plate of William de la Pole, Duke of Suffolk (1396–1450) at St George's Chapel, Windsor.

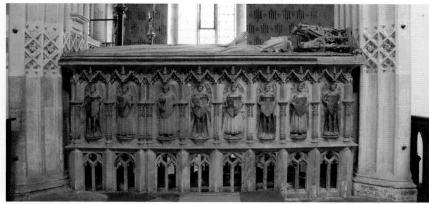

the English at the Battle of Formigny. With the French making such swift advances on the other side of the Channel, the people of Kent were now increasingly concerned by the threat of invasion – with good cause. In 1448 the coastal towns of Rye and Winchelsea had been burned by the French, and on 21 April 1450 the Isle of Sheppey in Kent was raided. Their fears were compounded by rumours that the king intended to turn their county into a 'wilde forest' as punishment for their perceived involvement in Suffolk's murder.

'we have not now a foote of londe in Normandie'
James Gresham to John Paston, 19 August 1450

LEFT Winchelsea was one of the privileged Cinque Ports, a confederation of coastal towns that included neighbouring Rye, Dover and Sandwich, all of whom enjoyed benefits, including exemption from many taxes and some legal jurisdiction, in exchange for a commitment to provide ships and crews to the Crown. Their fleets played a significant role in the English campaigns against the French during the Hundred Years War but, being on the front line, the Cinque Ports were also repeatedly attacked, the buildings burnt, inhabitants slaughtered, and property pillaged.

CADE'S REBELLION

By early June several thousand people – 'the comons of Kent'[2] – had converged on Blackheath, outside London, under the leadership of a certain John (Jack) Cade. Amongst their grievances, which included complaints about local corruption and extortion, the rebels demanded that certain of the king's advisors – 'his traytours abowt hym' – be removed from office and punished, declaring 'that his fals cowncell hath lost his law, his marchandyse is lost, his comon people is dystroyed, the see is lost, Fraunce is lost' and that he should 'take about his noble person his trew blode of his ryall realme, that is to say, the hyghe and myghty prynce the Duke of Yorke'.[3]

After initial inconclusive discussions between senior figures and the rebels, King Henry advanced in force to Blackheath, only to find the rebels had left overnight. Some of the king's men gave chase, a small royal force commanded by Sir Humphrey Stafford pursuing them into Kent, only to be ambushed at Sevenoaks on 18 June; Stafford and his cousin were amongst the dead, his expensive brigandine of velvet decorated with gilded nails, his sallet, and his spurs being taken by Cade himself. Despite punitive raids into Kent, the rebels regrouped and with growing

support among some of the king's own retainers, the king agreed to the arrest of some of those specifically singled out by the rebels as traitors, such as the treasurer Sir James Fiennes, Lord Saye and Sele, who had conspicuously benefitted from Henry's favour. As the situation became more unstable, the king fled to the Midlands and the safety of Kenilworth Castle, and at the end of June the emboldened rebels returned to Blackheath before advancing into London across London Bridge. Following sham trials, several officials were condemned, and Lord Saye and his hated son-in-law William Crowmer, Sheriff of Kent, were decapitated, their severed heads paraded through the city on poles and displayed on London Bridge.

The discipline Cade had initially proclaimed he could enforce within his horde now started to break down and, following an escalation of looting and other crimes, the citizens of London turned against the rebels. On the night of 5 July, Lord Scales led a force of Londoners to take London Bridge and drive them out of the city, and the ensuing fight at the Southwark end caused many casualties on both sides; 'ande many a man was slayne and caste in [the River]

BELOW LEFT Roger and James Fiennes both rose to prominence after their part in Henry V's victory at Agincourt, and with the profits they made from the war in France the brothers aggrandised themselves in the south-east. In 1441, Roger began building his sumptuous castle at the family manor of Herstmonceux in Sussex, as befitted his position as treasurer of the king's household.

BELOW CENTRE James Fiennes acquired the estate at Knole in Kent in the 1440s, extending it by the sometimes-forceful purchases of neighbouring land. His corruption and ruthless exploitation of his power in the county made him a hated figure and was one of the triggers for Cade's rebellion.

BELOW RIGHT Kenilworth Castle in Warwickshire.

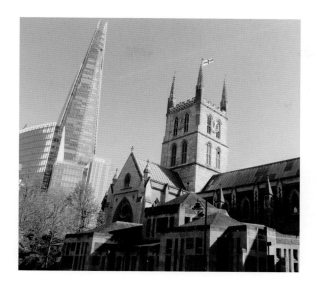

Southwark Priory (now a cathedral), heavily restored in the 19th century, has been witness to so much history from its location at the southern end of London Bridge, one of the main gateways into the medieval city. In its heyday it would have dominated its surroundings, but is now rather dwarfed by the modern world that has grown up around it, especially the nearby Shard.

ABOVE The duke of York's badges of the falcon and fetterlock. *Gregory's Chronicle* describes the appearance of York's retainers in 1460; 'hys lyvery was whyte and brewe [blue] in hyr clothing, and i-brawderyd [embroidered] a-bove with fetyrlockys'. (The British Library, Add MS 40472)

Temys, harnys [armour], body, and alle'.[4] During the struggle Cade's men set fire to part of the bridge, the repairs only being completed just before it once again became the scene of further violence and destruction after the Battle of Tewkesbury in 1471.

RICHARD, DUKE OF YORK

The man conspicuously named in Cade's manifesto as the remedy for the country's ills was Richard Plantagenet, Duke of York. A cousin of the king through their shared descent from Edward III, York was born in 1411 and his titles – and the considerable wealth from their associated vast estates across the country and in Wales and Ireland – were inherited from two of his childless uncles: his father's brother Edward, Duke of York, who had been killed at Agincourt, and his mother's brother, Edmund Mortimer, Earl of March and Ulster. Richard's own father, the earl of Cambridge, had been executed for treason against Henry V on the eve of the Agincourt campaign in 1415 and his title and estates forfeited, but his uncles' inheritance made him a very wealthy and powerful prince, the foremost duke in the country after Gloucester's death and, until Henry and Margaret produced a child, the strongest candidate as heir to the throne. Later, it would be claimed that his right to the throne was actually stronger than King Henry's. From the age of 12 he was brought up in the earl of Westmorland's household and he married Cecily Neville, the daughter of the earl and his wife, Joan Beaufort. The young duke attended Henry's coronations in London and Paris, and after Bedford's death he was appointed to succeed him as the king's lieutenant-general and governor in France. However, his service in France

Pardons were issued to help disperse the rebels, and a large bounty was placed on Cade's head resulting in his capture on 12 July. He died of his wounds before he could be brought to trial, but his body was still given the traitor's treatment of beheading and quartering as a dire warning to others. Apart from the few notable officials murdered, most of those named by the rebels continued their corrupt practices, and festering unrest sporadically erupted into violence.

Although Cade's Rebellion was primarily a Kentish affair, unrest wasn't confined to the southeast. On 29 June another of the king's hated advisers, William Aiscough, Bishop of Salisbury (who had conducted the royal wedding in 1445), was murdered at Edington in Dorset and his property plundered, and 'that same yere was slayne [William] Tresham, the man of lawe, that was Speker of the Parlymentt, and hys sone was soore woundyde in Northehampton schyre.'[5]

left him continuously out of pocket, leading to resentment with the government as his claims for recompense were often overlooked. Feeling increasingly sidelined as others were favoured by the king, York withdrew to his estates in Ireland in June 1449, where he was lord lieutenant, and he stayed there while the crisis unfolded in London and Kent.

To the consternation of some of the king's court, York returned in the autumn of 1450 and entered a London choked with dispirited soldiers and their families fleeing Normandy: 'cam thrugh Chepe diverse long cartes with stuff of armor and bedding and houshold as well of Englissh as of norman goodes and men women and children in right pouer array pitewus [piteous] to see driven out of normandy.'[6] The situation became more volatile as other lords with their armed and liveried retainers converged on the city for the opening of Parliament in November, and the duke of Somerset, recently returned from France with his defeated army, was hurriedly lodged in the Tower of London for his own safety as anger over his surrender of Normandy boiled over and he was attacked by a mob and his property ransacked; 'And that day he was robbyde of alle hys goodys, and hys jewyllys were takyn and borne a-way'.[7]

In a demonstration intended to display his power and crush the disorder, the king led his lords – including York, who had assured Henry of his loyalty – through

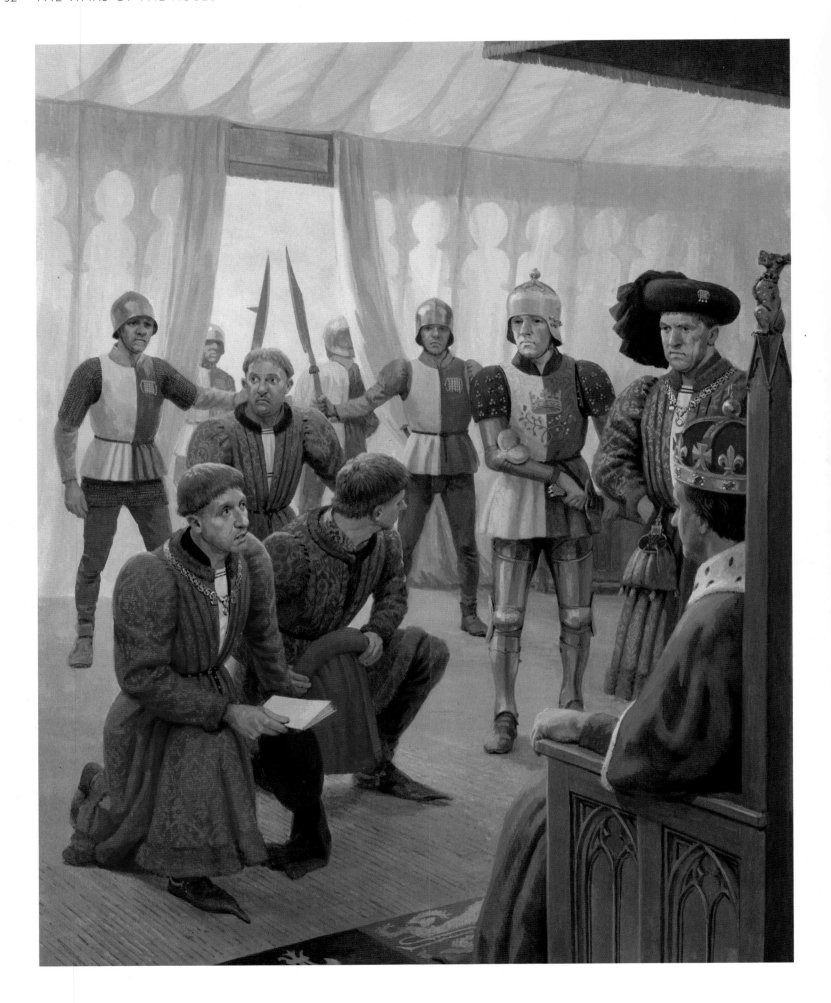

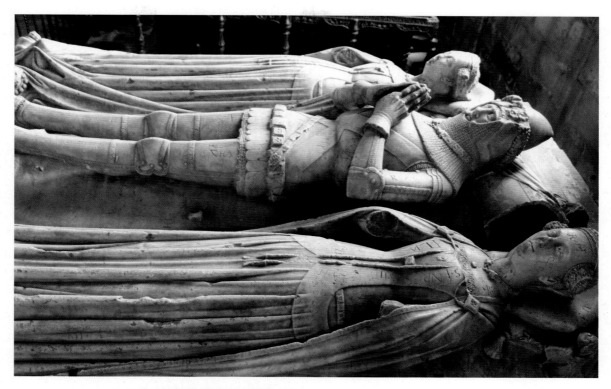

RIGHT The tomb of Ralph Neville, first Earl of Westmorland (1364–1425) and his two wives, Margaret Stafford and Joan Beaufort, at Staindrop church, County Durham.

BOTTOM RIGHT Raby Castle in Durham, birthplace of Cecily Neville, one of the fine Neville residences in the north, which included Brancepeth, Middleham and Sheriff Hutton.

'the hyghe and myghty prynce the Duke of Yorke'

Proclamation made by Jacke Cade, Capytayne of ye Rebelles in Kent

London, fully armoured and with a large armed force 'whyche was a gay and a gloryus sight if hit hadde ben in Fraunce, but not in Ingelonde, for hyt boldyd sum mennys hertys that hyt causyd aftyr many mannys dethe'.[8] He then moved through Kent and other disaffected counties, and commissions clamped down hard on those accused of continuing to cause trouble –

OPPOSITE
YORK'S HUMILIATION
Blackheath, 2 March 1452

Following a tense military standoff and lengthy negotiations, the duke of York kneels before Henry VI to present his petition, only to find his arch-rival the duke of Somerset standing beside the king, despite assurances to the contrary. With York are the earl of Devon and Lord Cobham, the only peers to offer their support. The *London Chronicle* reports the scene: 'And furthwith the duke sent his men home ageyne, and he mekely came and submitted himself at the Blak heth to the kyng, his adversaries there standing present, contrary to thappointment'.

Gouache, 12.3" × 17.6" (31cm × 45cm), 2023.

the spirit of reconciliation immediately after Cade's Rebellion was replaced by a series of trials and executions. A contemporary chronicler commented on the severity of the clampdown: 'Men calle hyt in Kente the harvyste of hedys'.[9]

Somerset's stay in the Tower had been brief, and he was at the forefront of the reprisals against the malcontents in Kent. He soon regained his position as the king's favourite and in April 1451 was appointed captain of Calais, the sole remaining English foothold in northern France. The French now turned their attention to the English possessions of Gascony and Bordeaux in south-western France.

York spent Christmas 1451 at Ludlow Castle, from where he restarted his political manoeuvrings, issuing a statement in February 1452 in which he reiterated his allegiance to the king and stated his aim was solely the removal of the duke of Somerset and a desire to take up what he considered his rightful position at the king's right hand. Refusing a summons to meet the king at Coventry, York marched on London with a substantial force where, finding the gates barred, he crossed the Thames at Kingston and set up camp at his property in Dartford, which was well defended with 'posts, ditches and guns'.[10]

When the king arrived soon after, his army formed up on Blackheath and high-ranking emissaries were despatched to open talks with York on 28 February. These included the earls of Salisbury and Warwick, York's Neville in-laws; the situation

had yet to ally them in a common cause, and at this stage the only lords to support York were the earl of Devon and Lord Cobham, who had sided with him as a result of their own West Country disputes. Following lengthy negotiations, Henry agreed to accept York's petition and remove Somerset from his council while York's grievances were considered.

So, believing that his case against Somerset would at last be heard, York, with Devon and Cobham, entered the king's tent on Blackheath on 2 March and knelt before him to present his petition, only to discover that they had been deceived – Somerset stood defiant next to the king. Disarmed, York was escorted to London and humiliatingly made to swear at St Paul's Cathedral that 'I, Richard, Duke of York, confess and beknow that I am and ought to be humble subject and liegeman to you, my sovereign Lord, King Henry the Sixth, and owe therefore to bear you faith and truth as to my sovereign lord, and shall do all the days unto my life's end', also stating 'I never shall anything attempt by way of fear or otherwise against your royal majesty'.[11] The proud duke was fortunate not to have been charged with treason, and he retired to Ludlow to lick his wounds.

> *'seeing that the said Duke [Somerset] ever prevaileth and ruleth about the King's person, [and] that by this means the land is likely to be destroyed, am fully concluded to proceed in all haste against him... R. York'*
>
> Duke of York's manifesto, 1452

DEFEAT IN FRANCE AND A CONSTITUTIONAL CRISIS

Just before Easter 1453, King Henry was delighted to hear that 'oure most entierly belovyd wyf the Quene was with child, to oure most singular consolation, and to all oure true liege people grete joy and comfort'.[12]

Queen Margaret undertook a pilgrimage to the shrine of Our Lady at Walsingham in Norfolk to give thanks, and during her return journey she granted an audience to Cecily, Duchess of York. Cecily, born in 1415, the year of the Battle of Agincourt, had her first child at the age of 24, ten years into her marriage, but by 1453 had given birth to 11 babies, including at least four surviving sons – two of whom would go on to be kings of England. She could therefore offer some empathy to Margaret, who at 23 was expecting her first child after eight years of marriage, giving the king hope for a long-awaited heir. In a letter to the queen written soon after, Cecily refers to the meeting between the two women and congratulates her on her pregnancy; 'it plesid our Lord to fullfill your right honerable body of the most precious, most joyfull, and most comfortable erthely tresor [earthly treasure] that myght come into this land'. The primary purpose of her approach to the queen was however to appeal to her to mediate on behalf of her husband, the duke of York, who was suffering 'infinite sorrow' due to his estrangement 'from the grace and benevolent favor of that most cristen, most gracious and most mercifull prince, the king our soverayn lord'. The letter reminds the queen that she received Cecily's appeal 'full benignly', but the outcome of the duchess's approach is unknown and would anyhow soon be overtaken by cataclysmic events.[13]

Following their reconquest of Normandy in 1450, the French focused their efforts against the English possessions of Gascony and Bordeaux in south-western France. Unlike relatively recently conquered Normandy, Aquitaine – or Gascony – had belonged to the English kings since the twelfth century. All seemed lost when Bordeaux capitulated on 12 June 1452, but the situation was temporarily reversed when a relief force under the great captain John Talbot, Earl of Shrewsbury, retook the city later in the year. However, a determined French advance in early June 1453 continued their previous successes, and on 17 July they won a decisive victory at Castillon, destroying the English army and leaving Talbot and his son Viscount Lisle amongst the dead. The conflict now known as the Hundred Years War had ended in defeat for the English, and Henry V's ambition to combine the two kingdoms under Lancastrian rule were finally extinguished.

The news was greeted with dismay in England and may have been a contributing factor to a situation that would cripple the government and have disastrous future consequences; Henry VI suffered a complete

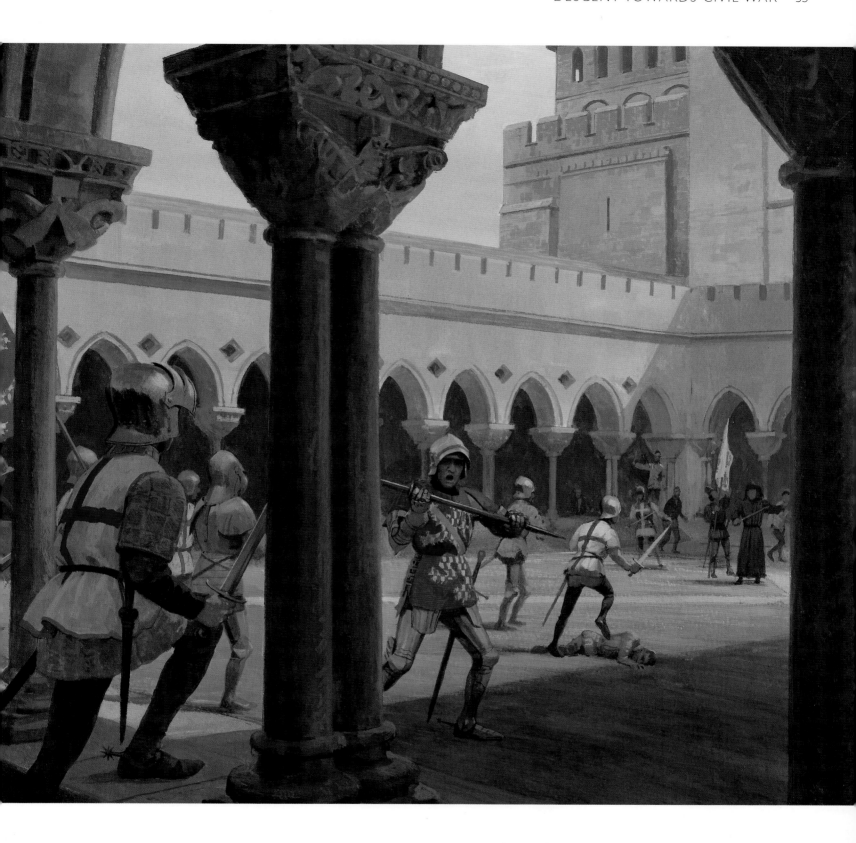

ATTACK ON THE PRIORY OF SAINT-FLORENT

Anglo-Gascon forces storm the Priory of Saint-Florent early in the morning of 17 July 1453, catching the defending French garrison by surprise. Lord Talbot's standard-bearer, Sir Thomas Evringham, can be seen encouraging the assault, while Pierre de Beauvau tries to rally the defenders and organise their retreat to the fortified artillery park east of the town of Castillon.

Gouache, 21.5" x 14.5" (55cm x 37cm), 2011.

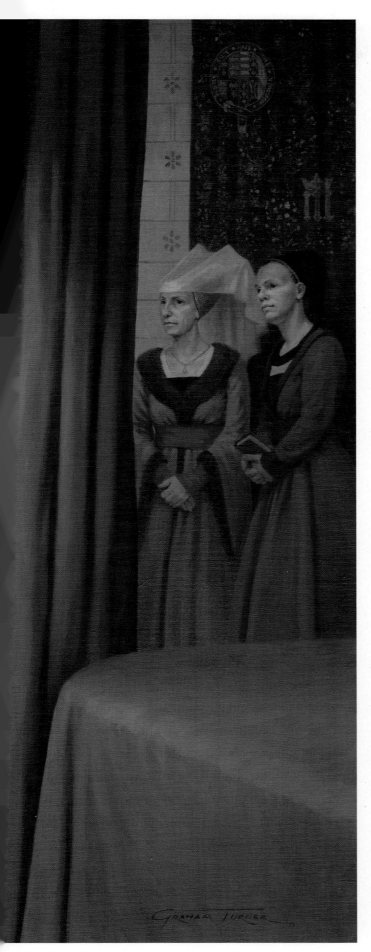

mental collapse, 'smyten with a ffransy and his wit and reson withdrawen'.[14] At first efforts were made to conceal the situation in the hope that the king would recover quickly, but it soon became apparent that with Henry in a catatonic state, the government could not function. The political rifts opened up once again; an attempt to exclude York from a great council meeting failed, and, without the protection of the king, Somerset was vulnerable. Accused of treason, he was taken to the Tower of London where he would remain, uncharged, for over a year. The struggle for power had turned in York's favour.

> *'And upon Seynt Edwardes day the*
> *Quene was delyvered of a fair Prynce,*
> *whos name was called Edward'*
> *Chronicles of London*

Queen Margaret gave birth to a son on 13 October, providing the still unresponsive Henry with his precious heir. When she tried to present the baby prince to Henry at Windsor, 'desiryng that he shuld blisse it', the king gave no answer, and only once 'he loked on the Prince and caste doune his eyene ayen [eyes again], without any more.'[15]

Her attempts to put herself forward to rule on Henry's behalf as regent until their son came of age were rejected and, amid an atmosphere of high tension, on 3 April 1454 the duke of York was officially appointed Protector and Defender of the Realm.

DUCHESS CECILY'S SUPPLICATION

Cecily Neville, Duchess of York, is granted an audience with Queen Margaret, on her way back to London from a pilgrimage to give thanks for her pregnancy at the shrine of Our Lady at Walsingham in the spring of 1453. Following the debacle of 1452, the disgraced duke of York was keeping a low profile at Ludlow, and Cecily's approach to the queen is an attempt to persuade her to intercede with the king on her husband's behalf and encourage him to accept York back into his 'grace and benevolent favor'.

On the wall of the chamber is a tapestry depicting St Margaret (the patron saint of childbirth), in the vase are marguerites (the flower she shared her name with is drawn in the manuscript illumination of her on page 27), and at her feet is a small dog. A letter from King Louis of France written straight after Margaret's death in 1482 suggests she had a passion for dogs, for it says that her dogs were all that remained of her possessions. He sent an equerry 'to bring me all the dogs you have had from the late queen of England. You know she has made me her heir, and that this is all I shall get; also it is what I love best.'

Oil on canvas, 32" x 24" (81cm x 61cm), 2023.

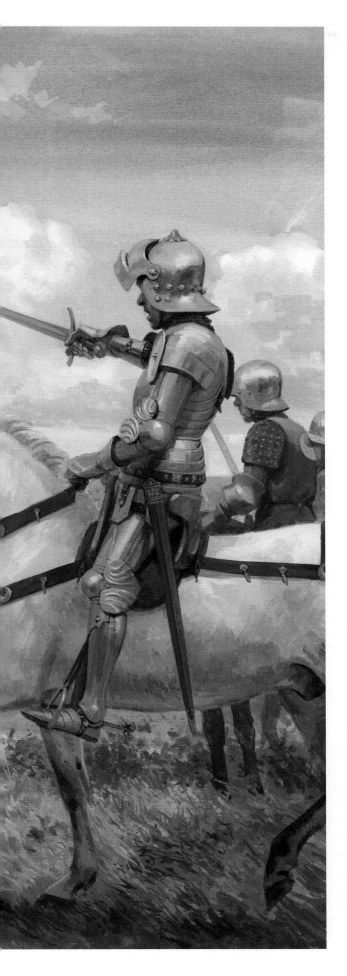

THE BEGINNING OF THE GREATEST SORROW IN ENGLAND

'And after the marriage, on the way back, there was a great division between Thomas Percy Lord Egremont and the said earl [Salisbury], near York. It was the beginning of the greatest sorrow in England.'
William Worcester, Annales Rerum Anglicarum

At various times of crisis during the period, when central power was lacking, some of the king's more ambitious subjects would grasp the opportunity to take the law into their own hands and escalate personal disputes, taking up arms against their rivals and waging private wars. One of the primary occupations of the rich and powerful was the continued expansion of their power, influence and wealth, something they devoted considerable effort to achieve. Advantageous marriages provided the enticing possibility of additional titles and land, but inevitably the complex web of relationships that resulted led to disagreements over inheritances – from the Crown all the way down through society. The rival claimants' attempts to strengthen their positions with alliances to others with even more power and influence than themselves eventually led to the division of society into the factions that would ultimately take up arms against each other in the coming Wars of the Roses.

One such disagreement involved a central figure of the Wars of the Roses – Richard Neville, Earl of Warwick, who would become known to history as the 'Kingmaker'. The oldest son of Richard Neville, Earl of Salisbury, his childhood marriage to Anne Beauchamp, daughter of the late Richard Beauchamp, Earl of Warwick, provided him with his title and the vast income from his estates. However, the duke of Somerset had married another of Beauchamp's daughters, from his first marriage, and laid claim to the inheritance for himself. It was while on a royal progress to quell a flare up of their disagreement in Glamorgan that King Henry stopped at the royal hunting lodge at Clarendon in Wiltshire, and it was here that he suffered his mental collapse.

In the north, the long-running struggle for regional dominance between the Neville and Percy families was another dispute to explode into violence in the summer of 1453. Thomas Percy, Lord Egremont, second son of the earl of Northumberland,

CONFRONTATION ON HEWORTH MOOR

Tensions between the rival Percy and Neville families come to a head on 24 August 1453, when, returning to Sheriff Hutton from the wedding of Thomas Neville and Maud Stanhope in Lincolnshire, the Nevilles find their route blocked by Thomas Percy, Lord Egremont, with a large force of men, on Heworth Moor to the east of York.

Behind them, beyond the large expanse of the King's Fishpool, York Minster towers over the walled city, and the Layerthorpe Bridge crosses the river Foss near St Cuthbert's church.

Gouache, 18.7" x 13" (48cm x 33cm), 2022.

was something of a troublemaker, and built up a particular enmity against Richard Neville, Earl of Salisbury, and his sons John and Thomas. The Percys were upset by plans to marry Thomas Neville to the niece and co-heiress of Lord Cromwell, Maud Stanhope, who stood to inherit some traditionally Percy-owned properties, so Lord Egremont decided to plan his own reception. On 24 August the newly married couple and their wedding party were returning from Cromwell's Tattershall Castle when, at Heworth Moor just outside York, they found their way blocked by Egremont and a large force. The Nevilles must have presented a strong deterrent because no fatalities are recorded, but this was just one of many altercations and standoffs between followers of the two families that occurred at this time. The lawlessness took on wider implications in 1454 when Henry Holland, Duke of Exeter, joined Egremont and began gathering armed men at the Percy manor at Spofforth, before threatening the city of York. The crisis was sufficiently serious for the newly appointed protector to head north and personally intervene. York's young sons Edward and Edmund wrote to him at this time; to 'oure most worschipfull and gretely redoubted lorde and fader, the Duke of Yorke, Protector and Defensor of Englonde… we conceyve your worschipfull and victorious spede ageinest your enemyse, to ther grete shame', reassuring him that 'we have attended owre lernyng… and schall here aftur; by the whiche we trust to God youre graciouse lordeschip and good Fadurhode schall be plaesid.'[16] Exeter was taken to Pontefract Castle and imprisoned, and, after a further 'battle' between the Nevilles and Percys at Stamford Bridge at the beginning of November, Egremont was also captured and jailed. He spent two years behind bars before breaking out of Newgate on the night of 13 November 1456, was with King Henry at Ludford Bridge in 1459, and then died defending him at Northampton in 1460.

The disputes involving the father and son Richard Nevilles, earls of Salisbury and Warwick, gave them and the duke of York common adversaries – the duke of Somerset and earl of Northumberland. This, together with their kinship – York was married to Salisbury's sister Cecily – made for a natural alliance between them, creating the foundation for what would emerge as the Yorkist faction in the coming wars, and have such an impact on history.

Along with the troubles in the north, on the Welsh borders and elsewhere, the peace was also shattered by

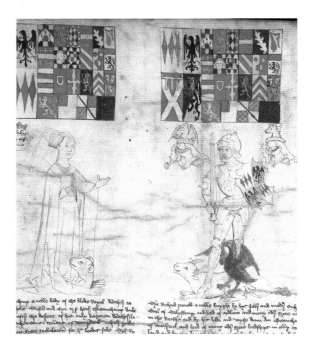

LEFT Richard Neville, Earl of Warwick, and his wife, Anne Beauchamp, with their heraldic pedigrees above them. From the Rous Roll, possibly commissioned c.1483 by their daughter, Anne Neville, Richard III's queen. (The British Library, Add MS 48976 f.7)

disturbances in the West Country, where a long-running dispute between the earl of Devon and Lord Bonville flared up into several outbreaks of violence throughout this unsettled period. The family of Thomas Courtenay, Earl of Devon, had been dominant in the south-west for centuries, but the rise of William, Lord Bonville, threatened their power and influence in the region. In 1451 Devon raised a large force to overawe his adversaries, Bonville and his ally the earl of Wiltshire, plundering Wiltshire's estates before besieging Bonville at Taunton Castle. The siege was lifted after the swift intervention of the duke of York, following which Devon and his adherent Lord Cobham attached themselves to the duke's cause and took up arms alongside him at Dartford in 1452. After the failure of that venture, Devon was detained and, stripped of his offices, his regional power was totally eclipsed by Bonville; for his part in the rebellion, Cobham was imprisoned in Berkhamsted Castle for two years. However, under York's protectorate Devon spotted an opportunity to re-establish himself and he restarted his campaign of violence and intimidation against his adversary, resulting in government censure for both parties and a warning against further trouble.

Devon's alliance with York waned at this point, and he stood with King Henry at the coming Battle of St Albans, where he was wounded. Devon and Bonville's dispute was far from settled, though, and would erupt again into violence later in the year.

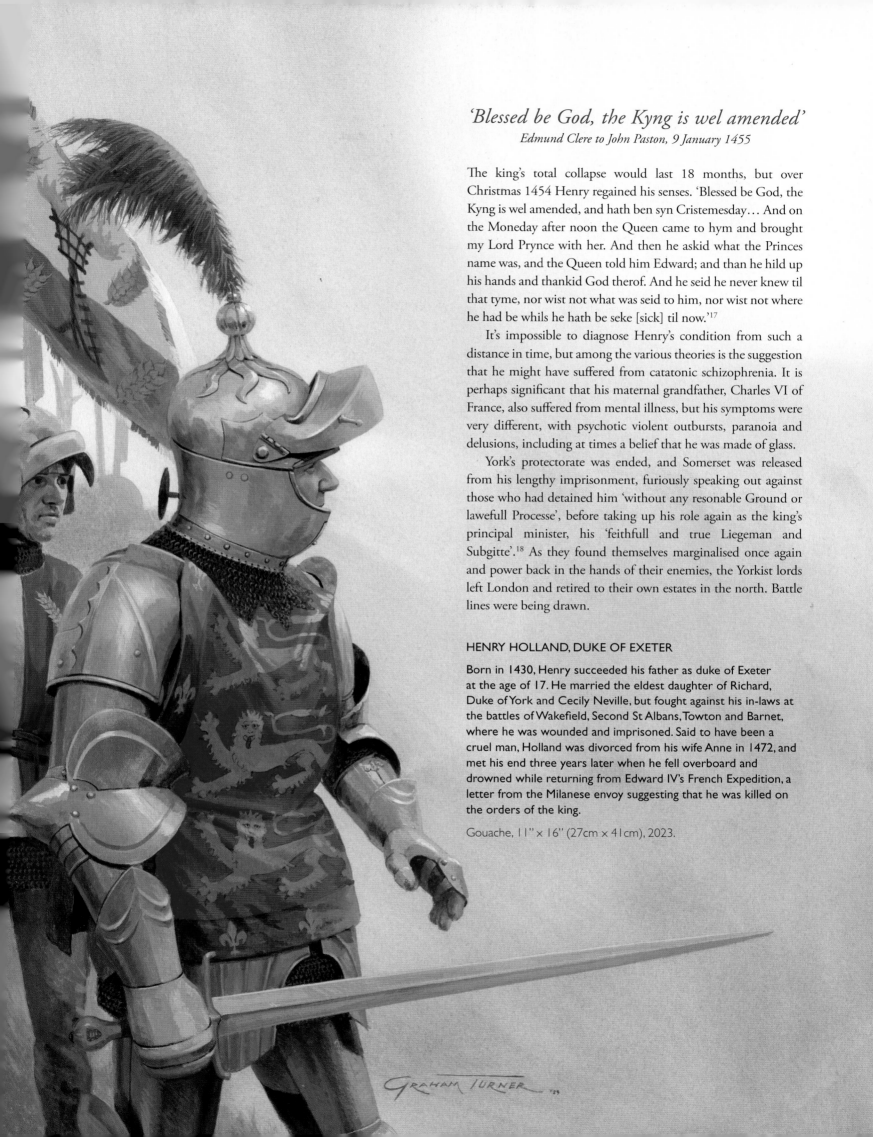

'Blessed be God, the Kyng is wel amended'

Edmund Clere to John Paston, 9 January 1455

The king's total collapse would last 18 months, but over Christmas 1454 Henry regained his senses. 'Blessed be God, the Kyng is wel amended, and hath ben syn Cristemesday… And on the Moneday after noon the Queen came to hym and brought my Lord Prynce with her. And then he askid what the Princes name was, and the Queen told him Edward; and than he hild up his hands and thankid God therof. And he seid he never knew til that tyme, nor wist not what was seid to him, nor wist not where he had be whils he hath be seke [sick] til now.'[17]

It's impossible to diagnose Henry's condition from such a distance in time, but among the various theories is the suggestion that he might have suffered from catatonic schizophrenia. It is perhaps significant that his maternal grandfather, Charles VI of France, also suffered from mental illness, but his symptoms were very different, with psychotic violent outbursts, paranoia and delusions, including at times a belief that he was made of glass.

York's protectorate was ended, and Somerset was released from his lengthy imprisonment, furiously speaking out against those who had detained him 'without any resonable Ground or lawefull Processe', before taking up his role again as the king's principal minister, his 'feithfull and true Liegeman and Subgitte'.[18] As they found themselves marginalised once again and power back in the hands of their enemies, the Yorkist lords left London and retired to their own estates in the north. Battle lines were being drawn.

HENRY HOLLAND, DUKE OF EXETER

Born in 1430, Henry succeeded his father as duke of Exeter at the age of 17. He married the eldest daughter of Richard, Duke of York and Cecily Neville, but fought against his in-laws at the battles of Wakefield, Second St Albans, Towton and Barnet, where he was wounded and imprisoned. Said to have been a cruel man, Holland was divorced from his wife Anne in 1472, and met his end three years later when he fell overboard and drowned while returning from Edward IV's French Expedition, a letter from the Milanese envoy suggesting that he was killed on the orders of the king.

Gouache, 11" x 16" (27cm x 41cm), 2023.

CHAPTER 4
THE ARMIES

The great magnates who wrestled for power during the Wars of the Roses were able to mobilise considerable numbers of men to fight for them. Aside from their personal households, lords attracted the service of lesser ranking men in exchange for their 'good lordship', the promise to look out for their interests and provide protection and backing in their own legal and other disputes. This system, known as livery and maintenance, created huge networks based on mutual support, and the larger these affinities grew, the more powerful all those within them became. These men wore the livery and badges of their lords to identify their allegiance, and when these affinities flexed their combined muscles for their own ends they created considerable law and order problems and terrible perversions of justice. In 1461, Edward IV attempted to tackle the rise in 'Extorcions, Robberies, Murdres' caused by the increasing scale of the practice of 'gyvyng of Lyverees and Signes', contrary to existing statutes. Among his measures were decrees limiting the issue of 'any Lyveree of clothyng' to resident household servants or councillors, and forbidding 'any Lyveree or signe, marke or token of compaignie' unless under special commandment of the king for the 'resistyng of his Ennemyes, or repressyng of Riottes within his lande'.[1] However, it appears these measures, and other statutes of 1468, were not enforced, and the practice of livery and maintenance continued unchecked.

The armies that fought in France had been raised by a system of contracts, indentures, drawn up between the king and his captains. These indentures, so called because they were divided in two with a zigzag cut – indented – with one half given to each party, detailed how many men would be provided, for how long, and for what fee. This led to the practice of magnates issuing lifetime contracts to a core of retainers who could be called upon to provide men at short notice (see right). A letter written at the time of the Lincolnshire uprising in 1470 by Sir John Paston records that 'the Kynge hathe sente ffor hys ffeodmen to koom to hym',[2] feedmen referring to those receiving a fee for being retained in his service. At the Second Battle of St Albans a chronicler

LEFT 'all arayed in rede jakettys with whyte raggyd staves upon them'. Retainers of the earl of Warwick wearing their master's livery with his badge of the ragged staff, from the *Beauchamp Pageant, c.*1483–85. (The British Library, Cotton MS Julius E IV-3 f.13r)

commented that 'The substance that gate [got] that fylde were howseholde men and feyd men.'[3]

The scale that these preparations could sometimes reach is illustrated in the household accounts of Sir John Howard (duke of Norfolk from June 1483), in an entry made in February of 'The first yere of Kyng Richard the thirdd' headed 'The names of the M. [1,000] men that my Lord hath graunted to the Kyng'. Before a long list of names it states 'certain men of his Lordshippes underwritten, to be ready at all tymes at my Lordes wages'.[4]

Another way in which armies were raised was through commissions of array, issued by the king in times of national emergency, enabling him to raise troops from towns or boroughs for the country's defence. In January 1461 Norwich agreed to provide King Henry with 120 soldiers to resist the Yorkist lords; William Rokewoode Esquire was appointed as captain, and they were to serve for six weeks, at sixpence each per day, paid for by the city. Complaints at the expense involved in complying with the requests for soldiers 'at every batell to come ferre

BELOW Although a man of standing in his own right, serving as a justice of the peace and Member of Parliament (Speaker in 1426), Derbyshire knight Sir Richard Vernon indentured to become a retainer of Humphrey Stafford, Earl of Buckingham, in 1440. Their agreement specifies that he would be paid an annual fee of £20 for life, 'to be redy at all tymes when he shall be sent for to com to the said erle upon reasonable warning to doe him service... on this side of the see', with a gentleman, four yeomen, a page and seven horses, adding that he would be provided with a 'liveree' and that reasonable costs would be reimbursed. His tomb at Tong, Shropshire, shows Sir Richard in a high quality armour that was slightly out of fashion at the time of his death in 1451, with a livery collar of esses showing his allegiance to the king.

Tomb effigies often show their owners wearing a livery collar, a powerful symbol of their connection to the king – those dating from the reigns of the Lancastrian monarchs made up of interlinked esses, while those honoured by the receipt of such a prestigious token under the Yorkist kings proudly display suns and roses, either with Edward IV's lion pendant or Richard III's boar. In 1467 Sir John Howard had 'a collar of gold with thirty-four roses and suns set on a corse of black silk with a hanger of gold garnished with a saphire'. Edward IV's 1478 ordinance stated 'Every lorde, knight, and squyer, aswele squyers for the body as other within the household, were daily a coler of the kings lyverye aboute their nekkes as to theym apperteyneth.'

ABOVE Sir John Carent, d.1478, Marnhull, Dorset.

CENTRE Boar pendant worn by Ralph Fitzherbert, d.1483, Norbury, Derbyshire.

RIGHT Sir Robert Whittingham, d.1471, Aldbury, Hertfordshire.

BELOW Silver gilt boar badge found at Bosworth, possibly lost by one of Richard III's retainers. (Bosworth Battlefield Heritage Centre/Leicestershire County Council)

oute there countreis at ther awne coste',[5] along with accusations that compliance was unreasonably demanded, sometimes 'upon pain of death', made the system unpopular. It didn't help that at times there were two rival kings demanding service! Before the Battle of Towton King Henry and King Edward both issued commissions of array in the king's name, which is one reason why the armies there were so large, and the Coventry records of 1469 include letters received in the run up to the Battle of Edgcote asking for soldiers to be provided – from King Edward himself, and also in Edward's name from the earl of Warwick, before his part in instigating the uprising against the king had been revealed. In

March 1471, with Henry back on the throne and Edward landed in the north, the earl of Oxford wrote that with 'the Kyngs gret enemys and rebellis, acompanyed with enemys estraungers… landyd in the north parties of this his land, to the utter destruction of his roiall persone, and subversion of all his realm… the Kings Highnesse hath comaunded and assigned me, under his seall, sufficient power and auctorite [authority] to call, reyse, gader, [raise, gather] and assemble, fro tyme to tyme, all his liege people of the shire of Norff., and other places, to assiste, ayde, and strenght me in the same entent.'[6]

Cash to fund military campaigns was often in short supply, and those in the higher levels of society might expect their support to be rewarded with lands and lucrative offices forfeited by the defeated. On 11 June 1483, Richard III wrote to Lord Neville asking him to provide as many men as he could, 'defensably arrayde', promising him 'do me nowe gode service, as ye have always before don, and I trust nowe so to remember you as shal be the makyng of you and yours.'[7] Similarly, a letter from Henry VII to Sir Robert Plumpton, written in 1489, thanks him in advance for his expected support 'for the reduceing of our people there to our subjection and obedience, to our singuler pleasure and your great deserts', promising 'to remember you in time to come in any thing that may bee to your preferment and advancement'.[8]

Most common soldiers expected cash payment, though, and the levies that came south with Queen Margaret in 1461 probably 'fledde a-way' because their wages ran out, leaving the 'howseholde' and 'feyd men' to fight and win at St Albans.[9] While serving in the north in 1464, John Paston III wrote to his brother asking for more money, 'for I may get leve for to send non of my wagyd men home ageyn; ne man can get no leve for to go home but if they stell a wey, and if they myth be knowe, they schuld be scharply

ponyschyd [punished].'[10] When the Lancastrian war-chest was captured in Northumberland during the same year, 'the men wolde not go one fote with hym [Henry VI] tylle they had mony'.[11] Keeping an army together after the contracted period was difficult, making organisational ability a critical attribute for success, something that Edward IV proved adept at during the campaigns to reclaim the throne in 1471. After Barnet he 'sent to all partes to get hym freshe men',[12] and following the Battle of Tewkesbury he 'thus preparyd a new armye'.[13]

Soldiers from overseas also found employment during the Wars of the Roses, some with specialist skills such as gunners from Burgundy, employed by the earl of Warwick at the Second Battle of St Albans and by Edward IV in 1471 when he returned from his exile with 'three hundred of Flemmynges with hande-gonnes.'[14] Henry Tudor's invading army of 1485 contained significant French and Scottish contingents, and the Yorkist army at Stoke in 1487 included a large proportion of German and Irish troops.

As would be expected in such a hierarchical society, the top positions of command were given to men from the highest tiers, some of whom proved to be good strategists and leaders of men, others less so. The contingents that served under them were led by men lower down the social ladder: knights, esquires and sometimes commoners. A few of low birth managed to achieve recognition as talented captains and were valued for their expertise. Notable amongst them was Andrew Trollope, who served in France and rose to high office at Calais under the earl of Warwick, who 'had greater faith in him than any other'. This faith was perhaps misplaced, for having led the men of the Calais garrison over to the king at Ludford Bridge in 1459, Trollope served the duke of Somerset and is credited with contributing to the victories at Wakefield and the Second Battle of St Albans, after which he was knighted. The opposite level of competency was also remarked upon at St Albans, where a chronicler commented that 'the kyngys mayny lackyd good gydyng, for sum were but newe men of warre'. A contingent from Dunstable was captained by a butcher who blamed himself for the deaths of many of his company 'for schame of hys sympylle gydynge', and 'for very sorowe… hunge hym selfe'.[15]

FRIEND OR FOE

'every man myghte knowe hys owne feleschippe by hys lyverey'
Gregory's Chronicle

Those of rank were identified by their personal heraldry, and their coats of arms could become very complex if they incorporated the arms of the various branches of their owner's proud pedigrees. The badge was therefore adopted as a simpler method of recognition, to be worn by their retainers and displayed on their standards and possessions. Much like a modern logo, these badges have become synonymous with their owners, the white and red roses associated with the rival royal houses of York and Lancaster being the most obvious, although the significance of the red rose to the Lancastrians is somewhat tenuous until Henry VII cleverly combined the two to create the iconic Tudor rose.

A ballad written after the Battle of Northampton refers to the Yorkist lords by their badges:

And ensaumple here of I take witnesse,
Of certeyne persones that late exiled were,
Whos sorrow is turned into joyfulnesse,
The Rose, the Fetyrlok, the Egle, and the Bere.[16]

The rose refers to Edward, Earl of March, the fetterlock to his father, the duke of York, and the eagle and bear to the earls of Salisbury and Warwick respectively.

After the Battle of Mortimer's Cross in 1469, Edward IV adopted the sun in splendour as one of his badges, incorporating it with the white rose to

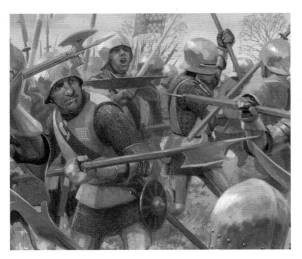

Over the white and blue livery of the duke of Somerset, with the Beaufort portcullis badge on his chest, this billman wears the Prince of Wales' 'bende of crymesyn and blacke with esteryge [ostrich] fetherys.'

(Detail from the painting of the Second Battle of St Albans reproduced on pages 98–99.)

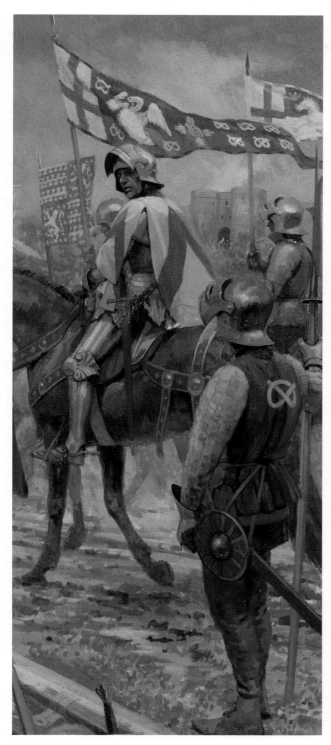

create the rose-en-soleil. In the fog at Barnet ten years later, confusion between this badge and the earl of Oxford's star would have disastrous consequences.

Livery is the issuing of cloth to a retainer, and certain colours have become synonymous with particular lords' affinities. However, in our desire to seek order we should try to avoid thinking of it in terms of a uniform as would be found in later armies, as these colours were not fixed or regulated, and various combinations might be issued at different times or for special occasions. In 1460 the duke of York returned from Ireland – 'hys lyvery was whyte and brewe [blue]… and i-brawderyd [embroidered] a-bove with fetyrlockys'.[17] White and blue is more usually associated with the Lancastrian Henry VI and the Beauforts, but of course the duke of York was also part of Henry's royal family. The shifting allegiances of civil war often throw up many similar contradictions and confusions; the arch-rival Percy and Neville families appear to have both issued black and red livery. Edward IV's account books contain entries detailing the provision of large quantities of jackets in his livery colours of murrey and blue. In 1469 an order for a thousand 'Jacquettes of blew and murry with roses' also included banners, standards, and forty jackets of velvet and damask with roses. These latter jackets made from such expensive cloth were clearly for important men, and a later entry in the wardrobe accounts shows the issue of velvet to two of the king's knights of the body; 'a yerde of velvet purpulle and a yerde of blue velvet for theire jakettes to be made of', with squires of the body issued with satin in the same colours – not the usual murrey and blue.[18]

In May 1455 the king wrote to Coventry requesting troops. The mayor ordained that one hundred 'goode-men' with 'bowes & arowes, Jakked & saletted' should be made ready to attend the king at St Albans, going on to detail the cloth required for a 'newe pensell' (flag), the captain's 'garment', and 25 yards of green and red cloth 'to make bendes' for the hundred men.[19] These 'bends' can be interpreted as a sash, worn diagonally across the body in the way that the heraldic term bend refers to a diagonal stripe.[20] In 1461 the Lancastrian soldiers are described as wearing such an item: 'and everye ys men bare hyr lordys leverey, that every man myghte knowe hys owne feleschippe by hys lyverey. And be-syde alle that, every man and lorde bare the Pryncys levery, that was a bende of crymesyn and blacke with esteryge [ostrich] fetherys.'[21]

The accounts for Nottingham in 1464 include payments for the cost of making jackets for their soldiers riding to the king at York: 'ix yerdes of rede clothe' and a finer cloth used for the captain's, the sheriff Walter Hilton, together with white fustian to make letters, and the cost for the cutting out and attaching of these letters.[22] Unfortunately, it doesn't specify which letters were used to identify these Nottingham men.

The duke of Buckingham rides past one of his soldiers, who wears the duke's red and black colours and the Stafford knot badge. Buckingham's personal heraldry is shown on his tabard, and behind him flies his standard, which displays several of his badges. A 1454 newsletter recorded, 'the Duc of Buk' hathe do to be made Ml. [2000] bendes with knottes, to what entent men may construe.'

(Detail from the painting of Ludford Bridge reproduced on pages 78–79.)

LEFT Edward IV's badge of the rose-en-soleil, depicted here in stained glass in the chapel at King's College, Cambridge.

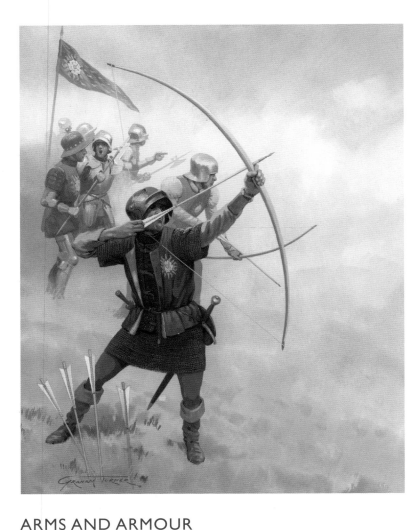

LEFT An archer wearing the blue and murrey livery of Edward IV over his brigandine and mail, with the king's rose-en-soleil badge on his chest and repeated on the pennon behind. At his waist hangs a sword and buckler and, unlike the man behind him, his sallet has a visor.

Gouache, 11" × 17" (25cm × 41cm), 2014.

ARMS AND ARMOUR

The English preference to fight on foot was developed alongside their use of massed archers, a tactic which had helped gain their famous victories in France such as Crécy, Poitiers and Agincourt. Archers therefore formed a large proportion of English armies, and archery duels were the precursor to the hand-to-hand mêlée at several Wars of the Roses battles.

The hundred archers Coventry intended to send to St Albans were equipped with jacks and sallets. The ubiquitous jack was the most prevalent defensive garment of the common soldier, made from many layers of fabric, usually linen, sewn together to create a jacket able to absorb cuts and blows with surprising effectiveness. Likewise, the sallet was the most popular type of helmet, enclosing the head and usually extending a short way down the back of the neck, often open faced but also made fully enclosed or with an opening visor. It could be paired with a bevor to protect the lower face and throat.

A list of men mustered in Bridport in 1457, for defence against possible French coastal attack,

provides the men's names and what equipment they brought with them. Alex Younge is typical, being equipped with jack, sallet, sword, buckler, dagger, bow and sheaf of arrows. Bills and glaives are listed, both being staff weapons, the bill originating from the agricultural tool and typically having a cutting edge, a top spike and a hook for dragging opponents down. A few possessed gauntlets, mail shirts or brigandines, and there is one breastplate. While shields had fallen out of general use, the small round buckler mentioned above remained popular with ordinary soldiers, held in the left fist to deflect blows and paired with a sword or the cleaver-like falchion. Pavises – large portable shields, often associated with gunners and crossbowmen – are also listed in the Bridport muster roll. Mail, made up of interlinked rings, had been in use since classical times and was still worn, either as a full mail shirt or to supplement other defences, where its flexibility made it ideal to fill any vulnerable gaps. Another list of 'men abul to do the king servys', compiled in Ewelme c.1480, includes the likes of Richard Slyhurst, who had 'a

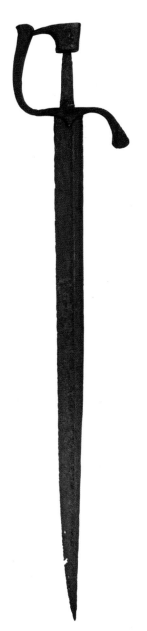

TOP A buckler, as depicted in the *Beauchamp Pageant* on pages 42 and 47. (British Museum)

ABOVE The falchion, with its single edged blade, was a popular sidearm, often paired with a buckler. (Royal Armouries, inv. no. IX.144)

RIGHT Archers wearing sallets, brigandines and mail, equipped with swords and bucklers. From the *Beauchamp Pageant*, c.1483–85. (The British Library, Cotton MS Julius E IV-3 f.4r)

BELOW The bill, developed from the agricultural tool into a variety of forms, incorporating a stabbing spike, cutting blade, hook, and sometimes one or more back spikes, mounted on a long shaft. (Royal Armouries, inv. no.VII.1513)

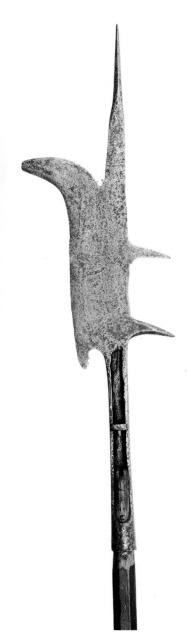

hernes [harness, i.e., armour] and abull to do king servis with his bowe', Thomas Saunton and John Holme with 'hole harness and both abull to do the king servis with bill'. John Pallyng had 'an harnes' but was 'not abull to wer it', for what reason is not explained. Among the others are archers, including two distinguished as 'a gode archar', 'an abull man with a staffe' and a few described as 'not abul'.[23] The household accounts of Sir John Howard also give a valuable insight into the arms and equipment of the typical Wars of the Roses soldier, but as he was providing for his better equipped household retainers, items such as the brigandine are more plentiful than at the Bridport muster. This was a 'waistcoat' made of small overlapping steel plates, rivetted to a strong fabric outer layer; Howard's accounts include entries such as 'Reynold Morgan on a bay nage of myn, and I lent hym a payr breganderys cueryd with blakke leder, and Walshe bylle and a salat of meleyn' (Reynold Morgan was lent a bay horse, a brigandine covered in black leather, a Welsh bill and a sallet made in Milan).[24] Even great lords, with full harnesses of plate armour in their possession, owned brigandines, which could be covered in a rich fabric such as velvet, their rivet heads gilded. Among other similar gifts made by Edward IV, two of his knights of the body received 'for the covering of theire Brygandyns... ij[2] yerdes and a quarter of crymysyn clothe of gold upon satin grounde'.[25] The Howard accounts list sallets with and 'wythowt a vyser', the visored ones being considerably more expensive than open faced examples, along with 'standardes off mayle' – protection for the vulnerable neck.[26]

Observing soldiers mustering in London in 1483, Dominic Mancini wrote:

Few there are that have no helmet, and none without bows and arrows. Their longbows and arrows are thicker and longer than those used by other nations, and equally their bodies are stronger, for they seem to have hands and arms of iron. The range of their bows is no less than that of our crossbows; and each man also carries at his side a blade [sword] no less long than ours, but heavy and sturdy as well. Along with the sword they always carry an iron shield [buckler]; on holidays it is a favourite pursuit of this nation for youngsters to engage in swordplay throughout the streets, with shields clashing against blunted swords or, in place of swords, stout staves. Then when they are older they go into the fields with bows and arrows; and not even the women themselves are unskilled at hunting with these kinds of weapons. The men wear no metal protection on their chest or other part of the body, except for those of higher degree who have breastplates and mail. Actually the common soldiery have tunics that are more practical which reach down below the groin and are stuffed with tow or some other soft material. They say that the softer the tunics, the better they withstand the blows of arrows and swords, and besides in summer they are lighter than metal, and in winter more serviceable. With this kind of equipment were the mustered soldiers protected when they arrived, and in addition some were mounted. Not that they normally fight on horseback, but horses are used to carry them to the field of engagement so as to arrive fresher and not fatigued by the hardships of the road. For this purpose they will ride out with horses of any kind, even pack-horses. On arriving at the field of battle they set the horses aside and all fight on equal terms so that no prospect of flight should exist.[27]

Contrasting with this glowing account, another continental commentator observed that the English soldiers who took part in Edward IV's 1475 French expedition 'seemed but raw and unused to action in the field'.[28] An account of the royal army at Ludford Bridge claims that the 'harneysyd men' were 'by-syde nakyd men that were compellyd for to come with the kynge' ('nakyd' referring to their lack of armour).[29] Clearly, in equipment, training and fighting ability, there were huge variations within the ranks of the soldiers who took to the battlefields of the Wars of the Roses.

ENCASED IN STEEL

From the beginning of the century, armourers had developed the skills and technology to protect the fighting man from head to toe in plates of steel, skilfully beaten and formed into complex, subtle shapes and articulated in such a way as to allow full movement. Their creations came at a price, however, and the need to balance protection with mobility also influenced what each man wore. Properly fitting armour would restrict a trained knight or man-at-arms very little and he would be able to wear his harness for sustained periods without difficulty. The idea that he'd need a crane to mount his horse, or flounder like a stranded beetle when on his back, are a nonsense, dreamed up long after armour ceased to be worn, perhaps because of the weight of some specialised jousting armours, or later harnesses that were manufactured from increasingly thicker steel to compete with developments in the use and power of gunpowder weapons.

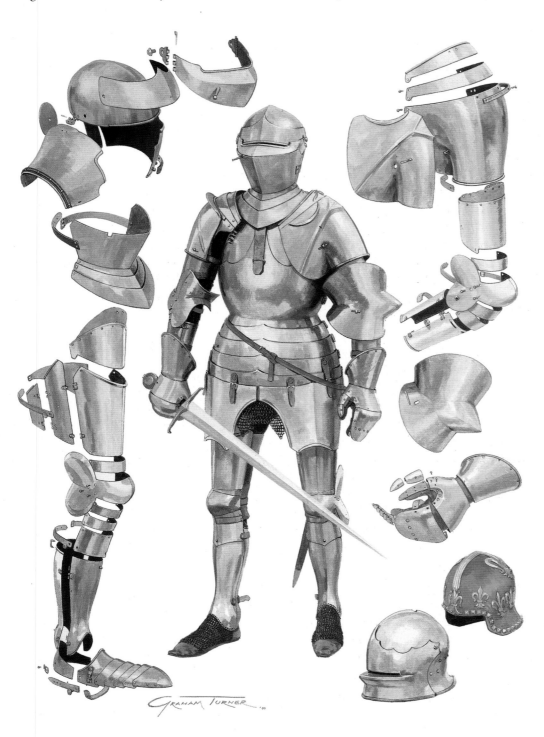

ITALIAN ARMOUR, c.1450

Armour made in Italy was imported to England in large quantities. This harness is based on the example now in the Scott Collection in Glasgow, but with an armet type of helmet, its hinged cheeks closing at the chin to fully enclose the head. An optional wrapper strapped to the front increased the protection provided.

Gouache, 13" x 17" (33cm x 43cm), 2000.

BELOW **Rondel dagger, with a stiff triangular section blade.** (Philadelphia Museum of Art, Bequest of Carl Otto Kretzschmar von Kienbusch 1977, accession no. 1977-167-678)

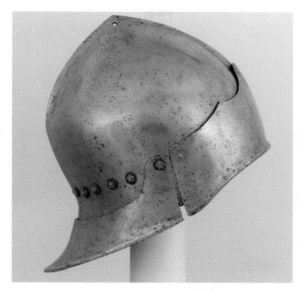

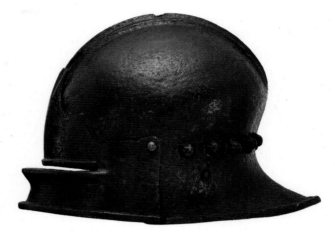

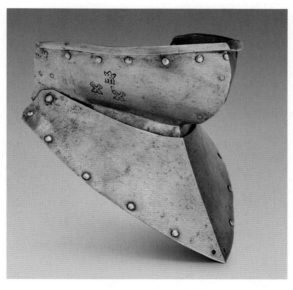

ABOVE **Sallet, West European, c.1475–80. From Witton-le-Wear, County Durham, on loan to the Royal Armouries.** (Royal Armouries, inv. no. AL.44.1)

ABOVE LEFT **Sallet, Italian, with a pointed skull in the West European style, c.1480.** (Metropolitan Museum of Art, New York, Bashford Dean Memorial collection, Bequest of Bashford Dean, 1928, accession no. 29.150.13)

LEFT **Bevor, designed to be worn with a sallet to provide protection for the lower face and neck. (Upper plate) Milan, c.1460.** (Philadelphia Museum of Art, Bequest of Carl Otto Kretzschmar von Kienbusch 1977, accession no. 1977-167-184)

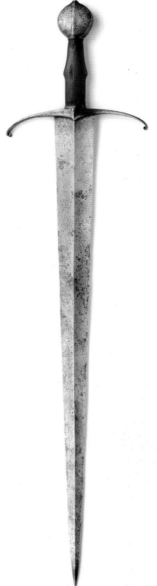

ABOVE **15th-century sword, with an acutely pointed stiff diamond section blade, designed for thrusting through vulnerable gaps in armour and piercing mail as well as cutting.** (Philadelphia Museum of Art, Bequest of Carl Otto Kretzschmar von Kienbusch 1977, accession no. 1977-167-547)

What we see today in museums and castles is a tiny fraction of what was made, and little of it is typical of what was worn in the Wars of the Roses. Much was destroyed or recycled when it became obsolete, and the fortunate survival of the few pieces we can see today is often down to chance. Many collections were built up during the 19th century, with armours being assembled by dealers to satisfy a market for 'gothic' armour, often using pieces of originally unassociated German armour mixed with recreated parts. The region now known as Germany is justly famous for its armour, with its distinctive pointy gothic style contrasting with the rounded functionality of Italian armour, but, while there is plenty of evidence for a thriving trade in Italian-made armour, there is little to suggest that German armour was used in England.

Italy was the most industrious centre for the manufacture of armour in the 15th century, with the ability to make and export it in huge quantities. This could be purchased off-the-peg, or, if funds allowed, individually crafted to create a bespoke harness (suit of armour). The Howard account books contain numerous references to armour 'of meleyn' (made in Milan), and a record survives detailing a shipment of arms and armour that arrived at Sandwich in 1463 that included over one hundred complete Milanese field harnesses and other pieces of armour. Along with the sallets, 'legge harneys' and gauntlets were 'harneys for horsehedys' and 'ij [2] horseharneys of boyled ledyr' (horse armour made of hardened leather, known as cuir-bouilli), one for the king and the other for the lord 'Warwic'.[30]

Armour made in the workshops of France and Flanders also found its way to England; in 1473, Sir John Paston corresponded with an armourer in Bruges, Martin Rondelle, regarding the purchase of a full harness. When Edward IV returned from his

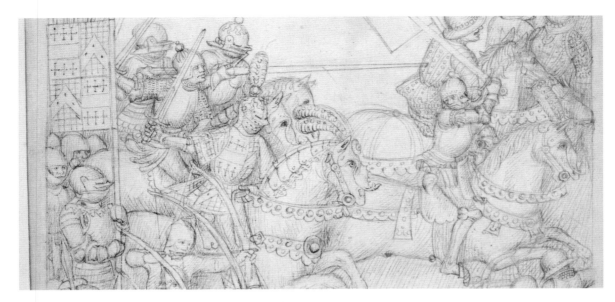

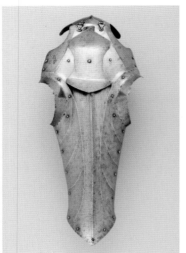

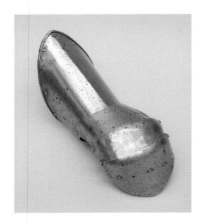

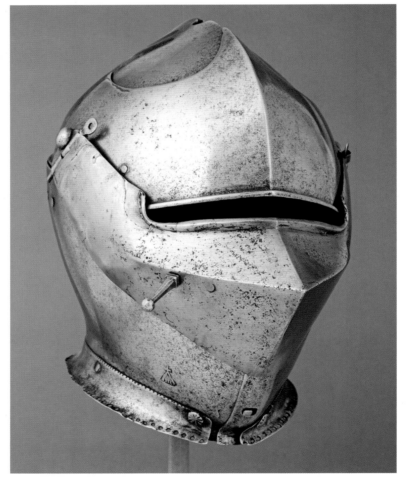

LEFT **A wide variety of weapons and armour are depicted in the** *Beauchamp Pageant, c.*1483–85. **Note the decorated helmets, and wide-brimmed kettle hats.** (The British Library, Cotton MS Julius E IV-3 f.20v)

BELOW LEFT **Shaffron, Italian – armour for a horse's head.** (Metropolitan Museum of Art, New York, Bashford Dean Memorial collection, Bequest of Bashford Dean, 1928, accession no. 29.150.9)

LEFT **Armet,** *c.*1475, **made in the famed Missaglia workshop, Milan.** (Metropolitan Museum of Art, New York, Bashford Dean Memorial collection, Bequest of Bashford Dean, 1929, accession no. 29.158.51)

BOTTOM LEFT **Gauntlet, mid-15th century, made in the Missaglia workshop, Milan.** (Metropolitan Museum of Art, New York, Bashford Dean Memorial collection, Funds from various donors, 1929, accession no. 29.158.228)

exile in 1471, he and his followers would likely have been wearing armour manufactured in Flanders. A letter in the correspondence of the Cely family of wool merchants, advising that they purchase 'sum standards of mayll' because they might do well out of them, indicates that, as has often been the case throughout history, there was money to be made in the arms and armour trade,

enough to tempt the Celys to diversify into a little small-scale speculation.[31]

In England, armour developed its own style to reflect the English preference to fight on foot, and during the 1430s and 40s, harnesses with extremely deep faulds – the hooped defences below the waist – are commonly seen on brasses and tomb effigies. This became less acute as the century progressed but

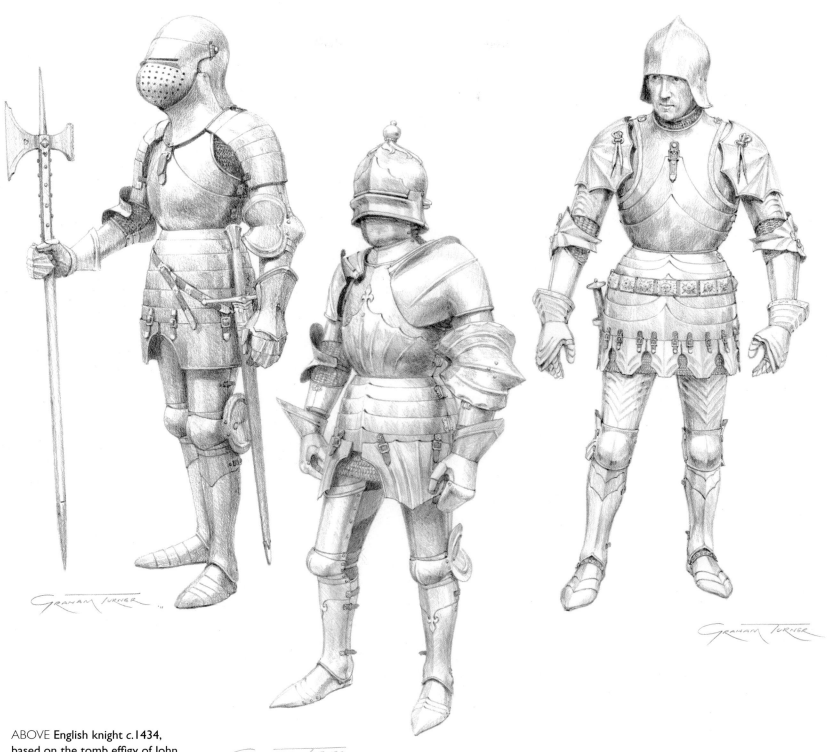

ABOVE English knight *c.*1434, based on the tomb effigy of John Fitzalan, Earl of Arundel, in the Fitzalan Chapel, Arundel. It exhibits many characteristics of English armour from this period, such as the great bascinet helmet and deep fauld protecting the loins with small tassets suspended from the lowest lame. Armours of this style would have seen action during the later stages of the Hundred Years War.

Pencil, 12" x 16.5" (30cm x 42cm), 2010.

ABOVE An Italian export armour, following Italian forms and construction but adapted to suit the taste and fashions of its English owner. Based on the tomb effigies at All Saints, Herstmonceux, Sussex.

Pencil, 12" x 16.5" (30cm x 42cm), 2011.

ABOVE English armour showing some design variations, most notably in the one-piece fluted shoulder defences. Based on the tomb effigy of Sir William Gascoigne, *c.*1461–65, All Saints, Harewood, Yorkshire.

Pencil, 12" x 16.5" (30cm x 42cm), 2007.

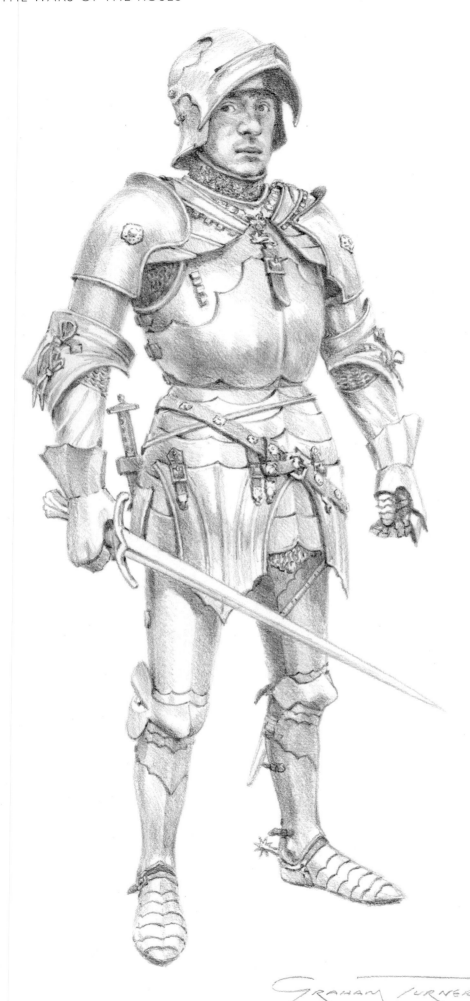

English armour of c.1475, based on the tomb effigy of Sir William Ryther, All Saints, Ryther, Yorkshire. This shares characteristics shown on other monuments of the period, but each has differences that make them unique. The small tassets hanging from the bottom edge of the fauld on the Gascoigne armour (previous page) would rise up with it when mounted, leaving the area at the top of the legs potentially vulnerable, but on this later harness the large tassets are attached half way up the deep fauld to allow this to collapse upwards underneath them, leaving the tassets in place. Sir William wears a Yorkist livery collar of suns and roses, with the lion pendant of Edward IV.

Pencil, 12" × 16.5" (30cm × 42cm), 2017.

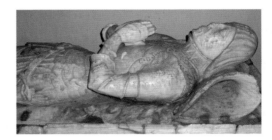

ABOVE Tomb effigy of Sir William Ryther, d.1475, All Saints, Ryther, Yorkshire.

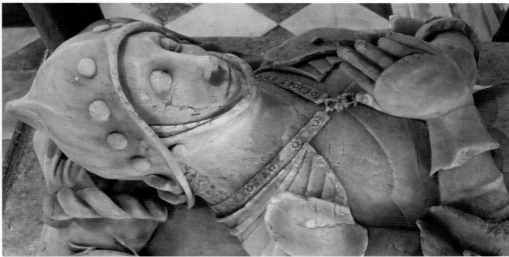

ABOVE Early close-helmet, incorporating the skull of a sallet. Probably Flemish, c.1480–1500. The close-helmet, with its face-plate and visor pivoting at the temples, would evolve to become the most prevalent helmet of the 16th century. (Royal Armouries, inv. no. AL.50)

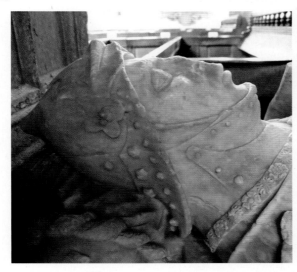

TOP An open-faced sallet with fluted skull raised to a point and large decorations, worn with a high-sided bevor. Tomb effigy of a member of the Browning family, c.1470–80, Melbury Sampford, Somerset.

ABOVE LEFT Fluted sallet with a visor, worn by Sir Thomas Martyn, c.1480–83, Puddletown, Dorset.

ABOVE RIGHT The ornate hip belt on the tomb effigy of Sir William Gascoigne, c.1461–65, Harewood, Yorkshire.

RIGHT Gothic tracery on the sword scabbard of Nicholas Fitzherbert, c.1480–85, Norbury, Derbyshire.

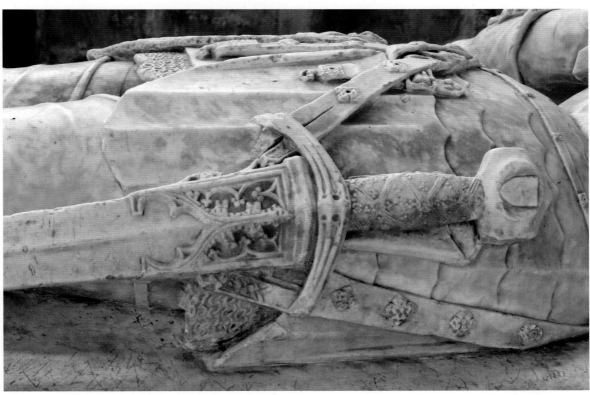

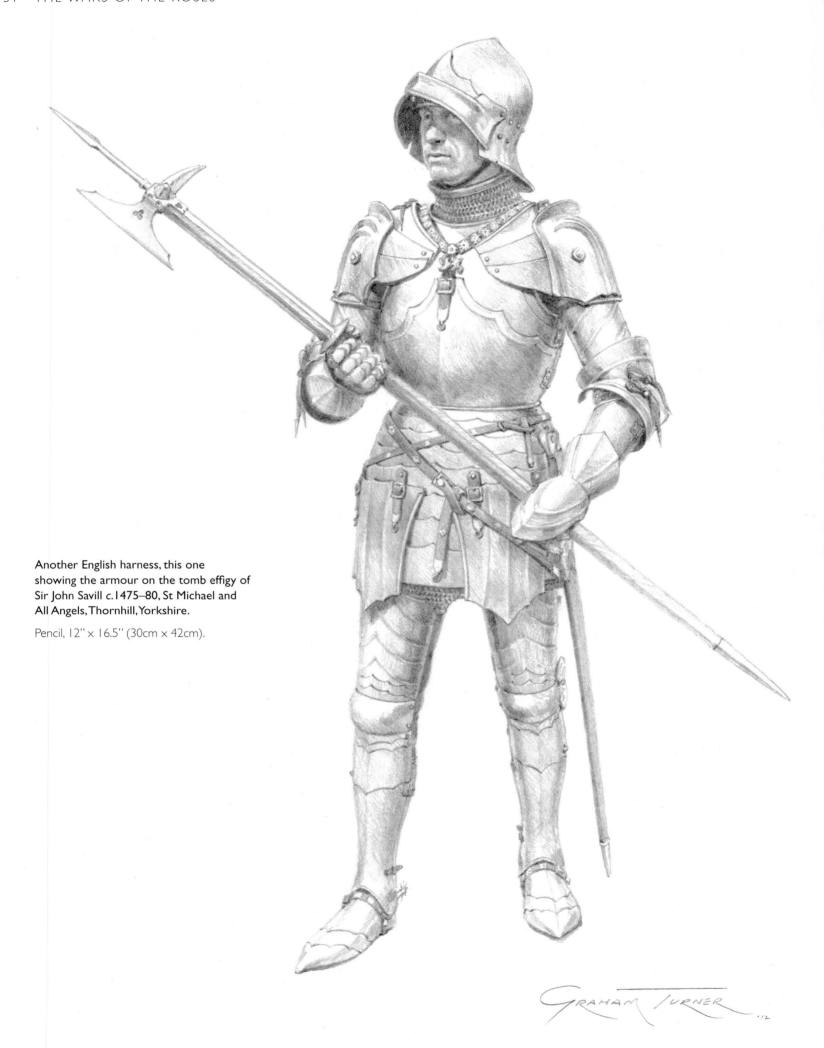

Another English harness, this one
showing the armour on the tomb effigy of
Sir John Savill c.1475–80, St Michael and
All Angels, Thornhill, Yorkshire.

Pencil, 12" x 16.5" (30cm x 42cm).

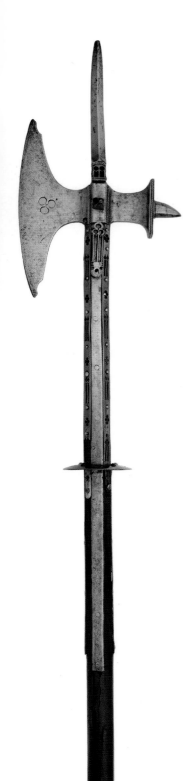

BELOW Poleaxe, late 15th century. Developed in the late 14th century and designed to crush and pierce plate armour, the name probably derives from the old English word 'poll', meaning head. Some examples were highly decorated, with pierced gothic tracery and inlaid brass. (Royal Armouries, inv. no. VII.1542)

was still a distinguishing feature of English-style armours during the Wars of the Roses, along with the almost organic fluted swirls and cusped edges. Very little English armour survives, but tomb effigies in churches across the country depict this distinctive style in amazing detail, and recent recreations show how accurate these sculptures can be and how well these armours function.

The Bridport Roll lists only two full harnesses, a certain Robert Brythe bringing 'a Whyte harnys wt a basenet'.[32] This possibly indicates he possessed an old armour, as the bascinet was the most prevalent helmet of the second half of the 14th century, usually equipped with a mail aventail to protect the neck and throat. At the time of Agincourt, this was evolving into the great bascinet, with steel plates replacing the flexible mail to create a very protective but more restrictive helmet that endured throughout the century, particularly on the tournament field, but which was falling out of popularity on the battlefield as the Wars of the Roses began.

Alongside the sallet, in all its forms, and older style great bascinet, several other types of helmet would have been seen on the battlefields of England. The kettle hat, with its wide brim, had been popular for centuries and would go on to provide the inspiration for British infantry helmets in the 20th century. The armet, developed in Italy where it was most popular, found its way to northern Europe in smaller numbers, but the all-enclosing protection it offered appealed to some. Towards the end of the 15th century the true close helmet was developed, some early examples utilising sallets or armets as their basis.

A full harness not only offered the wearer great levels of protection, but it made him look spectacular too. In an age when conspicuous display helped define a person's social standing, the armour of the wealthy could have been enhanced with gilding or precious stones – the Howard accounts include payments made to goldsmiths for the decoration of helmets, and if the representations of armour in art and tapestries are anything to go by, some would have looked very different from the plain steel we are used to seeing in museums today.

The sword continued to be carried by most soldiers during the 15th century, the knightly weapon – either a longsword or shorter single-handed arming sword – often of an acutely pointed form developed to thrust through vulnerable gaps as well as cut. It was a light and well-balanced weapon, not the unsophisticated bar of steel good for nothing but bludgeoning an opponent as is often depicted, and the art of swordsmanship was widely practised, studied and taught, alongside the mastery of other weapons. The scabbard and fittings provided another opportunity for the wealthy to demonstrate their love of decoration and display, whether on the heavily decorated hip belt of the first half of the century, or the narrower diagonal arrangement that superseded it.

With armour now providing such effective protection, the sword was increasingly relegated to a backup role, while the poleaxe became the knightly weapon of choice. With an axe blade at the front, a beak or hammerhead behind (for crushing plate armour), and spikes at both ends, it was a formidable tool. Interestingly, quite a few poleaxes are listed in the Bridport muster roll previously mentioned, indicating that it was also popular with soldiers possessing very different levels of equipment.

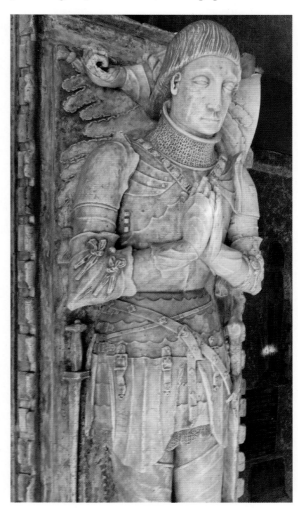

ABOVE The tomb effigy of Nicholas Fitzherbert, c.1480–85, Norbury, Derbyshire.

CHAPTER 5
FIRST BLOOD

THE BATTLE OF ST ALBANS

Following the end of the duke of York's protectorate, and the return to power of their rivals, the Yorkist lords had retired to their estates in the north.

A meeting at Westminster, to which York and his allies were conspicuously not invited, created yet more resentment, further fuelled when they heard that their loyalty would be high on the agenda of a great council summoned to assemble at Leicester, so while the royal court prepared to travel north from London, York, Salisbury and Warwick headed south with a large retinue to intercept them. Surprised by the speed and strength of the Yorkists' advance, the royal party hurriedly summoned reinforcements and reached St Albans, not far from the capital, early on 22 May.

As York's forces formed up outside the town, negotiations began with the king's commanders within. It seems Henry played little part in the discussions, but whether this was because he was deliberately excluded by Buckingham and Somerset, as was later suggested, or he was still suffering from the effects of his illness, perhaps aggravated by the stress of the perilous situation he found himself in, is not clear.

With King Henry and the dukes of Somerset and Buckingham were also the earls of Northumberland, Dorset (Somerset's 19-year-old son), Stafford, Wiltshire and Devon, along with lords Clifford, Egremont, Dudley, Roos and others.

When it became clear that Somerset would not be surrendered – York's main demand – the Yorkists advanced on the barriers that had been thrown across the roads approaching the centre of town. The fighting across the barriers was intense, but 'Lord Clyfford kept strongly the barrers that the seyde Duke of York myght not in ony wise, with all the power that he hadde, entre ne breke into the toun.'[1] The impasse was finally broken when Warwick's men found their way through gardens and passageways at the other end of town, where their emergence caused panic amongst the defenders.

As his men cried 'A Warrewyk! A Warrewyk!',[2] his archers rained arrows down on the king and his entourage beneath the royal banner. Buckingham was hit in the face several times, his son the earl of Stafford in the hand, and Henry Beaufort, the young earl of Dorset, was injured sufficiently seriously to be taken away in a cart. Most shockingly for contemporaries, though, Henry VI, the anointed King of England, was wounded in the neck or shoulder.

ABOVE The Beaufort portcullis badge, seen here in King's College Chapel, Cambridge, with the crown added after the symbol was adopted by the son of Lady Margaret Beaufort, Henry VII. It has remained a royal badge ever since and is today used as the emblem of the Houses of Parliament.

LEFT The market place at St Albans, looking towards the Abbey.

EDMUND BEAUFORT, DUKE OF SOMERSET

A staunch supporter of the Lancastrian King Henry VI, Somerset's rivalry with the duke of York was one of the causes of the Wars of the Roses. Their struggle for power and control of the king would escalate into open warfare at the Battle of St Albans in 1455, where Beaufort would meet his death.

Gouache, 11" x 17" (28cm x 43cm), 2018.

'the Kyng, our sovereyne Lord,
[hurt] in the neck with an arrowe'
Contemporary newsletter preserved in the Paston Letters

As the survivors fled, the royal banner was abandoned, propped against a wall, and the slightly injured king reportedly sought refuge in a tanner's cottage, where he was discovered and escorted to the Abbey. Somerset and a few of his men had taken refuge in the Castle Inn; 'And at once York's men began to fight Somerset and his men who were in the house, which they defended valiantly. And at last after the doors were broken, Somerset saw that there was nothing for it but to come out with his men; this he did and immediately they were surrounded by York's men. And after some were stricken down and the Duke of Somerset had killed four men with his own hand, he was, it is said, felled with an axe, and was at once wounded in so many places that he died.'[3]

RIGHT
CONCEALED ATTACK

Soldiers in the earl of Warwick's service advance through the back streets and alleys of St Albans to launch a surprise attack on Henry VI's forces in the town centre.

Gouache, 12.5" × 20" (32cm × 51cm), 2016.

OPPOSITE
ROYAL BLOOD

As the earl of Warwick's troops rain arrows down on them and the duke of York's men advance from the opposite direction, King Henry VI is 'hurte with the shotte of an arowe in the necke' as he finds himself exposed in the centre of the Yorkist assault at St Albans. Behind him the duke of Buckingham is wounded 'with an arrowe in the vysage', as were others of the king's entourage; 'the Lord of Stafford in the hond, with an arowe; the Lord of Dorsette, sore hurt that he myght not go, but he was caryede hom in a cart; and Wenlok, Knyght, in lyke wyse in a carte sore hurt; and other diverse knyghtes and squyers sore hurt.'

Although famously a most unwarlike king, at St Albans a chronicler recorded that 'Kyng Harry was in harnys hys owne propyr person'. The same account also says that the earl of Wiltshire 'sette the kyngys baner agayne an howse ende and fought manly with the helys [heels]' – in other words, he ran away, an action he would repeat at the Battle of Mortimer's Cross six years later.

Gouache, 14" × 18.5" (36cm × 47cm), 2022.

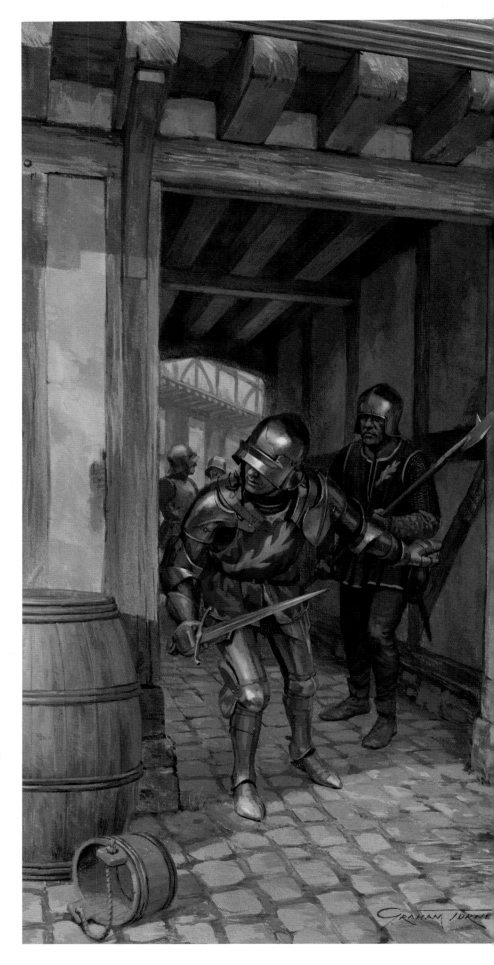

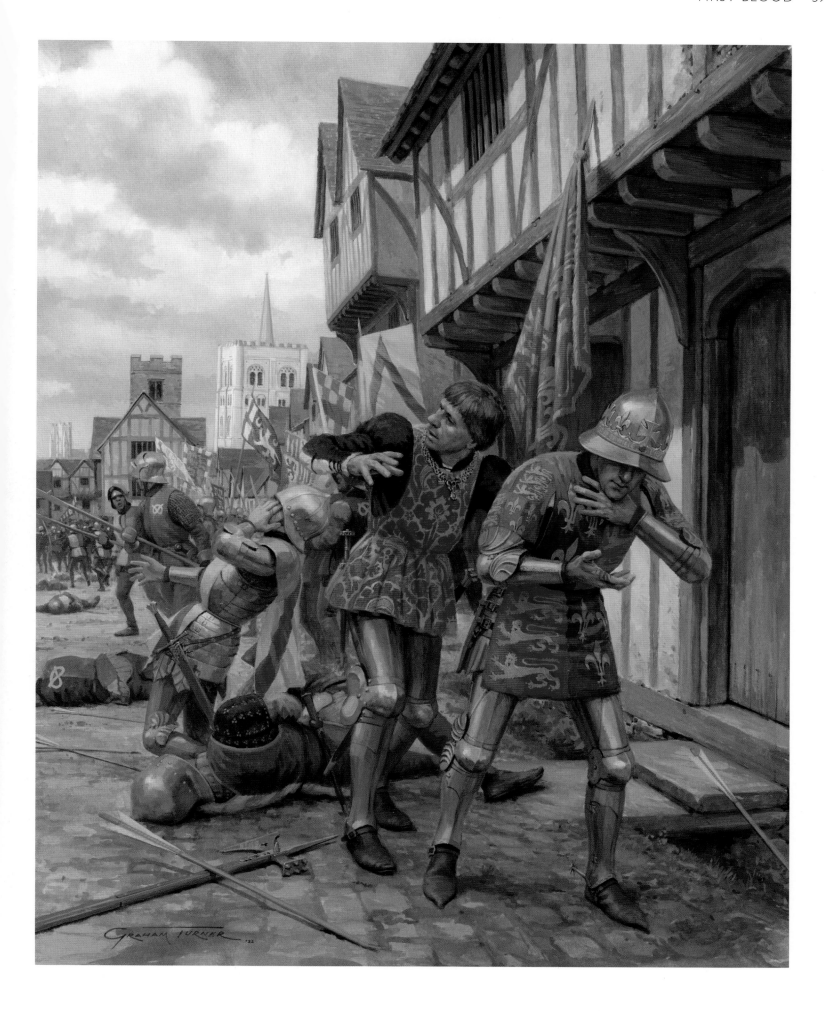

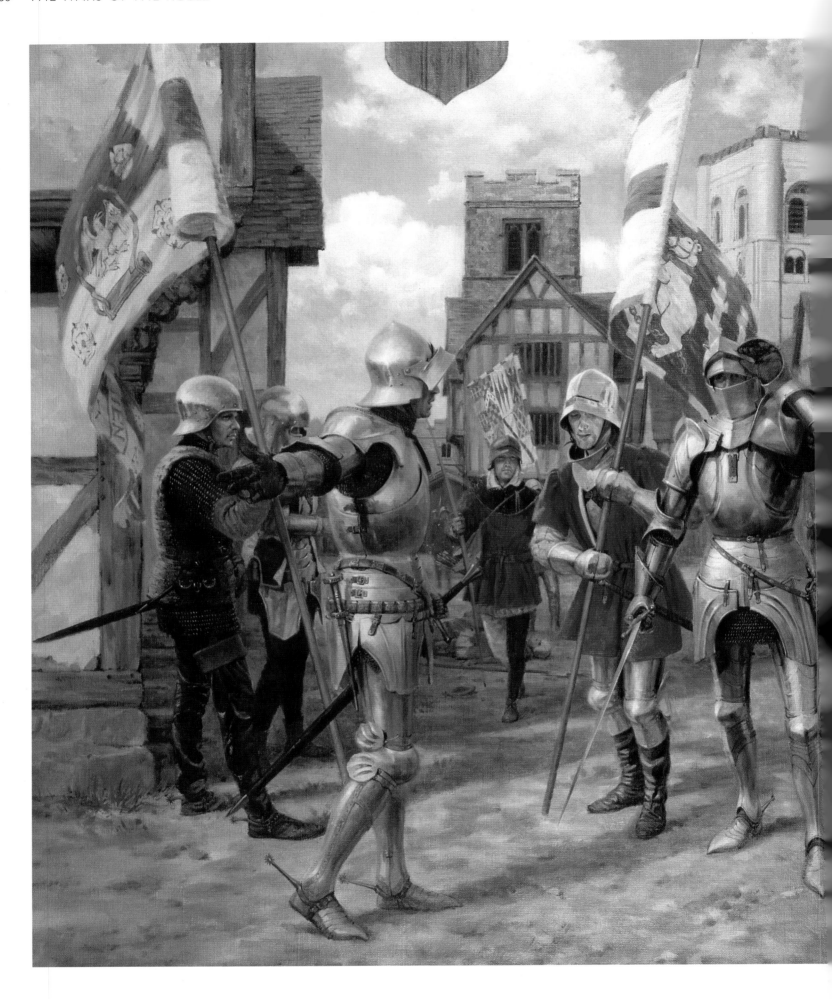

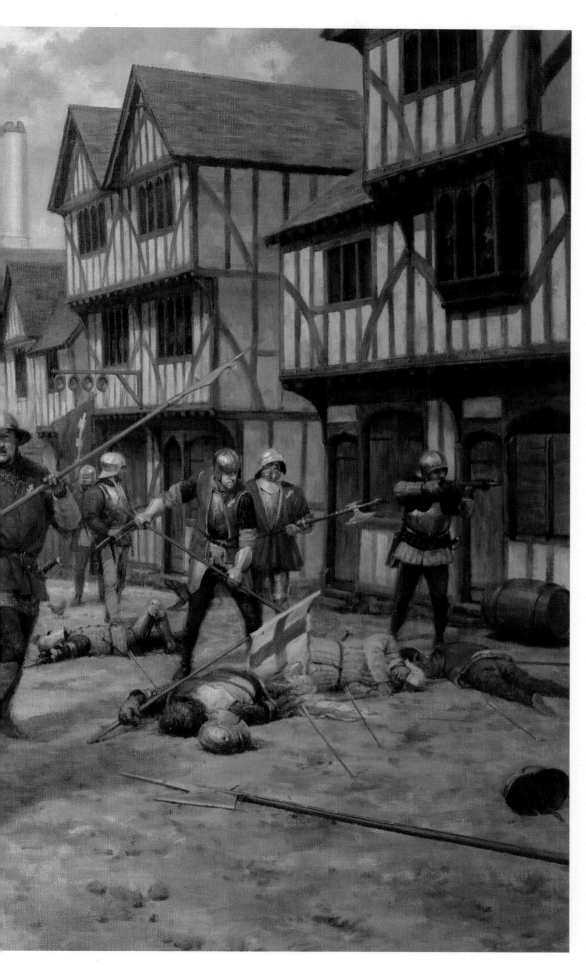

THE BATTLE OF ST ALBANS
22 May 1455

The earl of Warwick (centre) raises his visor to greet the duke of York (left) in the market place, with the Abbey towering over the proceedings in the background. York is indicating towards the Castle Inn, site of the duke of Somerset's last stand.

Oil on canvas, 45" x 32" (114cm x 81cm), 1998.

Abbot John Whethamstede, an eyewitness to the battle, later wrote, 'here you would have seen one man lying with his brain struck out, there another with his arm cut off, there a third with his throat cut, there a fourth with his chest pierced, and the whole [market] place beyond filled with corpses of the slain'.[4]

However, the overall death toll at St Albans was comparatively light, with contemporary estimates ranging between 60 and 200 killed. Compared to the casualty lists of other battles, St Albans is often dismissed as nothing more than a skirmish, but politically it marked a watershed of considerable significance. Amongst the dead were a disproportionate number of nobles and royal servants, including the earl of Northumberland and Lord Clifford, who, along with Somerset, could well have been deliberately targeted. Their deaths would begin a cycle of retribution over the coming years as their heirs sought revenge – the Wars of the Roses had begun in earnest.

While some of their men ran amok, looting both the defeated and townsfolk, the victorious York, Salisbury and Warwick knelt before the king in the Abbey and begged his forgiveness: 'and be sought hym of his Heynesse to take hem as hys true legemen, seyng that they never attendyde [intended] hurt to his owne persone, and ther fore [the] Kyng oure soveryn Lord toke hem to grace, and so desyred hem to cesse there peple, and that there shulde no more harme be doon.'[5]

King Henry's request for troops from Coventry (see page 45), and no doubt other places, was delivered on 22 May, the day the Battle of St Albans was fought, so too late for their contribution to play any part in proceedings. The carefully prepared 'bendes, garment and pensell were put & delyverd into the wardens kepeng', stored away for another occasion.[6]

The following day the Yorkist lords escorted King Henry into London and publicly demonstrated that he was king – and that they were his loyal subjects – with a crown-wearing ceremony at St Paul's Cathedral. Once again York was appointed protector and attempts at reconciliation followed, but tensions, understandably, remained high.

ABOVE The clock tower in St Albans, built at the lower end of the market place facing the abbey and completed c.1405.

'the Duke and his had the victory; and in this fyght
was slayn the Duke of Somerset, the Erles of Northumberland
and... the lord Clyfford, with many other Gentilmen'
Chronicles of London, Vitellius A XVI

CHAPTER 6
UNEASY PEACE

YORK'S SECOND PROTECTORATE

Following the upheaval of the Battle of St Albans, the earl of Devon and his sons returned to their personal battle with Lord Bonville in the West Country, their attacks plumbing new depths that would shock their contemporaries. According to a letter written to John Paston and the graphic narrative provided by a subsequent legal petition, just before midnight on 23 October 1455, Devon's son Thomas Courtenay arrived in force at the home of the elderly and distinguished Nicholas Radford, Bonville's associate and legal advisor. Starting fires to gain entry, Courtenay drank Radford's wine while his companions ransacked the house, going so far as to roll Radford's invalid wife out of bed so they could steal the sheets. Radford was then lured outside and with a glaive struck a 'hidious dedlye stroke overthwarte the face and felled him to the grounde', and then dealt 'a noder stroke upon his heade behinde that the brayne fell oute of heade'.[1] A few days later they returned, held a mock inquest and passed a 'verdict' absolving them of the murder, before tipping their unfortunate victim's naked body into an open grave and crushing it with the stones intended for his tomb.

TOP RIGHT The heavily restored tomb of Hugh de Courtenay, 2nd/10th earl of Devon (1303–77), and his countess, Margaret de Bohun, in Exeter Cathedral. Their great-great-grandson Thomas, the 5th/13th earl (1414–58), occupied the city in 1455 during his struggle for local dominance with Lord Bonville that caused so much upheaval in the region. Following Thomas's death, he was succeeded by two of his sons: first the eldest, also Thomas, who would be beheaded and attainted after the Battle of Towton in 1461, and then John, who would style himself earl until he was killed in battle at Tewkesbury ten years later.

RIGHT Now overshadowed by the modern road network to the east of Exeter, the medieval bridge over the river Clyst has witnessed two battles in its long history: on 15 December 1455 between the forces of the earl of Devon and Lord Bonville as they squabbled over power in the region, and a century later in 1549 during the Prayer Book Rebellion.

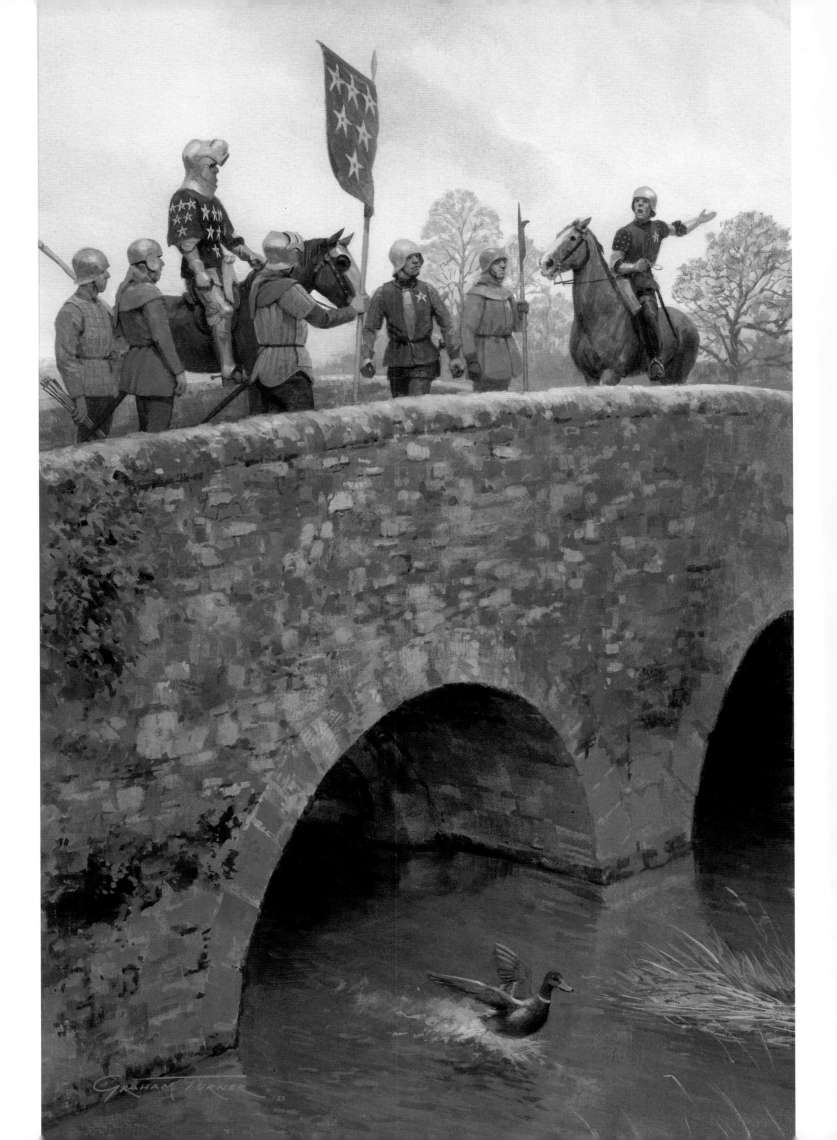

FAR RIGHT A statue of
Margaret Beaufort looks
down from above the gate at
Christ's College, Cambridge,
surrounded by her Beaufort
and Tudor heraldry.

ABOVE Powderham Castle,
to the south of Exeter, was
battered by the earl of
Devon's artillery as he laid
siege to his estranged cousin
Sir Philip Courtenay.
Powderham was also subject
to attack in the 17th century
during the English Civil War,
and the current appearance
of the castle is mostly due to
the rebuilding carried out in
the 18th and 19th centuries.

Within days of this horrific crime, Devon and his
sons entered Exeter with an army and ruled over the
city until just before Christmas, ransacking the
houses of Bonville and his associates and menacing
the clergy to enable them to steal Radford's valuables
from the cathedral. From Exeter Devon sent out
parties to attack other targets, including nearby
Powderham Castle, which belonged to an estranged
distant cousin, Sir Philip Courtenay. After fighting
off the first attack, Sir Philip appealed to Bonville for
help as Devon battered his home with artillery.
Bonville made a retaliatory attack on Devon's
fortified house at Colcombe but was beaten back as
he tried to reach his besieged ally. Devon continued
his attacks from his base at Exeter, and then, on
15 December, 'departed out from the City with his
people into ye feld by Clist and there bykered and
faughte with ye Lord Bonevyle and his people and
put them to flight and so returned again that night
into the City again with his people'.[2] Sadly, details
about the battle at Clyst are scant, but the Exeter city
records note that they paid for a quantity of 'red
wine given to the Earl of Devon 15th day of
December by order of the aforesaid Mayor and his
fellows 26/8. Also four flagons of red wine were
given to the men of the Lord Earl watching at the
gate of the City at the same time 2/8.'[3] Whether this
was because the mayor and his fellow officials were
pleased with the outcome, or concerned to keep in
favour with the victorious earl, is not recorded.

*'the said Erle of Devon departed out from the City with his people into ye
feld by Clist and there bykered and faughte with ye Lord Bonevyle and
his people and put them to flight'*

Exeter Mayor's roll

OPPOSITE

THE BATTLE OF CLYST
15 December 1455

As he crosses the bridge
over the river Clyst, word
reaches Lord Bonville that
the earl of Devon has left
Exeter and is marching
towards him.

Gouache, 9.3" × 15.3"
(24cm × 39cm), 2023.

The alarming news arriving in London from the
south-west was one factor that encouraged Parliament
to appoint the duke of York as protector for a second
time. As York approached to suppress the troubles 'in
oure counte of Devonshire', where 'there is assembled
grete people the which robbe and spoile daily',
Devon surrendered himself and was conveyed to the
Tower of London.[4]

York's second protectorate was fundamentally
different to the first in that the king was not
incapacitated, although there are some suggestions
that he may have suffered some kind of relapse after
St Albans, an idea supported by his inability to deal
with the violence in Devon himself. However, York

only had three months to try to improve government
until, facing opposition from the court, on 25
February 1456 he was discharged from the position
of protector by King Henry.

The earl of Devon was released soon after and,
with his sons, was pardoned of all offences, including
waging private war and the murder of Nicholas
Radford. The issuing of royal pardons was a feature
throughout the period and would allow many to
escape justice, especially those with the right political
connections. The earl of Devon would die in 1458
and the title pass to his son Thomas, Radford's
murderer, who, as their local feud was overtaken by
events of a much larger scale, would meet his own end

*'The Quene is a grete and strong labourid woman,
for she spareth noo peyne to sue hire thinges to an intent and
conclusion to hir power.'*
John Bocking to Sir John Fastolf, 9 February 1456

after the Battle of Towton. Bonville's son and grandson would be killed in 1460 at Wakefield fighting with York, and Bonville himself would be shown no mercy after the Second Battle of St Albans in 1461.

Although the Yorkist lords remained involved in some aspects of political life after the protectorate ended, their relationship with the court continued to deteriorate and over the next few years several personal confrontations and attacks were reported.

In the summer of 1456 the king, queen, their young son and court moved to the loyal city of Coventry, which they made their residence for much of the rest of the decade. Tensions and disorder in London were probably the reason for this unusual move, but it further separated Henry from effective government and diminished his authority.

With her husband seemingly incapable of providing effective leadership – whether because of his personality, beliefs or health – in the late 1450s Queen Margaret stepped beyond her traditional place in the accepted order to increasingly become the focus of opposition to York's ambitions. She found a way to wield practical power in her son's name through his newly established council, for although the members of the council were men, they could only act 'with the approval and agreement of our best-loved consort the queen', cleverly circumventing some of the limitations placed on her by the social structures of the time.[5] Her emergence provoked criticism from contemporaries and established her reputation as a ruthless and strong-willed woman – 'every lord in Englond at this tyme durst nat disobey the Quene, for she rewled pesibly al that was done About the Kyng, which was A gode, simple, and Innocent man'.[6] Some of this hostility was predictably due to her being a woman – 'she beyng a manly woman, vsyng [wishing] to rule and not to be ruled'[7] – and a foreign one at that, while some was undoubtedly the creation of Yorkist propaganda. Whatever the motives of these critics, her reputation and the truth behind her actions has been tarnished ever since and, as with Richard III, the real Margaret has become hidden behind Shakespeare's theatrical creation, exemplified by these words he puts into the mouth of the duke of York:

Pembroke Castle, birthplace of Henry Tudor on 28 January 1457.
(Getty Images/ Lynda Morris Photography)

She-wolf of France, but worse than wolves of
France;
Whose tongue more poisons than the adder's
tooth!
How ill-beseeming is it in thy sex,
To triumph, like an Amazonian trull,
Upon their woes whom fortune captivates!
But that thy face is, visor-like, unchanging,
Made impudent with use of evil deeds,
I would assay, proud queen, to make thee blush:
… Women are soft, mild, pitiful, and flexible;
Thou stern, obdurate, flinty, rough, remorseless.

Henry VI: Part III[8]

Following disturbances in Wales, Queen Margaret journeyed to the borders to help reassert royal authority in the region. Sir William Herbert and Walter Devereux – both retainers of the duke of York and soon to provide vital support to his son Edward – had seized Carmarthen Castle and imprisoned the king's half-brother, Edmund Tudor, Earl of Richmond. Edmund wasn't held for long but died soon after, possibly of plague, leaving his 13-year-old widow Margaret Beaufort to give birth to their son Henry Tudor in Pembroke Castle on 28 January 1457. Margaret was the daughter of John Beaufort, Duke of Somerset, who had died in 1444, and as a wealthy heiress with royal blood in her veins, she was a valuable pawn. Edmund Tudor had been her second husband and was soon followed by Henry Stafford, son of the duke of Buckingham, then Thomas, Lord Stanley following Stafford's death after the Battle of Barnet. Her devotion to her only child throughout her turbulent life was finally rewarded when he took the crown from Richard III at Bosworth in 1485, and she would live to see her grandson succeed him as Henry VIII.

Edmund Tudor's brother Jasper, Earl of Pembroke, now became Henry VI's representative in Wales, under the king's young son, Edward, Prince of Wales, and his position within the royal household was further enhanced when he was elected a Knight of the Garter.

CALAIS – THE LAST ENGLISH OUTPOST IN FRANCE

High on York's agenda during his second protectorate had been the defence and control of Calais, the last remaining English foothold in France. Along with the port itself, Calais extended along about 20 miles of coast and inland by six miles. There were castles at Calais itself, and at Hammes and Guisnes, and raids from the duke of Burgundy's neighbouring lands were a frequent threat. The settlement was also commercially important, with the lucrative monopoly for the export of English wool belonging to the Merchants of the Staple. The earl of Warwick, whose future reputation had been greatly enhanced by the decisive part he played in the Battle of St Albans, replaced the late duke of Somerset as captain, and efforts were made to quell the mutinous garrison and pay their outstanding wages, and negotiate with the merchants on whose income the outpost depended. Although Warwick had been appointed as captain in 1455, it wasn't until July 1456 that these problems had been addressed satisfactorily enough for him to take up his post. Warwick's captaincy would go on to serve a vital role in the Yorkists' future successes, providing a refuge in times of crisis, and a base from which to launch fresh campaigns.

The threat from France remained ever present, and an attack on Sandwich in the summer of 1457 was another brutal reminder of the vulnerability of England's coastal towns. The invaders spent all day in the town, burning buildings, killing townsmen and stealing valuables, making off with a reported 33 ships and prisoners for ransom.

Following the attack on Sandwich, Warwick was appointed as keeper of the seas and continued to build his reputation as a man of action. The French attack was quite possibly in retaliation for English piracy, aimed at removing some of the ships they saw as being responsible for attacks on their own vessels. Piracy was rife: in February 1457, ships from

*'the erle of Warrewyk, having a strong and a myghte naveye,
kepte the strayte see'*
An English Chronicle

Zeeland carrying wool belonging to Italian merchants had been seized off Tilbury by ships from Calais and Sandwich, and among many complaints of similar acts, one of Warwick's own officers is named in more than one incident; 'certain pirates in a carvell of Andrew Trollop of Calais with other pirates in other vessels took le Julian [of Blakeney, belonging to Sir Thomas de Roos]… contrary to the friendship between the king and them of the Hanse.'[9] Ironically, Warwick himself was commissioned to arrest Trollope.

Despite his commission stressing that he was to protect the king's subjects and allies while waging 'war against the king's enemies… and to arrest pirates',[10] Warwick seemed unwilling to differentiate, and his indiscriminate attacks on enemies and allies alike caused despair within government – who had the complaints of friendly powers to deal with – but inspired admiration from not only his soldiers, whose wages these attacks were paying, but also many of his countrymen, who saw his exploits as some recompense for the humiliating defeats in France.

On 28 May 1458 a Spanish fleet of 28 ships was spotted, 'wherof there was xvj. [16] grete schippis of forecastell', against which Warwick sent 'fyve schippis of forecastell and iij. [3] carvellis and iiij. [4] spynnes'. The battle off Calais is described in a letter from John Jernyngan, who was involved, to Margaret Paston: 'and ther we toke vj. [6] of her [their] schippis… And as men sayne, ther was not so gret a batayle upon the se this xl. [40] wyntyr'.[11]

Not long after this, Warwick's ships intercepted the Hanse salt fleet – allies of England – capturing up to 17 ships, and amongst other attacks, one on another heavily laden Spanish fleet attracted yet more attention; 'the erle of Warrewyk… faugt with the Spaynardys and kylde many of thaym, and tooke theyre grete vesselles and a carake of Jene [Genoa], and gate in theym grete rychesse'.[12]

KEEPER OF THE SEAS

English ships flying the colours of the earl of Warwick, captain of Calais, attack a heavily laden Spanish fleet in the Channel in 1458.

Gouache, 18.5" x 13.5" (47cm x 35cm), 2021.

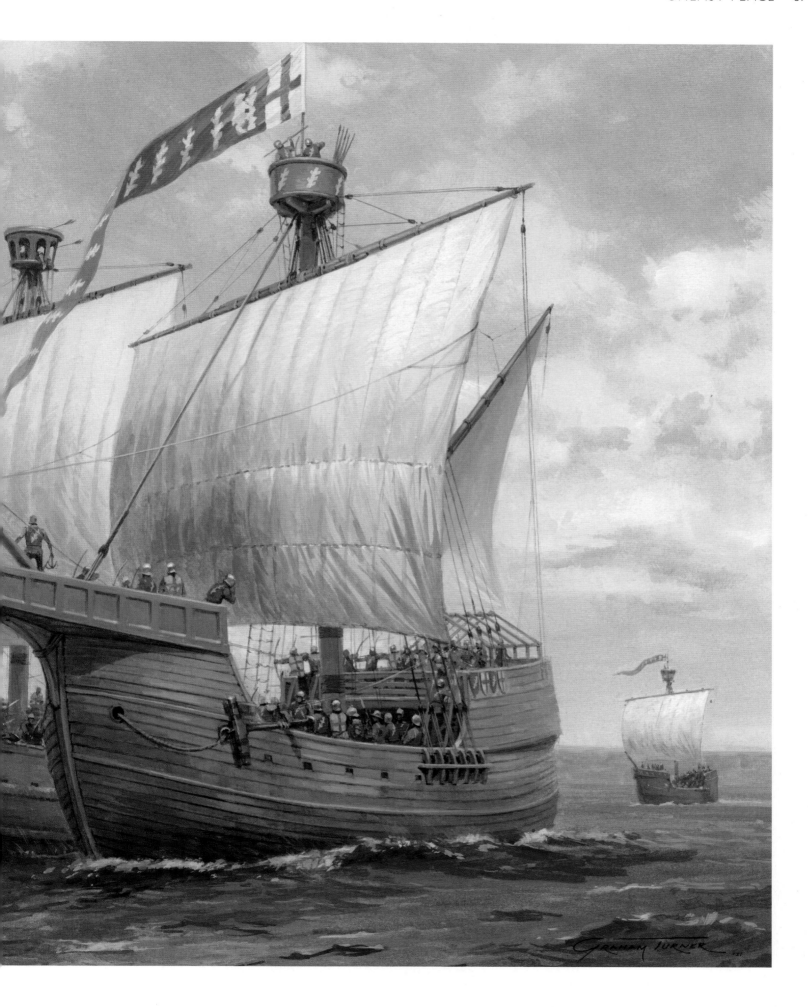

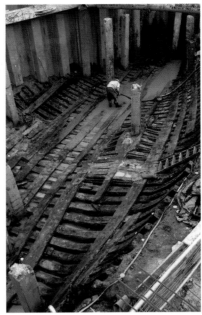

FAR LEFT One of several ships depicted in the *Beauchamp Pageant, c.*1483–85. By this time the idea of carrying cannon on board was beginning to be explored. (The British Library, Cotton MS Julius E IV-3 f.25r)

LEFT The excavation of the Newport ship in 2002. (Newport Museums and Heritage Service)

On 7 December 1461 a grant for life was awarded 'to William Staveley, for his good services for fifteen years at Calais and at sea, and because he was wounded and probably maimed for life in the company of the king's kinsman Richard, earl of Warwick, resisting the Spaniards and their caracks', a reminder of the individual cost of these conflicts.[13]

During the 15th century, significant developments were made in the design of ships. Traditionally built with clinker-built hulls – overlapping planks – and a single mast, as the century progressed additional mizzen and foremasts began to appear, as did the smooth planking over a frame 'carvel' type of construction developed in the Mediterranean. Carvels are mentioned in the accounts of Warwick's encounters of the 1450s, representing the latest in ship design, while carracks were the great ships of the period.

Sea battles were fought and won by boarding the enemy, and warships were fitted with 'castles' fore and aft – the 'schippis of forecastell' mentioned in the account above. Guns were slow to be adopted in naval warfare, but started to make an appearance later in the century, the *Beauchamp Pageant* of the 1480s illustrating guns on the main deck but not yet lower in the ship with gunports, as would become the norm in the next century and beyond.

BELOW LEFT An archer's wrist-guard, embossed with the Latin word *amilla* (meaning bracer), found with the Newport ship. (Newport Museums and Heritage Service)

BELOW A long-toed poulaine shoe, one of several items of footwear found with the Newport ship. (Newport Museums and Heritage Service)

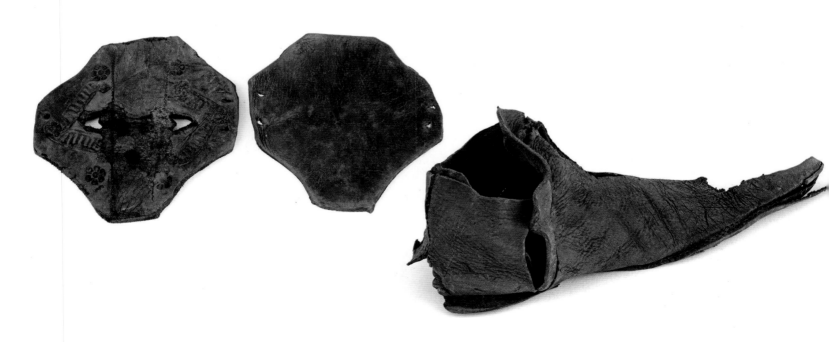

A remarkable discovery is helping to shed some light on the type of ship that plied its trade across the Channel and into the Mediterranean, and engaged in the earl of Warwick's actions, during this period. Building work in Newport in 2002 uncovered the remains of a ship which has been dated to the mid-15th century, and tantalisingly linked to the earl of Warwick. Of clinker-type construction with a length of around 30 metres and a displacement estimated at just under 400 tons, the Newport ship was built in the Basque country in *c*.1449. After the Battle of Edgcote, the lordship of Newport was one of William Herbert's possessions seized by Warwick, and a letter signed by him in November 1469 authorises payments for work to 'the ship at Newport'. It is thought that while in dry dock for this work, the timbers supporting the ship collapsed and it was decided to salvage what could be reused and abandon the hull, which quickly became silted up and buried for the next five centuries.

AN ATTEMPT AT RECONCILLIATION

Unlike previous captains, Warwick spent a considerable amount of time in Calais, overseeing his operations there himself, but he did on occasion return to England. One such visit was in 1458, when he arrived in London on 14 February with about 600 retainers 'all arayed in rede jakettys with whyte raggyd staves upon them' – his instantly recognisable livery.[14]

The royal court had returned to Westminster from Coventry and the great lords were summoned, each, like Warwick, arriving with large numbers of retainers – to the understandable alarm of the authorities. Amongst these were the sons of the lords killed at St Albans: Henry Beaufort, Duke of Somerset, Henry Percy, Earl of Northumberland and John, Lord Clifford. The young duke of Somerset was declared 'nearly of full age' and authorised to take possession of his inheritance, wasting no time in attaching himself to the court party and taking up where his father had left off. Tensions were high; one chronicle claims that 'they came ageyns the pease… forto dystroy utterly the sayde duk of York and the erle of Salesbury, and of Warrewyk'.[15] In the face of such a volatile situation, 'the mayer… had dayly in harnesse [armour] v.M. [5,000] cytezyns, and rode dayly about the cytie and subburbys of the same, to see that the kynges peace were kept'.[16] King Henry's motives for the summons appear to have been to genuinely encourage peaceful reconciliation between his powerful subjects. He commanded his great council to settle 'suche variaunces as ben betwixt divers lordes of this oure reaume [realm]',[17] and York, Salisbury and Warwick promised to endow the Abbey at St Albans to sing masses for the souls of those killed in the battle there. York also agreed to pay compensation to the new duke of Somerset and his widowed mother, and likewise Warwick was to compensate the Clifford family, and Salisbury the Percys. On 25 March the proceedings were rounded off with a solemn procession to St Paul's Cathedral, the king wearing his crown and robes, and the erstwhile enemies walking hand in hand. Unfortunately, Henry's 'love-day' would prove to be a well-meaning but naïve attempt to paper over the ever-growing divisions between the increasingly entrenched Yorkist and court factions, divisions that would soon be bloodily exposed once again.

OPEN WAR RETURNS

THE BATTLES OF BLORE HEATH & LUDFORD BRIDGE

After celebrating Easter in St Albans, the king and queen returned to London, where they were entertained by jousts at the Tower and Greenwich, the duke of Somerset and Anthony Woodville prominent amongst those taking part. Woodville would go on to build quite a reputation in the chivalric arena and, with his family, rise to play a central role in the Wars of the Roses.

Through the rest of 1458 and into 1459, antagonism between the Yorkist and court factions deepened: 'For this y[ear] olde racour and malyce, which nevyr was clerely curyd, anon began to breke out'.[1] In November 1458, while in London, 'fylle a grete debate betwene Richard erle of Warrewyk and theym of the kynges hous, in so moche that they wolde have sleyne the erle; [had he not] escaped to his barge, and went anone after to Caleys'.[2] The propaganda from both sides sought to undermine the other; 'The quene with such as were of her affynyte rewled the reame as her lyked, gaderyng ryches innumerable… The quene was defamed and desclaundered [slandered], that he that was called Prince, was nat hir sone, but a bastard goten in avoutry; wherefore she dreding that he shulde nat succede hys fader in the crowne of Englond'. In seeking to strengthen her position Queen Margaret 'allyed un to her alle the knyghtes and squyers of Chestreshyre' and distributed the swan badge of her son the Prince of Wales 'to alle the gentilmenne of the contre, and to many other thorought the lande; trustyng thorough thayre streynghte to make her sone king'.[3]

The final straw for the Yorkist lords came when word reached them that they had been proclaimed traitors at a great council meeting in Coventry. With a huge royal army gathering in the Midlands, York, Salisbury and Warwick armed their followers and made arrangements to join forces. York was at Ludlow and this is where Warwick and Salisbury headed for, Warwick from Calais with 500 soldiers of the Calais garrison, and Salisbury with his retinue from his principal residence at Middleham Castle in Yorkshire. Salisbury was able to sidestep the king's

army at Nottingham, but another force assembled by Sir James Touchet, Lord Audley, intercepted him on 23 September at Blore Heath, near Newcastle-under-Lyme on the Welsh border.

Sir James was a 61-year-old veteran of the French wars who held estates in the area, and his substantial army included a large cavalry element. He had responded to the royal summons to join the king 'wyth as many personys defensebylly arayid as they myte',[4] and now he found himself in the front line of this rapidly escalating situation as it tipped once again into open warfare.

With most medieval battles the exact course of events can be very difficult to deduce from the available sources of information, and those relating to Blore Heath are especially sparse. Even battles where accounts are plentiful can be frustrating to try to explain with any certainty – a battlefield is a confusing place and it's hardly surprising that even eyewitnesses have difficulty in following how events are unfolding.

It seems that Salisbury formed his army up on a ridge in front of a wood, with Audley facing them on the opposite side of a small but steep-sided stream called Wemberton Brook. One interpretation suggests that Salisbury feigned a retreat to goad Audley into advancing, and when his first cavalry attack across the brook was repulsed by a barrage of arrows, Lord Audley personally led a second charge during which he was killed. Command was assumed by Lord Dudley, another local landowner, but after a bitter and long-running struggle, Salisbury's men emerged victorious.

Salisbury had won the battle, but his position was still precarious, with other royal armies in the area searching for him. One account has him persuade a friar to repeatedly fire a gun through the night to

THE BATTLE OF BLORE HEATH
23 September 1459

Sir James Tuchet, Lord Audley, leads the Lancastrian cavalry across Wemberton Brook and towards defeat at the hands of the earl of Salisbury's Yorkist army.

Gouache, 18" x 13" (46cm x 33cm), 2020.

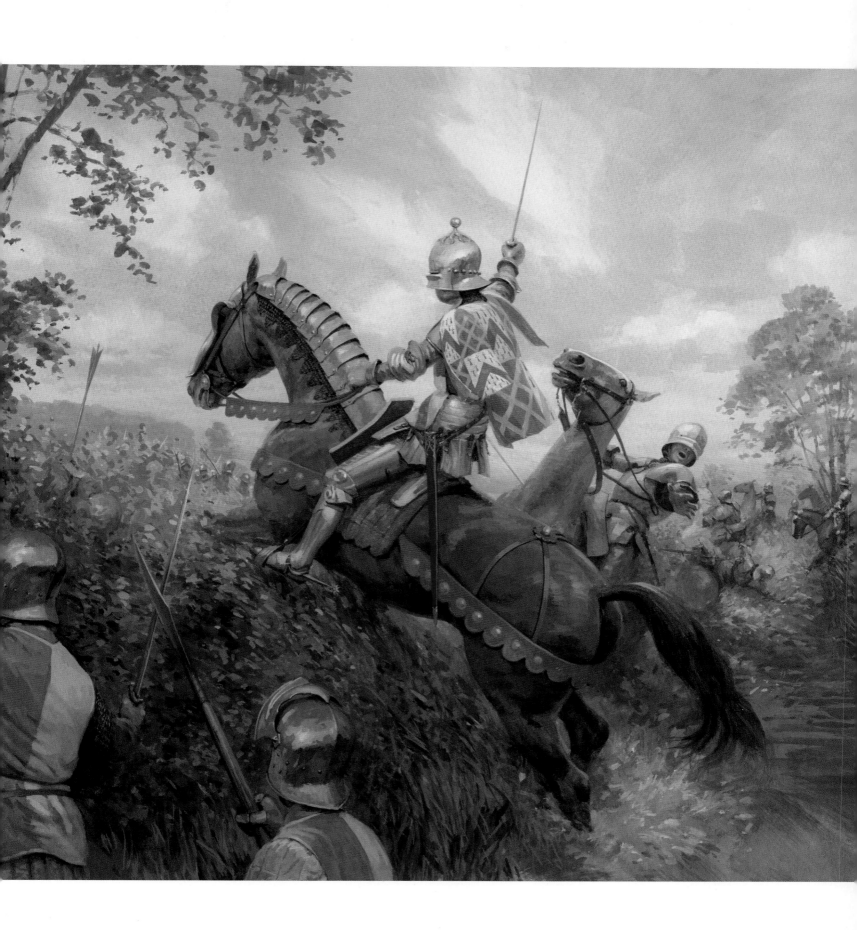

'And there was the lorde Audeley sleyne, and meny of the notable knyghtes and squyers of Chesshyre that had resceved the lyvery of the swannes; and there were take prysoners, the erlles ij. [2] sones of Salisbury, Thomas and Johan, and ser Thomas Haryngtone, and emprysoned in the castelle of Chestre.'

An English Chronicle

confuse his pursuers of his whereabouts. He narrowly avoided capture and continued his journey, but will have been acutely aware of the effect his actions might have on the future of his imprisoned sons, Thomas and John, who would remain in custody until after the Battle of Northampton in 1460.

Among the 'notable knyghtes and squyers' to be 'killed at Bloreheth, co. Stafford, in the king's service' was Sir William Troutbeck – 'spoiled of horses, harness and other goods'. His death left his wife and four children not only without a husband and father, but with such financial loss 'she cannot support them', forcing her to appeal to the king in April the following year.[5]

York, Salisbury and Warwick finally joined together and advanced to Worcester, where they again appealed directly to the king, who once again responded with an offer of a pardon – with the specific exclusion of Salisbury and those involved at Blore Heath. The offer was rejected:

First, because we have had other and various pardons, and still have them. [Yet even] though we have had them confirmed [by] Parliament, they have not been of profit to us or done us good... Nor were we summoned to councils or Parliaments, or admitted to any other business. It was as if [the king] had no faith at all in us; nor had he trust in his heart or mind.

Second, because, despite the pardons we obtained, the familiars of the king are so bold – almost all of them – that they do not fear to disobey royal commands. Nor do they fear, when they have transgressed, to be notorious on account of their misdeeds. They are a group of men without prudence or counsel.[6]

Avoiding battle with the vastly superior royal army, the Yorkists returned to Ludlow. King Henry marched with his army, 'not sparyng for eny ympedyment or difficulte of wey' and he 'logged [lodged] in bare feld somtyme two nyghtes togider with all youre Host in the colde season of the yere'.[7] Although he is usually portrayed as completely

ineffectual, Henry clearly had some physical strengths, which he also demonstrated while evading capture for a year in the north in 1464/5.

The force that arrayed in support of King Henry on the wet meadows beside the river Lugg at Ludford Bridge made it very clear how isolated the Yorkist lords had become, with most of their fellow peers favouring loyalty to their anointed king over rebellion. Among those who had answered the king's summons were the dukes of Buckingham, Somerset and Exeter, the earls of Northumberland, Shrewsbury, Devon, Wiltshire and Arundel, Viscount Beaumont, and at least five barons. Devon was now with the king, for although he had been one of the few to stand with York at Dartford seven years earlier, the two men had fallen out over the handling of his dispute with Bonville.

The Yorkists had prepared 'a grete depe dyche and fortefyde it with gonnys, cartys, and stakys'[8] and 'than and there shotte their seid Gonnes, and shotte aswele at youre most Roiall persone, as at youre Lordes and people with you'.[9]

As at the Battle of St Albans, the presence of the king still had enormous significance, for despite any shortcoming he might have had, the idea of fighting against your anointed king was considered sacrilegious, not to mention treasonable. Clearly, some of York's army decided that this was a step too far and, as night fell on 12 October 1459, they began to melt away, Yorkist hopes being finally crushed by the defection of

TOP The Audley Cross marks the possible spot where Lord Audley met his end at the Battle of Blore Heath, with the steep slope down towards Wemberton Brook behind. (Glenn Foard)

ABOVE Salisbury's stall plate in St George's Chapel, Windsor, home of the Order of the Garter, shows the Neville saltire quartered with the arms of Montacute and Monthermer, the titles he gained by right of his wife.

LEFT Ludlow town and castle, one of the duke of York's principal residences and the seat of Yorkist power in the border region with Wales.

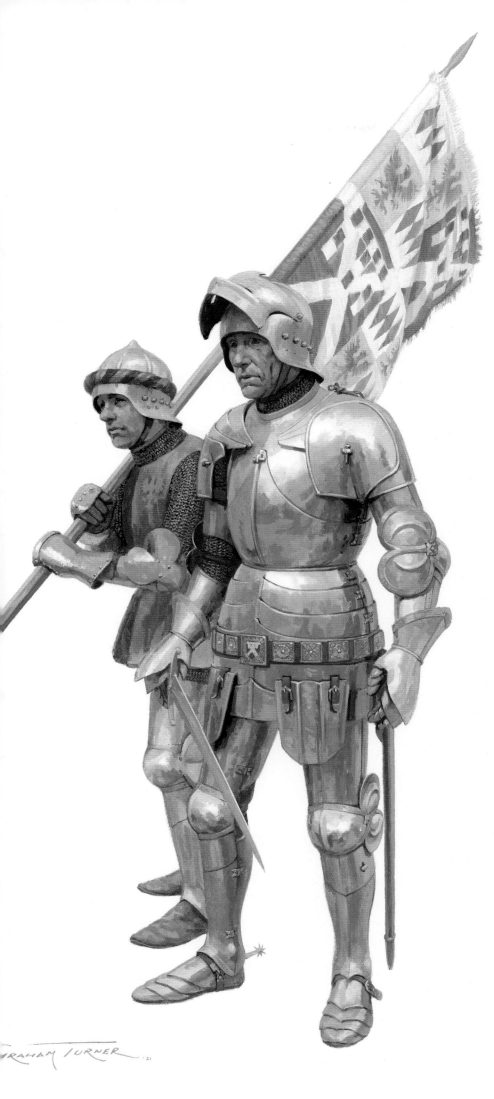

RICHARD NEVILLE, EARL OF SALISBURY

Richard Neville was born in 1400, the son of Ralph Neville, Earl of Westmorland, and Joan Beaufort (see page 33). Knighted in 1420, he gained his title through his wife Alice, only daughter of Thomas Montacute (Montagu), 4th earl of Salisbury (see drawing on page 18), when he was killed by cannon fire while commanding the English forces at the siege of Orléans in 1428. In 1436 Richard was created a Knight of the Garter, and he would go on to play a significant role in the early stages of the Wars of the Roses. His family's struggle for regional dominance against the Percys caused considerable unrest in the north, boiling over into outright violence on several occasions, and this pushed him and his son Richard, Earl of Warwick, into their alliance with the duke of York – who was married to Salisbury's sister Cecily – creating the foundations of the Yorkist faction.

Gouache, 11" x 17" (29 x 43cm), 2021.

most of the Calais garrison under Andrew Trollope to the royalist side 'wher thei wer receyved joyously'.[10]

According to the act of attainder that afterwards condemned them as traitors, stripped them of their lands and offices and disinherited their heirs, 'Almyghty God… smote the hertes of the seid Duc of York and Erles soddenly from that most presumptuouse pryde, to the most shamefull falle of Cowardise that coud be thought, so that aboute mydnyght… they stale awey oute of the Felde… levyng their Standardes and Baners in their bataill directly agenst youre Feld, fledde oute of the Toune [Ludlow] unarmed, with fewe persones into Wales'.[11]

York fled to Ireland with his son the earl of Rutland, while Warwick and Salisbury, with York's oldest son Edward, Earl of March, escaped to Calais. Ludlow was sacked – 'The mysrewle of the kyngys galentys at Ludlowe, when they hadde drokyn i-nowe [drunk enough] of wyne that was in tavernys and in othyr placys… and thenn they robbyd the towne, are bare a-waye beddynge, clothe, and othyr stuffe, and defoulyd many wymmen.'[12]

With her husband in exile, Cecily Neville, Duchess of York, 'com unto Kyng Harry and submyttyd hyr unto hys grace',[13] and she was placed in the custody of her sister, the duchess of Buckingham. Abandoned with her at Ludlow were their daughter Margaret and sons George and Richard, the youngest, who celebrated his seventh birthday there on 2 October; they all faced an uncertain future.

From their overseas havens, with their backs to the wall and nothing left to lose, the Yorkists planned their fightback.

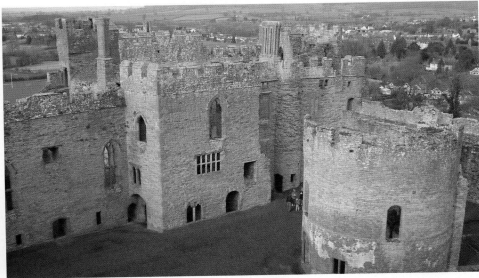

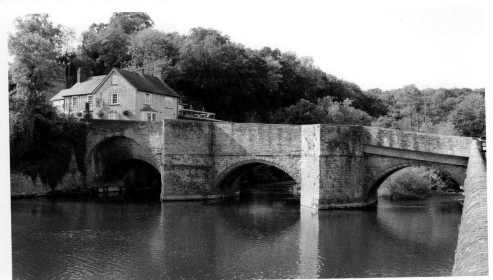

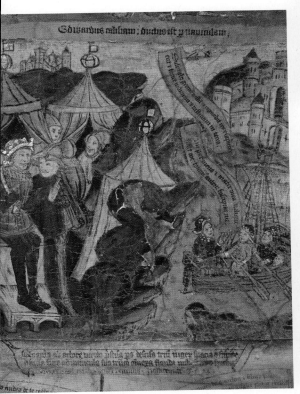

DIVIDED LOYALTY

OPPOSITE

Ludlow Castle – Autumn, 1459

A soldier from the Calais garrison considers the awkward dilemma he finds himself in; sworn to protect the king, yet now expected to take up arms against him by his captain, the earl of Warwick, who has joined the duke of York in his stand against Henry VI and his court favourites. He proudly wears the cross of St George – the livery of England – while holding a red bend bearing Warwick's badge of the ragged staff he is expected to put on. Where does his loyalty lie – is he prepared to follow his captain in open rebellion against the Crown, to become a traitor?

Oil on canvas, 18" × 24" (46 × 61cm), 2019.

'Almyghty God... smote the hertes of the seid Duc of York and Erles soddenly from that most presumptuouse pryde, to the most shamefull falle of Cowardise that coud be thought, so that aboute mydnyght... they stale awey oute of the Felde... levyng their Standardes and Baners in their bataill directly ayenst youre Feld, fledde oute of the Toune unarmed, with fewe persones into Wales; understondyng that youre people hertes assembled, was blynded by theym afore, were he more partie converted by Goddes inspiration to repent theym, and humbly submytte theym to You, and aske youre grace, which so didde the grete part; to whom, at our Lordes reverence and Seint Edward, Ye ymparted largely youre grace.'

Rotuli Parliamentorum Vol. V p.349

ABOVE Garter stall plate in St George's Chapel, Windsor, of Humphrey Stafford, Duke of Buckingham, born in 1402 and created a Knight of the Garter in 1429.

LUDFORD BRIDGE

Henry VI's army sweeps across Ludford Bridge and into Ludlow on the morning of 13 October 1459. Reluctant to commit treason, many of those facing them had dispersed or gone over to the king, and, with the situation seemingly lost, the Yorkist lords had fled during the night, abandoning their remaining soldiers – along with the duke of York's duchess, Cecily, their daughter Margaret, and younger sons George and Richard.

Here, some of the soldiers who had remained loyal to York, Warwick and Salisbury sit dejectedly as Humphrey Stafford, Duke of Buckingham, rides by. Having submitted to the king they desperately hope to be granted his pardon, but for now their futures hang in the balance.

The banners and standards from left to right are: Henry Holland, Duke of Exeter (on the bridge); John, Lord Clifford; King Henry VI; Henry, Lord Fitzhugh; John, Lord Lovell; Humphrey Stafford, Duke of Buckingham; William Fitzalan, Earl of Arundel. Buckingham himself is in front of his standard, and his soldiers are identified by their black and red livery jackets bearing the Stafford knot.

Gouache, 21" x 15.5" (54cm x 39cm), 2021.

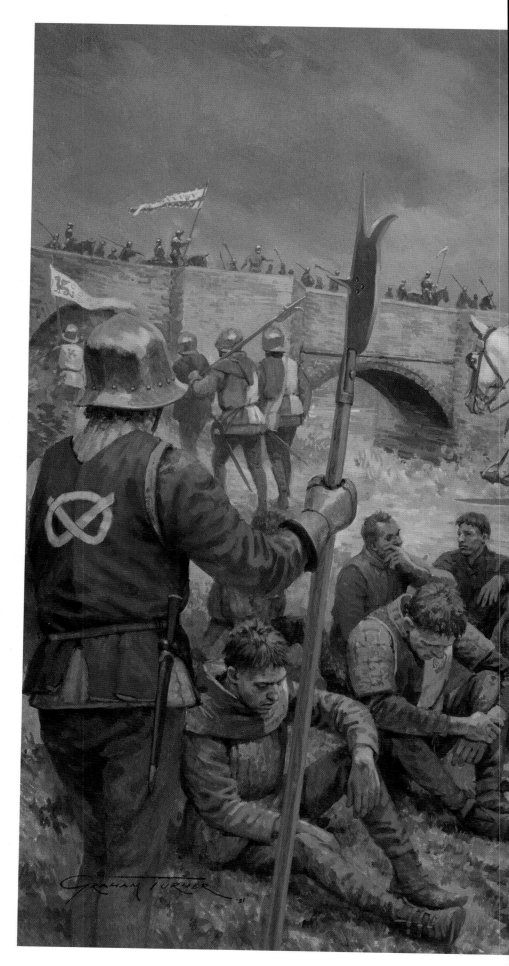

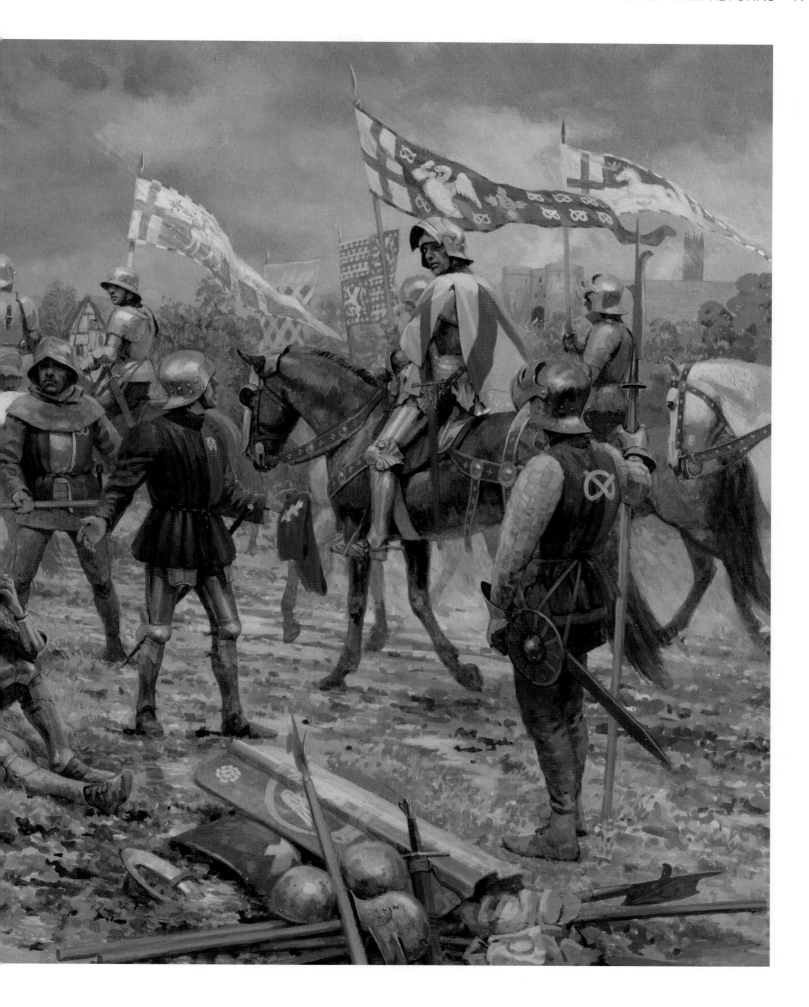

CHAPTER 8
THE WHEEL OF FORTUNE TURNS

The wheel of fortune was a popular allegorical theme in medieval Europe, and the concept of the temporary nature of power and how the mighty must fall is reflected in literature and art of the time. This philosophy certainly applies to the events of the Wars of the Roses, especially those of 1459–61 and again in 1469–71.

In November 1459 a Parliament met in Coventry, its prime purpose being to condemn the Yorkist lords and their allies 'for their seid traitorous reryng [raising] of werre [war] agenst youre seid moost noble persone, at Ludeford ofore specified', and they were 'declared, adjugged, demed and atteynted of high Treson, as fals traitours and enemyes ayenst youre moost noble Persoon, high Mageste, Croune and Dignitee'.[1]

Concerted attempts were made to dislodge the earl of Warwick from his refuge at Calais, the duke of Somerset and Andrew Trollope taking the neighbouring fortress at Guisnes and proceeding to harass Warwick's men; their efforts ended after a violent skirmish at Newham Bridge that saw Somerset's force routed. Warwick continued to receive aid and men from Kent, the popularity he had gained from his earlier exploits proving crucial in his time of need. In January 1460 Warwick boldly launched a raid on the port of Sandwich and took several of the ships that had been supplying Somerset in Guisnes – putting them to good use in his subsequent invasion fleet. Also captured were Richard Woodville, Earl Rivers, and his son Anthony, who were taken back to Calais where Rivers was berated by Salisbury, Warwick and March; 'callyng hym knaves son… that his fader was but a squyer, and broute up with Kyng Herry the V, and sethen hym-self made by maryage and also made Lord'.[2] Rivers had married the widow of the duke of Bedford back in 1435, and this haughty attack on his family's more humble origins and condemnation of them as unworthy upstarts would be repeated over the coming years as the Woodvilles came to play a central part in events. The young earl of March would have to modify his opinion of them when they became his in-laws four years later!

Jasper Tudor, Earl of Pembroke, was appointed to tackle the threat posed by the duke of York in Ireland by subjugating the duke's Welsh lands and castles that held out for him, especially Denbigh, which had been his favoured crossing point. York remained secure in

LEFT **The Wheel of Fortune, as depicted in a manuscript of *c.*1460.** (The British Library, Royal MS 18 D II f.30v)

BELOW LEFT **The Battle of Northampton, as depicted in a manuscript of 1461–*c.*1470.** (The British Library, Harleian MS 7353)

Ireland, where he held long-established power and position and enjoyed considerable support.

As the authorities worked to take control of the lands confiscated from the Yorkist lords, accounts of heavy-handedness and atrocities were reported – perhaps exaggerated by pro-Yorkist authors as part of the propaganda war: 'therlle of Wylshyre [the earl of Wiltshire] tresorer of Englond, the lorde Scales, and the lorde Hungreford, havyng the kynges commyssyone went to the toune of Newbury, the whyche longed to the duk of York, and there made inquysycione of alle thayme that in any wyse had shewed any favoure or benyvolence or frendshyppe to the sayde duk, or to any of hys; whereof some were found gylty and were drawe[n] hanged and quartered, and alle other inhabitantes of the foreseyde toune were spoyled of alle theyre goodes'.[3]

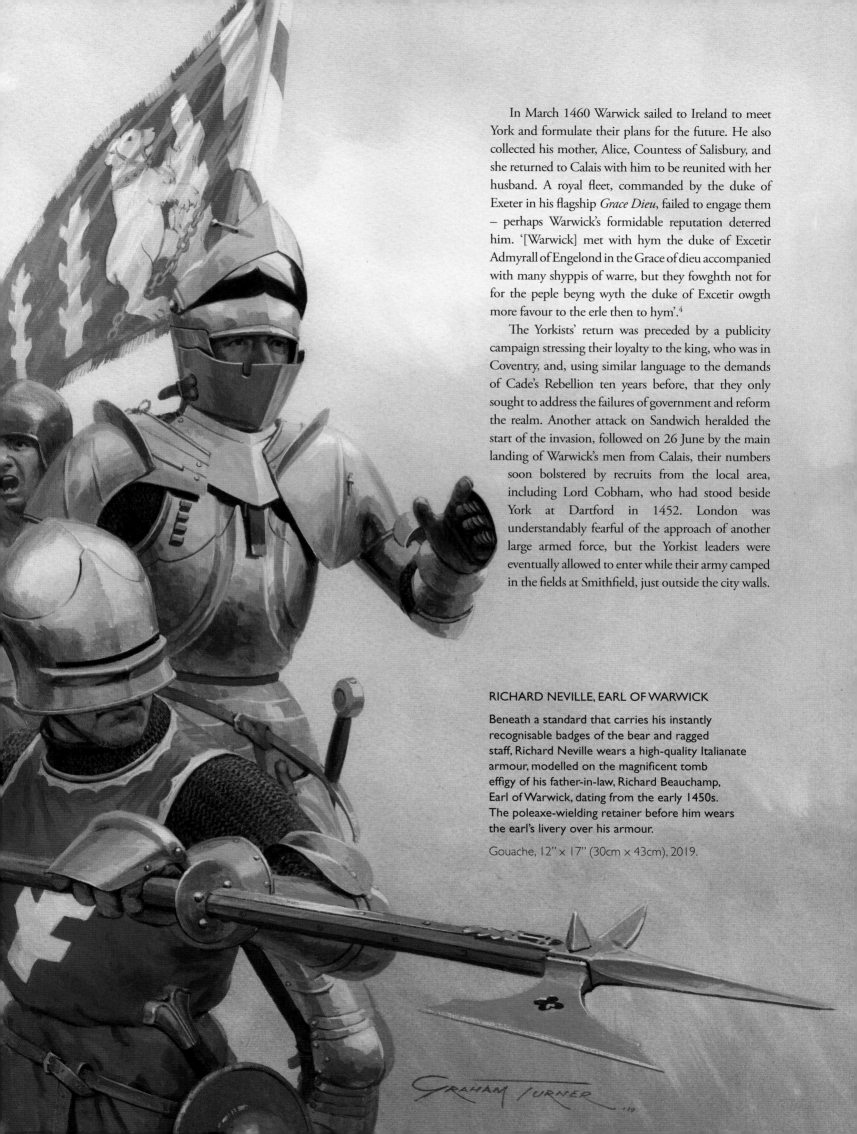

In March 1460 Warwick sailed to Ireland to meet York and formulate their plans for the future. He also collected his mother, Alice, Countess of Salisbury, and she returned to Calais with him to be reunited with her husband. A royal fleet, commanded by the duke of Exeter in his flagship *Grace Dieu*, failed to engage them – perhaps Warwick's formidable reputation deterred him. '[Warwick] met with hym the duke of Excetir Admyrall of Engelond in the Grace of dieu accompanied with many shyppis of warre, but they fowghth not for for the peple beyng wyth the duke of Excetir owgth more favour to the erle then to hym'.[4]

The Yorkists' return was preceded by a publicity campaign stressing their loyalty to the king, who was in Coventry, and, using similar language to the demands of Cade's Rebellion ten years before, that they only sought to address the failures of government and reform the realm. Another attack on Sandwich heralded the start of the invasion, followed on 26 June by the main landing of Warwick's men from Calais, their numbers soon bolstered by recruits from the local area, including Lord Cobham, who had stood beside York at Dartford in 1452. London was understandably fearful of the approach of another large armed force, but the Yorkist leaders were eventually allowed to enter while their army camped in the fields at Smithfield, just outside the city walls.

RICHARD NEVILLE, EARL OF WARWICK

Beneath a standard that carries his instantly recognisable badges of the bear and ragged staff, Richard Neville wears a high-quality Italianate armour, modelled on the magnificent tomb effigy of his father-in-law, Richard Beauchamp, Earl of Warwick, dating from the early 1450s. The poleaxe-wielding retainer before him wears the earl's livery over his armour.

Gouache, 12" x 17" (30cm x 43cm), 2019.

THE BATTLE OF NORTHAMPTON

The Yorkist army marched out of London and met the king's well-positioned forces near Delapré Abbey, outside Northampton, on 10 July 1460.

'The kyng at Northamptone… ordeyned there a strong and a myghty feeld, in the medowys beside the Nonry [Nunnery], armed and arrayed wythe gonnys, havyng the river at hys back'.[5]

As usual, negotiations were attempted, but when their overtures were rejected the Yorkist army attacked the king's fortified position from all sides. Perhaps learning from the defeat at Castillon, the king had brought a large number of guns to Northampton, but these would play no part; 'The ordenaunce of the kynges gonnes avayled not, for that day was so grete rayne, that the gonnes lay depe in the water, and so were queynt [quenched] and myghte not be shott'.[6]

Despite being reprieved from facing withering artillery fire, the assault against the strongly defended Lancastrian position would have been a daunting prospect, with a muddy ditch and ramparts to negotiate under a storm of arrows, but the Yorkists' outlook took a sudden turn for the better when Lord Grey of Ruthyn defected to their cause and helped them over the defences in what must have been a pre-arranged move; 'as the attacking squadrons came to the ditch before the royalist rampart and wanted to climb over it, which they could not quickly do because of the height… the lord [Grey] with his men met them and, seizing them by the hand, hauled them into the embattled field'.[7]

The battle turned into a 'great slaughter', many perishing as they tried to cross the river Nene. Among the dead surrounding King Henry's tent were the duke of Buckingham, earl of Shrewsbury, and lords Beaumont and Egremont.

As his father had done after St Albans, Edward, Earl of March, apparently now knelt before the king and pronounced his loyalty; 'Most Noble Prince, dysplease yow not, thoughe it have pleased God of His Grace to graunt us the vyctory of oure mortalle enemyes, the whiche by theyre venymous malyce have untruwly stered and moved youre hyghenesse to exyle us oute of youre londe, and wolde us have put to fynalle shame and confusyone. We come not to that entent for to inquyete ne greve youre sayde hyghenesse, but for to please youre moste noble personne, desiryng most tendrely the hyghe welfare and prosperyte thereof, and of alle youre reame, and for to be youre trew lyegemen, whyle oure lyfes shalle endure'.[8]

The captive King Henry was escorted back to London by the victorious earls of Warwick and March, Warwick carrying the king's sword before him in the solemn procession. It was clear that although Henry was still king, it was the Yorkists who were now in charge. One contemporary description paints an image of the unfortunate king that has endured – 'more timorous than a woman, utterly devoid of wit or spirit'.[9] They entered a city under fire from within; when the

LOYAL SUBJECTS – THE BATTLE OF NORTHAMPTON

Edward, Earl of March, kneels before Henry VI and proclaims his loyalty, having defeated the Royal army at Northampton on 10 July 1460. The earl of Warwick and Yorkist troops look on, while one of the guns that failed to fire in the rain stands impotently in the foreground.

Gouache, 21.5" x 16.5" (54cm x 42cm), 2006.

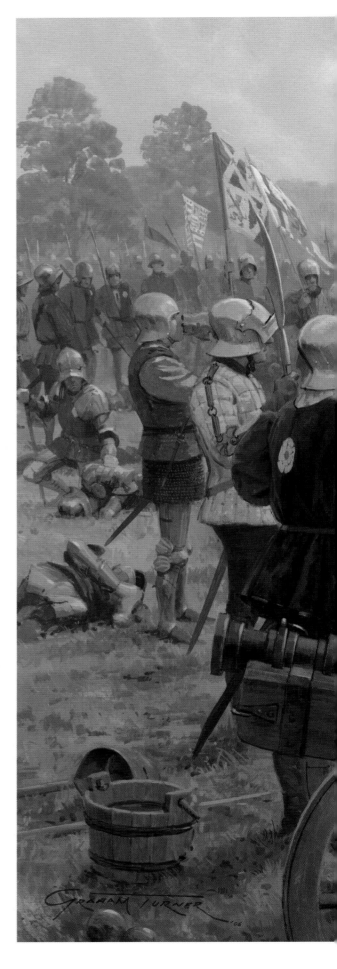

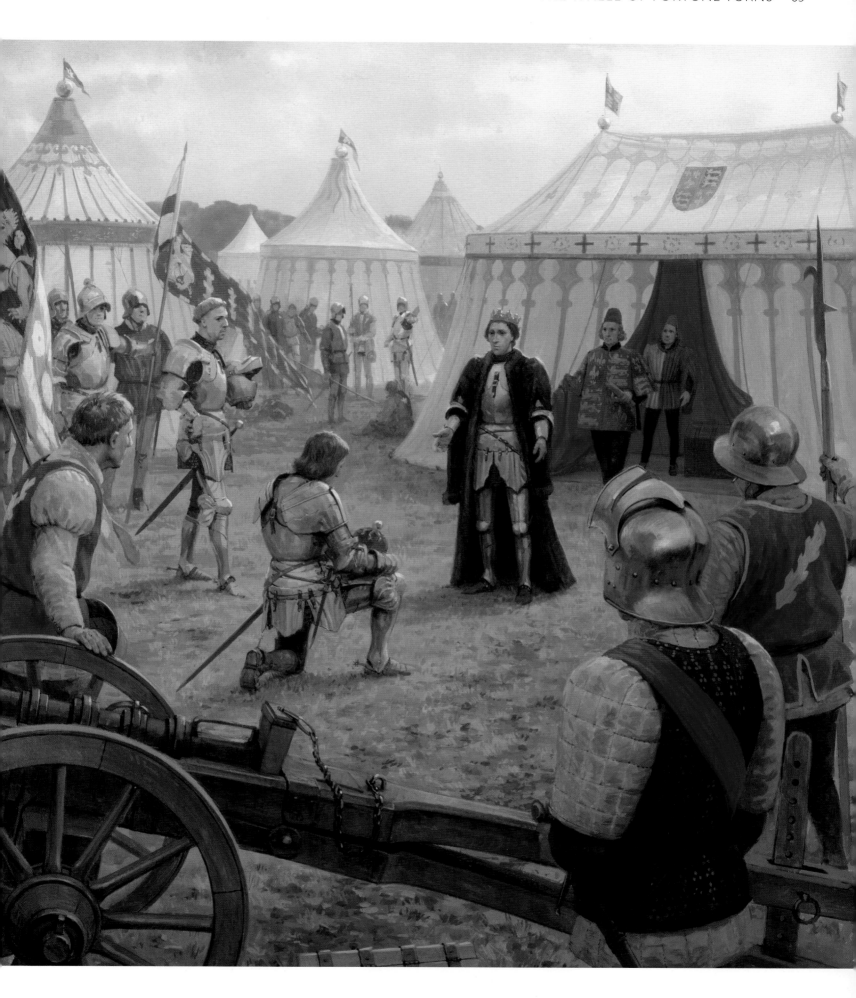

Yorkists had arrived earlier in the month, the lords Scales and Hungerford and other loyal Lancastrians had locked themselves within the walls of the Tower, and the earl of Salisbury had stayed behind with Lord Cobham and Sir John Wenlock to deal with the threat. Scales and Hungerford proceeded to bombard the city – 'thay that were wythynne the toure caste wyld fyre in to the cyte, and shot in smale gonnes, and brend and hurte men and wymmen and children in the stretes. And they of London leyde grete bombardes on the ferther syde of the Thamyse agayns the toure and erased the walles therof in diverse places'.[10] Realising that their situation was hopeless, they negotiated surrender and made plans to escape, but Scales was recognised and killed as he travelled along the Thames towards hoped-for sanctuary at Westminster; 'And grete pyte it was, that so noble and so worshypfulle a knighte, and so welle aproned in the warrys of Normandy and Fraunce, should dy so myschevously'.[11] With Londoners clamouring for retribution against those who had turned the Tower's guns onto the city, several of those who had surrendered were later condemned to be drawn, hanged, 'and ther hedis smitten of'[12] at Tyburn.

The queen and Prince Edward escaped to Wales, but not without incident; 'a servand of hyr owne that she hadde made bothe yeman and gentylman, and aftyr a-poyntyd [appointed] for to be in offysce with hyr sone the prynce, spoylyde hyr and robbyde hyr, and put hyr soo in dowt of hyr lyffe and sonys lyffe also. And then she com to the Castelle of Hardelowe [Harlech]'.[13]

From Wales they sought refuge in Scotland to appeal for help from Queen Mary of Guelders, who herself had just been widowed when her husband, James II, was killed by an exploding cannon as he besieged Roxburgh Castle. Mary ruled as regent on behalf of their eight-year-old son James III, but like their neighbours, Scotland was divided by rivalry. England and Scotland had a long history of conflict, and the borders were in an almost constant state of war. During the 1450s James had conducted several raids into England to exploit the troubles across the border; this was another potential opportunity for the Scots.

After news reached him of the victory at Northampton, York returned from Ireland. His stately journey through England attracted comment as it seemed more like a royal progress, an impression heightened by his display of the royal arms undifferenced (without the label to distinguish him as a lesser relation). As he approached London he

LEFT Westminster Hall, one of the few parts of the medieval palace to survive after several centuries of development and the catastrophic fire of 1834. (Getty Images)

BELOW LEFT The battlefield at Northampton, viewed from near the Eleanor Cross.

BOTTOM LEFT Beside the Northampton battlefield is the Eleanor Cross at Hardingstone, one of the monuments erected along the route the body of Edward I's queen took from Lincoln to London in 1290.

'he was the Duke of Yorke ys secunde sone,
one the beste dysposyd lorde in thys londe'
Gregory's Chronicle

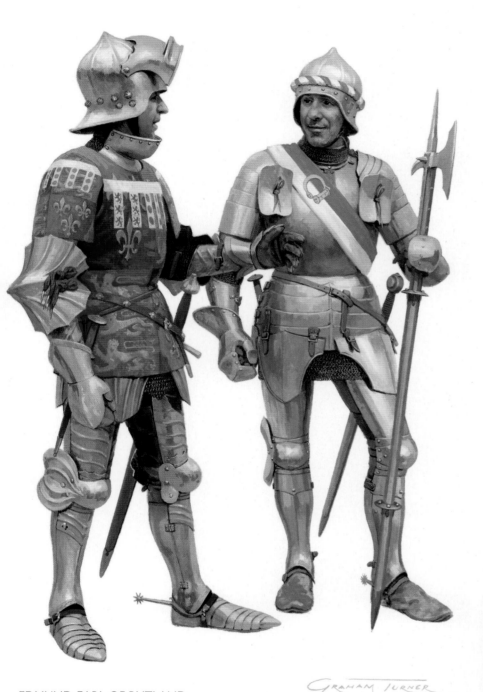

EDMUND, EARL OF RUTLAND

The second son of the duke of York and Cecily Neville, Edmund was born on 17 May 1443. In December 1460, while his elder brother headed west to take his first command, 17-year-old Edmund travelled north with his father. He is shown here wearing armour of West European style, over which is his identifying heraldic tabard bearing the royal arms differenced with a label. He is accompanied by a more experienced man-at-arms wearing a Milanese armour with a bend displaying the duke of York's fetterlock badge.

Gouache, 11" x 15" (28cm x 38cm), 2023.

was met by Duchess Cecily, and with trumpeters heralding his approach he regally entered the city with a sword carried upright before him. Making his way straight to the royal palace and then to Parliament, he 'walked straight on until he came to the king's throne, upon the covering or cushion of which laying his hand, in this very act like a man about to take possession of his right, he held it upon it for a short time'.[14] Clearly, York's ambitions had moved on from his proclaimed desire to be the king's chief minister.

The assembled lords were shocked and dismayed; York had completely misjudged the situation. He had done what the queen had for many years warned he would – and York had strenuously denied through numerous oaths of loyalty. Parliament proceeded to discuss the issue, and after a long debate recognized York's position and agreed to a compromise; in the resulting Act of Accord, 'the ryghte Hyghe and Myghty Prynce Richard Plantagenet, Duke of York' was named as Henry's heir.[15]

King Henry seems to have accepted the situation and, wearing his crown, he joined the lords at St Paul's Cathedral to seal the agreement. Queen Margaret was rather less compliant. The Act of Accord had disinherited her son Edward and she would do everything in her power to reverse the situation. With agreement reached with the Scots for military aid in return for the strategic border town of Berwick-upon-Tweed, she began mustering a large army to crush York, now without any doubt her bitter enemy. Amongst those joining her cause in Hull were the earl of Northumberland and Lord

ABOVE **The remains of the duke of York's once massive Sandal Castle.**

Clifford, with their considerable retinues, along with the duke of Somerset who, with the earl of Devon, had raised a large number of men in the West Country.

With the tenants of York and the Nevilles suffering at the hands of the queen's growing army, the threat developing in the north demanded prompt action and, early in December, the duke of York led an army out of London with his son Edmund, Earl of Rutland, and the earl of Salisbury. York's oldest son, Edward, was given his first independent command and set out to tackle the threat posed in Wales by Jasper Tudor, Earl of Pembroke, before planning to join his father in the north. Warwick remained in London in charge of the king.

There is a brief mention in the chronicles of an encounter between the forces of York and Somerset at Worksop, but no details are known; 'coming unexpectedly upon the troops of the Duke of Somerset at Worksop, their vanguard (the Yorkists) was destroyed'.[16] York's (possibly) mauled army arrived at Sandal Castle, his mighty fortress just outside Wakefield, a few days before Christmas, and celebrated as best they could with their enemies just a few miles away at Pontefract.

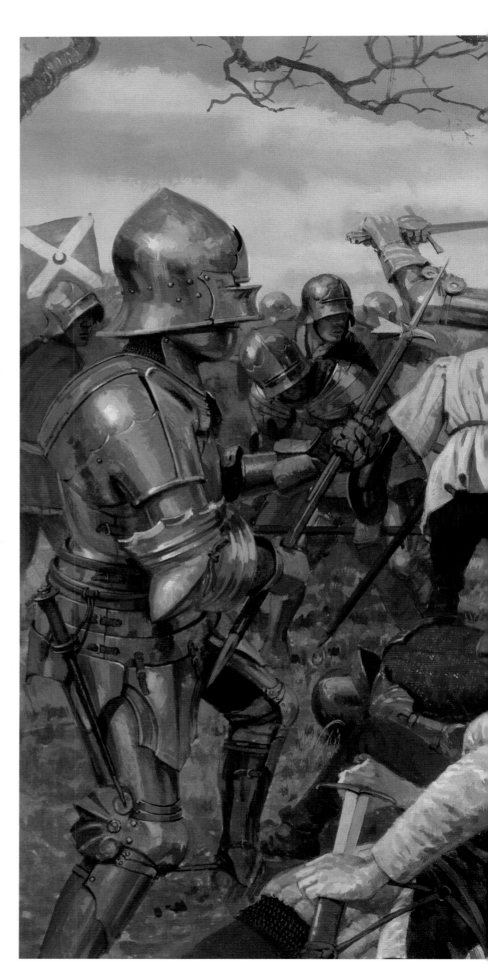

THE BATTLE OF WAKEFIELD
30 December 1460

Having been lured out from the safety of Sandal Castle, the duke of York and his retainers struggle in the fierce press of battle.

Gouache, 17" × 12.5" (43cm × 33cm), 2000.

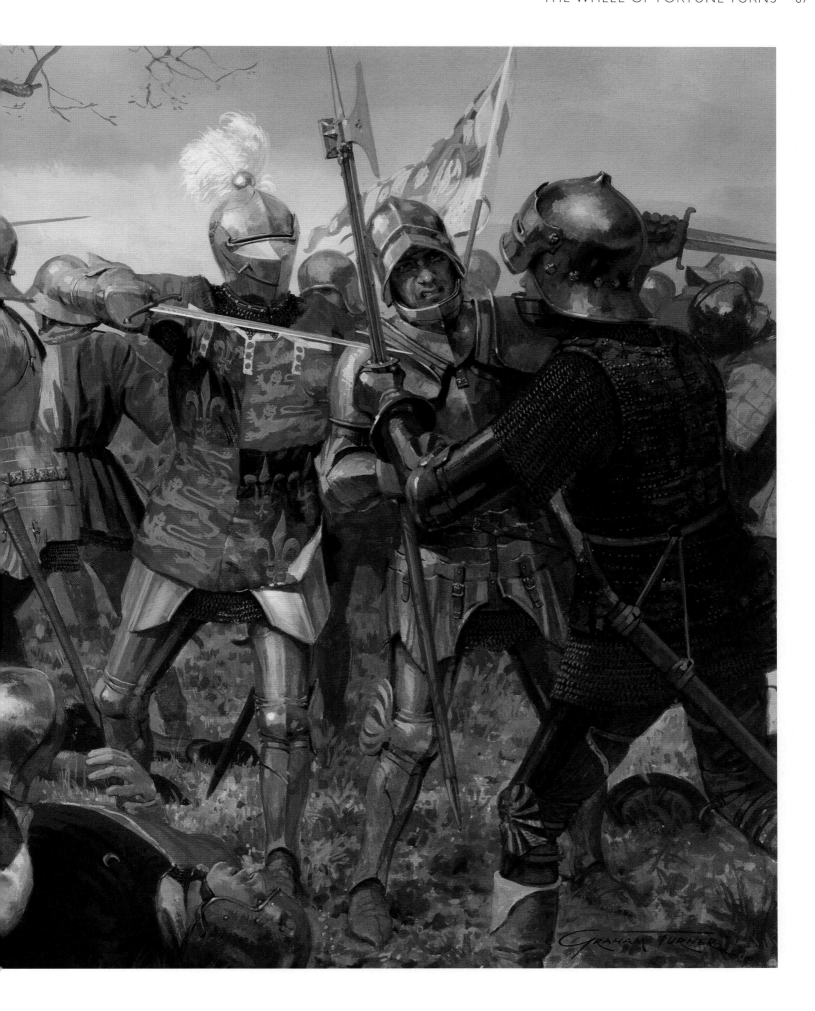

'*And the xxxth day of Decembre they met with the Quenys party at Wakefeld, where the Duke of York, and therle of Rutland, and Sir Thomas Nevill were slayne, and many other.*'
Chronicles of London, Vitellius A XVI

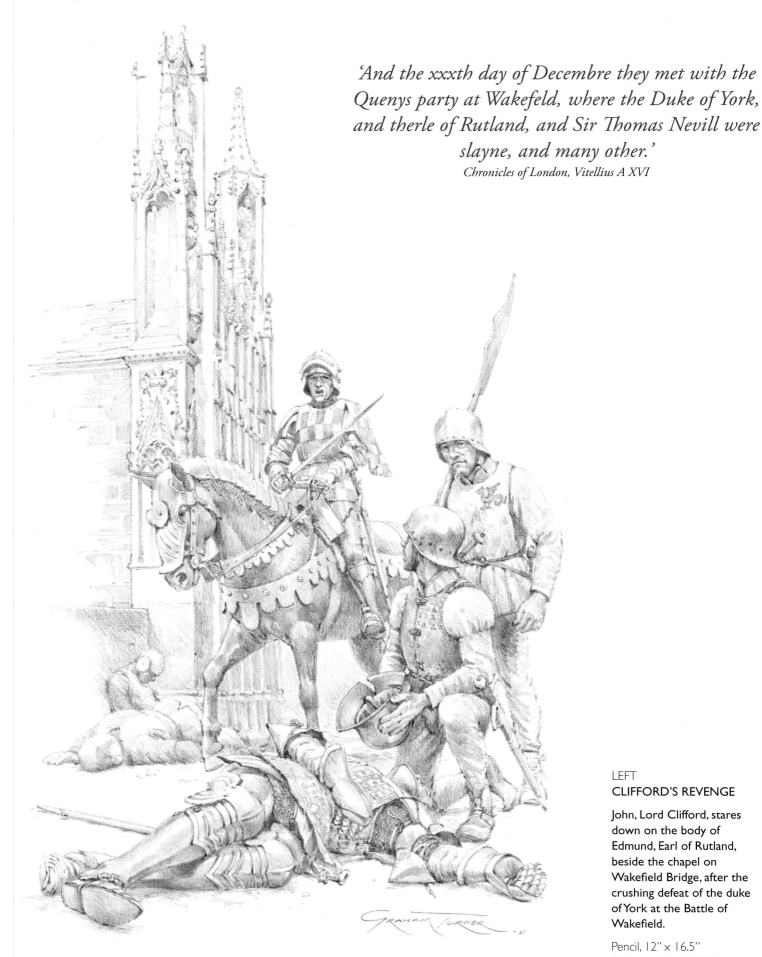

LEFT
CLIFFORD'S REVENGE

John, Lord Clifford, stares down on the body of Edmund, Earl of Rutland, beside the chapel on Wakefield Bridge, after the crushing defeat of the duke of York at the Battle of Wakefield.

Pencil, 12" x 16.5" (30cm x 42cm), 2021.

THE BATTLE OF WAKEFIELD

The queen's army arrived at Sandal Castle on 28 December, but what happened two days later to draw the Yorkist army out from behind the safety of the castle walls is open to debate. Was it to come to the aid of a foraging party, seeking out desperately needed supplies, or did York simply underestimate the size of the force that faced him? Another story is one of deceit; having recruited a large force in York's name, Salisbury's half-nephew John, Lord Neville, then turned against them in the battle.

The Yorkists fought hard but were eventually overwhelmed by the superior numbers that they faced, and York himself was killed as his army collapsed around him. As the survivors tried to find ways of escape, York's son Edmund, Earl of Rutland, was caught and killed, probably as he crossed Wakefield Bridge. His death was to become embellished by later writers such as Edward Hall to suggest that Rutland 'scarce of the age of xii. [12] yeres, a faire gentleman and a maydenlike person' was cold-bloodedly murdered by a vengeful Lord 'Butcher' Clifford in revenge for the death of his father at St Albans, pronouncing as he did the foul deed; 'by Gods blode, thy father slew myne, and so wil I do thee and all thy kyn'.[17]

As well as putting these words into Clifford's mouth, Hall is wrong about Rutland's age; he was actually 17, just a year younger than his brother Edward, who had fought at Northampton earlier the same year and was at this time commanding an army on the Welsh border. At a similar age a decade later their youngest brother Richard would fight in the thick of the action at Barnet and Tewkesbury, and in 1403 Henry V had been just 16 when he fought and was wounded at Shrewsbury. As was typical with boys of their class, the martial attributes of a warrior were instilled in them from a very early age, so Rutland would have been well prepared for war and fully armoured – for all the melodramatic notions of his death being an act of cruel revenge against a defenceless child, the reality, while still tragic, is that he was perhaps most likely cut down alongside his comrades in the horror of the rout that followed the battle. Hall's embroidered account has stuck though, no doubt helped by Shakespeare's retelling of his version of events in *Henry VI: Part 3*, which in turn inspired several romantic paintings in the 19th century.

Salisbury was captured alive and taken to Pontefract Castle by Somerset where 'the commune people of the cuntre, whyche loved hym nat, tooke hym owte of the castelle by violence and smote of his hed.'[18] His son Thomas was also killed. It had been Thomas's wedding that had brought the Neville–Percy feud to a head at Heworth Moor in 1453 (page 38), and he had been captured with his brother John at Blore Heath the previous year, imprisoned at Chester Castle until their elder brother Warwick's victory at the Battle of Northampton reversed their fortunes – for only a few months, as it turned out.

The bodies of York and Rutland were also decapitated, and their heads, with Salisbury's, were displayed on spikes over the city of York's Micklegate Bar. As a further act of macabre humiliation, a paper crown was added to York's head, alluding to his royal ambitions.

The sons of the lords killed at St Albans had now had their revenge, but in doing so had fuelled a vicious cycle of retaliation, for on the Welsh borders, young Edward, Earl of March, was brought the devastating news of the deaths of his father, brother, uncle and cousin.

BELOW This monument, erected in 1897, marks the supposed spot where Richard, Duke of York, fell during the Battle of Wakefield.

BELOW RIGHT Wakefield Bridge, with its chantry chapel at its centre. Built in the mid-14th century, it was restored five centuries later by Sir Gilbert Scott.

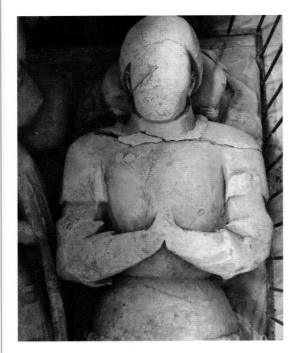

Bisham Priory was the traditional burial place of the Montacute earls of Salisbury, the title Richard Neville gained through his wife, but after the dissolution the priory was destroyed, with only the very badly mutilated effigies of Richard Neville and an earlier unidentified lady surviving from the many grand tombs it once housed. They can now be seen in St Mary's church, Burghfield.

Despite its poor state, it is clear that the effigy was originally of great quality, and it is possible to make out some of the heraldry on the surcoat, allowing identification to be made. The effigy also wears a Yorkist livery collar of suns and roses – possibly the earliest representation, as Salisbury died just before Edward IV was crowned, so he would not have worn one in life.

Following his execution after the Battle of Wakefield, the earl of Salisbury's head spent several months impaled above Micklegate Bar before being reunited with his other remains and first buried at Pontefract, then moved and reinterred at Bisham Priory two years later, alongside his recently deceased widow, Alice Montacute, and their son Thomas, who had also died at Wakefield. They would later be joined by their other sons, Richard, Earl of Warwick, and John, Marquess of Montagu, after their deaths at Barnet in 1471 (Montacute, Montague and Montagu are alternative spellings of the same name).

Micklegate Bar, York.

THE ROSE OF ROUEN

'For to save all Englond the Rose did his entent'

Rose of Rouen, c.1461

Edward, Earl of March, was born in Rouen on 28 April 1442, the oldest son of Richard, Duke of York, and Cecily Neville. He would grow to be a tall, athletic and, according to contemporaries, handsome young man. From their surviving portraits his physical resemblance to his grandson Henry VIII is clear, and they would both suffer from over-indulgence later in life. Now, though, he was in his prime.

The above quotation is the opening line of the 'Rose of Rouen', a Yorkist political poem written after the events of 1461, referring to Edward as the Rose

after the Yorkist white rose badge. Edward was at Shrewsbury when he received the devastating news of the deaths of his father, brother, uncle and cousin at Wakefield, and soon moved to his castle at Wigmore. He was now the duke of York and in theory heir to the throne but, from his remote outpost, the 18-year-old must have felt isolated and alone. He was a long way from being able to 'save all Englond'.

Edward's title as earl of March was inherited through his mother's Mortimer side of the family, the Mortimers being descended from Edward III's

second son, Lionel, Duke of Clarence. The name held great sway in Herefordshire and the Welsh borders, a region referred to as the Welsh Marches – from which the earldom received its name. From his stronghold at Wigmore he was able to count on the local support of powerful men such as Richard Croft from nearby Croft Castle and Sir William Herbert and Walter Devereux, both of whom he would later come to rely on and reward for their service.

As he considered his next move, Edward received news of an army under Jasper Tudor, Earl of Pembroke, accompanied by his now elderly father, Owen, advancing from Wales. With the Tudors was the earl of Wiltshire, returned from his overseas interlude with mercenaries from Ireland, France and Brittany.

Edward had time to prepare and chose Mortimer's Cross, on the road from Wales towards Hereford, as the ideal place to make his stand.

As the sun rose to illuminate a clear bitterly cold day, a rare meteorological phenomenon occurred that struck fear into Edward's men; there 'were seen iij sonnys in the fyrmament shynyng fulle clere, whereof the people hade grete mervayle, and therof were agast. The noble erle Edward thaym comforted and sayd, "Beethe of good comfort, and dredethe not; thys ys a good sygne, for these iij sonnys betokene the Fader, the Sone, and the Holy Gost,

and therefore late us have good harte, and in the name of Almyghtye God go we agayns oure enemyes."'[19]

What they had witnessed was a parhelion (sometimes called a sun dog), caused when ice crystals refract the sun's light, giving the appearance of three suns. Edward's quick-witted response to the situation undoubtedly reversed what could have been a morale-destroying disaster, and he clearly recognised the significance of this moment when he later adopted the sun in splendour as one of his primary badges.

Edward formed up his army on the flat ground next to the river Lugg and, joining his soldiers in the front line, faced the advancing force of Pembroke and Wiltshire. The battle was hard fought, but when Wiltshire once again abandoned the field as he had at St Albans, the Yorkists gained the upper hand and the victory. Pembroke was able to escape the carnage, but his father Owen was captured. Edward was not in a forgiving mood, and Owen, along with other captives, was beheaded in Hereford. As the collar of his red velvet doublet was torn off and he realised the fate that was about to befall him, in reference to his late wife Katherine, Owen apparently remarked; 'That hede shalle ly on the stocke that was wonte to ly on Quene Kateryns lappe', before he 'put hys herte and mynde holy unto God, and fulle mekely toke hys dethe.'[20]

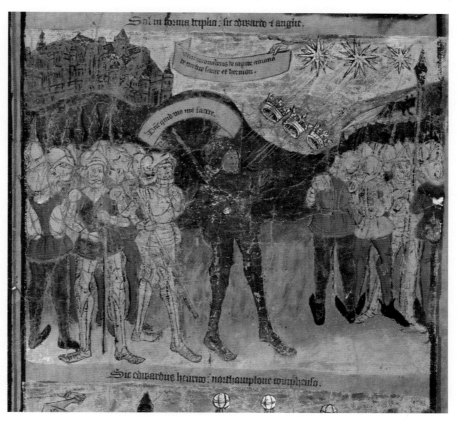

The earl of March marvels at the three suns before the Battle of Mortimer's Cross, as depicted in a manuscript made soon after the events of 1461. (The British Library, Harleian MS 7353)

'were seen iij sonnys in the fyrmament shynyng fulle clere, whereof the people hade grete mervayle, and therof were agast. The noble erle Edward thaym comforted and sayd, "Beethe of good comfort, and dredethe not; thys ys a good sygne, for these iij sonnys betokene the Fader, the Sone, and the Holy Gost, and therefore late us have good harte, and in the name of Almyghtye God go we agayns oure enemyes."'
An English Chronicle

THE SUN IN SPLENDOUR

Edward, Earl of March – soon to be King Edward IV – calms and inspires his army as they marvel at the sight of three suns on the frosty morning before the Battle of Mortimer's Cross.

Oil on canvas, 36" x 26" (91cm x 66cm), 2021.

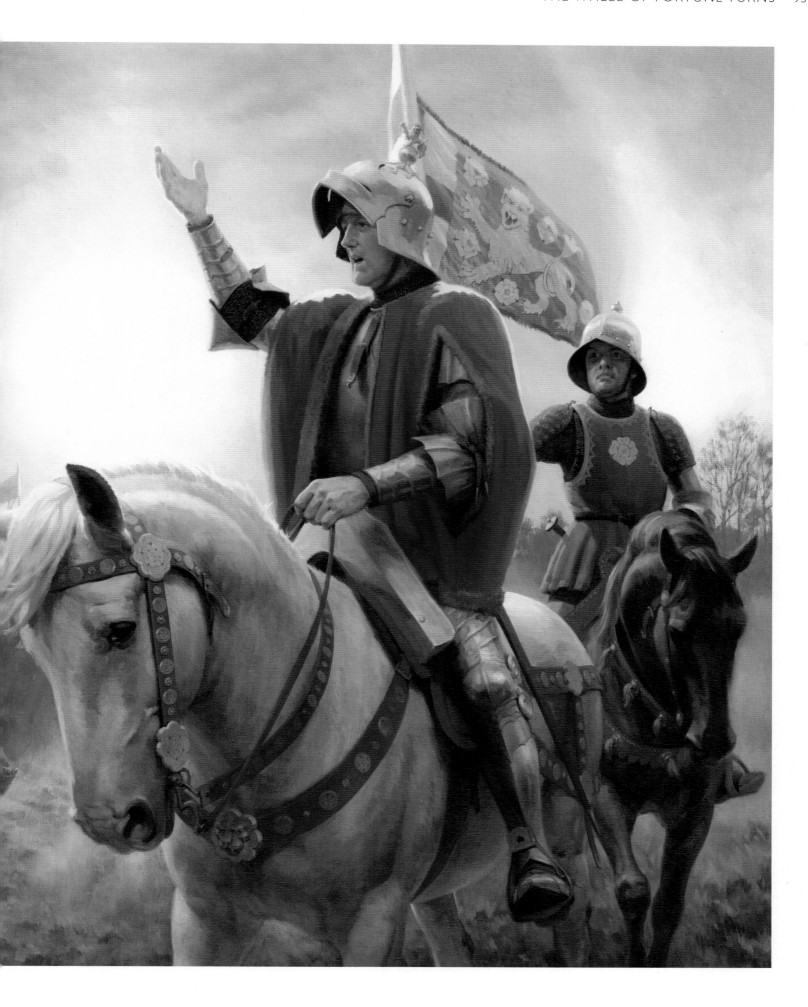

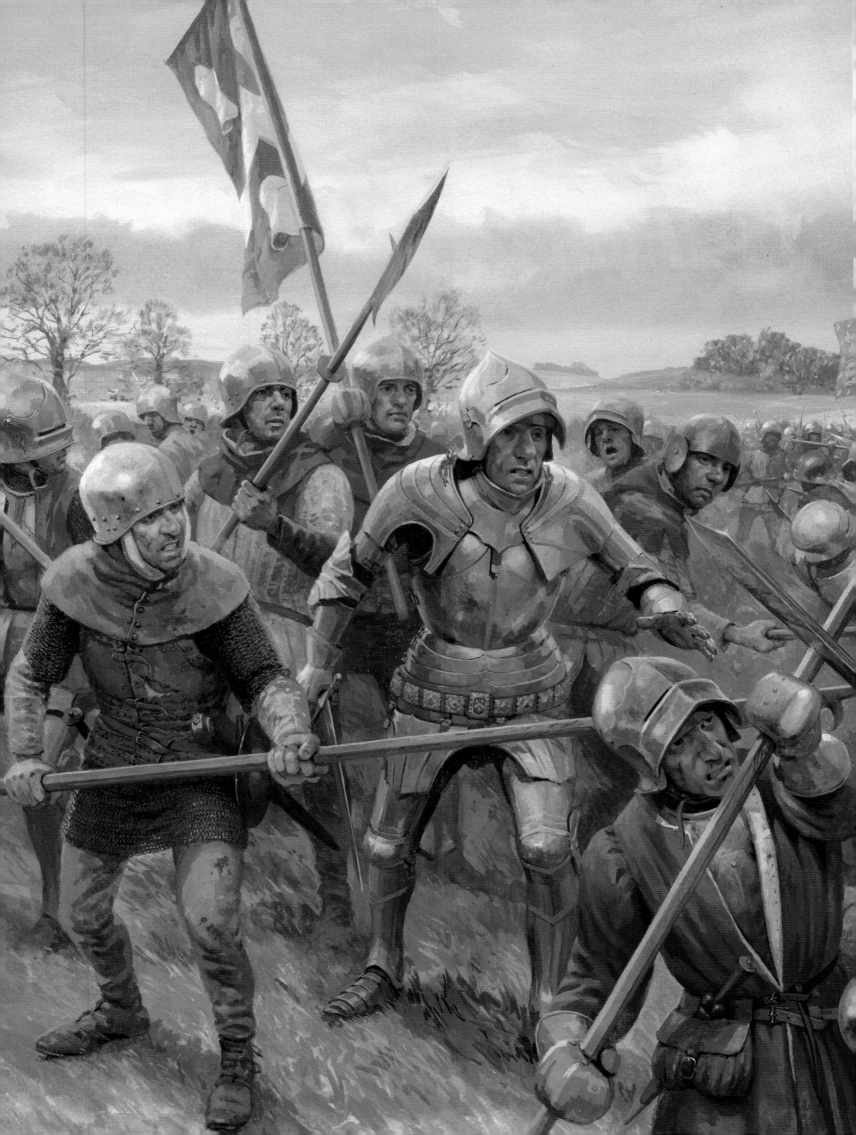

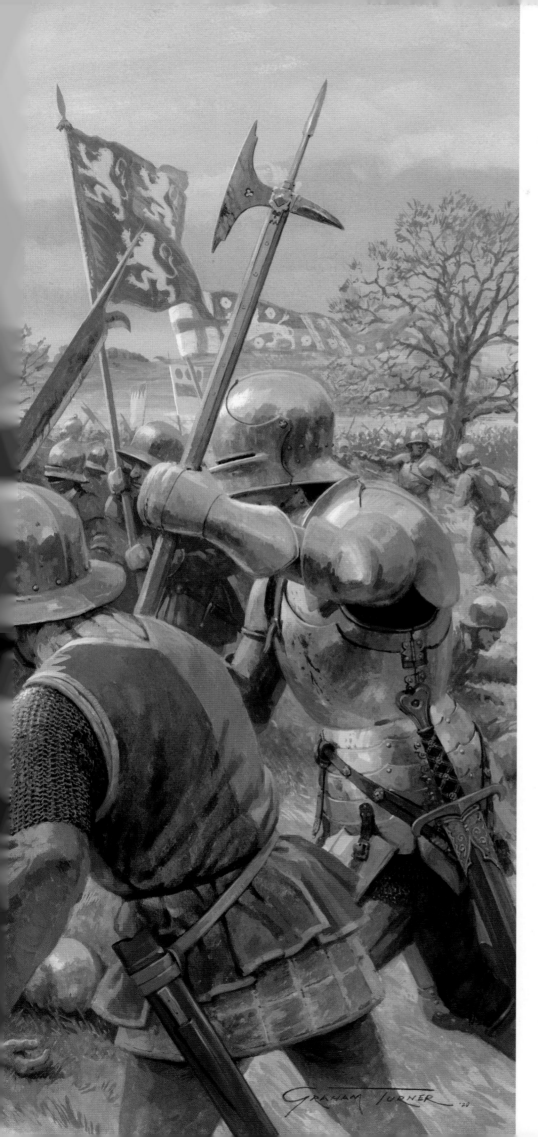

'Ande in that jornay was Owyn Tetyr [Tudor] i-take and brought unto Herforde este, an he was be heddyde at the market place'
Gregory's Chronicle

THE BATTLE OF MORTIMER'S CROSS
2 February 1461*

Owen Tudor finds himself in the thick of the action as the battle swirls around him and his men come under attack by retainers of Sir William Herbert. Behind can be seen the banners of his son Jasper, Earl of Pembroke, and the wavering earl of Wiltshire, about to flee the field and leave the victory to the Yorkist Edward, Earl of March.

*some sources suggest the battle was fought on the 3rd

Gouache, 22.5" x 16.75" (57cm x 42cm), 2020.

'ye have well in yor remembrance the great dishonor and rebuke that we & yee now late have by traytor Marche, Herbert, and Dwnns, with their affinityes, as well in letting us of our journey to the Kinge, as in putting my father yor Kinsman to the death, and their trayterously demeaning, we purpose with the might of our Lord, and assistance of you and other of our kinsmen & frinds, within short time to avenge.
J. Pembrook.'

Jasper Tudor, Earl of Pembroke, to Roger Puleston and John Eyton

THE SECOND BATTLE OF ST ALBANS

Following victory at Wakefield and the death of the duke of York, Queen Margaret recognised the opportunity to remove the Yorkist threat once and for all, rescue her husband from Warwick's clutches, and restore their son to his rightful inheritance. Marching south for London with her young son Edward and an impressive array of some of the mightiest in the land – men such as the dukes of Somerset and Exeter, earls of Northumberland, Devon and Shrewsbury, and lords Clifford, Roos, Grey of Codnor, Fitzhugh, Greystoke, Welles and Willoughby – her large army cut a swathe through England, the news of their impending approach throwing the population into panic. 'Thus did they proceed with impunity, spreading in vast multitudes over a space of thirty miles in breadth, and, covering the whole surface of the earth just like so many locusts, made their way almost to the very walls of London'.[21] Some of these reports very likely exaggerated the destruction of the 'whirlwind from the north', but the reputation the queen's army earned as it 'robbed, plundered and devastated' would have a crucial bearing on what was to follow.[22]

In London Warwick prepared to meet this marauding army, sending the duke of Norfolk to raise men in East Anglia and the earl of Arundel, Viscount Bourchier and Lord Bonville to do likewise in the southern counties. The Yorkists had now attracted the support of a few more magnates, and the approaching northern threat helped Warwick's recruitment efforts. These new recruits to the Yorkist cause were bolstered by a contingent of gunners from Burgundy, armed with the latest developments in battlefield technology; 'the burgeners [Burgundians] hadde suche instrumentys that wolde schute [shoot] bothe pellettys of ledde [lead pellets]

and arowys… with a grete mighty hedde of yryn [iron]…, and wylde fyre [wild fire]'.[23]

As his army assembled, Warwick managed to find time for a few diversions; his brother John Neville was elevated to the peerage as Lord Montagu and, with much pomp and ceremony, on 8 February Warwick himself was elected, with others, to the prestigious Order of the Garter. Four days later, on 12 February, his army eventually marched out of London – taking King Henry with them – and formed up to the north of St Albans. The newly created Lord Montagu commanded the Yorkist division on the edge of the town, on land known as Bernards Heath (sometimes referred to as Barnet Heath), Warwick himself took charge of the centre, and the duke of Norfolk the right wing, possibly as far out as Nomansland Common, which today gives an impression of what the landscape of the entire area might have looked like before subsequent housebuilding. Warwick's artillery was probably assembled in a fortified area and aimed north, in the direction of the expected attack. The defences included 'nettys made of grete cordys of iiij fethem of lengthe and of iiij fote brode… and at every ij knott there was a nayl stondyng uppe right, that there couthe no man pass ovyr hyt by lyckely hode but he shulde be hurte.' Also listed are other daunting anti-personnel obstacles such as caltrops, which no matter how they are dropped always present a spike pointing upwards, and pavises, large rectangular shields for gunners and crossbowmen to shelter behind; these, though, had nails sticking out of the back so that 'whenn hyr shotte was spende and done they caste the pavysse by-fore hem, then there might noo man come unto them ovyr the pavysse for the naylys that stode up-ryghte, but yf he wolde myschyffe hym sylfe.'[24]

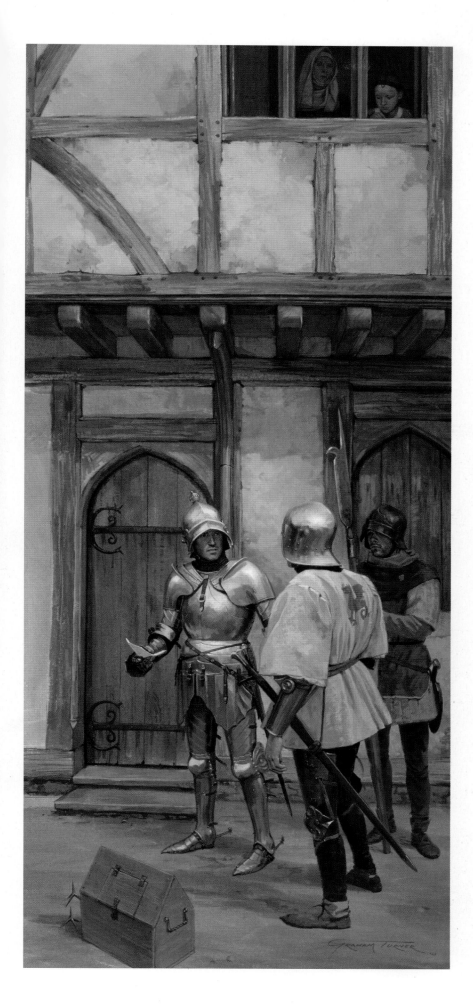

Warwick's decision to focus his attention towards the north would prove to be a crucial mistake. On reaching Royston, the queen's army diverted west and reached Dunstable on 16 February, where they crushed a small local detachment before continuing their approach to St Albans from the north-west, outflanking Warwick's carefully prepared defences.

Arriving on the edge of St Albans at dawn on 17 February 1461, the queen's vanguard appears to have made it to the southern end of the market place near the Abbey without opposition, the Yorkists apparently unaware of the change in direction of the queen's army. However, they soon came under an intense barrage of arrows, unleashed by Yorkist archers positioned in the surrounding buildings, and they were forced back. Scouts seeking a way round the impasse found a suitable unguarded route, and a second attack, led by the duke of Somerset, broke through into St Peter's Street, the broad main thoroughfare through the centre of town.

Once the town centre was taken, the queen's army regrouped and advanced past St Peter's church and onto the open land of Bernards Heath, where they engaged with Montagu's division – who would have had to redeploy to face the unforeseen attack from the town. As the struggle intensified and more soldiers streamed out of the town to attack them, Montagu's men grimly held out in the hope of reinforcements from his brother Warwick, which never came. As his men eventually broke, Montagu was captured, along with Lord Berners.

Despite artillery and handguns being such a notable part of Warwick's plans, they would have little part to play in the battle because of the unexpected direction of attack; 'Before the 'goners and borgeners [Burgundians] couthe levylle hyr gonnys they were besely fyghtyng, and many a gynne of wer was… [of] lytylle a-vayle or nought.'[25]

DISTURBING THE PEACE

Lancastrian soldiers confer in St Albans before pressing their attack on the flank of the main Yorkist army, formed up on heathland outside the town. Locals peer warily from their window above, this being the second time in six years that St Albans had been the scene of such violent bloodletting.

The foreground man wears the livery of Lord Clifford, with his red wyvern badge.

Gouache, 25.5" x 12.5" (65cm x 32cm), 2005.

'The northern men… immediately entered the said town, desiring to pass through the middle of it and direct their army against the king's army… Then, after not a few had been killed on both sides, going out to the heath called Barnet Heath, lying near the north end of the town, they had a great battle with certain large forces, perhaps four or five thousand, of the vanguard of the king's army.'
Whethamstede

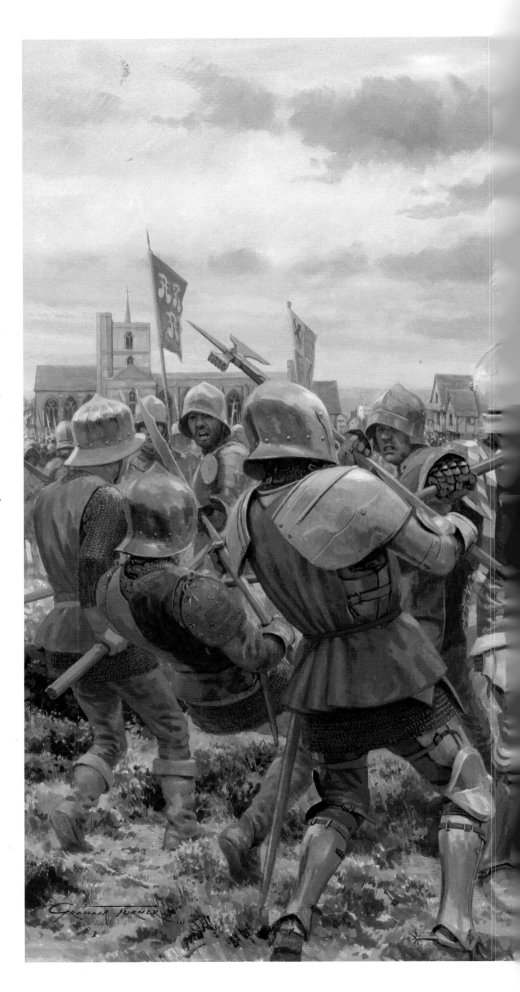

THE SECOND BATTLE OF ST ALBANS
17 February 1461

Henry Beaufort, Duke of Somerset, leads the Lancastrian army past St Peter's church and out of St Albans onto Bernards (or Barnet) Heath to attack the left wing of the Yorkist army, commanded by Lord Montagu.

Gouache, 23.6" × 17.3" (60cm × 40cm), 2021.

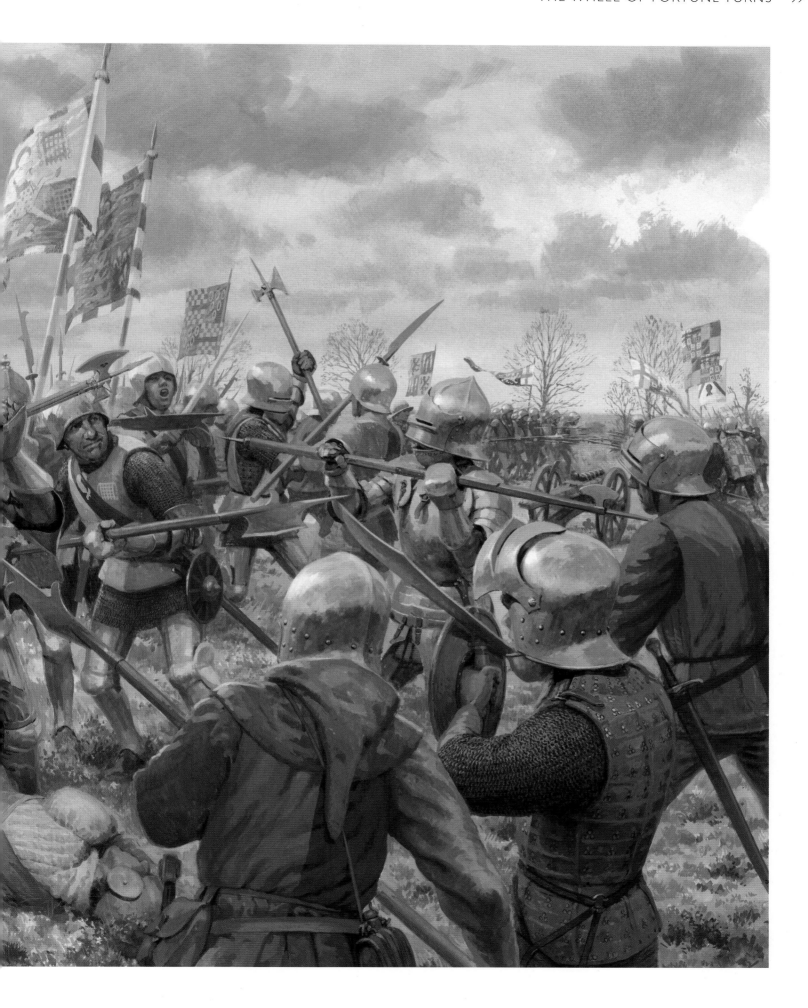

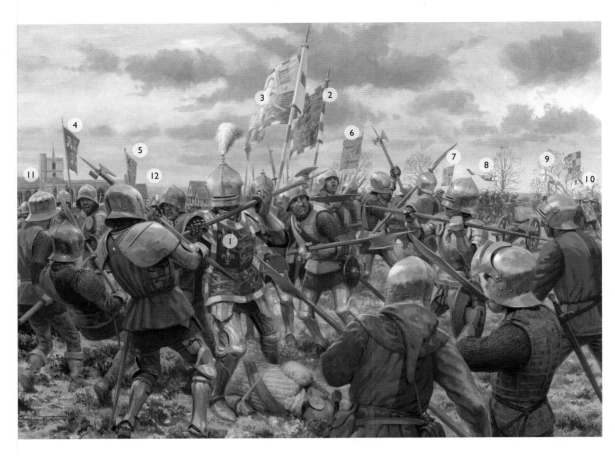

1 Henry Beaufort, Duke of Somerset

2 Banner of Duke of Somerset

3 Standard of Duke of Somerset

4 Banner of Thomas, Lord Roos

5 Banner of Lionel, Lord Welles

6 Banner of John, Lord Clifford

7 Banner of Henry Percy, Earl of Northumberland

8 Standard of Henry Percy, Earl of Northumberland

9 John Bourchier, Lord Berners, with his Banner and Standard

10 Banner of Sir John Wenlock

11 St Peter's church

12 St Albans Abbey and Clock Tower

As the day wore on and they pressed home their advantage, the combined effects of the long march and continuous fighting must have left many in the queen's army exhausted. When they failed to push home one final attack on Warwick's surviving soldiers, now on Nomansland Common, he was able to slip away in the gathering darkness with a significant number of men.

As the battle had raged, King Henry somehow found his way over to the queen's side, but reports of how this happened are confused – as probably was Henry. According to one source, a gentleman called Thomas Hoo approached the king and suggested that a message should be sent to the earl of Northumberland, after which several lords returned and escorted Henry to Lord Clifford's tent, where he was reunited with Queen Margaret and their son Edward.

When he saw them, he was overjoyed in his inmost heart, just as a betrothed man rejoices over his betrothed, or a father over his son who after he had 'perished' was found again and brought again into his presence. He embraced them in his arms, kissing them, and exclaimed at once, 'May the Lord God be blessed, who has done such great things in the people of the North that it was enough to restore to us again my wife wrenched away for a time, to drive off all the enemy they met in this, and happily to triumph over the enemy!'[26]

In the celebrations which followed, King Henry knighted his seven-year-old son Edward – who wore a brigandine covered 'with purpylle velvyt... with golde-smythe ys worke' – who in turn bestowed the same honour to 30 others who had distinguished themselves.[27] These included Andrew Trollope, who had established his long military career fighting in France before being appointed to the post of master porter of Calais, from where he made waves as a 'pirate' before leading the Calais garrison over to the king's side at Ludford Bridge. He was with the duke of Somerset when they subsequently tried to winkle Warwick out of his Calais refuge, and this notable professional soldier would play an increasingly important role in Queen Margaret's efforts against the Yorkists in the campaign of 1460–61, advising her titled commanders such as Somerset and fighting in the front line at Wakefield, St Albans and, by then knighted, at the bloody battle of Towton to come. Edward, Earl of March, certainly considered him a significant enemy, putting a £100 bounty on his head. Trollope would have been hobbling as he accepted his knighthood, as he had stepped on a

ABOVE Caltrops, designed to always fall with a spike pointing upwards. (Royal Armouries)

RIGHT A 1634 map of St Albans showing Bernards Heath at the top right, with the road leading down past St Peter's church towards the Abbey (centre).

BELOW St Peter's church was heavily restored in the late 19th century. By comparing the current church building with the map and drawings pre-dating the restoration, along with a thorough exploration of the area, I was able to recreate the church and the view down the road into St Albans as shown on pages 98–99. The whitewashed tower of the Abbey can just be made out before the land drops away even more steeply. It's a tiny part of the painting, but vital for placing the scene.

BOTTOM Although Bernards Heath is now mostly built upon, part of the open heathland that would have covered the whole area survives on Nomansland Common, further down the road – the site of Warwick's final withdrawal.

ANDREW TROLLOPE

Andrew Trollope established his reputation as a professional soldier in France before being promoted to the important post of master porter of Calais, from where his acts of piracy gained him some notoriety. His decision not to back his captain, the earl of Warwick, at Ludford Bridge, and to lead the Calais garrison over to the king would subsequently see his talents used to great effect by the Lancastrians at Wakefield and against Warwick at the Second Battle of St Albans. After the victory Prince Edward made several knights; 'The fryste that he made was Androwe Trolloppe, for he was hurte and myght not goo for a calletrappe in hys fote; and he sayde, "My lorde, I have not deservyd hit for I slowe but xv men, for I stode stylle in oo place and they come unto me, but they bode stylle with me."'

With the battle won, Andrew Trollope takes a moment to have his injured foot seen to, before being summoned into the royal presence by the approaching herald. The pauldrons (shoulder defences) of his Milanese armour are being removed, revealing the points (laces) that attach the pieces of armour to the arming doublet beneath. The billman behind him wears the badge of Lord Clifford on his livery, with a bend overall: 'And be-syde alle that, every man and lorde bare the Pryncys levery, that was a bende of crymesyn and blacke with esteryge [ostrich] fetherys.'

Gouache, 12.6" x 16.3" (32cm x 41cm), 2023.

caltrop during the battle, injuring his foot; Warwick's elaborate defences hadn't been totally in vain.

During the wars in France men of rank and wealth had enjoyed a certain safety net when they engaged in the dangerous business of war, not only due to chivalric notions but the more practical consideration of their ransomable value as prisoners. A pronouncement apparently made by the earl of March before the Battle of Northampton reversed this usual order of things; 'no man shuld laye hand upponne the king ne on the commune peple, but onely on the lords, knyghtes and squyers'.[28] The killing of men of rank in battle would soon evolve into the vengeful executions which followed Wakefield and Mortimer's Cross, starting a cycle that would quicky escalate and become one of the defining aspects of the Wars of the Roses. After the Second Battle of St Albans, Lord Bonville and Sir Thomas Kyriell were brought before the queen and Prince Edward; the young prince, learning fast, 'was jugge ys owne sylfe', and they were immediately beheaded.[29]

Amazingly, John Neville, Lord Montagu, was spared. As the brother of the earl of Warwick, one of the chief architects of the rise of the Yorkists, he would surely have expected no mercy, but Warwick held the duke of Somerset's younger brother captive in Calais, possibly a factor that secured his life and

that of Lord Berners. Instead of facing death, they ended up being imprisoned in York, the second time John Neville had been locked away after battle; in 1459 he had been incarcerated in Chester Castle after Blore Heath.

Warwick's defeat left London dangerously exposed and Cecily, Duchess of York, once again found herself abandoned with her younger children as she had been 16 months earlier at Ludlow. Mourning her husband and son Edmund's recent deaths at Wakefield, she was understandably fearful for her younger sons' safety should Queen Margaret's army gain entry into the city. With Edward's victory at Mortimer's Cross providing no immediate comfort to his mother, she made the desperate decision to send 11-year-old George and eight-year-old Richard across the sea to the Burgundian Low Countries, where she hoped they might find some safety. The Duchy of Burgundy valued and vigorously defended its independence from France, ruling lands that spread from the heart of the country up into what is now Belgium, Luxembourg and the Netherlands, and the ever-shifting political machinations between the kings of France and dukes of Burgundy would play a significant part in the Wars of the Roses, with both providing assistance and a safe haven to various members of the rival Lancastrian, Yorkist and eventually Tudor

'and the Quene and her party had the victory, and therle of Warwyk with his company fled.'
Chronicles of London, Vitellius A XVI

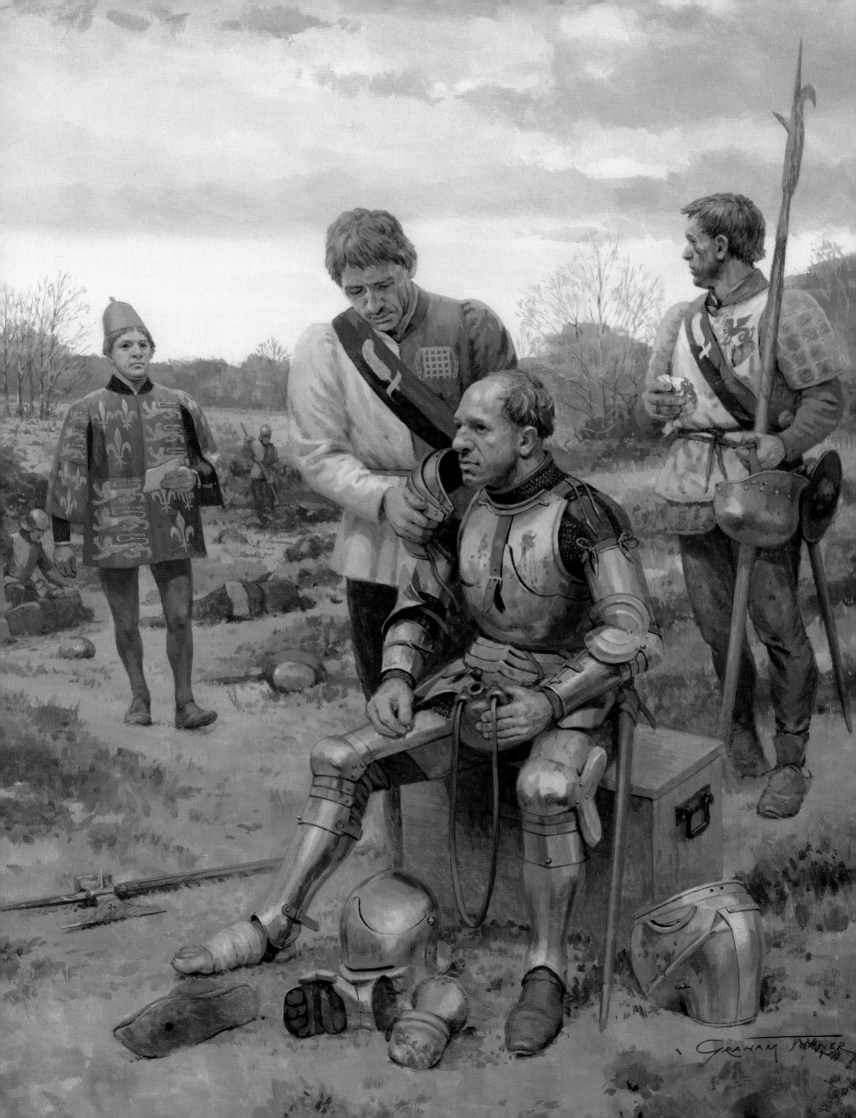

claimants to the English throne during their times of crisis. The two youngest sons of the late duke of York, separated from their mother and sister who remained in London, and their older brother who was desperately fighting for the survival of their family's future on the Welsh border, found themselves thrown into the uncertain care of this strange overseas court, where the political embarrassment their presence might have caused the duke of Burgundy was minimised by tucking them away in distant Utrecht.

To Duchess Cecily's undoubted relief, London's gates were kept firmly closed and the fate she and many others in the city feared was avoided: 'London, dredyng the manas and the malyse of the queen and the duke of Somerset and other, leste they wolde have spoyled the cyte… certain speres and men of armes were sent by the sayde duk, for to have entered the cyte before his commyng; whereof some were slayne, and some sore hurte, and the remanent put to flyghte. And anone after, the comones for the savacione [salvation] of the cyte, toke the keyes of the gates were they shulde have entered, and manly kept and defended hit fro theyre enemyes, unto the commyng of Edwarde the noble erle of Marche.'[30]

'And this was the downfall of King Henry and his queen for, if they had entered London, they would have had all at their mercy'.[31] If Queen Margaret, now with King Henry restored to her, had been able to take London, the future could have been very different; as it was, with her army overstretched, their numbers dwindling due to desertion, now faced with defiant Londoners and the approach of the earl of March and his army, they headed north once again.

Following his victory at Mortimer's Cross, Edward, now duke of York, his army reinforced with fresh soldiers so keen to join him that they came at their own cost, met up with the remnants of Warwick's defeated army in the Cotswolds, either at Burford or Chipping Norton, before marching to London and entering the city on 26 February.

The battle fought at St Albans six years earlier in 1455 was an incredibly significant watershed, marking the point when political manoeuvring finally descended into open warfare, but as battles go it was relatively small and quickly over. The Second Battle of St Albans was a much greater affair, involving considerably larger forces and fought across an extensive area from dawn until nightfall, with the number of casualties likely over 2,000; one chronicle claims a very specific 1,916 dead, while another states 'The number of ded men was xxxv c [3,500] an moo that were slayne'.[32] Among the dead on the queen's side was Sir John Grey of Groby, who left behind a young widow and two sons. Elizabeth Grey (Woodville) was the daughter of Richard Woodville, Lord Rivers, and Jacquetta of Luxembourg, who, as already mentioned, had caused a stir when they married in 1435; their daughter would create controversy of far greater magnitude three years from now.

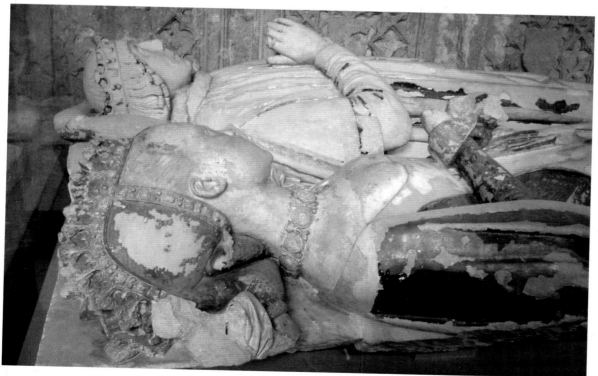

LEFT The tomb effigies of William Fitzalan, Earl of Arundel (1417–87), and his wife, Joan Neville (sister of the earl of Warwick), in the Fitzalan Chapel, Arundel, Sussex. William was with King Henry at Ludford Bridge, and afterwards on a commission to arrest and imprison the Yorkists, but he changed sides and allied himself with them just before the Second Battle of St Albans.

CHAPTER 9
TWO KINGS OF ENGLAND

EDWARD IV'S STANDARD-BEARER AT TOWTON

Ralph Vestynden, a yeoman of the king's chamber, who was awarded an annuity of £10 'for the good and agreable service which he did unto us, in beryng and holding of oure standad of the blak bulle'. The black bull was one of the badges of the House of York, used by Edward and later associated with his younger brother George, Duke of Clarence, who at the time of Towton was only 12 years old.

Gouache, 11" x 17" (28cm x 43cm), 2012.

'And upon the Thursdaye ffoluyng The erls of march & of warwyk with a grete power of men, but ffewe of name entrid Into the Cyte of London, The which was of the Cytyzyns Joyously Ressayved.'[1]

Edward's claim to the throne was spelled out in an address given to a large crowd assembled at St John's Fields in Clerkenwell by the Lord Chancellor, George Neville – who happened to be another of Warwick's brothers – and when asked if 'they wold have Therle of march for theyr king… they Cryed with oon voys ye ye'.[2] At his late father's London home of Baynard's Castle, Edward was officially offered the crown and, on 4 March 1461, he was proclaimed king at St Paul's Cathedral before processing to Westminster, where, seated on the throne with St Edward's sceptre in his hand, 'took thys noble prynce possession of this Realm of Engeland'.[3]

Until this point the war had been about securing influence with, and then control of, King Henry VI, fought out between the court favourites and the disaffected Yorkist lords. Now there were two kings of England, Henry VI and Edward IV, one Lancastrian and one Yorkist – the names that have become the recognised way to differentiate between the two sides.

Despite the embarrassment of his defeat at St Albans, where he also lost King Henry, the earl of Warwick considered himself central to the Yorkist success, as did some observers: the papal legate Francesco Coppini reported, 'Just now, although matters in England have undergone several fluctuations, yet in the end my lord of Warwick has come off the best and has made a new king of the son of the Duke of York.'[4] Warwick's reputation as 'Kingmaker' had begun, but he would soon find that his protégé Edward had a mind of his own, and a strong will to match.

With the Lancastrian army at large in the north, the coronation itself would have to wait. On 6 March 1461 Edward IV issued proclamations across the country, calling for his acceptance as king and offering 'grace and pardon of his life and goods' to any supporter of Henry VI who submitted to him within ten days.[5] Excluded from this were several named individuals, including Andrew Trollope, along with anyone with an income greater than 100 marks a year, probably in an effort to isolate the Lancastrian lords.

'At London, therle of Marche, Edward, bi the grace of God the oldest son of Richard, Duke of Yorke, as rightful heir & next enheritour to his fadre, the iiijth day of Marche, the yere of oure Lorde God M cccclxi, toke possession of the Reame of England at Westmynster in the gret hall, & after, in thabbey church;... & forthwith it was proclaimed through the Cite, Kinge Edwarde, the Fourt of that name.'

The Brut

As Edward hurried to raise fresh troops and build up his army – funded by further loans from London – in York the Lancastrians were also recruiting in King Henry's name.

One of these letters survives, written to Sir William Plumpton and dated 13 March:

Trusty and wellbeloved we greete you well, and for as much as we have very knowledge that our great trator the late earl of Mearch hath made great assemblies of riotouse and mischeously disposed people; and to stir and provocke them to draw unto him he hath cried in his proclamations havok upon all our trew liege people and subjects, theire wives, children & goods, and is now coming towards us. We therefore pray you and also straitely charge you that anon upon the sight herof ye with all such people as ye may make defensible arrayed come unto us in all hast possible wheresoever we shall bee within this our realme, for to resist the malitious entent and purpose of our said trator.[6]

Sir William thought he was doing the right thing by supporting King Henry, who had been his king for nearly 40 years, but the coming bloodbath at Towton would upturn the world he knew. Mourning his son and heir, Sir William was brought before Edward IV at Newcastle, where he agreed to pay a £2,000 bond to ensure his good behaviour. Failing to raise the sum, he was imprisoned in the Tower of London, finally being pardoned by Edward IV 'of his abundant special grace' on 5 February 1462, then released from his bond that September.[7]

Henry VI still had the allegiance of a large majority of the nobility: the powerful dukes of Somerset and Exeter, the earls of Northumberland and Devon, Viscount Beaumont, along with many barons such as lords Clifford, Roos, Welles and Dacre, all rallied round Henry, Queen Margaret and the prince of Wales. The remark that Edward and Warwick entered London with 'but ffewe of name' is telling, highlighting the fact that the Yorkists still had very limited support amongst the higher nobility. Besides Edward – the new king – the list was headed by the duke of Norfolk, the earl of Warwick, and the duke of Suffolk; amongst the barons were Warwick's brother, Lord Montagu, his uncle, the experienced Lord Fauconberg, and lords Scrope, Fitzwalter and Grey of Ruthin – who had so dramatically defected to the Yorkists at Northampton. Critically, Warwick also counted on support from many towns and counties to provide soldiers for the campaign (the 'Rose of Rouen' mentions contingents from Canterbury, Bristol, Coventry, Salisbury, Worcester, Gloucester, Leicester, Nottingham, Windsor and Northampton), allowing Edward to raise a huge army by the standards of the day, but an army that was still smaller than the one he would have to face. Because both sides used commissions of array to legally force men to fight for their respective 'kings' in this campaign, the numbers involved were of an unprecedented scale. The city of York later lamented the 'many [that] was slaine', from the thousand men supplied 'at ther oune costs' to fight for King Henry.[8]

The duke of Norfolk departed for East Anglia to recruit men for Edward's army on 5 March – the day after Edward had been proclaimed king – and Warwick headed into the Midlands to do likewise. While raising troops in Coventry (which collected £80 to pay for 100 men 'which went with oure soverayn liege lord king Edward iiijth to the felde yn the north'),[9] Warwick captured the illegitimate son of the duke of Exeter and had him beheaded for his alleged part in the execution of his father after Wakefield. The vengeful nature of the war continued.

On 11 March William Neville, Lord Fauconberg, led a large division of footmen out of London, to be followed two days later by Edward with his own troops. As they headed north, the Yorkist army was joined by

TOP RIGHT **Two of Edward IV's standards, showing his rose-en-soleil badge, a merging of the white rose and sun in splendour. Note how the lower standard includes white and red roses; the red rose was not an exclusive Lancastrian badge.** (College of Arms, MS 1.2, p.17)

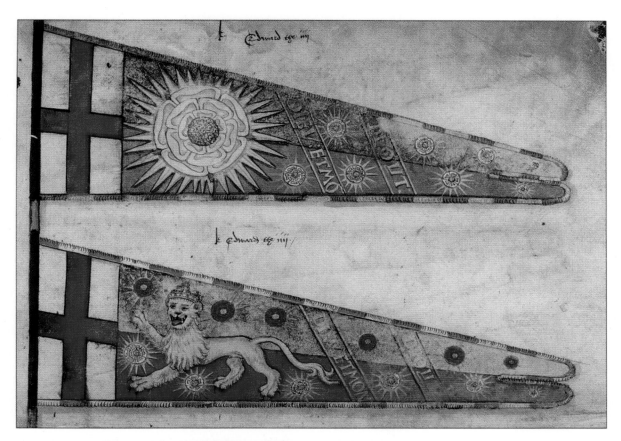

FAR RIGHT **Skipton Castle, ancestral home of the Clifford family.**

RIGHT **Clifford heraldry in Skipton Castle.**

Warwick's large contingent, possibly at Doncaster, and although the duke of Norfolk and the men he had raised in East Anglia had still not caught up, possibly because of delays caused by the ageing duke's ill health, they decided to push on to Pontefract Castle, where they arrived on about 27 March.

As the Lancastrian army marched out of York to meet them, they passed the decomposing heads of York, Rutland and Salisbury that had been displayed over Micklegate Bar since Wakefield over two months before. It is said that the queen ensured space was left for Edward's and Warwick's heads to join them. King Henry, Queen Margaret and Prince Edward stayed in the city, leaving Somerset and the other noble commanders to champion their cause and rid the king of 'our

great trator'. They passed through Tadcaster and set up camp ready to take up position on the high plateau between the villages of Towton and Saxton, ten miles south-west of York.

From Pontefract Edward quickly despatched a small force under John Ratcliffe, Lord Fitzwalter, to seize the crossing over the river Aire at Ferrybridge two miles away. From what can be deduced from the sources, it seems the Yorkists found the bridge had been broken by the Lancastrians, and they proceeded to rebuild some sort of crossing 'so that our men could only cross by a narrow way which they had made themselves after the bridge was broken.'[10] However, having done what they could to effect repairs, Fitzwalter's small detachment failed to take adequate defensive

THE BATTLE OF FERRYBRIDGE
28 March 1461

Lord Clifford's men try to stop the Yorkist army from crossing the broken bridge over the river Aire.

Gouache, 21.5" × 14.5" (55cm × 37cm), 2002.

'the lord Clifforde determined with his light horsemen, to make an assaye to suche as kepte the passage of Ferybridge'
Hall's Chronicle

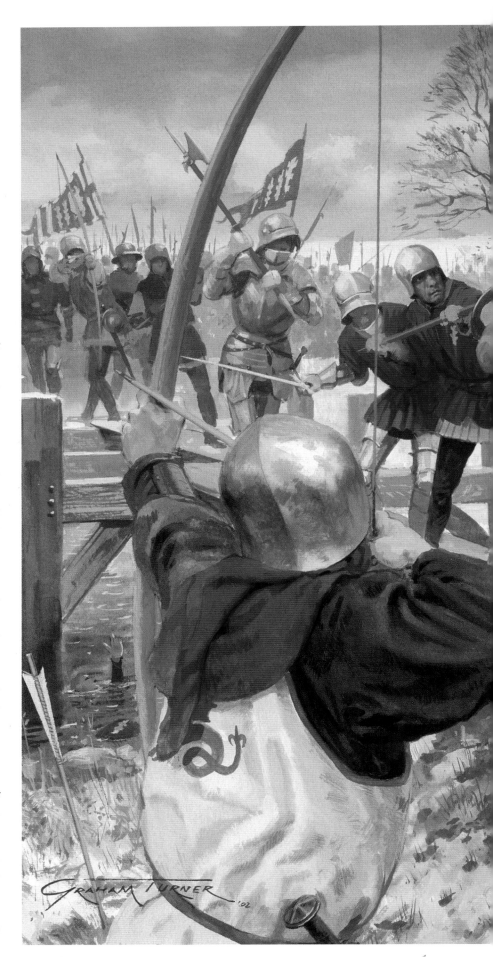

precautions. Early on 28 March,[*] Lord Clifford and his elite body of retainers, 'The Flower of Craven' – hardened by years of border fighting from their Cumberland base of Skipton Castle – attacked, and Fitzwalter 'and many with hym was slayne and drownyd.'[11]

For 25-year-old John, Lord Clifford, 'beyng in lusty yought, & of francke corage', the Wars of the Roses were intensely personal.[12] The death of his father at the Battle of St Albans in 1455 would come to dominate the rest of his short life, as he sought vengeance on those he held responsible. As a teenager he was involved in the skirmish at Heworth Moor, taking the side of the Percy family in their feud with the Nevilles, and, after he inherited his father's title and the family seat at Skipton Castle, he firmly attached himself to King Henry and Queen Margaret's cause. Finally, at Wakefield (where he was knighted by Somerset before the battle) he was at last able to quench some of his thirst for revenge with the deaths of York, Salisbury and Rutland; responsibility – or credit – for the latter was laid squarely at his door (see page 88) and the story, heavily embroidered with each retelling, earnt him the sobriquet 'Butcher Clifford' long after the event.

Having reported the defeat at Ferrybridge to Edward, in order to reinvigorate the falling morale of their men Warwick dismounted and 'slewe his horse

[*] Traditionally, Ferrybridge and Towton are considered as different engagements, fought on two consecutive days: 28 and 29 March 1461. However, a recent re-evaluation of the sources suggests an alternative interpretation that this was one battle, beginning before dawn at Ferrybridge, before moving through Dintingdale and on to the plateau near Towton, where the main body of the Lancastrian army was drawn up.[13]

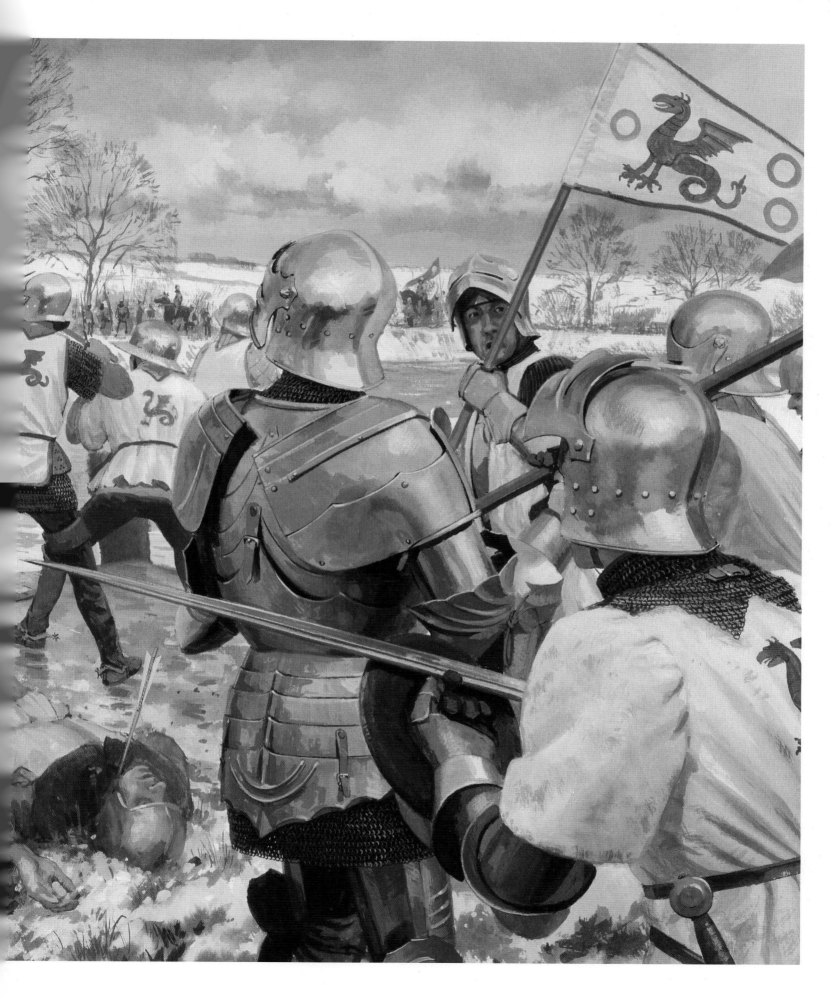

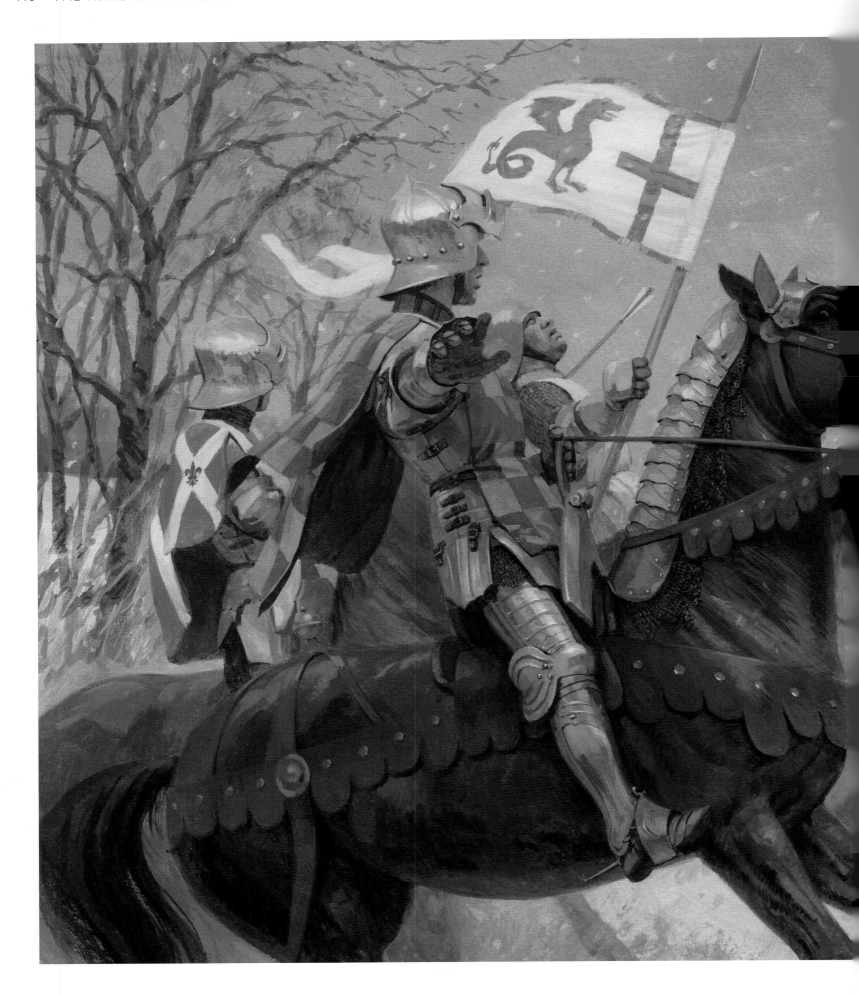

with his swourde, saying: let him flie that wil, for surely I wil tary with him that wil tary with me'.[14] That is according to the Tudor chronicler Edward Hall but, like the story surrounding Clifford's murder of Rutland at Wakefield, this is quite likely another product of his fertile imagination, stories of chivalric speeches and melodramatic gestures appealing to his readers; it would also help cement Warwick's legend in the popular imagination. Whatever fate befell his horse, Warwick did indeed stay and fight and, with King Edward on foot at their head, the Yorkists advanced towards the bridge.

As the Yorkists struggled to cross the broken river crossing and engage Clifford's strongly positioned men on the north bank, 'the Erle of Warwycke was hurte yn hys legge with an arowe'.[15] Recognising that their attack was stalled and Clifford could hold them off indefinitely, Edward ordered Lord Fauconberg to take a detachment of men west to the next crossing point at Castleford, three miles away, then return on the opposite bank to attack Clifford's flank.

'For the lord Clifforde,… and all his company almost were there slayn, at a place called Dintingdale, not farr from Towton.'
Hall's Chronicle

CLIFFORD'S END

Almost within sight of the main Lancastrian army formed up near Towton, Lord Clifford and his company are cut off by a Yorkist force at Dintingdale. Behind Clifford is Sir John Neville.

Gouache, 16.9" x 12.3" (43cm x 31cm), 2023.

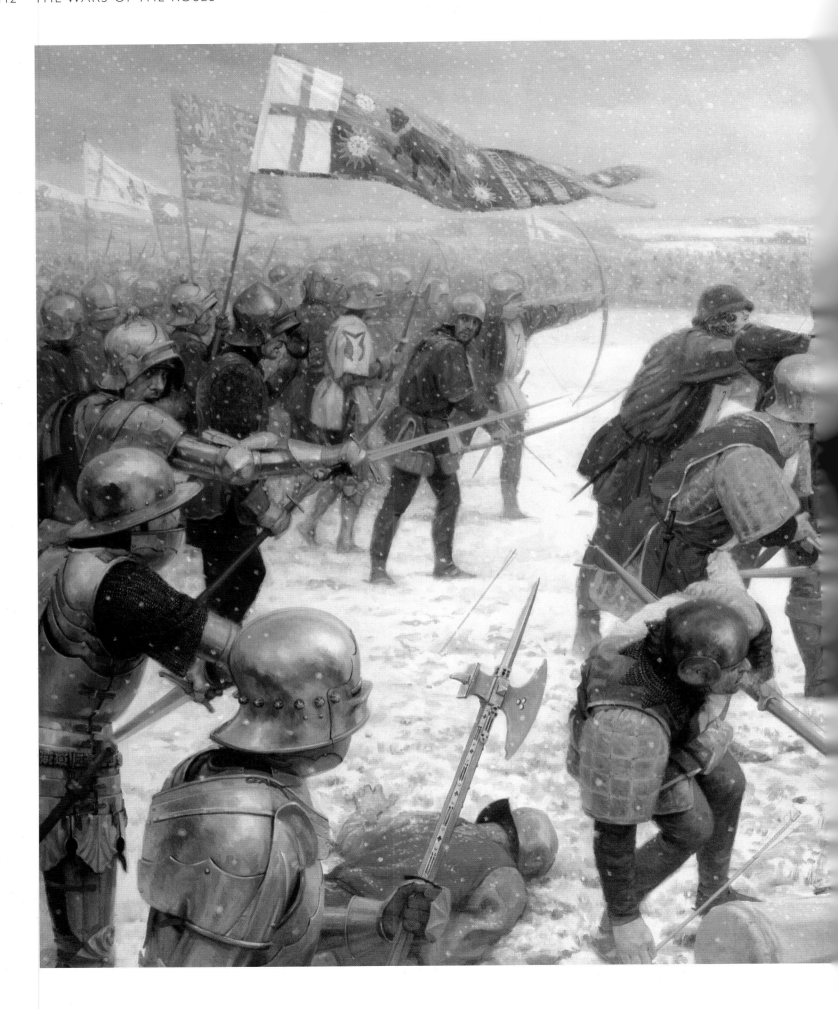

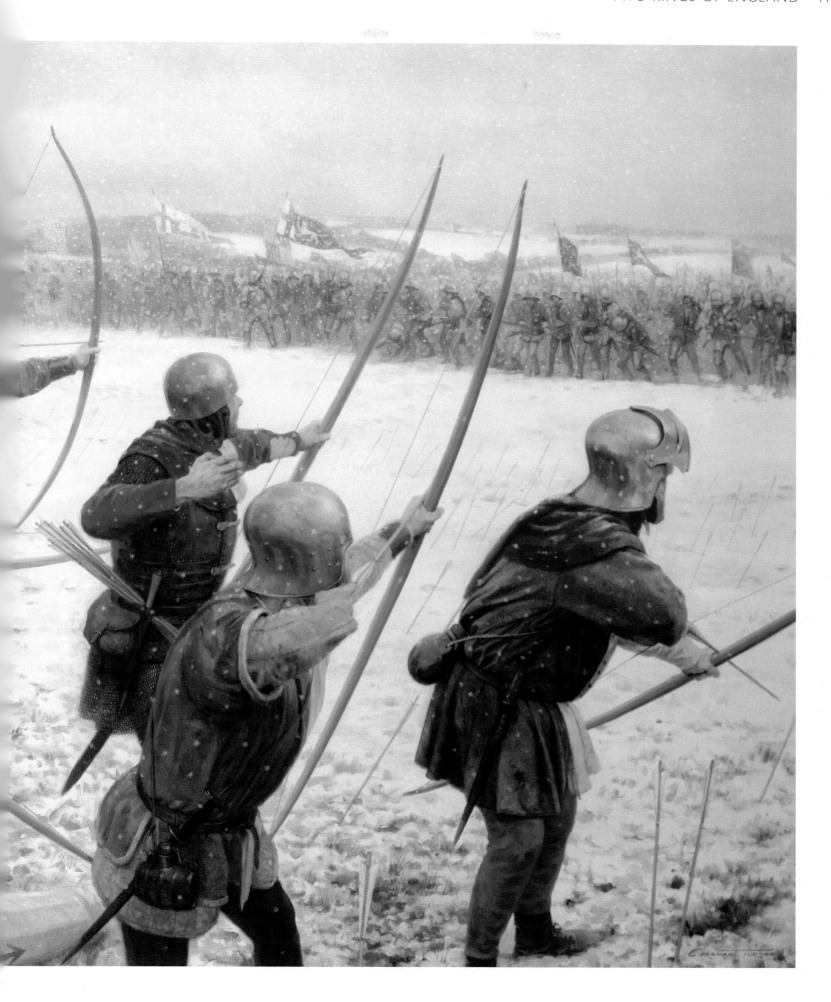

PREVIOUS PAGES
THE BATTLE OF TOWTON
29 March 1461

With the wind and driving snow at their backs, the Yorkist archers shoot their deadly volleys of arrows into the advancing Lancastrian army, while Edward IV and his knights and men-at-arms move through the ranks to meet their oncoming foe.

Oil on canvas 53" x 32" (135cm x 81cm), 2002.

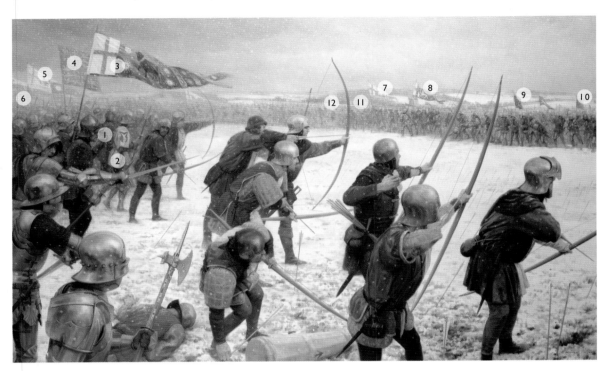

1 Edward IV

2 William, Lord Hastings

3 Edward IV's standard

4 Royal banner

5 Standard of Lord Scrope of Bolton

6 Standard of William, Lord Fauconberg

7 Henry VI's standard

8 Banner and standard of the earl of Northumberland

9 Banner of Sir Andrew Trollope

10 Banner of Henry, Lord Fitzhugh

11 Banner of John Bigod, Lord Mauley

12 Banner of Randolph, Lord Dacre

When he saw what was happening and realised that his small force would soon be outnumbered and assailed from two sides, Clifford ordered his men to withdraw, and they 'departed in great haste' back towards the main Lancastrian army at Towton, Yorkist horsemen in hot pursuit. In a shallow valley called Dintingdale, tantalisingly close to Towton and relief, Clifford's men were caught and butchered.

Without further delay, the rest of the Yorkist army crossed the river Aire and followed the same route through Dintingdale to Towton.

Whether it was a continuation of a battle that started at Ferrybridge on the same day or the previous day, all agree that the Battle of Towton was fought on Palm Sunday, 29 March 1461. The two opposing armies assembled into their battles, or divisions: 'The earl [Edward IV] called for his captains and told them to put their men in formation and to take their positions before the enemy came too close.'[16]

As the opposing armies came into view, 'they made a great shoute'[17] and it started to snow. Wearing armour in freezing temperatures is not at all pleasant, the steel being a very efficient heat-exchanger, drawing the body's heat out, and although not many will have experienced that, most will know what it's like to wear wet clothes and, more crucially, have soggy feet, in freezing, damp weather. Given that the plateau they were forming up on is very exposed, and a strong wind was blowing to further add to the chill, we can only try to imagine how unpleasant it would have been for those present – even before you consider the thousands facing them, baying for blood. A clue to the hardships the soldiers at Towton faced is provided by this line from one of the chronicles: 'it was so cold from the snow and hailed so much that the armed men and horses were a pitiful sight and what made it worst for them, they were badly supplied'.[18]

The battle commenced with the traditional archery duel, a very one-sided contest at Towton due to the strong wind driving the snow 'into the faces of them, which were of king Heries parte'. 'The lord Fawconbridge, which led the forward of king Edwardes battaill, being a man of great polecie, and of

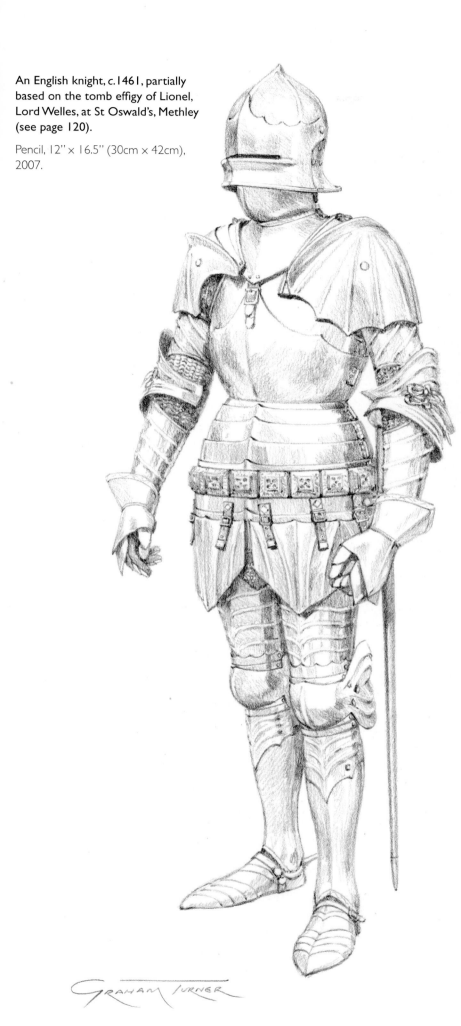

An English knight, c.1461, partially based on the tomb effigy of Lionel, Lord Welles, at St Oswald's, Methley (see page 120).

Pencil, 12" × 16.5" (30cm × 42cm), 2007.

TOP **View across the exposed battlefield at Towton.** (Julian Humphrys)

ABOVE **The battlefield cross at Towton.**

much experience in marciall feates, caused every archer under his standard, to shot one flyght and then made them to stand still. The northern men, feling the shoot, but by reason of y snow, not we vewing y distaunce between them and their enemies, like hardy men shot their schiefe arrows as fast as they might, but al their shot was lost, & their labor vayn for they came not nere the southermen.'[19] The Yorkists had provoked the Lancastrian archers to waste their arrows, shooting them into the driving wind and snow without seeing that they were falling woefully short of their targets. They then advanced and shot not only their own sheaves of arrows, but also retrieved Lancastrian arrows and shot them back.

Unable to withstand the withering barrage of Yorkist arrows, and having no effective reply, the Lancastrian men-at-arms advanced through the decimated ranks of their bowmen. 'At that moment… [Edward IV] saw the army of the Earl of Northumberland coming for battle carrying the banner of King Henry'. This account goes on to say how Edward then gave a spirited address to his army, reminding them why they all wanted to make him king and how the throne 'had been usurped by the Lancasters a long time ago.' His exaltations

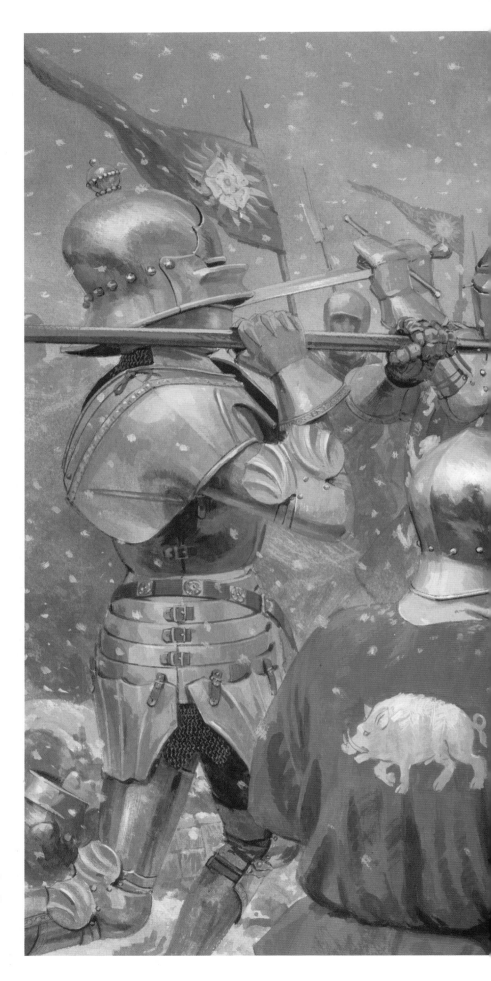

THE BATTLE OF TOWTON

The opposing armies struggle for victory at the height of the Battle of Towton. In the foreground, soldiers in the Lancastrian front line wear the livery of the earl of Devon, while amongst the Yorkists facing them, William Herbert and Walter Devereux can be identified by their heraldic tabards.

Gouache, 21.5" x 14.5" (55cm x 37cm), 2002.

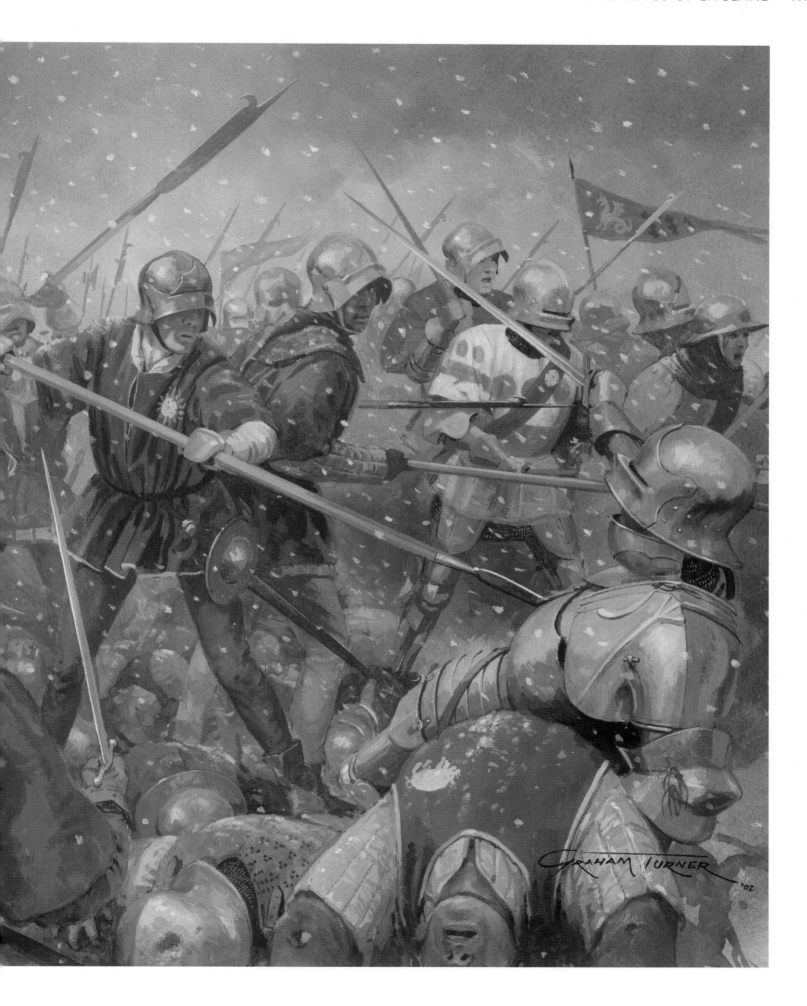

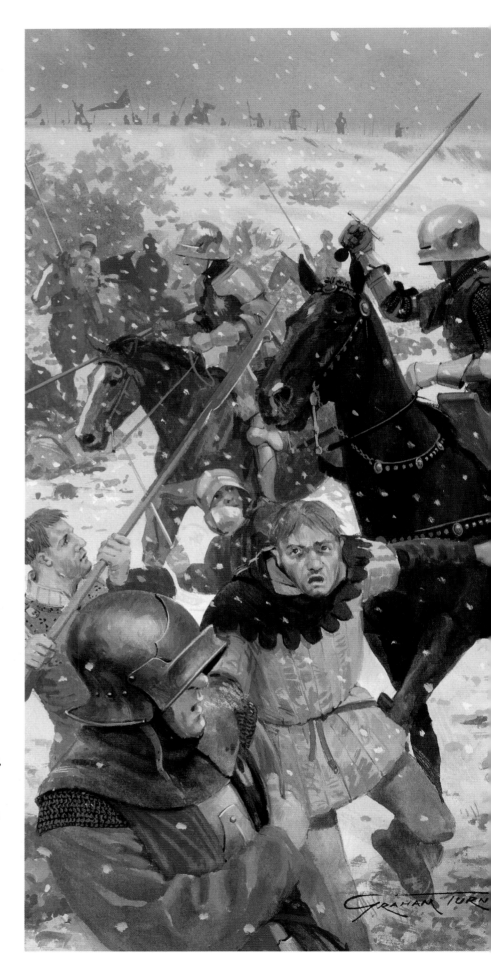

TOWTON – THE ROUT

The defeated Lancastrian army flees from the battlefield, down Towton Dale towards the river Cock, pursued and cut down by the victorious Yorkists.

This painting was influenced by the research done on the human remains found in a mass grave at Towton in 1996. The figure on the right is based on the facial reconstruction of one of these victims of the battle who had survived an earlier severe wound to the face – and yet had returned to fight one final time – while the central figure was inspired by a skull that had a square hole punched in it, illustrating the devastating damage medieval weapons could inflict.

Gouache, 21.5" x 14.5" (55cm x 37cm), 2002.

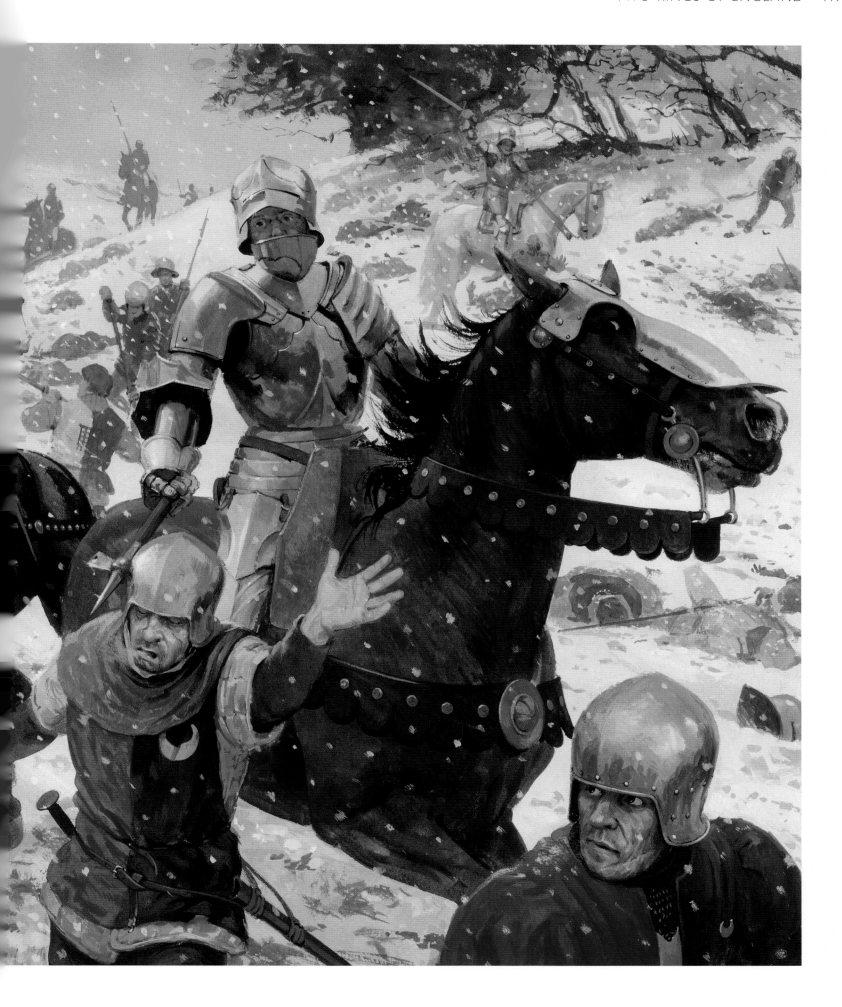

elicited a spirited reply, his 'troops and knights' shouting 'in unison that they would follow him until death if necessary. Hearing this support [Edward] thanked them, jumped down from his horse and told them, sword in hand, that he would live or die with them in order to give them courage. Then he came in front of his banners and waited for the enemy which was marching forward with great noise and shouting "King Henry! King Henry!"'[20] The two sides collided, and, under the banners of their leaders, the grim slaughter of the mêlée began.

'When their arrows were spent the matter was dealt by hand strokes'; as the soldiers in the front line hacked and stabbed for their very survival, there was 'so great slaughter that the very dead carcasses hindered them that fought.'[21]

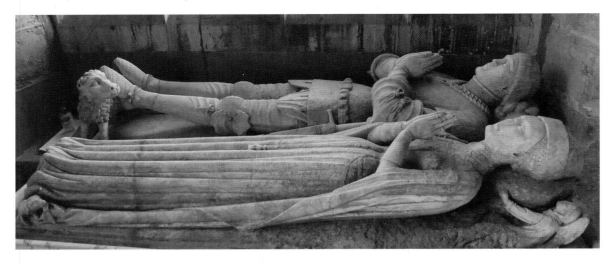

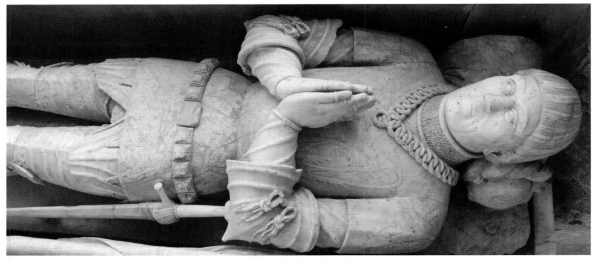

LEFT A few miles from the battlefield at Towton is the beautiful church of St Oswald's at Methley, where the tomb of Lionel, Lord Welles, and his wife Joan Waterton can be found. Welles was born in 1406, knighted by the infant Henry VI in 1426, and made a Knight of the Garter in 1457. He served in France and fought at the battle of Blore Heath, the Second Battle of St Albans, and Towton, where he was killed.

Detail of the Garter worn by Lord Welles.

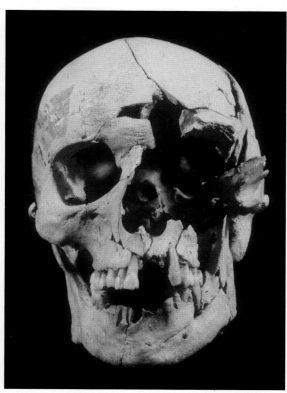

FAR RIGHT TOP **The skull of one of the Towton dead discovered in a mass grave in 1996, belonging to a 46- to 50-year-old man, showing the massive wound across his face, one of several he suffered. A well-healed wound to his jaw suggests he had been in battle before, and the reconstruction of his face is included in the foreground of the painting on the previous page.** (Bradford University)

ABOVE RIGHT **The tomb of Lord Dacre, Saxton. The remains of a Latin inscription translate as 'Here lies Randolph, Lord Dacre and Gilsland, a true knight, valiant in battle in the service of King Henry VI, who died on Palm Sunday, 29 March 1461, on whose soul may God have mercy, Amen.'**

RIGHT **View down to the river Cock, which became so full of bodies 'that men alyve passed the ryver upon dead carcasis.'**

FAR RIGHT **Warhammer, French, c.1450, seen being wielded to deadly effect in the painting of the rout at Towton.** (Metropolitan Museum of Art, New York, Rogers Fund, 1904, accession no. 04.3.49)

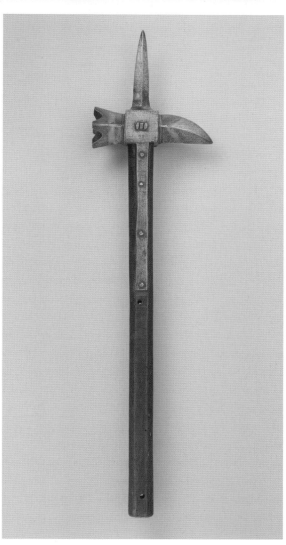

The battle ebbed and flowed for many hours, 'the result remaining doubtful during the whole of the day',[22] but as time passed the higher numbers on the Lancastrian side started to have an effect and the Yorkists were slowly pushed back, despite the efforts of King Edward, who 'so coragiously comforted his men, refreshyng the wery, and helping the wounded.'[23]

When a Lancastrian victory looked to be on the cards, with perfect timing (for the Yorkists) the duke of Norfolk's division, which had been delayed on the march north, advanced up the Ferrybridge road and appeared on the battlefield; 'when aboute the noone [midday] the forsaide John Duke of Northfolke with a fresh band of goode men of warre cam in to the ayde of the n[e]w electe King E'.[24]

As the new force engaged and the tide of the battle began to turn, the attention of some Lancastrian soldiers turned towards seeking out a way to escape. On seeing 'the forces of his foes increase, and his owne somewhat yeelde, whom when by newe exhortation he had compelled to presse on more earnestly', the duke of Somerset, 'with a fewe horsemen removing a little out of that place, expected the event of the fight; but beholde, sodenly his souldiers gave the backe, which when he sawe he fledd also'.[25]

With the pressure on their front ranks increasing and the sight of their comrades fleeing from the

battlefield, the Lancastrian army collapsed, and the panicked survivors fled in whatever direction they could. On the edge of the battlefield plateau the river Cock – which had previously protected the Lancastrian flank – now became a death-trap. The steep and slippery slopes leading down to the swollen river became choked with fleeing soldiers, while others who tried to stick to the gentler slopes in their attempts to escape the slaughter were chased down by Yorkist horsemen.

The river Cock was described as being choked with the dead 'and drowned, in so much that the common people there affirme, that men alyve passed the ryver upon dead carcasis... & of all the water comyng from Towton, was colored with bloude.'[26]

'For, their ranks being now broken and scattered in flight, the king's army eagerly pursued them, and cutting down the fugitives with their swords, just like so many sheep for the slaughter, made immense havoc among them for a distance of ten miles, as far as the city of York. King Edward, however, with a part of his men, as conqueror, remained upon the field of battle, and awaited the rest of his army, which had gone in various directions in pursuit of the enemy.'[27]

'aftyr a sore & long & unkeyndly ffygth for there was the Sone agayne the ffadyr, The brothyr agayn brothyr, The Nevew agayn Nevew, The victory ffyll unto kyng Edward, To the grete losse of people upon bothe partyes'.
The Great Chronicle of London

The scale of the losses at Towton remains a constant source of debate. Contemporary sources claim some truly astonishing figures: 'This feelde was sore fougten. For there were slayne on bothe partyes xxxiii m. [33,000] men, and all the season it snew',[28] and is the reason why Towton is considered the bloodiest battle to be fought in Britain. However, modern historians have suggested that based on the number of lords present, the Lancastrian army might have been 25,000 strong, with 20,000 Yorkists facing them (plus another 5,000 with Norfolk), meaning a considerably lower death toll is more likely. The truth is that with the limited information available, we will never know, but however you calculate it, the battles fought at Ferrybridge and Towton resulted in a horrific loss of life.

The duke of Somerset managed to escape, but the earl of Northumberland was not so fortunate, either dying in battle or from his wounds shortly after. Lord Dacre is said to have been killed by an arrow as he removed his helmet to take a drink during the battle, and his tomb can be seen in Saxton churchyard, where many other fallen soldiers are also buried in mass graves. Lord Welles's body was removed from the battlefield by his family and laid to rest in St Oswald's church in Methley, not far from the scene of his death, where his tomb is topped with a fine alabaster effigy. Also lying amongst the dead were Lord Willoughby, Lord Mauley and Sir Andrew Trollope, whose colourful life and career now abruptly ended.

Other Lancastrian nobles were caught in the days to follow. 'The Erle of Devynschyre was seke [in York], and might not voyde a waye, and was take and be heddyd. And the Erle of Wylte schyre was take [much later] and brought unto Newe Castell to the Kynge. And there hys hedde was smete of, and send to London to be sett upon London Brygge.'[29] The same chronicler records that 42 Lancastrian knights met a similar fate.

In the aftermath of such great slaughter that left the 'blood of the slain, mingling with the snow... [running] down in the furrows and ditches along with the melted snow, in a most shocking manner, for a distance of two or three miles',[30] burying the dead would have been a priority, but one record states that 'one might have still seen the bodies of these unfortunate men lying unburied' a week later.[31] Most were eventually piled into mass graves, 'piled up in pits and in trenches prepared for the purpose', several of which have been identified across the battlefield.[32] One such mass burial was uncovered during building work at Towton Hall in 1996, and the subsequent archaeological investigation has provided a great deal of important information about the men who fought and died at Towton, their lives leading up to their deaths and the way they met their ends.

CHAPTER 10
EDWARD IV – CONSOLIDATING HIS CROWN

On hearing the disastrous news of the defeat of their great army at Towton, King Henry, Queen Margaret and Prince Edward fled York in the middle of the night, heading towards Scotland, and on the following day, Monday 30 March, King Edward entered the city 'wyth grete Tryumph & Joye'.[1] One of his first actions was to have the heads of his father and brother taken down from Micklegate Bar, replacing these with those freshly severed from the earl of Devon and three others. His father's and brother's heads were reunited with their bodies and buried at Pontefract, a temporary resting place before their eventual reburial at Fotheringhay 15 years later, where his father's tomb would be inscribed 'Richard Plantagenet, 3rd Duke of York, King by Right'.

Edward stayed in York for three weeks, then journeyed north to Durham and Newcastle, where he witnessed the execution of the earl of Wiltshire. He left the north in the care of the Nevilles, since John, Lord Montagu had been released from his imprisonment in York where he had been held since his capture at the Second Battle of St Albans a month earlier. Edward then progressed slowly south, making his state entry into London on 26 June. With the mayor and aldermen 'all in scarle[t] with iiii c. [400] commoners well horsid and cladde in grene', he processed to the Tower of London, where he created 32 new Knights of the Bath, who then led him to

Westminster Hall where he was 'solemnely crownid by the handis of tharchebushop of Cauntorbury, with grete triumphe and honor' on Sunday 28 June 1461.[2]

Among those to be honoured at Edward's coronation were his two brothers, George and Richard, now returned from their short stay in Burgundy. Both were knighted, and the day after the coronation George – propelled into the position of

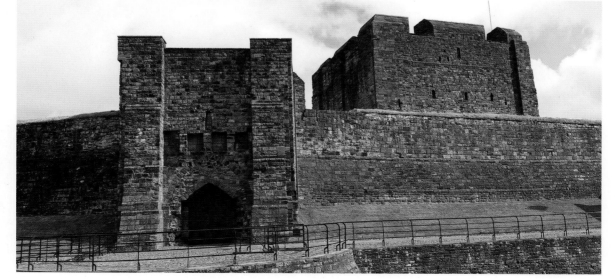

ABOVE RIGHT The castle at Fotheringhay has now gone, leaving just the church from the duke of York's once grand estate, where he was laid to rest with great ceremony in 1475, 15 years after his death at Wakefield.

RIGHT **Carlisle Castle.**
(Julian Humphrys)

BLEAK OUTPOST

After their catastrophic defeat at the Battle of Towton in 1461, Lancastrian survivors retreated within the walls of their Northumberland strongholds, the castles of Alnwick, Bamburgh and Dunstanburgh, keeping the cause of King Henry VI alive. Here, an archer wearing the Percy family livery keeps watch from this bleak coastal outpost.

Gouache, 9" x 14" (23cm x 35cm), 2017.

FAR RIGHT Bamburgh Castle. After the 1464 siege, Bamburgh fell into decay, and a large part of the impressive castle visitors see today is the result of the rebuilding works carried out in the early 20th century by Lord Armstrong.

LOWER RIGHT Dunstanburgh Castle on the exposed North Sea coast was begun by the earl of Lancaster in 1313 and subsequently developed by John of Gaunt later in the century. The remote fortress would change hands several times during the 1460s before falling into disuse.

RIGHT The Lilburn Tower at Dunstanburgh Castle.

heir to the throne until Edward had a son of his own – was created duke of Clarence. Later that year Richard would also join the highest ranks of nobility when he was made duke of Gloucester.

Many of those who had supported Edward at the battles that had given him his throne would also be rewarded: Viscount Bourchier became the earl of Essex, Lord Fauconberg the earl of Kent, and knights such as Hastings, Herbert, Devereux and Wenlock were made lords. Many of these men would play crucial roles in the new Yorkist regime.

As the new king settled into his role, he would have been acutely aware that his throne was far from secure while King Henry, Queen Margaret, their son Prince Edward and a large number of their supporters remained at large. Still with a relatively narrow base of support, Edward embarked on a pragmatic policy of reconciliation to win over the ranks of the establishment in order to keep the government functioning. Henry VI had been king for almost 40 years – the bureaucracy couldn't just be swept away and replaced. At the Parliament in 1461 sentences of

attainder were passed against a large number of those who had fought against him, but many others were forgiven, and Edward's reign would repeatedly see clemency and a return to royal favour offered to those who had fought against him, some of whom would again turn against his rule.

However, there were many who were not prepared to give up the fight. After Towton Henry and Margaret had fled to Scotland and by 25 April they had reached an agreement with Mary of Guelders for military aid in exchange for the strategic border town and castle of Berwick. In June a combined Scottish–

BOTTOM RIGHT The Percy stronghold of Warkworth Castle, from which the earl of Warwick made daily visits to his forces besieging the surrounding fortresses in 1462. (Julian Humphrys)

BOTTOM LEFT Alnwick Castle, one of the key Percy strongholds in Northumberland that became central to Lancastrian attempts to maintain a foothold in England. (Julian Humphrys)

TOP RIGHT Norham Castle on the Scottish border.

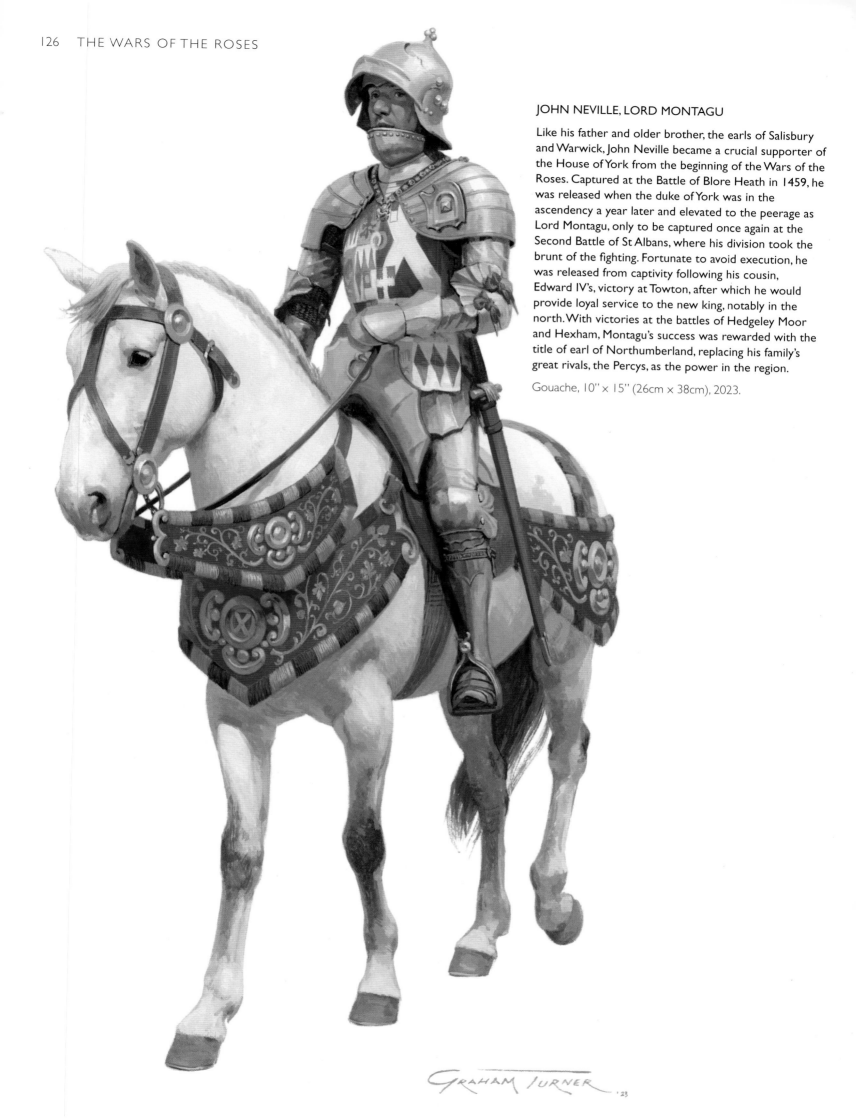

JOHN NEVILLE, LORD MONTAGU

Like his father and older brother, the earls of Salisbury and Warwick, John Neville became a crucial supporter of the House of York from the beginning of the Wars of the Roses. Captured at the Battle of Blore Heath in 1459, he was released when the duke of York was in the ascendency a year later and elevated to the peerage as Lord Montagu, only to be captured once again at the Second Battle of St Albans, where his division took the brunt of the fighting. Fortunate to avoid execution, he was released from captivity following his cousin, Edward IV's, victory at Towton, after which he would provide loyal service to the new king, notably in the north. With victories at the battles of Hedgeley Moor and Hexham, Montagu's success was rewarded with the title of earl of Northumberland, replacing his family's great rivals, the Percys, as the power in the region.

Gouache, 10" × 15" (26cm × 38cm), 2023.

Lancastrian force attacked Carlisle, and later in the month Henry VI himself was part of a force that reached as far south as Brancepeth Castle near Durham, where he briefly raised his standard. The siege of Carlisle was quickly raised by Lord Montagu and locals forced the raiders at Brancepeth to retreat, but these events highlighted the lack of authority Edward had in the north.

There was also trouble in Wales, where the castles of Denbigh, Harlech and Pembroke were held by Jasper Tudor. Sir William Herbert and Sir Walter Devereux, now Lord Herbert and Lord Ferrers, both of whom had considerable experience in the area, were appointed to eliminate the rebels, and Pembroke Castle surrendered in September (among those taken was a four-year-old Henry Tudor, who would thereafter live in Herbert's household until he was a teenager). On 16 October Herbert defeated Jasper Tudor and Henry Holland, Duke of Exeter, at Twt Hill near Caernarfon and by January 1462 Denbigh had also given itself up, leaving just Harlech to hold out for King Henry, under the command of Sir Richard Tunstall.

In the north the earl of Warwick and his brother Montagu began the process of subduing Northumberland, the mighty Percy fortress of Alnwick submitting in mid-September, with Dunstanburgh capitulating soon after. The constable of Dunstanburgh was Sir Ralph Percy, who was inexplicably left in command of the castle after his surrender. Unsurprisingly, given that his father had been killed at St Albans and his brothers at Northampton and Towton fighting against the Yorkists, it wasn't long before he turned the castle over to the Lancastrians once again. Alnwick was also recaptured for the Lancastrians, but by mid-July 1462 it was once again Yorkist after being besieged by Lord Hastings.

Alongside the inconclusive fighting, diplomatic efforts to gain the upper hand continued, King Edward negotiating with the Scots to exploit their divisions and try to persuade them to abandon their support of the Lancastrians. Disillusioned by the wavering support in Scotland, Queen Margaret travelled to France in April 1462 where she met the new king, Louis XI, who had succeeded his father Charles VII following his death from complications after a tooth extraction the previous year. Despite his initial reluctance, Louis was persuaded to offer financial aid in exchange for a promise to give him the last remaining English possession in France: Calais.

Wildly exaggerated rumours of a huge invasion force being assembled in France had caused widespread fear, and beacons were set along the south coast to warn of an approaching invasion fleet. Other disturbances were reported across the country, and in this uncertain atmosphere of suspicion and unease a plot was uncovered headed by the earl of Oxford and his son, Aubrey de Vere, who were executed on Tower Hill in February 1462 along with a number of co-conspirators.

Queen Margaret's invasion didn't live up to the hype. With a force of around 800 French soldiers she returned to Scotland, collected King Henry, and landed on the Northumberland coast at Bamburgh on 25 October. With Dunstanburgh still held by Percy and Alnwick coming under their control yet again, the Lancastrian threat in Northumberland took an alarming turn for Edward. He immediately summoned most of the nobility to his side and made preparations to leave London; faced with this substantial show of Yorkist might, Margaret and Henry once again fled for Scotland leaving their castles well garrisoned. As they sailed north, Margaret's small fleet was struck by a storm, her ship sunk and riches lost. She transferred to a fishing boat and was landed at Berwick, but about 400 of her Frenchmen were driven ashore at Lindisfarne, where many were killed or captured.

Edward arrived in Durham in November, but when he was taken ill with measles, overall command of the military campaign was undertaken by Warwick. From his base at Warkworth he made a daily tour of the three besieged castles as the defenders were inexorably starved into submission. Their one hope was in a relief force from Scotland, but it arrived too late to prevent the surrender of Bamburgh and Dunstanburgh. The duke of Somerset, Sir Ralph Percy, and other leading defenders were taken to the king in Durham, where once again he showed his merciful side – considered by many as his weakness – when he not only pardoned them, but again restored Percy as commander of Bamburgh and Dunstanburgh.

At the start of 1463 only Alnwick remained in Lancastrian hands, and on 5 January the combined Franco-Scottish relief force arrived on the scene. For some reason Warwick withdrew his besieging army from their positions and allowed the defenders under Lord Hungerford to march out and head for the border. One account suggests that his failure to engage in battle was because of the low morale of his

BELOW John Neville was made a Knight of the Garter at the start of Edward IV's reign. This is his stall plate in St George's Chapel, Windsor. Neville's Garter can be seen below his left knee in the painting opposite.

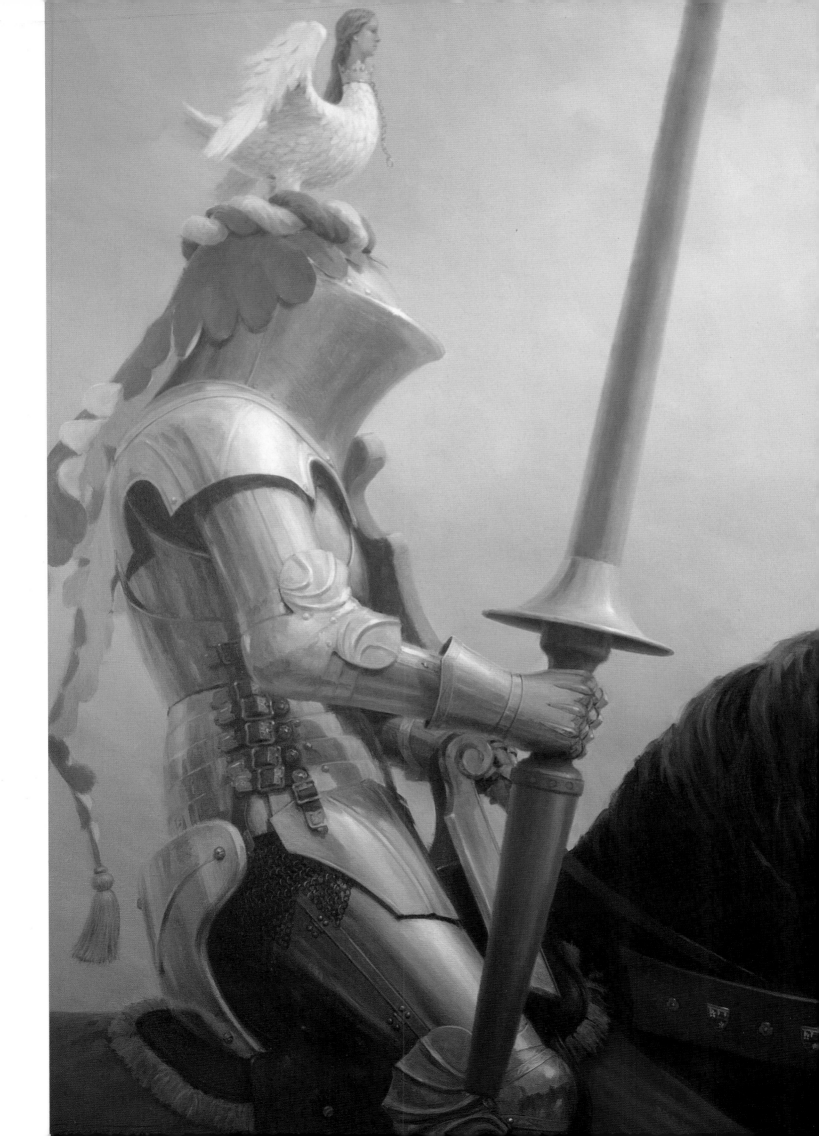

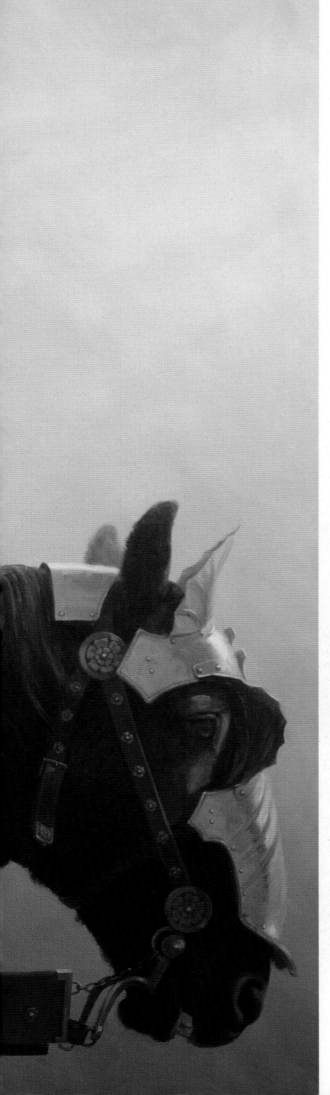

soldiers: 'thei hade lye ther so longe in the felde, and were greved with colde and rayne, that thei hade no coreage to feght'. The last Lancastrian fortress in Northumberland had fallen and Edward 'was possessed of alle Englonde, excepte a castelle in Northe Wales called Harleke'; once again he and Warwick headed south.[3]

It wasn't to last. In March 1463 Sir Ralph Percy reverted to his natural inclination and turned Bamburgh and Dunstanburgh over to a Franco-Scottish force, and in May Sir Ralph Grey, constable of Alnwick, defected and, betraying the captain, Sir John Astley, allowed Lord Hungerford to retake the castle unopposed. Sir John had started his long military career in France and was a jouster of some renown, being invested as a Knight of the Garter in 1461. After his betrayal it appears he was held in France, where he remained until 1466 when his ransom was paid. His long career resumed after that brief interlude; he was one of four knights who carried the canopy at Edward IV's funeral, and he also attended Richard III's coronation before his death in 1486.

The Yorkist efforts of the previous year had been for nothing. Warwick left London on 3 June with Lord Stanley and a large force to join Montagu in Northumberland and face a fresh invasion from Scotland led by Queen Mary and her young son the king of Scotland, along with Henry VI and Queen Margaret, who laid siege to Norham Castle near Berwick on the Scottish border.

Urgent messages were sent urging Edward to come north with reinforcements, but the king was delayed at Northampton when rioting broke out because the duke of Somerset accompanied him. Since his surrender Somerset had become a firm favourite of the king, who 'lovyd hym welle', and 'made a grete justys [jousts] at

Sir John Astley was a Knight of the Garter from 1461 until his death in 1486. This is his stall plate in St George's Chapel, Windsor.

ANTICIPATION

Lance in hand, attention fully focused on his opponent at the far end of the lists, a knight – his helmet crowned with his fantastic heraldic crest – inwardly battles to control his, and his horse's, excitement and nerves, split seconds before this moment of apparent calm explodes into a blur of adrenalin-pumping action…

The crest – a harpy – is that of Sir John Astley, who took part in a notable feat of arms at Smithfield in 1442, after which he was knighted by the king. 'And this yer the xxx day of Janyver was a feet of armes doon in Smythfeld betwene a knyght of Aragon and John Asteley squyer which John for his deed doyng was made knight in the said feld by the kyngs handes forthwith.' Sir John was betrayed at Alnwick Castle in 1463 and held in France for the next three years.

Oil, 31" x 31" (80cm x 80cm), 2008.

Westemyster, that he shuld se sum maner sporte of chevalry', and when Edward left London he trustingly – or naively – appointed Somerset and 200 of his men as his bodyguard. However, the people of Northampton weren't as forgiving: 'The comyns a rosse uppon that fals traytur thee Duke of Somersett, and wolde have slayne hym with yn the kingys palys. And thenn the kynge with fayre speche and grete defeculte savyde hys lyffe for that tyme, and that was pytte, for the savynge of hys lyffe at that tyme causyd mony mannys dethys son aftyr, as ye shalle heyre.' Somerset was sent to north Wales and his men to Newcastle to help with the town's defence, while the citizens of Northampton were given 'a tonne of wyne that they shulde drynke and make mery.'[4]

While at Northampton news arrived informing Edward that his army in Northumberland had put the invaders to flight, pursuing them 60 miles into Scotland, burning and pillaging as they went. Margaret and Prince Edward escaped to Berwick where they boarded a ship to Sluys in Flanders, while King Henry sought safety behind the walls of Bamburgh Castle. He would never see his wife or son again.

The three Northumberland castles remained in Lancastrian hands for the rest of 1463 while diplomatic efforts concentrated on isolating them from their overseas support. A truce between England and Scotland lasting until October 1464 was signed in December, and an agreement for further peace talks made.

'Where sodainly thesaied lords, in maner, without stroke striking, fled, and onely sir Raufe Percy abode, and was there manfully slain'
Hall's Chronicle

THE BATTLE OF HEDGELEY MOOR
25 April 1464

As his allies flee the battlefield, Sir Ralph Percy makes his final desperate stand against Lord Montagu's Yorkist army.

Gouache, 21.5" x 15" (54cm x 38cm), 2020.

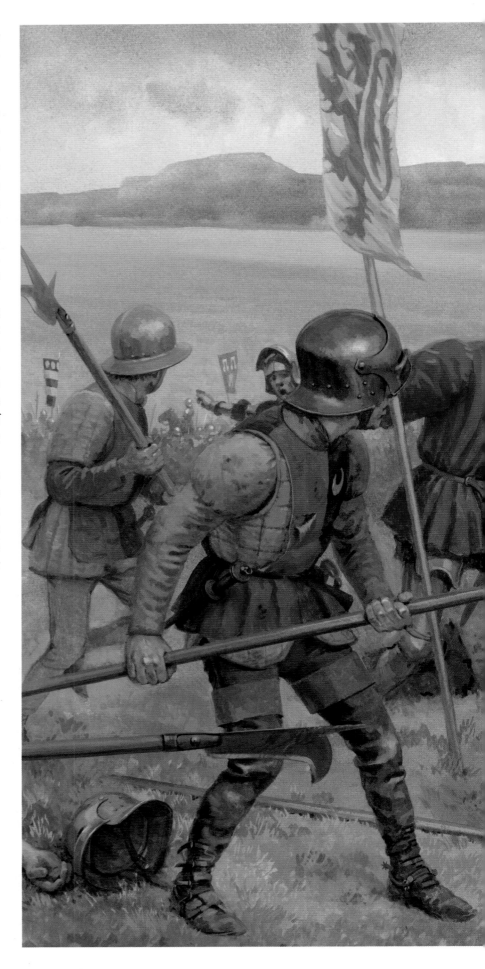

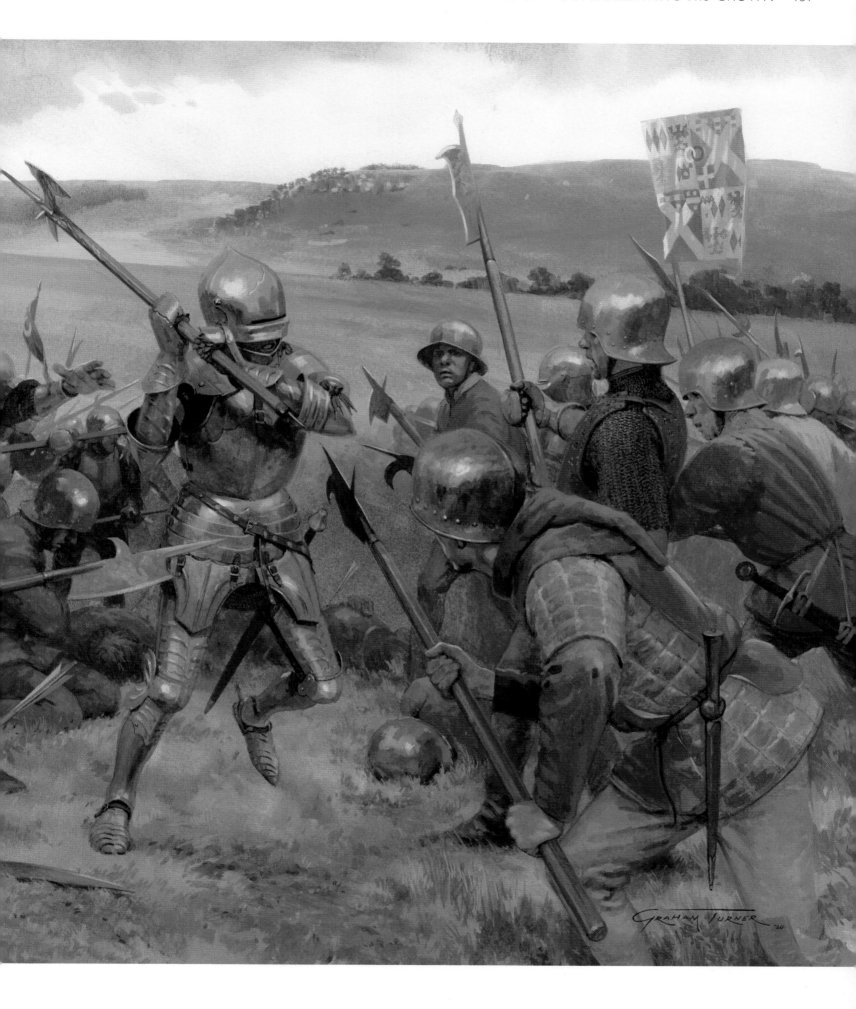

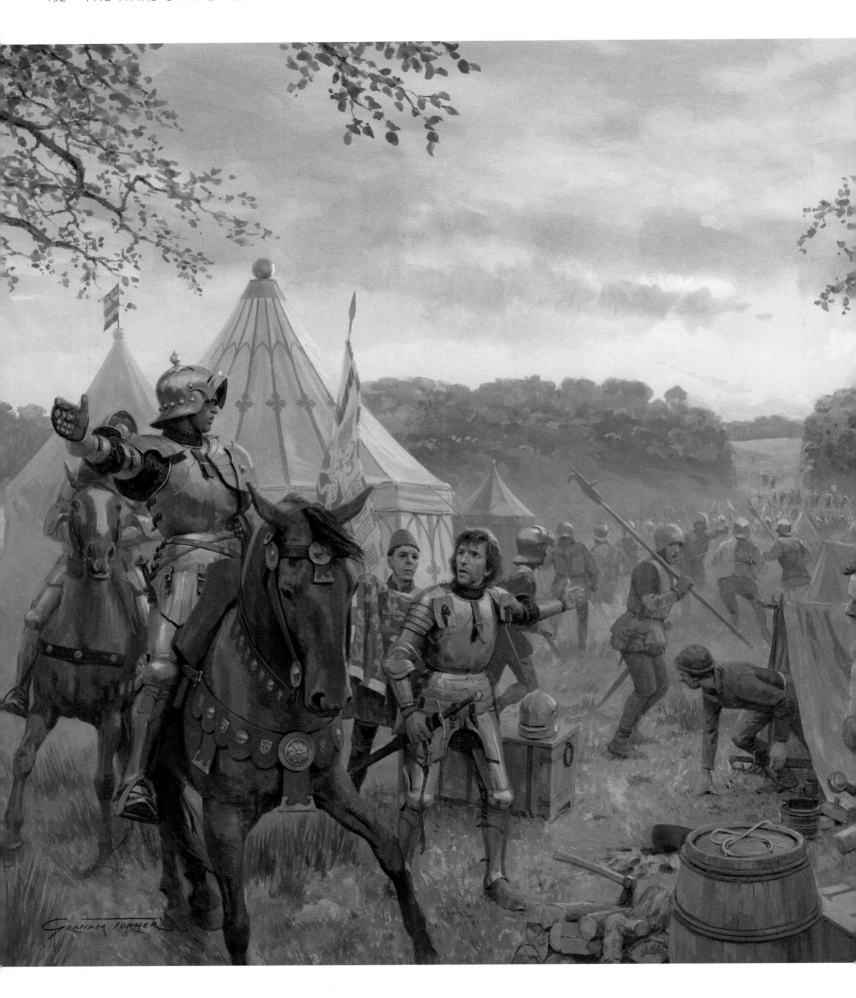

It didn't take long for the duke of Somerset to demonstrate that the king had been misguided in trusting him, and in December 1463 he left Wales and headed for Newcastle, hoping to be reunited with his men who now formed part of the garrison there. At Durham he was recognised and narrowly avoided capture while he slept, escaping barefoot in his nightshirt and leaving his armour behind. His retainers in Newcastle attempted to steal away but 'sum of hem were take and loste hyr heddys for hyr labur.'[5] Somerset managed to make his way to Bamburgh where he joined King Henry and the remains of his resistance, and from here they organised raids and took several towns.

In mid-April John Neville, Lord Montagu, was despatched to the border to escort Scottish envoys through what was now hostile territory to the peace talks that had been delayed by further unrest in Wales and the south, and also relocated from Newcastle to the safer venue of York. Montagu managed to avoid an ambush laid by Sir Humphrey Neville, son of Lord John Neville who had betrayed the Yorkists at Wakefield, but then found his way blocked by a larger Lancastrian force at Hedgeley Moor on or around 25 April.

The Lancastrian army included the duke of Somerset, lords Roos and Hungerford, Sir Ralph Percy and Sir Ralph Grey. Details are scarce, but Sir Ralph Percy was 'manfully slain',[6] along with many of his retinue, seemingly abandoned by his comrades who made their escape. Legend has it that two boulders mark the spot where Percy made his final leap having received his death blow, and a roadside memorial marks this spot.

Montagu continued his journey and escorted the Scottish envoys from Norham safely to York, where they awaited King Edward, delayed for reasons that would later become clear (shockingly to many contemporaries!). The peace talks in York would eventually prove successful, and on 1 June King Edward signed a 15-year peace treaty with Scotland.

When Montagu returned from York to Newcastle he received intelligence that Somerset and his army were camped just outside Hexham, in a meadow called

'Ande the xiiij daye of May nexte aftyr, my Lorde of Mountegeue toke hys jornaye toward Hexham from the Newecastelle. And there he toke that fals Duke Harry Beuford of Somersett, the Lord Roos, the Lorde Hungerforde, Syr Pylyppe Wenteworthe, Syr Thomas Fyndorne, whythe many othyr; loo, soo manly a man ys thys good Erle Mountegewe, for he sparyd not hyr malysse, nor hyr falssenysse, nor gyle, nor treson, and toke meny of men and slowe many one in that jornaye.'
Gregory's Chronicle

THE BATTLE OF HEXHAM
15 May 1464

As Lord Montagu's army sweeps into their camp, Henry Beaufort, Duke of Somerset, tries to urge lords Roos and Hungerford to stay and fight.

Gouache, 23.2" x 16.5" (59cm x 42cm), 2022.

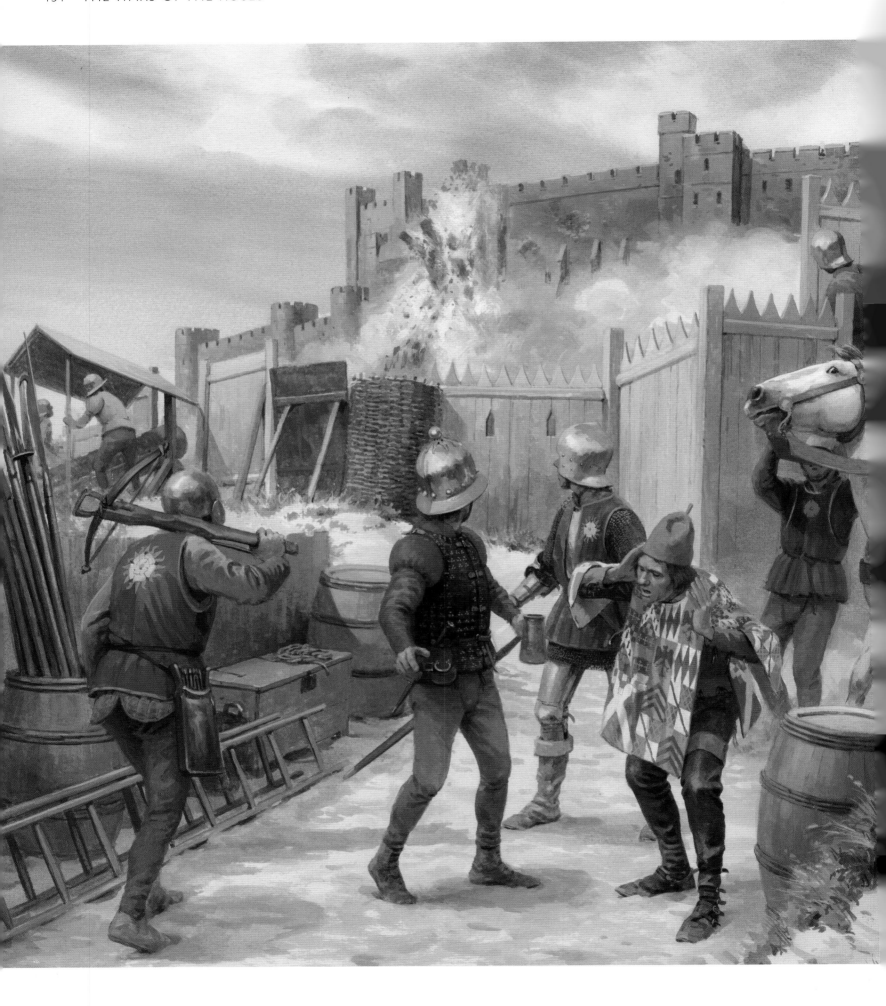

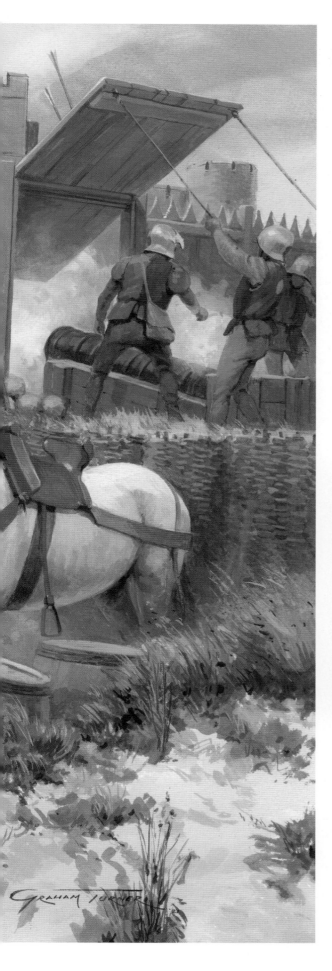

Linnels near Devil's Water. He immediately set out to find them, his army now including former Lancastrians Lord Greystoke and Lord Willoughby. Early on 15 May they marched past Bywell Castle, where unbeknown to them King Henry was staying, and swept downhill straight into Somerset's camp, largely taking the Lancastrians by surprise. With their backs to the aptly named fast-flowing Devil's Water, Somerset's army had nowhere to retreat, and many were cut down or drowned as they tried to escape. Twenty-eight-year-old Henry Beaufort, Duke of Somerset, found his luck had finally run out and he was promptly executed in Hexham with four others, while lords Roos and Hungerford were part of another group to meet the same fate two days later in Newcastle. Another seven were similarly despatched at the earl of Warwick's Middleham Castle on the 18th, and a further 14 were 'tried' in York before being executed in two batches on 25 and 28 May. In July the fugitive Sir William Tailboys was found hiding in a coalpit with a large sum of Lancastrian gold and silver in his possession, intended for soldiers' wages; Sir William lost his head and the money vanished into his captors' purses. Only Henry VI evaded capture: 'and kyng henry was soo nere pursuyd that the said lord mountagw took certain of his ffolowers trappid with blew velvet, and upon oon of the hedys of the sayd ffolowers king henryes bycokett Rycchely garnysshid with ij [2] Crownys of gold The which the said lord mountagw browgth & gave unto the kyng shortly aftyr'.[7] Henry would remain in hiding for a further year, until he was eventually taken 'bysyde a howse of religione in Lancaschyre... in a wode called Cletherwode, besyde Bungerly Hyppyngstones [stepping-stones]' and

'alle the Kinges greet gonnes that were charged at oons to shute unto the said Castelle, Newe-Castel the Kinges greet gonne, and London the second gonne of irne; the which betide the place, that stones of the walles flewe unto the see'
Warkworth's Chronicle

Large block of fallen masonry at Bamburgh Castle.

THE SIEGE OF BAMBURGH CASTLE

The battle for control of the mighty fortresses of Northumberland had seen them change hands repeatedly in the early 1460s, but by June 1464 Bamburgh was the last to remain holding out for Henry VI. Terms for the defenders' surrender were delivered by the earl of Warwick's herald; when these were rejected, King Edward's siege artillery was brought into action, causing considerable damage as the great guns pounded the walls. From behind the siege-lines, Warwick's herald witnesses the power of this formidable bombardment as one of Bamburgh's towers comes crashing down.

Gouache, 17.3" x 13.3" (44cm x 34cm), 2021.

ABOVE **The monument near Hedgeley Moor known as Percy's Cross bears the Percy family's badges of the crescent, shackle bolt, and luce, or pike fish. The crescent can be seen being worn by Sir Ralph Percy's soldiers in the painting of the Battle of Hedgeley Moor on pages 130–131.** (© Copyright Russel Wills, CC BY-SA 2.0)

ABOVE LEFT **Devil's Water, which would claim many lives as the defeated Lancastrian army broke and fled from the battlefield near Hexham.**

'caryed to Londone on horse bake, and his lege bownde to the styrope, and so brought thrugh Londone to the Toure'.[8] Apart from his brief reinstatement in 1470, he would live the rest of his life imprisoned there.

John Neville, Lord Montagu, had displayed great resolve and achieved notable success for King Edward, and his reward was to be elevated to the title of earl of Northumberland, along with a substantial grant of confiscated Percy lands. Henry Percy, whose father the third earl had died at Towton and his title and lands been forfeited, was currently imprisoned in London, but his rehabilitation later in the decade would add a further twist to the course of the Wars of the Roses.

After the crushing defeat at Hexham and the round of executions that followed, the only Lancastrian resistance that remained in the region was the three Northumbrian castles. Faced with the approach of the victorious Montagu, now earl of Northumberland, with a substantial force equipped with siege artillery at his command, Alnwick and Dunstanburgh surrendered without a fight on 23 June. Only Bamburgh resisted. The heralds of the king and Warwick offered the same terms of surrender given to the castle's neighbours, which included full pardon for the garrison but specifically excluded the commander, Sir Ralph Grey; Grey understandably declined. The heralds then conveyed a message from Warwick saying that they would besiege the castle for seven years if necessary, and that the king desired the castle – 'this Juelle' – undamaged; 'if ye suffre any greet gunne laide unto the wal, and be shote and prejudice the wal, it shall cost yowe the chiftens hede; and so proceding for every gunne shot, to the leest hede of any persoune within the said place.'[9]

The battering began. Edward IV's 'greet gonnes' pounded the castle so that 'stones of the walles flewe unto the see'. One gun named Dijon put its shot through Grey's chamber 'oftentymes' and Sir Ralph was injured by falling masonry. Finally, the castle surrendered, and Sir Ralph was taken to the king at Doncaster to be tried for treason by the earl of Worcester, John Tiptoft, Constable of England. Condemned to death, he was drawn through the town 'to a scaffold maade for thee, and that thou shalt have thyne hede smite of thi body'.[10]

Guns had first been used by the English during the first half of the 14th century, small cast bronze weapons designed primarily for defence. Subsequent technological advances in gunmaking were accompanied by the production of better – and most importantly cheaper – gunpowder, allowing the development of the huge iron bombards that could demolish walls and terrify defenders. Bombards and smaller guns were deployed in significant numbers by Henry V at the siege of Harfleur in 1415, during the Agincourt campaign.

During the campaign to subdue Lancastrian resistance in the north, Edward IV had his royal guns shipped from London to Newcastle, from where they were transported overland to the siege lines at Bamburgh – a huge logistical exercise. Among the various pieces arrayed against Bamburgh's walls were his 'greet gonnes', huge bombards with names such as 'Newe-Castel' and 'London'. These bombards were made from strips of wrought iron laid side-by-side to form a tube and bound in place by great iron hoops – much in the same way as a wooden storage barrel would be made, hence the term 'gun barrel'. 'Mons Meg', the most famous surviving example of this type of weapon, the super-guns of their time,

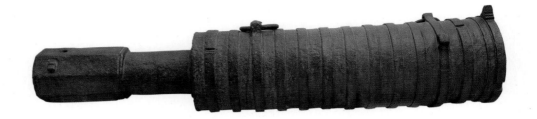

The huge barrel of a
bombard. (Royal Armouries)

can be seen today in Edinburgh Castle. Constructed at huge cost in Mons in 1449 for the duke of Burgundy, it was later sent as a gift to James II of Scotland. James's death at the siege of Roxburgh in 1460, when a gun he was firing exploded and shattered his thigh, demonstrates that operating these guns could be a dangerous business, although the risk the guns posed to their operators is sometimes greatly exaggerated. The great bombards were generally muzzle loaded and fired huge stone balls – Mons Meg has a bore of 480mm – but smaller field guns mounted on more manoeuvrable carriages, sometimes made with a separate breech to allow a faster rate of fire, more usually fired lead projectiles; examples found on the battlefield at Bosworth vary between 30mm and 94mm in diameter, some cast around iron cubes or stones.

The deployment of guns created a requirement for new types of specialist. In 1456 a royal warrant appointed John Judde as Master of the King's Ordnance. He was possibly present at the English defeat at Castillon in 1453, but whether or not he personally witnessed that devastating demonstration of artillery deployed in a defensive position, he subsequently devoted himself to gunpowder weaponry. By 1457 he had provided the king with 26 new serpentines – a type of cannon – and associated apparatus, which were stored at Kenilworth Castle. In 1459 Judde was commissioned to seize 'all the ordnance and habiliments of war' belonging to the duke of York and earls of Warwick and Salisbury,[11] following their defeat at Ludford Bridge, where the Yorkists had 'fortefied their chosen ground, their Cartes with Gonnes, sette bifore their

MASTER OF THE KING'S ORDNANCE

John Judde overseas the transport of the king's ordnance from the Tower of London to Northampton in June 1460.

Gouache, 18" x 14.5" (45cm x 37cm), 2012.

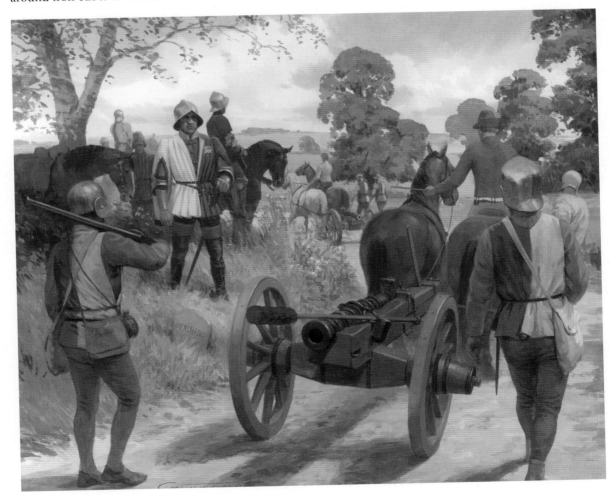

Batailles'.[12] Another commission in 1460 illustrates the diverse professions that were required to deploy and operate guns, listing wheelers, cartwrights, carpenters, stonemasons, smiths, plumbers, and others. On 22 June 1460, while transporting '30 cartloads loaded with canon, powder for them, lances, axes, and other ordinances of war' from the Tower for the king,[13] John Judde was killed between St Albans and Dunstable. It is fair to assume he was involved in the defensive preparations before the Battle of Northampton, where Henry VI arrayed his army within a fortified position defended by guns in the manner so effectively employed at Castillon, a tactic followed – likewise without success – by the earl of Warwick at the Second Battle of St Albans in 1461. A pro-Yorkist chronicler wasn't sorry to report the death of this 'caitif', claiming he 'malicously ymagined and laboured to ordeyn and make all

things for werr to the distruccion of the seid duke of yorke and all the other lords'.[14]

Alongside these larger weapons, smaller 'handgonnes' were also developed, the forerunner of the musket. In its simplest form the handgonne had a short barrel mounted on a wooden stock, ignited when a burning match was applied to the touch-hole to set off the gunpowder charge. Another type, known as a hackbut, had a long metal tiller and a hook towards the front of the barrel that might be used to brace the weapon on something solid such as a wall top. As the 15th century progressed the matchlock was developed, a mechanism with a simple trigger to apply the burning match to the charge, and the weapon took on the more familiar look of the arquebus.

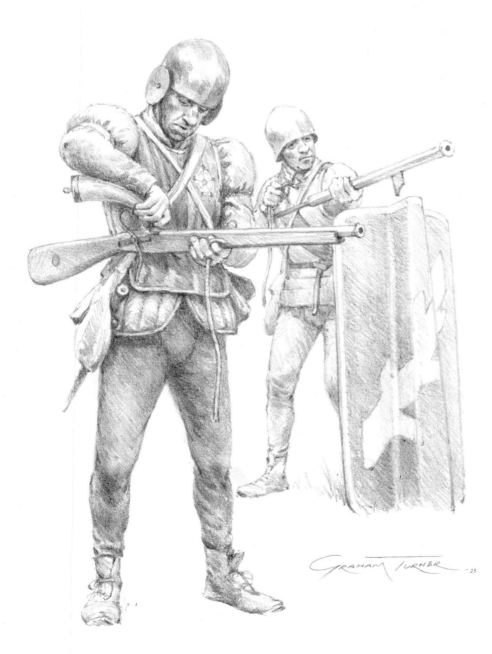

A 'BLAK AND SMOKY SORT'

A handgonner primes his weapon, this one fitted with the latest development of matchlock to ignite the charge, while behind a pavise that bears the ragged staff badge of the earl of Warwick, another prepares to fire his hackbut.

Pencil, 9" x 12" (23cm x 30cm), 2023.

CHAPTER 11
A NEW QUEEN

Edward was 'in the flower of his age, tall of stature, elegant in person, of unblemished character, valiant in arms', wrote a commentator in 1461.[1] When his coffin was opened in 1789 his skeleton measured 6ft 3½ in. Tall, good looking, athletic, and victorious in battle, he was the archetypal medieval warrior-king.

Even before he became king, various marriage proposals had been made and considered but, following his accession to the throne, he became Europe's most eligible bachelor. His marriage offered great opportunities for an advantageous international alliance, and matches were explored with Burgundy, Scotland, Spain and France, though it was the French proposal, championed by the earl of Warwick, that was most seriously considered.

Edward would soon wreck these plans. In 1464 he had taken longer to reach the Anglo-Scottish peace talks in York than expected. The reason wouldn't become clear until September. En route he had stopped at Stony Stratford in Northamptonshire,

and early on 1 May he rode over to nearby Grafton where he secretly married Elizabeth Woodville, daughter of Richard Woodville, Lord Rivers, and Jacquetta of Luxembourg, widow of the duke of Bedford, Henry V's brother. Elizabeth herself was a widow; her husband, Sir John Grey, had been killed fighting for Henry VI at the Second Battle of St Albans, and she had two young sons.

We don't know when Edward and Elizabeth met, or why he chose her as his queen. It could well have been a romantic and impulsive love-match, but another theory that subsequently gained favour was that marrying her was the only way she would give in to his advances. Edward had something of a reputation as a womaniser, with a passion for 'boon companionship, vanities, debauchery, extravagance and sensual enjoyments',[2] or more politely, 'men mervelyd that oure soverayne lorde was so longe with owte any wyffe, and were evyr ferde that he had be not chaste of hys levynge'.[3]

> 'That same yere, the fyrste day of May be fore sayde or wrete, oure soverayne lorde the Kynge, Edwarde the iiij, was weddyd to the Lorde Ryvers doughter; hyr name ys Dame Elyzabethe… And thys maryage was kepte fulle secretely longe and many a day'
>
> Gregory's Chronicle

ABOVE **Garter stall plate of Richard Woodville, Lord Rivers, at St George's Chapel, Windsor.**

RIGHT **Anthony Woodville presents a copy of his translation of 'Dictes or Sayengis of the Philosophres', one of the first English-language books to be printed in England, to King Edward IV and Queen Elizabeth, his sister.** (© Lambeth Palace Library / Bridgeman Images)

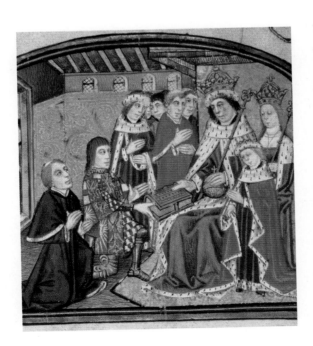

While Edward acted as if nothing had occurred, his envoys continued with the French negotiations, and in June Warwick was in St Omer for talks, which were postponed until October. It was only when the French marriage was being discussed at a Council meeting in Reading in September that the truth came out. Edward's revelation certainly shocked the establishment and created much gossip overseas, one writer claiming that the 'greater part of the lords and the people in general seem very much dissatisfied at this'.[4] However, English chroniclers seemed rather more accepting, mostly recording the fact without criticism, although some do hint at reservations within the nobility: 'relying entirely on his own choice, without consulting the nobles of the kingdom'.[5]

Much is made of Elizabeth's supposed lowly birth, but while she was not from as humble origins

as is often suggested – her mother was of noble French descent – she was not considered a suitable match for a king. As already noted, young Edward had himself berated her father for his lowly birth, describing him as 'made by maryage',[6] when he and her brother Anthony had been captured and taken to Calais in 1460. Both had also fought for Henry at Towton, for which they had received pardons and were beginning to rehabilitate themselves with the new king.

Edward's marriage to Elizabeth is often cited as the start of the breakdown of his relationship with Warwick, and it certainly demonstrated that the earl's protégé was very clearly his own man and was not going to be easily influenced or controlled. But the marriage was a *fait accompli*, and for now Warwick accepted the situation, publicly at least; he and the king's brother Clarence escorted the new queen to her formal introduction to the royal court.

The king now had to make suitable provision for Elizabeth's many relatives, and he lost no time in doing so. Her sister Margaret was quickly betrothed to the heir of the earl of Arundel, and more controversially, her 20-year-old brother John to the wealthy dowager duchess of Norfolk, Warwick's aunt, who was at least 45 years his senior and had survived three previous husbands. Within two years, four more of her sisters had found matches with the upper echelons of the nobility, and her son Thomas Grey took the place of John Neville's son to be betrothed to Anne Holland, daughter and heiress of King Edward's sister the duchess of Exeter. It is these marriages that likely fuelled Warwick's growing resentment, not just because they directly involved a number of his relatives, but also because they removed potential high-ranking husbands for his own daughters.

History has not been kind to the Woodvilles and they are usually perceived as a greedy and grasping lot, but, besides the raft of marriages, their rewards were generally no greater than those given to some of their fiercest opponents, some of whom had been promoted from similarly humble backgrounds. This view of the family has inevitably been clouded by later anti-Woodville propaganda, promoted by Warwick in 1469 and Gloucester in 1483, but it is also easy to see how contemporaries could have held them in snobbish contempt for overstepping their 'place'. Elizabeth's father had already been on the upward path, since he became a knight banneret in 1442, was ennobled as Lord Rivers in 1448, and

ABOVE In 1468, Edward IV was nominated as a member of the Burgundian Order of the Golden Fleece. His arms can be seen alongside his fellow knights at the Church of Our Lady in Bruges.

TOP LEFT Foot combat with poleaxes, from the *Beauchamp Pageant* of c.1483–85 (British Library Cotton MS Julius E IV-3 f.7v)

ABOVE LEFT AND LEFT Great bascinet for foot-combat, c.1490, possibly British or Flemish, formerly part of a funeral achievement at St Mary's church, Aylesbury. (Metropolitan Museum of Art, New York, Gift of William H. Riggs, 1913, accession no. 14.25.591)

TOURNAMENT ARMOUR

The main figure is armed for the tourney with blunt swords, wearing a brigandine and great bascinet. At the top left is a specialised armour for the joust, with a frog-mouthed helm which could be either strapped or screwed to the cuirass, as in the case of this example from c.1500. Below this is a great bascinet from Wimborne Minster in Dorset, a lance with a three-pronged coronel for the jousts of peace, and next to it a sharp head for jousts of war. In the centre is a high saddle with extensive protection for the rider's legs, and at the bottom is an early 15th-century jousting helm associated with Henry V.

Gouache, 13" × 17" (33cm × 43cm), 2001.

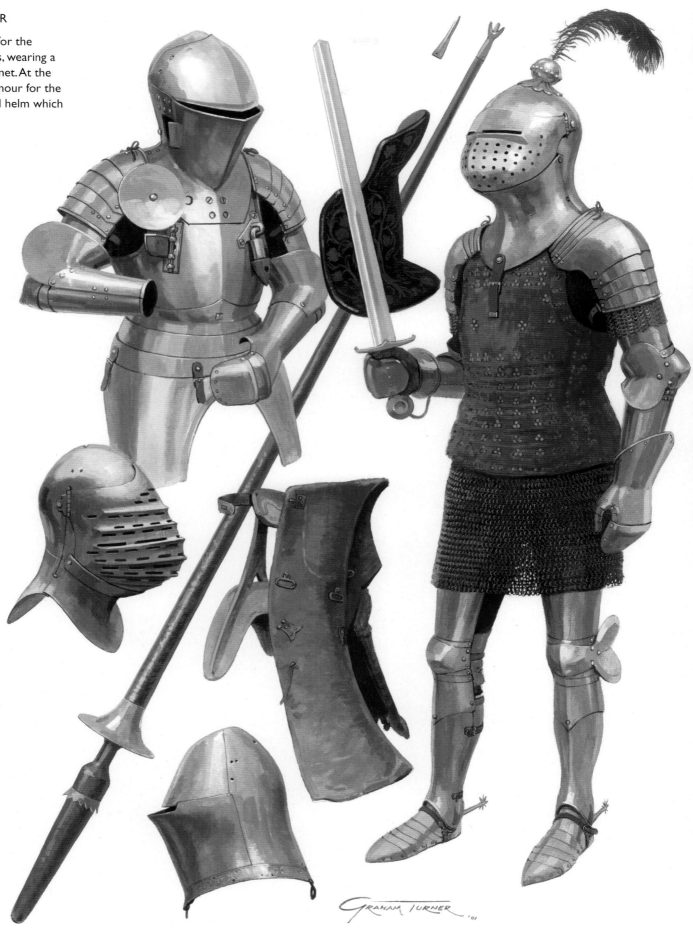

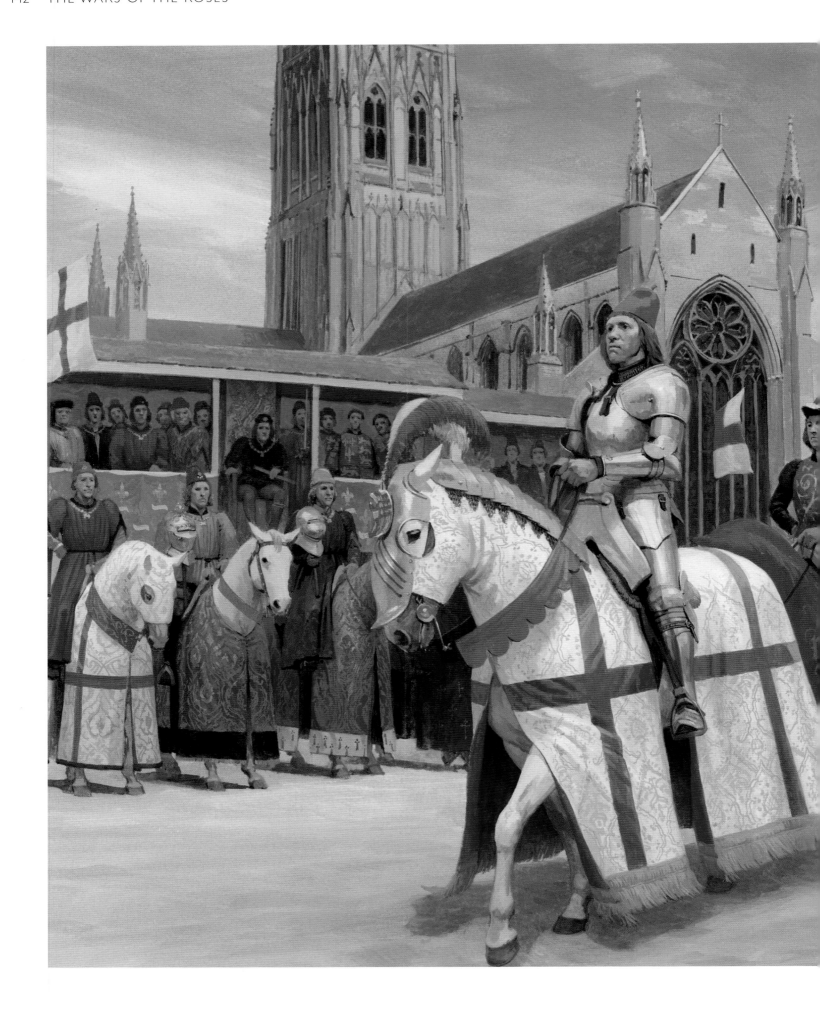

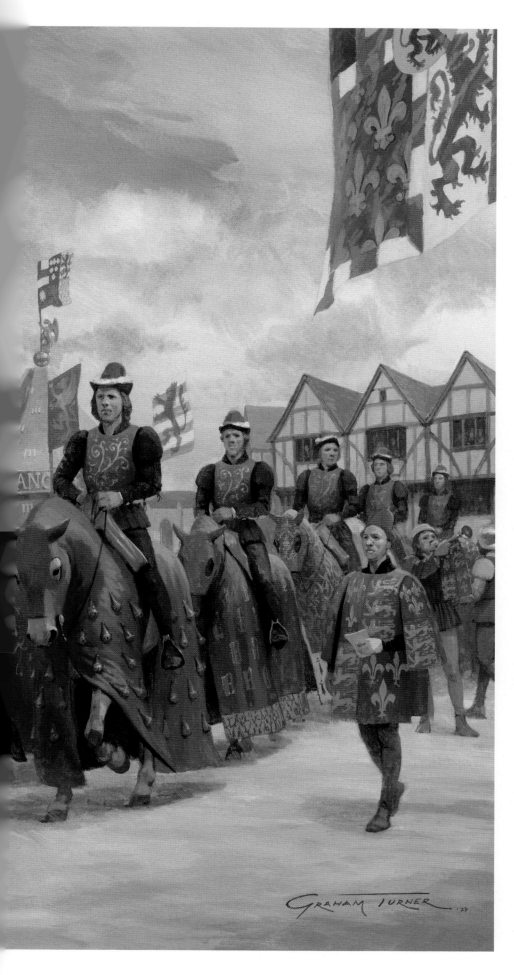

'The Kyng sittyng in his estate, the lords about hym; the seide Lorde Scales entrid the feeld with the seide ix. folowers so richely beseen; and came before the Kynges highness and did hym reverence as appteyned, and retrayed to his pavylon in the southest corner of the felde before richely sett.

First. His owne hors, trappid in a di trappe of white cloth of goolde, with a crosse of Seint George of crymsyn velewet, bordird with a fringe of golde half foote long.

The secunde hors, in a juste cloos trappere of velewet tawny, accomplisshid with many grete belles.'

Sir John Paston's Grete Booke

RIGHT NOBLE AND WORSHIPFUL KNIGHT AND LORD, SIR ANTHONY WOODVILLE THE LORD SCALES

Anthony Woodville, Lord Scales, makes his magnificent entry before King Edward IV at Smithfield, to undertake his challenge with Antoine, Count de La Roche, Bastard of Burgundy, on 11 June 1467. In front of the king's stand, bearing Woodville's helms, are the duke of Clarence and earl of Arundel, who preceded him onto the field with the duke of Buckingham, the earl of Kent, and lords Herbert and Stafford, 'evyvh of them beryng oon of the wepens'.

Towering above the scene is the priory of St Bartholomew the Great, only a small part of which survives today, now absorbed within the surrounding buildings of the city.

Gouache, 21.8" × 15.6" (55cm × 40cm), 2023.

made a Knight of the Garter in 1450, but it's unlikely he would have been appointed to the lucrative posts of treasurer and constable of England, or been made an earl, if his daughter hadn't married the king.

Queen Elizabeth's coronation on 26 May 1465 was a magnificent occasion. Pageants, banquets and a tournament were enjoyed by those present, which included most of the nobility of England and a Burgundian party who accompanied the queen's uncle, Jacques of Luxembourg. King Edward created around 40 new Knights of the Bath, including his new brothers-in-law Richard and John Woodville.

The reputation of Elizabeth's older brother, Sir Anthony Woodville, has managed to rise above the rest of his family. He held the title Lord Scales through his wife Elizabeth, whose father had been killed in 1460 (see page 84), and is remembered for his literary interests and early patronage of the pioneering printer William Caxton, his pilgrimages, and most especially for his tournament and jousting exploits. Sir John Paston wrote of his part in a tourney at Eltham in 1467, where his 'hand was hurte' while fighting on the side of the king and Lord Scales; Sir John Woodville was part of the opposing team.[7] Later the same year Anthony Woodville again tested his martial prowess, but this time on a much bigger stage, at an event with chivalrous ideals at its heart but serious international diplomacy behind the glorious spectacle.

This particular challenge began two years earlier in 1465. According to his surviving account, when visiting his sister the queen, Anthony knelt before her, 'and as I spake to hir ladiship on knee, the bonnet from myne hede, as me aught… till the ladies of hir compaigne aryvid aboute me; and they of theire benyvolence, tied about my right thigh a Coler of goolde… And to that Coler was tied a noble Floure of Souvenaunce, enamelid, and in maner of an emprise.' He immediately realised that this golden collar with an enamelled flower pendant was to be the prize for a chivalrous enterprise, and as he rose up to thank them for the great honour they had done him he discovered a small piece of parchment had been placed in his 'bonet', 'rollid & closid with a litill thred of goolde…'. Having thanked 'right humbly the Quene' and her ladies for the honour they had done him, he took the parchment to the king, who broke the seal and commanded the contents be openly read. The document carefully detailed certain challenges he should undertake on 'horsbak and on foote' in

London in October against a 'noble man of foure lynages and without any reproche'.[8]

Of course, this tableau is something straight out of the chivalric romances, the literary world of fair ladies and honourable knights which formed an important part of the deeply held beliefs and values of men like Anthony Woodville. What followed shows how this rather stylised ideal could be woven into the politics and diplomacy of the real world.

Political tensions between the French crown and the dukes of Burgundy and Brittany pushed each of them to seek an alliance with England. In this Machiavellian world, the earl of Warwick was courted by King Louis of France and, as he became drawn deeper into the French king's schemes, so it became harder and more humiliating for him to change course. However, although King Edward IV was happy to play the two sides off against one another, he began leaning towards a Burgundian alliance, no doubt influenced by England's long-standing hostility to their traditional enemy. Duke Philip was unwell, leaving his son Charles, Count of Charolais, in control, and despite his previous sympathies towards the Lancastrians, the threat from France pushed him towards the Yorkist King Edward.

In 1465 his second wife had died, and tentative proposals were made for a match with King Edward's sister Margaret. Between 1465 and 1467 embassies criss-crossed the Channel and negotiated to secure favourable terms for peace and commerce. On 28 May 1467 Warwick returned to France, where he was again courted by Louis and showered with expensive gifts in an effort to secure Anglo-French cooperation against Burgundy and bring the duchy under French control. Meanwhile, the negotiations with Burgundy continued under cover of a great chivalrous contest.

Anthony Woodville's challenge had been sent to Antoine, Count de La Roche, 'Bastard of Burgundy', an illegitimate son of Philip, Duke of Burgundy. The Burgundian court was considered the most splendid in Europe, and its tournaments provided the model for many such spectacles. Antoine was held in high regard, had led Burgundian armies into battle, and was a Knight of the Golden Fleece, the Burgundian equivalent of England's Order of the Garter (to which Anthony Woodville belonged). The originally proposed October date for their meeting was postponed until June 1467, two years after the challenge was originally made, and it was probably no coincidence that Warwick had been despatched

to France at precisely the same time. The Count de La Roche and his party were received with great honour, and after the precise rules of combat were agreed, the much-anticipated feat-of-arms finally went ahead amidst magnificent ceremony and display at Smithfield, just outside London's walls. The tournament itself appears to have not quite lived up to expectations, however. In front of King Edward with 'many noble lordes aboute hym', Anthony, Lord Scales, made his entry, fully armoured and on

horseback, his horse bedecked in a caparison of white cloth of gold with a crimson velvet cross of St George. Before him his two helmets were borne by the duke of Clarence and earl of Arundel, and his weapons were carried by the earl of Kent, duke of Buckingham, Lord Herbert and Lord Stafford. He retired to his pavilion 'of double blewe saton' and, in a similar display of magnificence, the Bastard entered the field. Following their proclamation to abide by the rules, the constable commanded a herald to cry 'lessez aler' (let go) and the two combatants charged into action. After a pass with lances, where they both missed, they removed the jousting reinforcing pieces from their armour and went at each other again with swords. It now went tragically wrong; as they collided the Bastard's horse went down, apparently killed when it hit its head on Scales's saddle.

The feat-of-arms continued the following day, beginning with the grand entrance of the participants and their noble supporters, then, when they were prepared, the combat commenced on foot with axes. Once again the fight was brief, for after just a few 'thik strokes', Scales caught his opponent on the side of the visor of his bascinet and the king, seeing 'the cruell assaile, cast his staff, and with high voice, cried, 'whoo!'.[9] The next few days saw further martial contests and sumptuous banqueting, but the Burgundians' visit to England was curtailed when news arrived of the death of Duke Philip of Burgundy, and they returned home.

Following the chivalric events at Smithfield, and the discussions that no doubt took place behind the scenes, it appears Edward had reached a decision. A French embassy at the end of June was virtually ignored by the king, who left it to Warwick to entertain them. Negotiations with Burgundy continued in earnest, and details of the complex terms of the agreement, which included defence, commerce, fishing, and many other issues, took a considerable time to agree, but eventually, on 3 July 1468, Margaret of York and Charles, Duke of Burgundy, were married.

The wedding, and the spectacular festivities surrounding it, reflected the full opulent splendour of the Burgundian court. After the wedding ceremony itself, the new duchess of Burgundy was escorted into Bruges by Lord Scales and many lords and ladies of England and Burgundy, where she was welcomed with magnificent processions, entertained with pageants, and presented with gifts as she made her way through the decorated streets of the city to

ABOVE Margaret of York's crown, preserved in the treasury of Aachen Cathedral. (PA Images / Alamy Stock Photo)

RIGHT The towering market hall in Bruges.

the ducal palace. The only thing that tried to spoil things was the weather; it rained all day, something we can certainly relate to today.

This began nine days of festivities, with banquets, pageants, plays and, most importantly, a great tournament – the Pas d'Armes de l'Arbre d'Or (Passage of Arms of the Golden Tree). Organised by Antoine, Count de La Roche, as a follow up to the Smithfield tournament, the following eight days would witness great displays of martial skill and chivalry, intertwined in a theatrical story that included giants, dwarves and other characters of medieval romance.

A golden tree was erected in the market place in Bruges, and each challenging knight would have his coat of arms added to the tree when he took part. The entry of each of the challengers into the lists provided an opportunity for them to display their magnificence and wealth, and they paraded in front of the assembled spectators with their many richly caparisoned horses and retainers, some adding further touches of theatre to the spectacle. The Count de La Roche had undertaken to defend the Golden Tree, and his first entry into the lists was within a yellow pavilion embroidered with golden trees, borne in by pages dressed in gold and then opened to allow him to emerge in all his glory, fully armoured and mounted. John Paston the younger was overawed at the riches of the Burgundian court: 'and they that have jostyd with hym into thys day, have ben as rychely beseyn [equipped], and hymselve also, as clothe of gold, and sylk and sylvyr, and goldsmyths werk, myght make hem; for of syche ger, and gold, and perle, and stanys, they of the Dwkys [duke's] coort, neythyr gentylmen nor gentylwomen, they want non; for with owt that they have it by wyshys, by my trowthe, I herd nevyr of so gret plente as ther is.'[10]

On the sixth day of jousting the challenger was Anthony Woodville, Lord Scales, but de La Roche handed over the role of defender to Adolf of Cleves, Lord Ravenstein, because he and Scales had 'mad[e] promyse at London that non of them bothe shold never dele with othyr in armys'.[11] This pairing proved to be one of the best of the tournament, with the two jousters breaking 28 lances against each other, but de La Roche painfully discovered that taking part might have been safer for him when he was kicked in the knee by a horse and badly injured as he watched proceedings.

Each day saw yet more drama and excitement, with some knights gaining great praise, and others whose experiences were memorable for the wrong reasons: after all the pomp and display of his arrival, the Marquis of Ferrara's horse flatly refused to run, and he suffered the embarrassment of having to retire without making a single pass against his opponent – a scenario that anyone who knows horses can surely recognise! Maybe the occasion got the better of their nerves.

On the final day the injured Count de La Roche returned in great style in a horse-litter, and from a special scaffold he watched the duke of Burgundy himself joust against Lord Ravenstein, after which the barriers were dismantled and the knights divided into two teams of 25 for the final mêlée. The initial massed lance charge was followed by sword combat, and as the swirling mêlée became too intense, the duke had to step in and separate the battling knights, taking off his helmet so he could be recognised. The final feast saw the prizes presented, that for the tournament being awarded to the duke, who refused it and, perhaps influenced by its political value, it was then presented to John Woodville, brother of the queen of England.

PAS D'ARMES DE L'ARBRE D'OR

Antoine, Count de La Roche, spurs his horse forward, releasing its pent up energy into spectacular action as he launches himself down the lists towards his opponent. He had undertaken to defend the golden tree (L'Arbre d'Or) against a succession of challengers for eight days, the highlight of the lavish celebrations held in Bruges to mark the marriage of Charles the Bold, Duke of Burgundy, to Margaret of York, sister of Edward IV.

Oil on canvas, 30" x 40" (76cm x 102cm), 2004.

CHAPTER 12
THE OVERMIGHTY SUBJECT

'they have but two rulers, Monsieur de Warwick and another, whose
name I have forgotten'

Jean de Waurin, Anchiennes Cronicques d'Engleterre

That was the opinion of the writer of a report to King Louis of France in 1464, a view that may well have been shared by the mighty earl of Warwick himself. Considering himself to be the man to whom Edward IV owed his throne, Richard Neville, Earl of Warwick, didn't take it at all well when his protégé started to exercise power without him, married without consulting him, and surrounded himself with men he considered well below him. He had seen his loss of control over King Edward very publicly demonstrated by the treaty with Burgundy in preference to the alternative Warwick had been negotiating with France, but after initially retiring to his Yorkshire estates he managed to mask some of his hurt feelings to be part of the noble party who escorted Margaret of York from London to the coast on her journey to Burgundy for her marriage. He also continued to receive further generous rewards from the king, but his pride and insatiable ambition demanded more.

He found a suitably malleable ally in the king's brother, George, Duke of Clarence. Despite the riches and privilege Edward's accession to the throne had provided him with, the ambitious Clarence wasn't satisfied, and Warwick was able to convince him that he deserved – and could achieve – more. When Warwick's proposal that Clarence should marry his daughter Isabel was not permitted by the king, Clarence seemingly took little persuading to join Warwick's scheming against his brother.

Hints of Warwick's involvement in treasonable plotting began in the autumn of 1467, when a messenger, travelling between Queen Margaret and those who still held Harlech Castle for her and King Henry, was intercepted and named Warwick under interrogation. After refusing the king's summons to explain himself, Warwick did eventually return to the fold, but continued to become more openly hostile to the Woodvilles and others he considered to be undeservedly in Edward's particular favour.

Built by Edward I following his 1282 campaign to conquer Wales, Harlech Castle's strong position on a rocky crag overlooking the sea allowed it to hold out against Yorkist rule long after other fortresses had fallen. (Getty Images)

Unrest began to increase across the country, and Harlech Castle continued to be a thorn. Lord Herbert was despatched to put an end to Jasper Tudor's continued defiance in Wales, but Tudor managed to burn the town of Denbigh before Herbert finally defeated him and forced him to flee to Brittany. This, and a disappointingly small amount of aid from King Louis, prompted the demoralised Harlech defenders to finally surrender on 14 August 1468.

The final Lancastrian fortress had fallen, but reports and rumours of possible Lancastrian conspiracies led to a wave of arrests and several high-profile executions in the latter part of 1468, indicating how nervous Edward's government had become. The initial optimism that Edward's reign would bring about significant improvements had been replaced by a measure of disillusionment, and Warwick would

'Alle so that yere the Lorde Herberd of Walys gate the castelle of Hardelowe [Harlech] in Walys; that castylle ys so stronge that men sayde that hyt was inpossybylle unto any man to gete hyt'

Gregory's Chronicle

OPPOSITE
KEEPING THE LANCASTRIAN FLAME BURNING

Jasper Tudor – 'the olde Lorde Jesper and sum tyme Erle of Pembrok' – leaves Denbigh in flames during his brief return to Wales during the summer of 1468. He would narrowly avoid capture by William Herbert's army, going into hiding before sailing back to his exile in Brittany.

Gouache, 12.6" x 12.5" (32cm x 40cm), 2022.

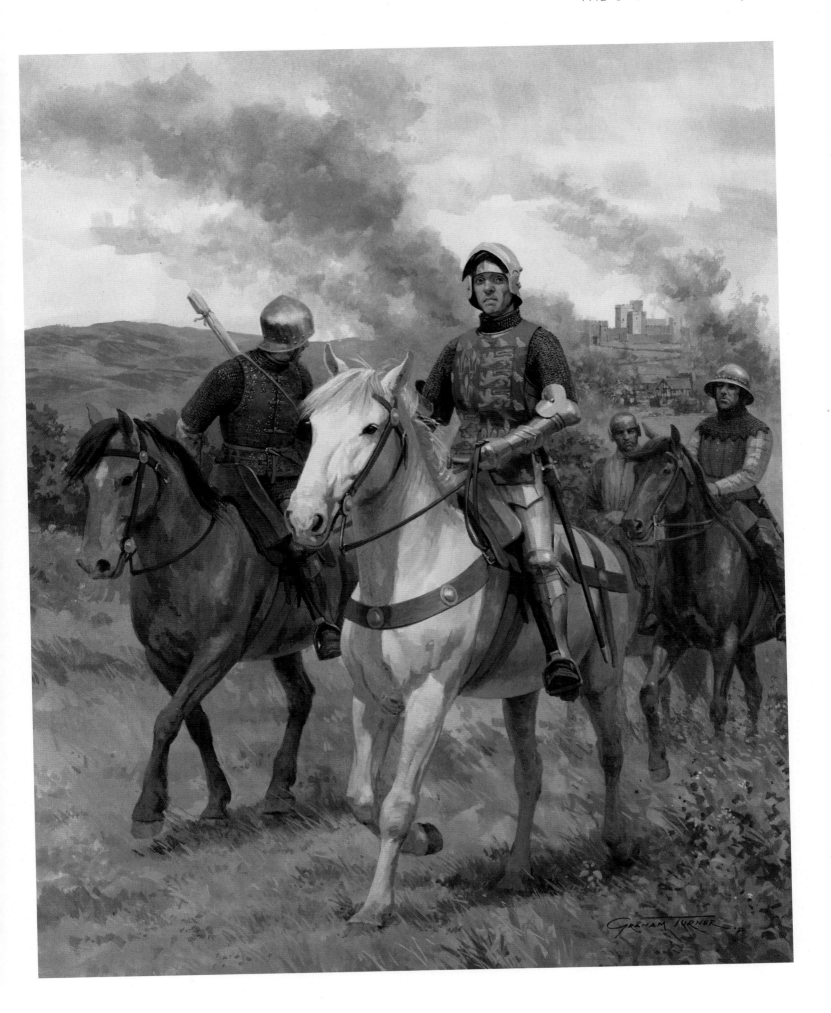

'And when the Erle of Warwyke come home and herde hereof [of Edward's marriage], thenne was he gretely displesyd withe the Kyng; and after that rose grete discencyone evere more and more betwene the Kyng and hym…

After that the Erie of Warwyke toke to hyme in fee as many knyghtys, squycrs, and gentylmennc as he myght, to be stronge…
but thei nevere loffyd [loved] togedere aftere.'
Warkworth's Chronicle

skilfully manipulate this dissatisfaction to begin two years of turmoil that would see Fortune's wheel spin and reverse many times as every conceivable twist and unbelievable turn of fortune played out between the middle of 1469 and May 1471.

In April 1469 trouble flared up in Yorkshire and two rebellions are recorded, led by Robin of Redesdale and Robin of Holderness – both undoubtedly pseudonyms. John Neville, Earl of Northumberland, successfully suppressed the initial risings and executed 'Holderness' at the gates of York in April or May, but 'Redesdale' would later reappear as a much more serious threat. There has been much debate on who exactly this 'Robin of Redesdale' was, but among all the candidates suggested, either Sir John Conyers or his son Sir William seem most likely. They were both indentured retainers of the earl of Warwick, and Sir John was steward of Middleham Castle.

Content that John Neville had contained the trouble in the north, King Edward continued with business as usual, which included electing Charles, Duke of Burgundy, as a knight of the Order of the Garter at Windsor, returning the compliment the Burgundians had paid Edward when he had been nominated to their Order of the Golden Fleece the previous year. Warwick and Clarence were among those present. In June Edward went on a leisurely

pilgrimage in East Anglia with his brother Gloucester and various Woodville in-laws, including Rivers and Scales, but by mid-June he was clearly taking the uprising more seriously when he issued an order to the royal wardrobe for a thousand jackets in his murrey and blue livery colours 'with roses', banners, standards, 'and suche other stuffe for the felde as muste nede be had at this tyme'.[1]

Edward travelled north from Norwich to Fotheringhay, where he was joined by the earls of Norfolk and Suffolk, then together they continued through Grantham and Nottingham to arrive in Newark on 8 July. As he slowly moved towards the rebels he sent out increasingly urgent demands for more soldiers; his letter of 5 July to the city of Coventry asking for 100 archers was followed five days later by another demand that these men, 'with moe if ye godly may', be despatched immediately, 'without fayling,

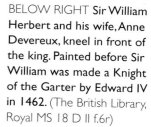

BELOW RIGHT Sir William Herbert and his wife, Anne Devereux, kneel in front of the king. Painted before Sir William was made a Knight of the Garter by Edward IV in 1462. (The British Library, Royal MS 18 D II f.6r)

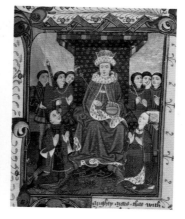

FAR LEFT Raglan Castle was begun by William ap Thomas (d.1445) in the first half of the 15th century, with the gatehouse being one of the additions made by his son, William Herbert, in the 1460s.

TOP LEFT Herbert's badge of the bascule, a drawbridge counterweight, carved into the wall of his castle at Raglan.

WILLIAM, LORD HERBERT

Closely based on the manuscript painting opposite. Sir William's armour is mostly covered by his heraldic tabard, but the legs suggest a European style, perhaps Milanese. Around his neck, William wears a livery collar bearing Edward IV's badges of suns and roses, with the lion of March suspended from it. Sir William's standard-bearer is inspired by a figure from a manuscript in the Bodleian Library (MS Bodl.421), wearing a brigandine over a mail shirt, armoured legs and riding boots, and a livery jacket that is heavily cut away at the sides. The standard bears Herbert's badge of the bascule – as can be seen carved into the wall at Raglan (opposite).

Gouache, 11" × 17" (29 × 43cm), 2022.

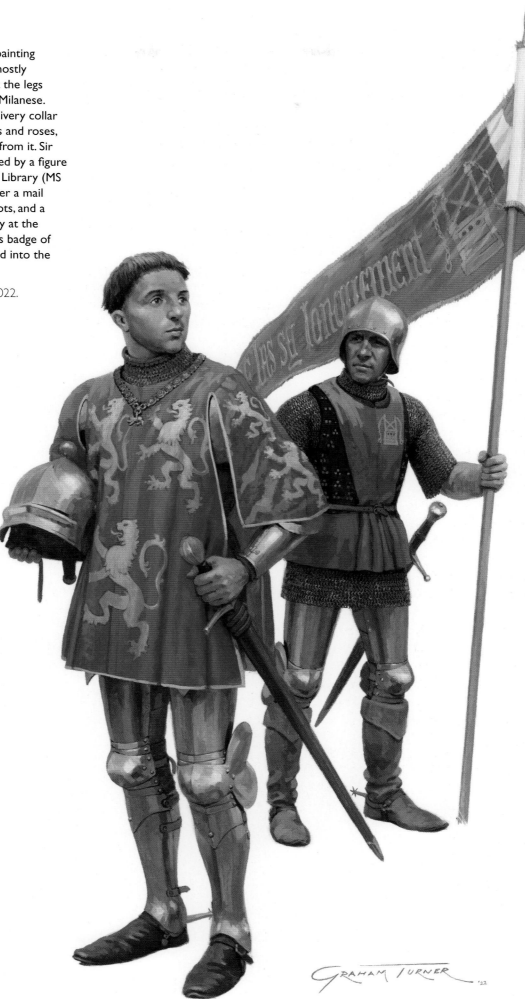

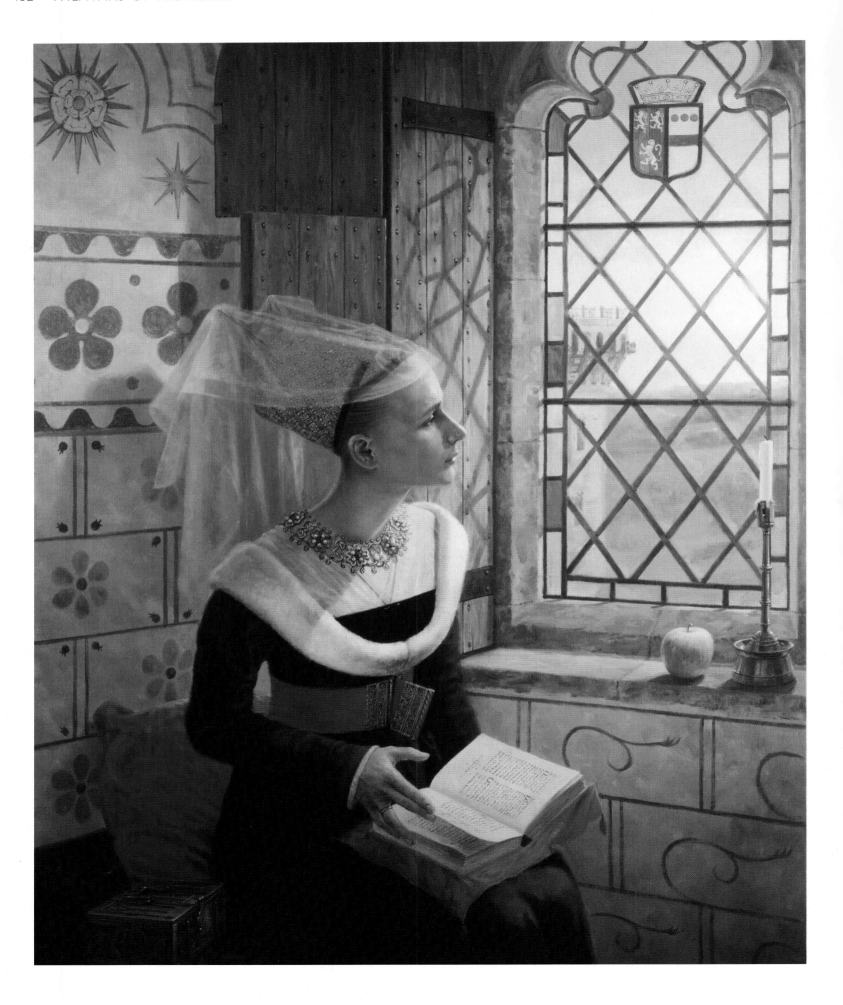

OPPOSITE
REVERIE

Sitting at the window of a great castle, a fashionably dressed lady looks up from her book, her mind lost in distant thoughts.

The view through the window identifies the setting as Raglan Castle, home of Sir William Herbert, Earl of Pembroke, and the heraldry in the window is that of Sir William and his wife, Anne Devereux. So perhaps this is Anne herself, awaiting news of her absent husband who has been urgently summoned to support King Edward IV in the summer of 1469.

Oil on canvas, 30" x 40" (76cm x 101cm), 1998.

While the shape of the hennin in 'Reverie' follows that shown in the manuscript painting on page 150, the intricate decorative detail is based on the tomb effigy of Elizabeth Fitzherbert (Marshall) at St Mary and Barlock's church, Norbury, Derbyshire.

alle expenses leyde a-parte, apon the faith & ligeance ye owe unto us'.[2] The following day the king returned to Nottingham having finally realised the scale of the threat, and sent the Woodvilles away to safety knowing that they had been singled out by the rebels for particular censure. With rumours growing that Warwick was involved in this treason, Edward wrote to him saying: 'To our Cosyn th'erl of Warr[wick]. Cosyn, we grete you well... And we ne [do not] trust that ye shulde be of any suech disposicion towards us, as the rumour here renneth, consederyng the trust and affeccion we bere in you.'[3]

He wrote similar letters to Clarence and Warwick's brother, George Neville, Archbishop of York, asking for reassurances of their loyalty, but by now the three of them had sailed to Calais, where the archbishop performed the wedding ceremony between Clarence and Isabel Neville on 11 July, in defiance of Edward's wishes. In the five years Edward and Queen Elizabeth had been married they had produced three daughters; until they had a son, Clarence, as the king's oldest brother, was heir to the throne. With this marriage Warwick was one step away from making his daughter queen of England.

Edward had urgently summoned William Herbert and Humphrey Stafford, Earl of Devon, to raise men in Wales and the West Country and come to his aid, and he waited in Nottingham for their arrival. William Herbert had cemented his position in Edward's life at Mortimer's Cross in 1461, his backing being crucial to Edward's victory there and his subsequent rise to the throne. Herbert's father, Sir William ap Thomas, had established himself as a man of standing in south Wales, becoming steward of the duke of York's estates in the region among other prestigious posts. He began the rebuilding of the castle at Raglan, which stands today as a memorial to his power and that of his son William, who raised the family to even greater heights. William was born

around 1429 and assumed the English-style surname Herbert. His early military career in France ended when he was taken prisoner at Formigny in 1450, after which it is assumed he was ransomed. In 1459 he married Anne Devereux, sister of Walter Devereux, Lord Ferrers, another staunch Yorkist adherent whose name is often linked with Herbert's. The pivotal moment in William's life came when he gambled everything to give his support to the young Edward, Earl of March, in his hour of need at Mortimer's Cross. He would be well rewarded; after Edward's coronation he was elevated to the peerage as Lord Herbert and granted considerable powers in Wales. A Knight of the Garter in 1462, he was made earl of Pembroke in 1468 after finally conquering Harlech Castle, replacing the previous earl, Jasper Tudor, with whom he had continuously struggled in Wales, and who would continue to fight on for the Lancastrian cause even after his exile. Herbert had been granted custody of Jasper's young nephew Henry Tudor after capturing him at Pembroke Castle in 1461.

Like Herbert, the ambitious Humphrey Stafford largely owed his position to King Edward. A distant relative of the earls of Stafford, later dukes of Buckingham, and the earls of Wiltshire, Humphrey held considerable lands in the West Country. His father had been killed during Cade's Rebellion in 1450, but Humphrey was persuaded to join the Yorkist cause, probably by Warwick in Calais in 1460. He fought alongside Edward and Herbert at Mortimer's Cross, was knighted by the new king after Towton, and quickly elevated to the peerage as Lord Stafford later the same year. He became Edward's trusted power in the south-west following the fall of the Courtenay family, and was granted their title of earl of Devon in May 1469.

Herbert and Stafford's rapid rise and closeness to the king did not sit well with many of the established nobility, and especially aroused the animosity and hatred of the earl of Warwick. Both were named (along with the Woodvilles) in the rebel's manifesto as amongst those who 'have caused oure seid sovereyn Lord and his seid realme to falle in grete poverte of miserie, disturbynge the mynystracion of the lawes, only entendyng to thaire owen promocion and enrichyng'.[4] The language was very similar to that used in the earlier petitions against Henry VI, and parallels were drawn with the loss of his throne and those of earlier deposed kings Edward II and Richard II.

Warwick and Clarence returned to England after the wedding, landing at Sandwich and, having

previously called for their supporters to meet them at Canterbury on 16 July 'with as many persones defensabyly arrayed as y can make', entered London on 20 July.[5] They were well received by the people of Kent, Warwick still enjoying popular support, but the authorities in London were more circumspect, despite Warwick's assurances that they came to aid the king against the northern rebels. Their numbers quickly swelled, boosted by supporters in the south and from Warwick's estates in the Midlands. King Edward had previously issued commissions of array in response to Robin of Redesdale's uprising, and Warwick tried to take charge of some of these contingents too.

By now the northern host, in its efforts to link up with Warwick and Clarence, had bypassed Edward in Nottingham, and was on a collision course with the forces of Herbert and Stafford. Near to Northampton, units from both armies clashed and Herbert's bloodied force retreated towards Banbury. It was here that Herbert and Stafford supposedly had a falling out over lodgings: 'at a towne, there felle in a varyaunce for ther logynge, and so the Erle of Devenschyre departed from the Erle of Penbroke withe alle his menne.'[6] The Tudor writer Edward Hall embroiders this with a tale that the disagreement was 'for the love of a damosell that dwelled in the house'.[7] Whatever the reason, several chroniclers agree that Stafford departed, taking his men with him, and it also seems likely that this left Herbert without any archers.

On receiving news of the initial skirmish at Northampton, Edward wrote to Herbert promising reinforcements, but these would not materialise in time. Herbert established his position on a hilltop near the village of Edgcote overlooking a large flat area of land known as Danes Moor. As the rebels approached in the evening of 23 July, an advance party led by Sir Henry Neville (son of Lord Latimer and Warwick's cousin) engaged elements of the royal army and, perhaps overly keen to prove his prowess, Neville charged into his enemies and 'went so farre

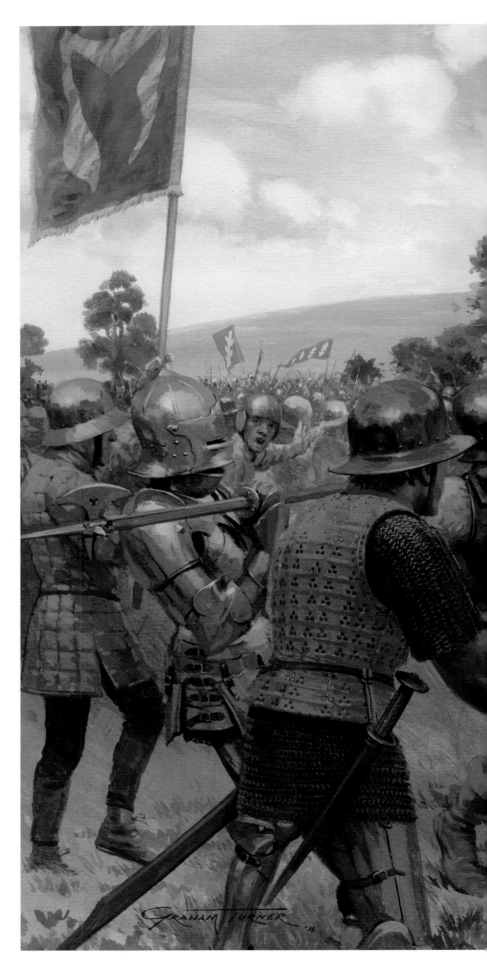

THE BATTLE OF EDGCOTE
24 July 1469

As Sir Richard Herbert cuts his way through the rebel army, his brother, the earl of Pembroke, nearby, banners bearing the earl of Warwick's badges are spotted advancing on the flank.

Gouache, 22.3" × 15.5" (57cm × 39cm), 2018.

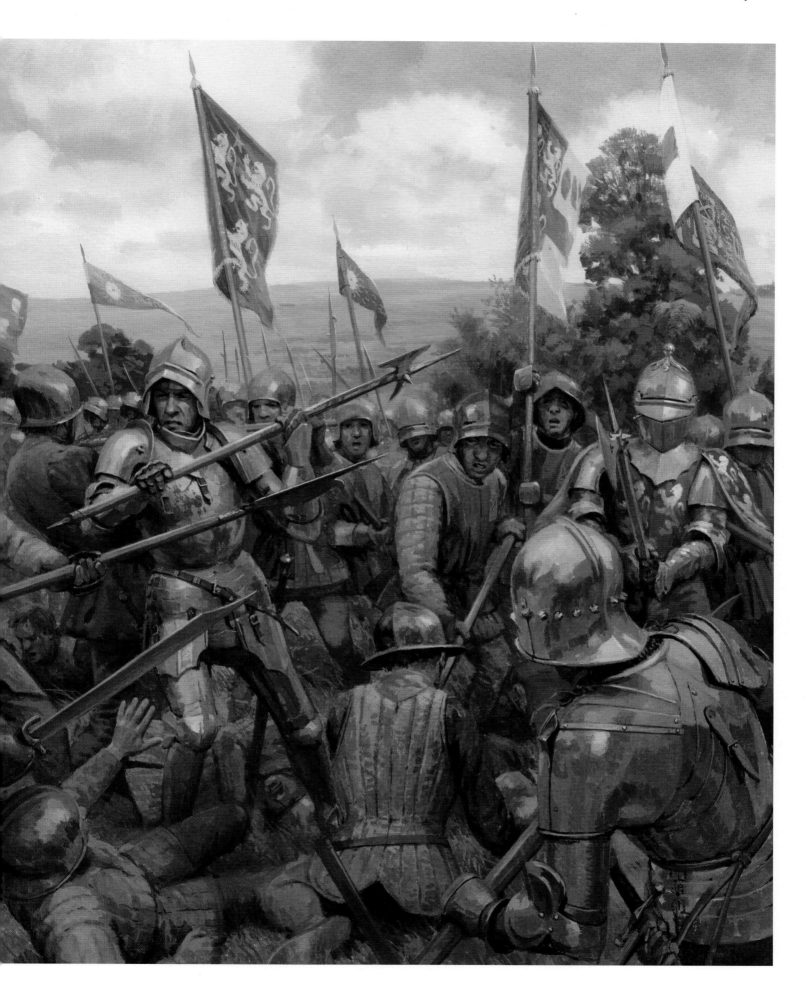

forward that he was taken and yielded'. He must have forgotten that the romantic laws of chivalry were a thing of the past, and that this was a civil war that had seen little mercy shown to the leaders of defeated enemies; unsurprisingly, given that he had just been hacking his way through their comrades, the Welshmen cut young Neville down and he was 'cruelly slain'.[8]

On the following day, 24 July 1469, the Battle of Edgcote began in earnest (for many years the battle has been said to have taken place on 26 July, but a recent reappraisal of the sources convincingly argues in favour of a revised timeline).[9] Pembroke was possibly provoked down from his strong position by rebel archers, and if the reports that suggest he had no archers of his own are correct, this would be the only way he could retaliate. Once on the flat ground of Danes Moor the rest of the rebel army engaged, bolstered by the arrival of two of Warwick's knights, Sir William Parr and Sir Geoffrey Gates, who presumably arrived with their retainers.

During the bloody fighting that followed, William Herbert's brother Sir Richard is recorded as distinguishing himself by cutting his way right through the enemy lines. 'Therle of penbroke behaved himself like a hardy knight, and expert capitain, but his brother sir Richarde Herbert so valiauntly acquitted himself, that with his polleaxe in his hand (as his enemies did afterward reporte) he twise by fine force passed through the battaill of his adversaries, and without any mortall wounde returned. If every one of his felowes and compaignions in armes, had doen but halfe thactes, whiche he that daie by his noble prowes achived, the Northremen had obtaeined neither savetie nor victory.'[10]

But as the battle looked to be going in favour of the Welshmen, more men appeared on the scene, bearing Warwick's badge on their banners, and crying 'a Warwycke, a Warwycke.'[11] Thinking that the earl had arrived with his mighty army, the morale of Herbert's men collapsed and they broke and fled. It would turn out that this force wasn't all it seemed, but was rather a servant of Warwick's, John Clapham

Esquire, with around 500 'rascals' from Northampton and surrounding villages he had rounded up to create a convincing ruse.

The fleeing Welshmen were shown no mercy 'for the cruelty they had shewed to the lord Latimers sonne',[12] and many were killed. William and Richard Herbert were among the captives taken to the earl of Warwick in Northampton, where they were beheaded in front of him. Possibly two other Herbert brothers were among the dead; with so much of Pembroke's army comprising Welshmen, the losses at Edgcote were deeply felt in Wales.

KINGMAKER'S CAPTIVE

Edward IV is escorted into the earl of Warwick's fortress at Middleham.

Pencil, 12" x 16.5"
(30cm x 42cm), 2021.

TOP RIGHT The tomb of Sir Richard Herbert, noted for 'hys goodely personage… and also for the noble Chivalry, that he had shewed in the felde the day of the battayl'; neither attribute saved him from losing his head after Edgcote. St Mary's Priory church, Abergavenny.

RIGHT The battlefield at Edgcote.

FAR RIGHT The Neville fortress of Middleham Castle in Wensleydale, Yorkshire.

The Dance of Death! Yesterday we were despoiled…
On Thursday God took away
the earl of both regions of Gwent and all south Wales…
Raglan was a vineyard for the nation,
Woe to him who shall never see its wine again!…
I was killed, I and my nation too,
the moment that this earl was killed…[13]

Humphrey Stafford fared no better. Having escaped Edgcote, apparently before the main battle was fought, he was 'take at Bryggewatere by the comons ther in Somersettschyre, and ther ryghte behedede.'[14]

What happened to Edward IV's own army remains unclear. Perhaps 'those who had hitherto remained firm in their allegiance to him, now became greatly alarmed, and basely deserting him by thousands, clandestinely took to flight'.[15] It appears that Edward was travelling towards Coventry with a relatively small entourage, no doubt angry and seeking revenge, but perhaps more realistically intending to meet and negotiate with his brother and cousin, Clarence and Warwick, when a party of soldiers, commanded by George Neville, forced their way into his lodgings. Edward at first refused Archbishop Neville entry into his chamber saying he had retired for the night, but he eventually relented and was told in no uncertain terms 'Sire, get up!… You have to get up and come to my brother of Warwick, and no objection is possible'.[16]

Edward was escorted to Coventry, then on to Warwick Castle, and another piece of the earl of Warwick's coup fell into place. However, he was not finished with retribution; the records of Coventry note: 'On Aug. 12 in the same year Lord Rivers then Treasurer of England was beheaded at Gosford Green, and Lord John Woodville, his son, likewise; they had been taken at Chepstow.'[17]

Shortly after murdering Edward's father-in-law and brother-in-law, Warwick moved the king to his fortress at Middleham. With Edward secured, he then set about trying to rule in his name, but Edward was no compliant puppet and, with no authority, Warwick found it difficult to govern.

CHAPTER 13
GREAT TROUBLES

'great troubles in divers parts of this land'
Warwick to the chancellor, 4 September 1469

During this latest period of chaos there were those who saw the opportunity to do as they pleased. There was rioting and pillaging in London, while in East Anglia the duke of Norfolk decided to move his dispute with the Paston family over ownership of Caister Castle beyond the law courts and begin rather more direct action.

THE SIEGE OF CAISTER CASTLE

Sir John Fastolf was a major figure during the Hundred Years War, and in 1432, having made his fortune in France, he set about rebuilding the family seat at Caister, in Norfolk, into a grand, brick-built castle. As he grew older and more irascible the old warrior began to increasingly rely on the advice and friendship of his neighbour, local gentleman John Paston.

On his deathbed at Caister in 1459, Fastolf supposedly dictated a new will leaving Caister and his estate to his 'best frende and helper and supporter', John Paston;[1] the dispute over the truth and legality of this bequest would lead to a long running and bitter legal battle, which would ultimately explode into direct military action over the coveted property ten years later.

The Pastons have left us a unique record of their lives thanks to the survival of their correspondence, providing a window into the trials and tribulations of this upwardly mobile Norfolk family as they navigated their way through the tricky waters of the Wars of the Roses. Their letters pass on news of local and national events, vividly convey their fears, worries and emotions during times of crisis, and also include touching requests for everyday items; 'as hertly as I can, I thank yow for the hatt, whyche is comyng'.[2]

The Pastons had experienced trouble over disputed property ownership before. The manor of Gresham had been bought in 1427 by John Paston's father but, after his death in 1444, ownership was claimed by Lord Moleyns through an old inheritance, and in 1448 his men took by force the village and Gresham Castle, within which stood a manor house built by the Pastons. While John fought the case in the London courts, his wife Margaret, in her early twenties, and their two young sons bravely moved back into one of their other properties at Gresham to try to re-establish their rights. Margaret's letters to her husband describe the standoff; Moleyns's men inside the fortified manor cut holes in the walls 'on every quarter of the hwse to schote owte atte, bothe with bowys and with hand gunnys' and she asked him 'to gete som crosse bowis, and wyndacs [windlasses] to bynd [wind] them with, and quarrels [crossbow bolts]… I sopose ze xuld have seche thyngs of Ser Jon Fastolf, if ze wold send to hym; and also I wold ze xuld gete ij. or iij. schort pelleaxis [poleaxes] to keep with doris [indoors], and als many jakkys [jacks], and ye may.' Revealing her practical

ABOVE **All Saints church, Gresham.** (Paston Footprints)

ABOVE LEFT **Site of the Paston's Norwich home on Elm Hill.**

LEFT **The church at Hellesdon. Among the items stolen from the church in 1465 was 'a coler of sylver of the Kyngs lyvery.'** (George Knee)

and unflustered nature, Margaret finished the letter with another request to; 'bye for me j. li [1 pound] of almands and j. li. of sugyr, and that ze wille byen sume frees [cloth] to maken of zour child is gwnys [gowns]'.[3]

Margaret Paston was finally forced out of Gresham on 28 January 1449 after a powerful force attacked them there. John told how Moleyns's men had 'myned down the walle of the chambre wher in the wiff [wife] of your seid besecher was, and bare here oute at the gates, and cutte a sondre the postes of the howses and lete them falle, and broke up all the chambres and coferes within the seid mansion, and rifelyd, and in maner of robery bare awey all the stuffe, aray, and money that your seyd besecher and his servauntes had ther'.[4]

As the legal fight over Gresham continued, and the local tenants continued to be harassed by Moleyns's men, Margaret's letters allow us to glimpse her completely understandable fears; 'for be my trowth I kan not ben wel att ese in my hert'.[5] Threatened with kidnap, her courage finally gave out and she left for Norwich.

Moleyns had enjoyed the backing of the duke of Suffolk, the mightiest magnate in the area at the time, but Moleyns's position was weakened when Suffolk was murdered in 1450 and, after yet more tribulations, the Pastons were finally able to recover Gresham in 1451. However, 'the maner is so decayed by the Lord Moleyns occupacion' that they could not live there, and it was never rebuilt.[6]

Protecting their interests was a continuous struggle for the Pastons, and their letters tell of the constant battles through the courts between themselves and their neighbours, the great lords of the region the dukes of Norfolk and Suffolk, and the earl of Oxford, and their assorted violent, intimidating servants. These times of trouble would ebb and flow – and be influenced by the wider politics that gripped the nation – but the letters also tell of peaceful interludes, when they could focus on the more pleasant aspects of life. John and Margaret had two sons, both confusingly also called John, who are now often referred to as John II (Sir John after he was knighted) and John III. When love blossomed between John III and Margery Brews in 1477, among the letters discussing the suitability of the match and business-like negotiations for their marriage – 'the mater betwyx my fader and yowe' – are touching comments showing their affection for each other, in one Margery addressing John as 'right wurschypfull and welebelovyd Volentyne'.[7]

After their wedding she wrote to him in London, thanking him 'for the tokyn that ye sent me', going on to say 'ye have lefte me sweche a rememraunse, that makyth me to thynke uppe on yow bothe day and nyth wanne I wold sclepe.'[8]

Their lives would enter a new period of turmoil following Sir John Fastolf's death in 1459 and John's subsequent claim to be his heir. Initial counter-claims by Fastolf's servants and other interested parties soon escalated. Having the backing of an influential lord was often the only way to achieve a successful outcome in the courts, regardless of the rights and wrongs of a case, and John was advised by his brother to make himself 'strong by lord chep [lordship], and by oder menes'.[9] However, the great magnates had their eyes on Fastolf's properties for themselves; the duke of Norfolk had previously tried to persuade Fastolf to sell Caister to him, and after the Battle of Towton, where he had played a significant part, Norfolk sent men to occupy the castle. The attacks also came from the new duke of Suffolk and his formidable mother Alice Chaucer, the dowager duchess. While the old duke had been a central figure in Henry VI's government, his 18-year-old successor, John de la Pole, had successfully distanced himself from his father's disgrace and downfall and placed himself in the centre of Edward IV's new regime by virtue of his marriage to the king's sister, and by fighting for him at St Albans and Towton. The Suffolks lost no time in seizing the manor of Dedham from the Pastons, and looked likely to threaten several other properties.

When the duke of Norfolk died in November 1461, leaving a 17-year-old heir, the pressure on Caister was temporarily relieved, but challenges to John Paston's claim to the Fastolf inheritance continued. In 1465 the duke of Suffolk renewed his claim on the Pastons' property at Hellesden, just outside Norwich, and on 8 July a large party of his men were seen off by Margaret and her son John II with their own company 'and gonnes, and suche ordynauns, so that if they had satte [set] uppon us, they had be distroyed'.[10] His tangled affairs had now landed John Paston Senior in the Fleet prison in London, and as he languished there his wife and sons did their best to fight off the threats that mounted up against them. On 15 October Hellesden was subjected to a concerted attack by Suffolk; 'The Duck ys [duke's] men rensackyd the church, and bare a way all the gode [goods] that was lefte ther, both of ours and of the tenaunts, and lefte not so

'The Duck ys [duke's] men rensackyd the church, and bare a way all the gode [goods] that was lefte ther, both of ours and of the tenaunts'

Margaret Paston to John Paston, 27 October 1465

Roof boss in Norwich Cathedral depicting the fourth horseman of the apocalypse – death. Death was ever present, and not just from war. The plague – the Black Death – that had devastated Europe in the 1340s continued to flare up sporadically. In 1454 a Paston letter tells of 'gret pestelens', and a decade later Margaret Paston fled Norwich because 'the pestylens ys so fervent' there. Another correspondent tells of 'a child ded… and on other lik to be ded in the same place'. In 1471 Sir John asked 'I praye yow sende me worde iff any off owr ffrendys or wellwyllers be dede, ffor I feer that ther is grete dethe in Norwyche', adding that he doubted 'that any Borow town in Ingelonde is ffree ffrom that sykenesse; God sease it whan it pleasyt Hym.' Margaret wrote of the same outbreak; 'we lewyn [live] in fe[a]r'. 1479 saw a particularly virulent outbreak, John III writing 'The pepyll dyeth sore in Norwyche, and specyally abought my house… and ben syke nye in every house of the towne.' From London Sir John wrote to their mother Margaret; 'wheroff the ffyrst iiij. dayes I was in suche ffeer off the syknesse, and also ffownde my chambr and stuffe nott so clene as I demyd, whyche troblyd me soor'. He died a few days later, not long after his young brother Walter and grandmother Agnes.

In this letter written in December 1462, John Paston III is signed John Paston the younger. (The British Library, Add MS 43489 f.20v)

moch but that they stode upon the hey awter [high alter], and ransackyd the images, and toke a way such as they myght fynd, and put a way the parson owte of the church till they had don, and ransackyd every mans hous in the towne v. or vj. tymys… they made youre tenauntys of Haylesdon and Drayton, with other, to help to breke down the wallys of the place and the logge both.' Margaret took refuge at Caister, protected by its garrison of 30 men 'for savacyon [salvation] of us and the place'.[11]

The strain took its toll, and on 22 May 1466, John Paston died suddenly in London; he was just 44 years old. Having consumed their father, the struggle to defend the family's fortunes now fell to his two sons. Having initially found it hard to be noticed at court, and, like many teenagers, experienced a falling out with his parents, John II started to find his feet after his father's death. He had been knighted in 1463 and spent much of his time in London, endeavouring to live the life of a courtier. In 1467 he wrote to his younger brother about a tournament at the king's palace at Eltham he had participated in; 'I would that you had been there and seen it, for it was the goodliest sight that was sene in Inglande this forty years of so fewe men. There was upon the one side, within, the Kynge, my Lord Scalles, myself, and Sellenger, and without, my Lord Chamberlyn [William, Lord Hastings], Sir John Woodvyle, Sir Thomas Mountgomery, and John Aparr.'[12] John III was unimpressed and more concerned with practical matters at home; 'I had lever [rather] se yow onys in Caster Hall then to se as many Kyngs tornay as might be betwyx Eltam and London.'[13]

John III was also making connections and establishing his reputation. In 1462 he had travelled to Northumberland in the retinue of the young duke of Norfolk as part of the campaign against the fortresses that held out in Henry VI's name, and he was also with the duke in Wales over the winter of 1463/64 helping subdue the Lancastrian resistance there. Both brothers would attend the event of the decade – the marriage of Charles, Duke of Burgundy and Margaret of York – Sir John as part of Margaret's entourage and John III in the retinue of Elizabeth, Duchess of Norfolk. They were suitably impressed: 'And as for the Dwkys [duke's] coort, as of lords, ladys and gentylwomen, knyts, sqwyers, and gentylmen, I hert [heard] never of non lyek to it, save Kyng Artourys [Arthur's] cort', wrote John III.[14]

Any friendship that remained between the Pastons and the duke of Norfolk was soon forgotten. As Norfolk's men harassed the tenants around Caister, Sir John hired four professional soldiers to assist his brother with the defense of the castle. 'They be provyd men, and connyng in the werr [war], and in fetys of armys, and they kan wele schote bothe

RIGHT The tall round tower at Caister soars above the truncated walls that are all that now remain of Sir John Fastolf's magnificent home.

FAR RIGHT As the surviving inventories of 1462 and 1470 show, Caister was well equipped with artillery, the walls being furnished with many gun loops and the eastern end being low built in line with contemporary defensive design.

gonnys and crossebowes, and amende and strynge them, and devyse bolwerkys [bulwarks], or any thyngs that scholde be a strenkthe to the place; and they wol, as nede is, kepe wecche and warde. They be sadde and wel advysed men, savyng on of them, whyche is ballyd, and callyd Wylliam Peny, whyche is as goode a man as gothe on the erthe, savyng a lytyll he wol, as I understand, be a lytel copschotyn [cupshotten]' – in other words, he liked to drink.[15]

While John III looked after matters at Caister, Sir John continued to try to obtain support at court, with some success. Norfolk received a reprimand for his actions, and the king and queen both started to show some interest, as did the queen's brother Anthony, Lord Scales. The family were feeling quite optimistic when the royal party visited East Anglia on a pilgrimage to Bury St Edmunds and Walsingham in June 1469, but unfortunately little was achieved for the Pastons during the visit, and when the king headed north to suppress the rising of 'Robin of Redesdale', events of a much greater magnitude took over.

With King Edward now Warwick's captive, the duke of Norfolk lost no time in sending an army to besiege Caister, and it arrived and surrounded the castle on 21 August, less than a month after the Battle of Edgcote and Warwick's coup had thrown England's governance into chaos.

With its elegant tall tower, brick construction and high, stepped gables, Caister's design was clearly influenced by the castles Fastolf encountered in Europe, and the ruins that survive today only hint at what this impressive building must have looked like. Now an empty shell, the castle would have contained

extensive ranges of buildings around its central courtyard, with a second structure alongside, of which only the lower wall now remains, pierced with many loopholes. The principal rooms were well furnished and decorated; an inventory of the items inherited from Sir John Fastolf includes coin, plate, jewellery and tapestries, along with 'fetherbeddes', 'pillows stuffed with downe', 'koshyns of tapseri [tapestry]. In my Master Fastolffes chambre', 'carpettes', 'tabill clothes' and many other domestic items.[16]

Surrounded by a moat, the castle's defences also included gunloops built into the walls, and these weren't just for show – the castle's artillery had seen action against French raiders in 1458 when 'ye shotte many gonnes'.[17] The inventory of 1462 referred to above also lists an impressive array of guns, ranging from large calibre weapons down to 'vij [7] hande gonnes with other apparel [be]longyng to the seid gonnes', along with other items of armour and weapons, including eight suits of white (polished) armour 'of old facion', ten brigandines 'febill', nine 'jakkes of horn, febill' (jacks reinforced with pieces of horn), ten bascinets, 24 sallets, six gorgets, nine bills and assorted pieces of armour and weapons, two mail habergeons 'and a barell to store hem' and four 'gret crossbows' of steel, 'ij of baleyn, iiij of ew'.[18]

Within the walls, John III commanded a garrison of about 30, which included his friend 'Daub' – John Daubeney, the younger son of another local gentry family, who had been part of the Paston household for almost a decade and involved in the struggle at Hellesden. Also present were John Pamping, Margaret Paston's cousin

Osbert Berney, and the four professionals hired eight months earlier: John Chapman, who had been employed by the duke of Somerset, 'cupshotten' William Penny, who had served in the Calais garrison, Peryn Sale, and Robert Jackson. Among the others was a certain Thomas Stompys, who had no hands but who insisted he could shoot a crossbow. The garrison's defenders took their preparations seriously, breaking three powerful steel crossbows as they practised; John III wrote to his brother asking if he could find someone in London who could repair them. Another inventory taken after the siege lists a considerable arsenal of 20 guns and suggests where some of them were sited; 'ij [2] gret fowlers with vj [6] chambirs lying in the Inner gates'; 'a smalle serpentyne with iij chambirs lying in Penys Towre' (a breech-loading gun with three separate breeches or chambers, perhaps in a tower where William Penny commanded or lodged); 'a gret serpentyne with iij chambirs lying vpon a Carte'; 'a short potte gonne with ij chambirs lying in the Chapel'; 'a fowler with iij chambirs lying in the kechyn', etc.[19]

Three days after Norfolk's forces surrounded the castle 'was a cruel day with guns fired at the castle'.[20] While this demonstrated the seriousness of their purpose, the intention must have been to starve the garrison of food and supplies, rather than damage the castle itself. As John III and his companions struggled to survive in their isolated outpost, Sir John in London tried to find a solution, while also calming their mother in Norwich. On 12 September Margaret wrote to him saying 'your brother and his felesshep stand in grete joperte [jeopardy] at Cayster, and lakke vetayll [victuals]; and Dawbeney and Berney be dedde, and diverse other gretly hurt; and they fayll gunnepowder and arrowes, and the place

sore brokyn with gonnes of the toder parte [the other party]'.[21] With the tension evident in their correspondence, Sir John replied to his mother's frantic letter saying: 'Moodr, uppon Saterday last was, Dawbeney and Bernay wer on lyve [alive] and mery, and I suppose ther com no man owt of the place to yow syn [since] that tyme that cowde have asserteynyd to yow of ther dethys.'[22] With only limited information reaching them, neither was correct; John Daubeney had indeed been killed by a crossbow bolt, most likely on 9 September, and in the escalating violence, two of the attackers had also lost their lives: John Colman and Thomas Mylys, killed by gunfire.

On 26 September, terms of surrender were issued by the duke of Norfolk, with a reluctant offer of safe-conduct for John III and the garrison to 'depart and goo out of the seid maneur without delay… the seid fellasship havyng their lyves and goods, horsse and harneys [armour]… except gonnes, crossebows, and quarells…'.[23] John III wrote to his brother explaining the situation: 'We wer sor lak of vetayl [victuals], gonepowdyr, menys herts [men's hearts], lak of suerte of rescwe, drevyn therto to take apoyntment.' In his defeat he remembered to praise his men; 'I pray yow geve them ther thank, for by my trowthe they have as well deservyd it as eny men that ever bare lyve.'[24]

As the family struggled with their losses, financial and personal, John III looked at the possibility of employment in the Calais garrison, 'for I am put out of wagys in thys contre.'[25] In January 1470 he told his older brother that Caister was shut up; 'Ther is now but iij [3] men in it, and the bryggys alwey [bridge is always] drawyn.'[26]

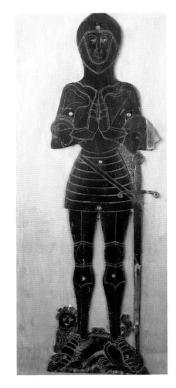

ABOVE **John Daubeney was buried at All Saints church in Sharrington, where he is commemorated with a brass of a man in armour. The style of armour dates this to around 30 years earlier, suggesting the brass was reused or purchased from old stock.** (Paston Footprints)

BELOW **The duke of Norfolk's letter, dated 26 September 1469, detailing the terms of the surrender of Caister Castle to him.** (The British Library, Add MS 43489 f.32r)

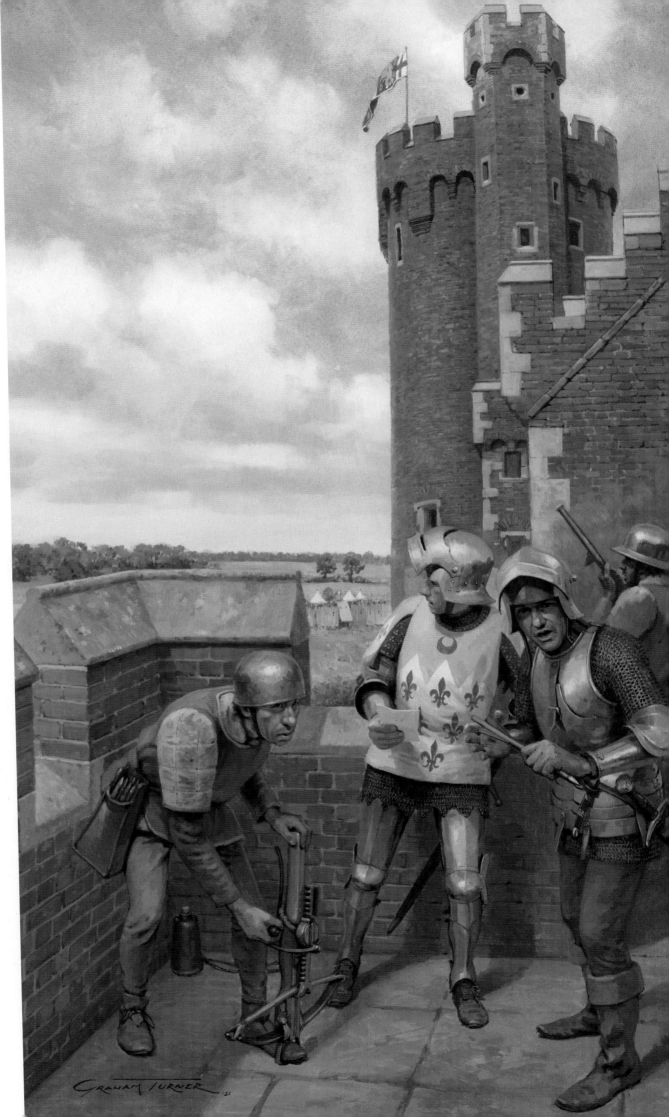

'your brother and his felesshep stand in grete joperte at Cayster, and lakke vetayll [victuals]; and Dawbeney and Berney be dedde, and diverse other gretly hurt; and they fayll gunnepowder and arrowes, and the place sore brokyn with gonnes of the toder parte'

Margaret Paston to Sir John Paston, 12 September 1469

THE SIEGE OF CAISTER CASTLE

John Paston III organises the defence of Caister Castle from the besieging forces of the duke of Norfolk during the summer of 1469. Alongside him the Pastons' long-standing friend and retainer John Daubeney – 'Daub' – retrieves a crossbow bolt that has sailed over the wall, and 'cupshotten' William Penny spans his crossbow.

Gouache, 12.2" × 20.5" (31cm × 52cm), 2021.

THE BATTLE OF NIBLEY GREEN

As Edward IV and the earl of Warwick fought for supremacy, the duke of Norfolk wasn't the only one to grasp the opportunity presented by the vacuum at the top of government to settle a private argument by violent means. In Lancashire there was trouble between the Stanleys and Harringtons, and in Yorkshire between Thomas, Lord Stanley, and Richard, Duke of Gloucester. The long-running inheritance dispute between William, Lord Berkeley, and the Talbot family, was another such disagreement to boil over into violence (not for the first time) when Thomas Talbot, Viscount Lisle, lost patience with the proceedings in the law courts and challenged Berkeley to combat. The two nobles and their armed retainers met early in the morning of 20 March 1470 at Nibley Green in Gloucestershire for what would be the last private battle fought on English soil.

Arriving at the village of North Nibley from the Talbots' house at nearby Wotton-under-Edge, Lisle advanced down Shankley Hill towards Berkeley's position on the edge of Michaelwood, only to be shot in the face with two arrows and killed. Local legend has it that one 'Black Will' was responsible for the fatal shot, but the lawsuit later brought by Lisle's widow would name John Beley, a farmer, and John Body, a painter, as the archers, with John Bendall finishing him off with a stab to the right side of his body. However, as it would have been very difficult to see who among a group of archers had shot particular arrows, there might well have been other factors that caused Margaret Talbot to name these particular individuals.

Although Lisle's death effectively decided the outcome of the battle, there were other fatalities, a John Lewis allegedly being cleaved through his forehead with a bill, along with two other wounds.

Despite its seemingly innocuous and charming name, Nibley Green was a nasty little battle, the result of two nobles allowing their dispute over an inheritance to become all-consuming, resulting in

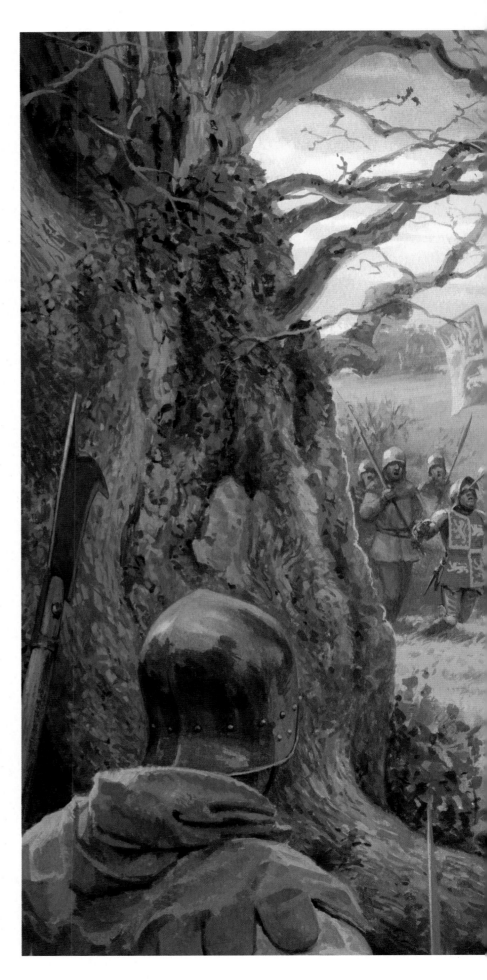

THE BATTLE OF NIBLEY GREEN

Viscount Lisle is killed as he advances down Shankley Hill towards Lord Berkeley and his men, positioned on the edge of Michaelwood.

Gouache, 19" x 12.75" (48cm x 32cm), 2020.

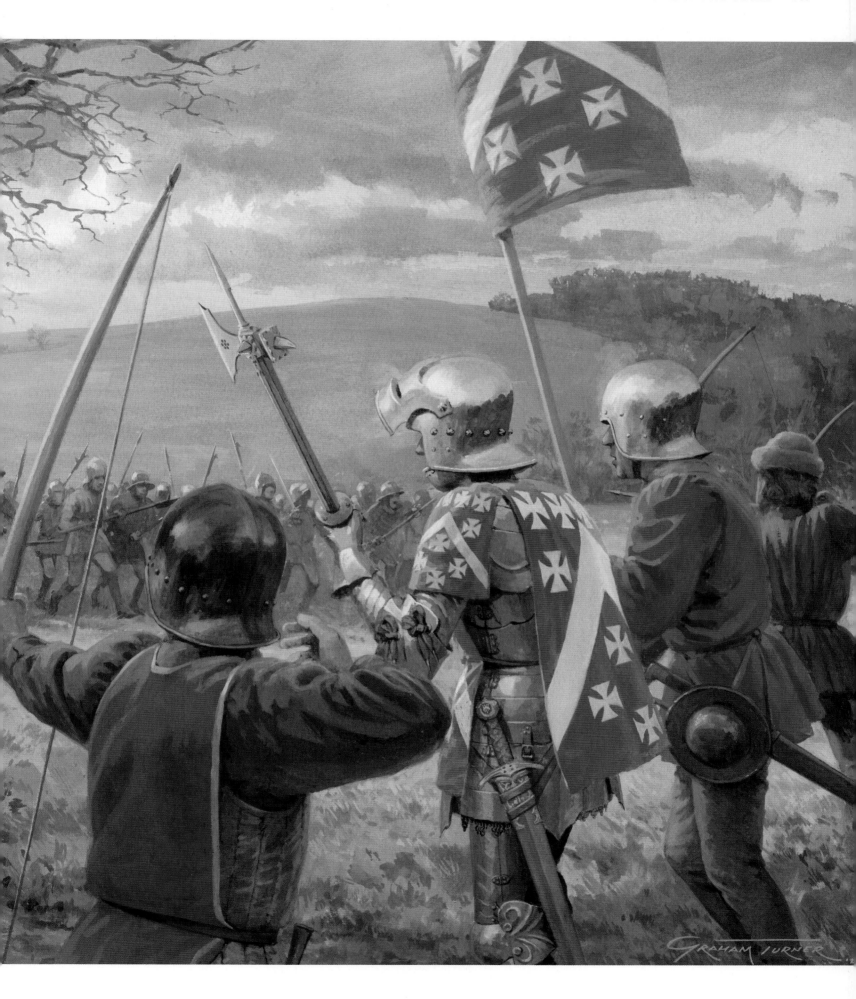

tragedy for the Talbots, not just through the death of Viscount Lisle – which it could be argued he brought upon himself – but in the aftermath his widow, Margaret (daughter of William Herbert), suffered a miscarriage shortly after the sacking of their house at Wotton by the victorious Berkeley.

Although the Battle of Nibley Green brought a temporary stop to hostilities between the two families, the inheritance dispute was far from over, and would drag on through various twists until finally being settled in 1609, 192 years after it began!

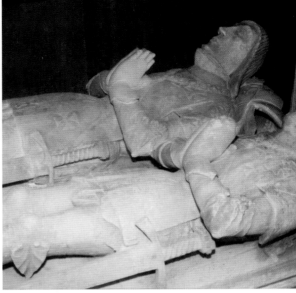

RIGHT The tomb effigies of James, Lord Berkeley (father of Sir William who fought at Nibley Green) and James' second son, also James, at Berkeley Castle. The younger James was killed fighting the French at Castillon in 1453, in the retinue of John Talbot, Earl of Shrewsbury, who was also killed alongside his son, Viscount Lisle. The Lisle title passed to his son Thomas, who would escalate the two intertwined families' antagonism and enmity until his young life ended at Nibley Green.

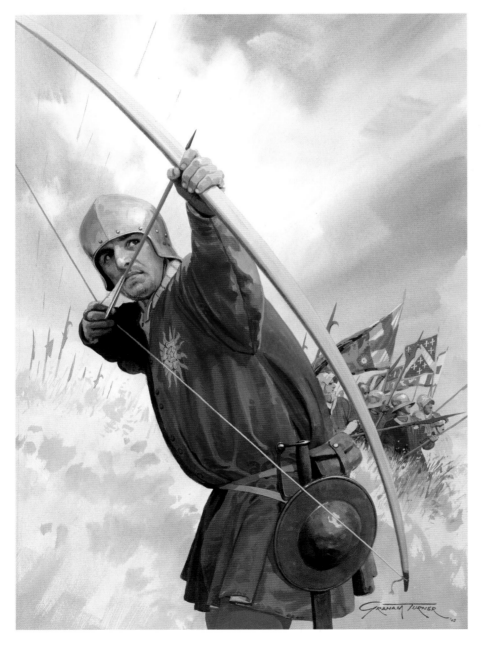

ABOVE This large solitary oak was once surrounded by many others before Michaelwood was reduced in size, so its younger self possibly witnessed the events of 1470. The tree in the painting is based on this remarkable survivor, repositioned to the edge of the wood.

LEFT
YORKIST ARCHER

Wearing the livery badge of Edward IV, an archer draws his powerful warbow. Archery was an integral part of English society, with legislation to encourage regular training; a statute of 1477 banned 'unlawful games, as dice, coits, tennis … but that every person strong and able of body should use his bow, because the defence of this land was much by archers'.

Gouache, 12" x 17" (30cm x43cm), 2002.

CHAPTER 14
RETURN OF THE KING

KING EDWARD'S RE-ENSTATEMENT AND THE BATTLE OF EMPINGHAM

'the Kyng hymselffe hathe good langage of the Lords of Clarance, of Warwyk, and of my Lords of York [George Neville, Archbishop of York] [and] of Oxenford, seyng they be hys best frendys; but hys howselde men have other langage, so that what schall hastely falle I cannot seye.'

Sir John Paston to Margaret Paston, October 1469

By recounting the troubles at Caister and Nibley Green, the impression might be given that some considerable time had passed since King Edward was imprisoned by the earl of Warwick after Edgcote. On the contrary, Warwick's attempts to rule in the name of his captive king were short-lived and unsuccessful. As 'great troubles in divers parts of this land' escalated,[1] he attempted to raise troops to quell another threatened northern uprising, but without the king's authority he found his calls largely ignored. Faced with his own impotence to deal with this looming collapse of law and order, Warwick's only realistic option was to release the king from his imprisonment in Middleham Castle, and King

RIGHT
SIR THOMAS BURGH

As he was one of Edward IV's knights of the body, the attack on Sir Thomas Burgh's property at Gainsborough was taken personally by the king, prompting him to take decisive action.

(Detail from the painting of the Battle of Barnet reproduced on pages 182–183.)

Edward IV appeared again in public in York sometime after 10 September. Troops were soon raised and the northern rising was easily crushed, its leaders meeting their grisly ends before the king in York at the end the month.

Joined by his brother Richard, Duke of Gloucester, and an impressive number of powerful nobles, Edward now travelled to London, arriving in full state in mid-October. Surprisingly, the king still leant towards forgiveness. While still embroiled in his own troubles over Caister Castle, Sir John Paston wrote; 'the Kyng hymselffe hathe good langage of the Lords of Clarance, of Warwyk, and of my Lords of York [George Neville, Archbishop of York] [and] of Oxenford, seyng they be hys best frendys; but hys howselde men have other langage, so that what schall hastely falle I cannot seye.'[2] Despite Edward's conciliatory words towards those who had rebelled and imprisoned him, and murdered his family and faithful friends, many observers clearly felt reconciliation appeared unlikely.

Initially excluded from court and positions of trust, the rebel lords were brought back from the brink, and at a meeting of the great council 'peace was made and the abandonment of all disagreements resolved upon.'[3] However, despite narrowly escaping the charge of treason and the gruesome death associated with it, Warwick couldn't help himself from continuing with his schemes. In March 1470 another personal feud would quickly escalate into a full-blown rising and provide him with the opportunity to attempt to overthrow Edward once again, only this time his plan would be to replace him on the throne with his brother Clarence.

The fight over Caister Castle was driven primarily by greed and, surprisingly, the two sides managed to

maintain an apparently cordial relationship after the dust had settled. What occurred in Lincolnshire in 1470 seems to have been much more personal, fuelled by another of the deadly sins – jealousy.

The Welles family were long-established in Lincolnshire, where they held lands and position. Along with many men of rank, Richard Welles, Lord Willoughby, naturally fought at Towton for King Henry VI, and his father, Lionel, Lord Welles, was killed there (see page 120). As they had fought on the losing side the Welles' lands and title were forfeited, but Sir Richard managed to regain his late father's properties by 1465 and inherited his title in 1467. While trying to re-establish his reputation with the new regime he fought for the Yorkists in the north, being with Lord Montagu at Hexham in 1464, although it is suggested that he wasn't totally trusted.

Having been part of the duke of Buckingham's household, Sir Thomas Burgh promptly committed himself to the Yorkists after the duke's death at the Battle of Northampton in 1460. He quickly rose to a position of great trust when he was appointed as an esquire to the king's body on 2 April 1461, immediately after Towton, and as such he would have personally waited on King Edward in his chamber. Later the same year he became steward of the king's holdings in Lincolnshire. He was knighted by 1463, then became master of the king's horse and a knight of the body by 1466, making him part of a privileged group around the king. In 1455 he had inherited the manor at Gainsborough in Lincolnshire from his mother, and in 1460 he was sheriff of the county. As he rose in the king's service he was granted extensive lands, including some confiscated from former Lancastrians in Lincolnshire, all of which greatly increased his position and standing in the county.

Burgh's rise into the king's favour had overshadowed his local Lincolnshire rivals and been at the expense of some of them whose lands he had been awarded. No doubt there was a gradual decline in relations between the two sides that went unrecorded, but it culminated in a violent and destructive attack on Burgh's manor house at Gainsborough by Lord Welles, his son Sir Robert Welles, and brothers-in-law Sir Thomas de la Launde and Sir Thomas Dymmock – they 'droff oute of Lyncolneshyre Sere Thomas a Burghe, a knyght of the Kynges howse, and pullede downe his place, and toke alle his goodes and cataylle that thei myghte fynde'.[4]

This attack on one of his intimates provoked the king into immediate action. He summoned Lord Welles and Dymmock to appear before him at Westminster to explain their actions, their understandable reluctance being soothed by an offer of pardon. On 4 March Edward sent out letters asking for troops to join him at Grantham on 12 March, then he quickly headed north, accompanied by the earl of Arundel, Lord Hastings, and other lords. As news of the king's approach preceded him, it was accompanied by widespread fears that he intended retribution against the people of Lincolnshire and Yorkshire for their part in Redesdale's rebellion the previous year. Emerging at the centre of the unrest, and stoking up these frightening rumours, was Sir Robert, son of Lord Welles; styling himself the 'grete capteyn of the comons of Linccolne shire', he issued notices summoning 'everye man to come to Ranby hawe upon the tuesday the vj. Day of Marche, upon payne of dethe… to resist the king', who was coming 'to destroie the comons of the same shire'.[5]

As Edward's growing army continued towards Lincolnshire, word reached him that additional forces were being raised against him in other counties, including Yorkshire, and planned to join the rebels at Stamford to create a vast army. Even now, he gave Clarence and Warwick the benefit of the doubt, and when Clarence wrote to say they'd be joining him he issued them with commissions to raise troops in his name.

While at Huntingdon King Edward had Lord Welles and Sir Thomas Dymmock 'examined' and their 'conspiracions' were admitted. Welles was instructed to 'sende to his sonne, commaunding him to leve hys felaship, and humbly submitte hym, or elles thay for theire seide treasons shulde have dethe, as they had deserved'.[6] The following day, now at Fotheringhay, news reached the king that the rebels had passed Grantham and that Warwick and Clarence were leading an army to rendezvous with them and trap him in a pincer movement. However, having received the letter threatening the life of his father, Sir Robert Welles hesitated at Empingham, near Stamford, where the royal army arrived to face them on 12 March.

With Sir Robert Welles 'armed with baniers displaied ayeinst hym, disposed to fight', King Edward was in no mood for mercy; 'wherfore his highnesse in the felde undre his banere displaied comaunded the said lorde Welles and sir Thomas

Gainsborough Old Hall survives today in the care of English Heritage. Investigations into the fabric of the building suggest that much of it pre-dates the attack, with only the west range being later – the chronicler's assertion that they 'pullede downe his place' is perhaps something of an exaggeration. (Julian Humphrys)

Dymmoke to be executed; and soo furthwith proceding ayeinst his saide rebelles, by the helpe of alle mighty God, acheved the victorie'.

In the brief fight before the rebel army collapsed and fled, they were heard shouting out the war cry 'A Clarence! A Clarence! A Warrewicke!', and a number in their ranks wore Clarence's livery. Even more damning evidence of Clarence and Warwick's 'most abhominable treason' was revealed in incriminating letters discovered on the body of one of Clarence's retainers, 'slayn in the chase'.[7]

The speed of Edward's victory was remarkable, but the idea that the losers threw off their coats as they fled, leading to it becoming known as the Battle of Losecoat Field, is most unlikely. The battle was fought in the parish of Empingham and the contemporary name for the battlefield was 'Hornfield in Empingham'. Losecoat more likely derives from the Old English 'hlose' and 'cot', literally meaning pigsty cottage![8]

After his decisive victory King Edward continued north and 'at Dancastre... ther was headed Sir Robert Wellys and a nothr great capteyn', Sir Thomas de la Launde having met the same fate in Grantham the previous day.[9]

Before his execution, Sir Robert Welles had been 'examyned', confessing his part in the uprising and confirming that Clarence and Warwick were 'partiners and chef provocars of all theire treasons.'[10] Having been told to disband their forces, the duke and earl ignored a summons to appear before the king and headed in the opposite direction, eventually making for the south-west. John Neville was commissioned to quash an attempted rising in Yorkshire, but the would-be rebels dispersed when news of Edward's victory reached them. It is notable that far from assisting Warwick, his brother actively demonstrated his allegiance to King Edward.

Further attempts were made to achieve the submission of Clarence and Warwick, but Edward now adopted a much stronger tone, his herald telling them that the king would 'entrete you according to your nyghenes of oure blood and oure lawez', but they would be punished if they did not stop 'that unlefull assemble of our people in peturbacion and contempe of our peas and commandement'. Demands for guaranteed safe passage and pardons were met with the angry reply that the king would treat them 'as a soveragne lord to use and entreate his subgettes...'[11]

A letter sent to Thomas Stonor asks him to join the king's host in pursuit of the 'Traitours and Rebelles... with such a fellasship on horssebak in defensible arraye as ye goodly can make, to come unto us wheresoever ye shal undrestande that we then shalbee.'[12]

Edward pursued his 'Traitours and Rebelles' down the length of the country, his growing army impressing commentators as they marched: 'wer never seyn in Inglond so many goodly men, and so well arreiyed in a feld.'[13] (Missing from these 'goodly men' were Lord Berkeley and Viscount Lisle, for they met in their own battle at Nibley Green on 20 March, the day the king left Doncaster.) However, when Edward's mighty force arrived at Exeter it was too late; Clarence and Warwick, with the countess of Warwick and her daughters, had sailed from Dartmouth for Warwick's old safe haven at Calais.

Warwick had first tried to take additional ships at Southampton, including his ship the *Trinity*, but Anthony Woodville (Earl Rivers since Warwick had ordered his father beheaded after Edgcote) was there, probably fitting out royal vessels, and he fought them off. Over 20 were captured and subsequently condemned as traitors by John Tiptoft, Earl of Worcester, after which they were 'hangede, drawne, and quartered, and hedede; and after that thei hanged uppe by the leggys, and a stake made scharpe at bothe endes, wherof one ende was putt in att bottokys, and the other ende ther heddes were putt uppe one'.[14] This particular twist on the usual gruesome traitor's death made the people 'gretely displesyd', and added to the earl's cruel reputation. The repercussions of his barbarous act would shortly catch up with him. The losses at Southampton were followed by further setbacks for the exiles when they approached Calais, for despite Warwick still holding the post of captain, they were turned away and forced to move out of gun range. The king had sent orders to the garrison that no assistance should be given to the traitors, and this time they decided it wise to heed the king's command. As they languished in their ships off Calais, tragedy struck the refugees; Isabel, Duchess of Clarence, went into labour with her first child, and although she survived the ordeal, the baby did not.

In the Channel Warwick was joined by his cousin, Thomas Neville, 'Bastard of Fauconberg' (an illegitimate son of William Neville, Lord Fauconberg), bringing several ships that had been serving the king. With their combined force they successfully attacked a large Burgundian merchant convoy on 20 April and although Earl Rivers and Lord Howard, commanding the remaining royal ships, managed to recapture some of these ships, Warwick and Clarence had an impressive fleet under their command when they anchored in the mouth of the Seine at the beginning of May, to seek the aid of King Louis XI of France.

'wherfore his highnesse in the felde undre his banere displaied comaunded the said lorde Welles and sir Thomas Dymmoke to be executed; and soo furthwith proceding ayeinst his saide rebelles, by the helpe of alle mighty God, acheved the victorie'.

Chronicle of the Rebellion in Lincolnshire

THE BATTLE OF EMPINGHAM

With his son Sir Robert Welles 'armed with baniers displaied ayeinst hym, disposed to fight', Lord Welles and Sir Robert Dymmock are ordered to be executed by King Edward.

Gouache, 19.3" x 13.3" (49cm x 34cm), 2022.

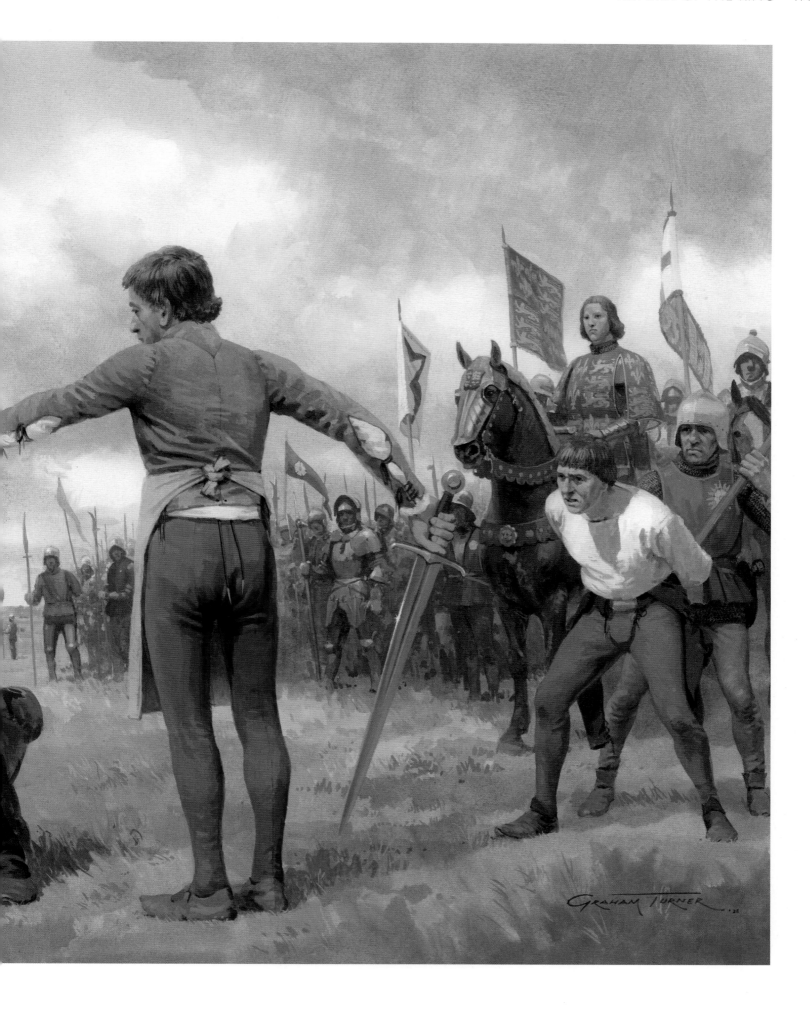

OUR SOVEREIGN LORD KING HARRY THE SIXTH

AN UNLIKELY ALLIANCE

Warwick's arrival off the French coast provided the ever-scheming King Louis with many enticing possibilities. The potential gains to be had by helping Warwick destroy King Edward and replace him on the English throne with a grateful ally, who would in turn support Louis in his efforts to bring Burgundy under his control, had to be weighed up against the risk of driving the Yorkists into a more active alliance with Burgundy and Brittany against France. Although he initially trod very carefully, it would prove a challenge that Louis couldn't resist.

Into his scheme Louis brought Queen Margaret, who had been living at her Anjou family home at St Michel in the duchy of Bar since fleeing from England in 1463 with her son, Prince Edward, now 16 years old. Although isolated from King Henry, who had been detained in the Tower of London since 1465, she had continued to hope and strive for an upturn in their fortunes, and now she was presented with an opportunity for the return to power she had wished for. However, first she had to reconcile herself to the previously unthinkable idea of making peace with her bitterest of enemies, the man who had fought to deprive her husband of his throne and her son of his inheritance – Richard Neville, Earl of Warwick. Warwick too had to do the unimaginable by overlooking years of enmity and the harm Margaret had caused to be inflicted on him and his family, including the deaths of his father and brother. It took all of Louis's skills to engineer an agreement, but eventually, after Warwick 'with great reverence... went on his knees and asked her pardon for the injuries and wrongs done to her in the past',[1] the queen, following 'many treat[i]es and metynges, pardoned th'Erle of Warwick'.[2] Against all the odds, Warwick pledged allegiance to King Henry VI and agreed to lead an invasion of England, supported by France, with the aim of restoring him to the throne. Central to the agreement was a marriage treaty between Prince Edward and Warwick's younger daughter Anne, and, after much delicate negotiating, the deal was finally agreed and the couple were betrothed on 25 July in Angers Cathedral.

Any ambitions for the throne that the duke of Clarence might have harboured had been discarded by the 'Kingmaker', for now Warwick had found another candidate who was already an anointed king, providing a legitimacy that his schemes with Clarence had so crucially lacked.

While Warwick prepared for his return from France, Edward's defensive arrangements centred primarily on his control of the Channel, with his fleet under Lord Howard supported by further ships commanded by Anthony Woodville, Earl Rivers, and the help of a large Burgundian fleet. Warwick had continued to make a conspicuous nuisance of himself from his foothold in France, attacking shipping and further inflaming Burgundy's relationship with France, which in turn applied additional pressure on Louis to agree to his demands. It was to retaliate against Warwick's piracy that prompted Duke Charles to assemble his powerful naval force, and on 2 July the combined Anglo-Burgundian fleet successfully raided Harfleur, destroying several ships before proceeding to blockade the Seine and harass the ports that sheltered Warwick's ships.

The invasion was delayed for several weeks by the blockading English and Burgundian fleet, but when these were scattered by a storm, Warwick's ships set sail early on 9 September 1470. Sailing with him and the duke of Clarence were Jasper Tudor, Earl of Pembroke, and John de Vere, Earl of Oxford, both of whom had also sought refuge in France, but absent, at Queen Margaret's insistence, was the eager-for-action Prince Edward, who would remain in France with his mother until England had been secured. As a seven year old, the prince had been encouraged to pronounce sentence on two unfortunate captives after the Second Battle of St Albans. A hint at how

ABOVE **Angers Cathedral, where the Lancastrian heir Prince Edward was betrothed to the earl of Warwick's daughter Anne.** (Getty Images)

his rather unconventional childhood might have twisted his personality comes from a correspondent in France in 1467, who tellingly remarked; 'This boy, though only thirteen years of age, already talks of nothing but cutting off heads or making war, as if he had everything in his hands or was the god of battle or the peaceful occupant of that throne.'[3]

WARWICK'S INVASION

Apart from the exceptionally brutal executions at Southampton, after Warwick's latest uprising Edward had generally followed his usual policy of reconciliation, and most of those who had transgressed received pardon.

Following his return to London in October 1469, King Edward had released Henry Percy from the Tower, having held him in custody since the death of his father, the earl of Northumberland, at Towton. The title had subsequently been granted to John Neville in recognition of his efforts to pacify the Lancastrian resistance in the north, but in early 1470, the king decided to restore Henry Percy to his birthright. As compensation for the loss of such a prestigious title, and the considerable lands that went with it, John Neville was given the theoretically higher rank of marquess, becoming known as Marquess Montagu, and he was awarded extensive estates in the south-west once belonging to the Courtenay earls of Devon. In addition, his son George was betrothed to the king's eldest daughter Elizabeth and given the title Duke of Bedford, but despite all this, Montagu felt snubbed, describing his new lands as a 'pyes [magpie's] neste to mayntene his astate withe'.[4]

In July Edward received reports of yet more unrest in the north; on 5 August Sir John Paston wrote to his brother: 'Ther be many ffolkes uppe in the northe, soo that Percy is not able to recyst them; and soo the Kynge hathe sente ffor hys ffeeodmen to koom to hym, for he woll goo to putt them downe.'[5] He also told him that people feared that Clarence and Warwick would land in England any day soon.

By then the king was on his way north to deal with the problem himself, arriving at York on 14 August to find the rebels dispersed. Despite anticipating the imminence of Warwick's invasion, he then allowed himself to delay, so he was still there when Warwick's force landed.

'the most nobylle and Crysten prynce, oure most dradde soverayne Lorde Kynge Hary the syxte, verrey true undoutyde Kynge of Englonde and of Fraunce, nowe beynge in the hondys of hys rebellys and gret enemy, Edwarde, late the Erl of Marche, usurpur, oppressour, and distroyer of oure seyde Soverayn Lorde, and of the nobylle blode of the reme of Englonde, and of the trewe commenes of the same, by hys myschevus and inordinate newe founden lawes and ordenaunces incoveniant...

the right hyghe and mighty Prynce George Duke [of] Clarens, Jasper Erl of Penbroke, Richarde Erl of Warewyke, and Johnne Erl of Oxenforde... [have come] into thys reme to... dylyver oure seyd Sopheraine Lord oute of hys grete captivite... and amende alle the grete myschevus oppressions, and alle odyr inordinate abusions, nowe raynynge in the seyde reme...

Also the sayde Duke and Erlys, in the name and behalfe of oure seyde soferaine Lorde Kynge Harry the syxt, chargyne and commawndyne that alle maner of men, that be betwen xvj. yeres and lx., incontinently and immediately aftyr thys proclamacion made, be redy, in ther best array defensabell, to attende and awayte upponne the sayde Duke and Erlys, to aschyst theme in ther jorney... upponne payne of dethe'*

Proclamation of Warwick and Clarence, September 1470

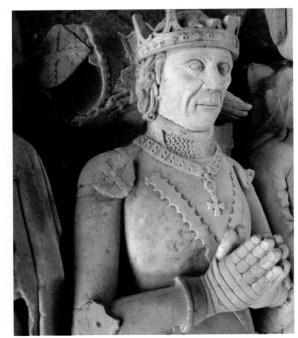

FAR LEFT House of Louis, Lord of Gruuthuse, in Bruges.

LEFT The magnificent Tiptoft tomb in Ely Cathedral is often attributed to John Tiptoft, Earl of Worcester, but the style of armour and Lancastrian collar of esses point towards this actually representing his father, also John, Lord Tiptoft, who was a Member of Parliament and of the Privy Council of Henry VI.

BELOW LEFT George, Duke of Clarence, and his wife, Isabel Neville, as depicted in the Rous Roll, c.1483. Over his wrist is draped a collar of suns and roses, and a black bull lies at his feet. (The British Library, Add MS 48976 f.7)

As Warwick's rapidly growing army headed north towards him, Edward left York, but paused to await the arrival of the soldiers that Montagu was gathering on his behalf. Henry Percy, who had replaced Montagu as the new earl of Northumberland, had proved unable to deal with the small uprising that had drawn Edward north, and the king's now disgruntled but previously dependable ally redirected his support to his brother Warwick. Rather than coming to his aid, John Neville, Marquess Montagu, was marching against him.

Woken with the shocking news that Montagu was very close and 'cummyng for to take him',[6] Edward had little choice but to run, and with a small group of retainers that included William, Lord Hastings, and his brother-in-law Anthony, Earl Rivers, they hurried east, narrowly avoiding drowning in the Wash, before taking ship from Lynn (now King's Lynn) on 2 October. The reversal of Edward's fortune couldn't be much more extreme; when they landed in the Low Countries after a perilous journey that had seen them closely pursued by Hanse ships, the penniless King Edward was forced to pay the ship master with his valuable fur-lined gown. Edward's brother Richard of Gloucester would join him in exile; whether they actually travelled together is unclear.

Word of their landing was immediately sent to Louis of Bruges, Lord of Gruuthuse, the governor of Holland, who welcomed Edward and his small party of exiles and escorted them to The Hague. Louis had been a famed jouster, going on to occupy a trusted

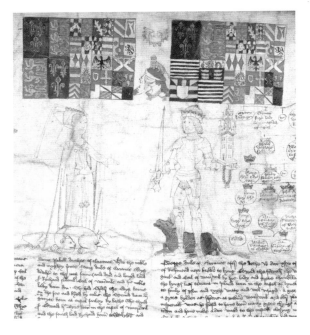

position in the duke of Burgundy's court. Knighted on the battlefield at Gavere in 1453, he became a knight of the Order of the Golden Fleece in 1461 and was involved in the organisation of the wedding of Charles, Duke of Burgundy, and Margaret of York. He was a patron of the arts and avid book collector. Having been an ambassador to England on several occasions, he knew the king personally, and he had recently been one of the commanders of the Burgundian fleet that had tried to halt Warwick's invasion. For the first two months of their exile, King Edward and his small group would be provided for by Louis, with just a small financial contribution from an initially reluctant Duke Charles.

HENRY VI'S READEPTION

Following Edward's flight, Warwick returned to a London in turmoil. His supporters in Kent had set upon the suburbs south of the river Thames, targeting the houses where 'duchmen dwellid' which they 'robbid and spoylid wythowth mercy'.[7] Prisoners were released and the rioting increased, forcing the authorities to close the city gates and deploy armed men to patrol the streets. Finding herself surrounded by this chaos and uncertainty, eight-month-pregnant Queen Elizabeth decided to leave the royal apartments in the Tower and seek sanctuary for herself, her mother, and her three young daughters at Westminster. King Henry was released from captivity and transferred to the richly appointed rooms which the queen had just vacated, and when Warwick rode into London on 6 October he immediately went to kneel before him, asking for forgiveness. A week later Warwick carried the king's train at the ceremony at St Paul's Cathedral to mark the resumption of Henry's reign. This final chapter of his confused life would become known as the Readeption, due to official documents from this period beginning with 'the 49th year of our reign and the first year of the re-adeption of our royal power' (*Anno regni Regis Henrici Sexti quadragesimo nono, et readempcionis sue regie potestatis primo*).[8]

Five years before, Warwick had escorted the captive Henry into London with his feet bound to the stirrups. Now he professed to once again be his loyal subject. The success the charismatic earl had enjoyed owed much to his considerable popular support, but the lords, both Yorkist and Lancastrian in sympathy, were understandably not so trusting. Lancastrians who had lost their lands and titles unsurprisingly expected them to be returned, but those who now held them, men like Warwick, Clarence and Montagu, weren't so keen to relinquish them. A few prominent Yorkists were arrested but soon released, with one notable exception: John

Tiptoft, Earl of Worcester, who, as constable of England, had earned notoriety and public hatred for the particularly barbaric additions he made to the already horrific penalty for treason. On the day of his execution the crowds clamouring to witness his death were so great that it had to be postponed until the following day, but on 18 October the 'Butcher of England' was successfully beheaded on Tower Hill.

Among the gentry, personal self-interest could have more of a bearing on their loyalties than national politics. With John de Vere, Earl of Oxford, supplanting the duke of Norfolk as the power in East Anglia, the Pastons lost little time in seeking his help in their continued efforts to recover Caister Castle. 'I tryst that we shall do ryght well in all owyr maters hastyly', John III wrote to their mother, 'and as for my Lord of Oxynforthe, he is bettyr Lord to me, by my trowthe, than I can wyshe'.[9] With Norfolk now more concerned with securing acceptance by the new regime, on 11 December 1470 he conceded Caister to the Pastons. After so much struggle things were at last looking up for the Paston family, but they would soon discover the flip side of their alliance with Oxford when their new patron called on the two brothers John to join him in arms, and they finally found themselves drawn into the larger conflict.

While Warwick tried to solve his numerous problems at home, an impatient King Louis now expected him to honour his side of their bargain and wage war on Burgundy as soon as possible. Orders were sent to Calais instructing the garrison to commence hostilities against the neighbouring Burgundian territories, but this move proved unpopular and additional attempts to raise men and funds for an overseas war met with resistance. Despite being married to King Edward's sister, Duke Charles's sympathies had remained predominately Lancastrian and he had provided shelter to the dukes

'the Bisshoppe of Wynchestere, be the assent of the Duke of Clarence and the Erle of Warwyke, went to the toure of Londone, where Kynge Herry was in presone by Kynge Edwardes commawndement, and there toke hyme from his kepers, whiche was not worschipfully arayed [dressed] as a prince, and not so clenly kepte as schuld seme suche a Prynce; thei hade hym oute, and newe arayed hym, and dyde to hyme grete reverens, and brought hyme to the palys of Westmynster, and so he was restorede to the crowne ageyne'

Warkworth's Chronicle

of Somerset and Exeter for several years, but in the face of growing Anglo-French aggression his attitude changed significantly and, having initially kept his distance from Edward and the Yorkist exiles, he finally agreed to give his support to their plans for a return to England.

Edward had been busy raising money and contacting potential supporters in England, including Henry Percy, who, despite his family's traditional support of Henry VI, feared he might once again lose his title to Montagu with Warwick in charge. He also wrote to his brother, the duke of Clarence, who now found himself held 'in great suspicion, despite, disdeigne, and hatered, with all the lordes, noblemen, and othar, that were adherents and full partakers with Henry, the Usurper, Margaret his wife, and his sonne Edward, called Prince.'[10] As a disappointed George saw his dreams were not turning out quite as he had hoped, Edward, with the assistance of their mother, Duchess Cecily, their sisters – especially Margaret, Duchess of Burgundy – and other family members, appealed to him to return to the family fold.

As the Yorkist invasion force began to assemble at Vlissingen (Flushing) and Earl Rivers negotiated to secure further vessels in Bruges, they were joined by two ships from England, captained by John Lyster and Stephen Dryver. Dryver had already served as a messenger for the exiles; he would now transport troops to England and fight in the coming campaign with five of his men 'at his owne charges and expenses'.[11] When Edward boarded his flagship *Antony* on 2 March, he commanded just 36 ships and around 1,200 men of mixed nationality, including 300 'blak and smoky sort of Gunners Flemyngys',[12] as they were described on their entry into London. After a lengthy nine-day delay the wind finally changed, and on 11 March the small force embarked on its perilous venture.

LEFT Garter stall plate of Sir Richard Tunstall, at St George's Chapel, Windsor.

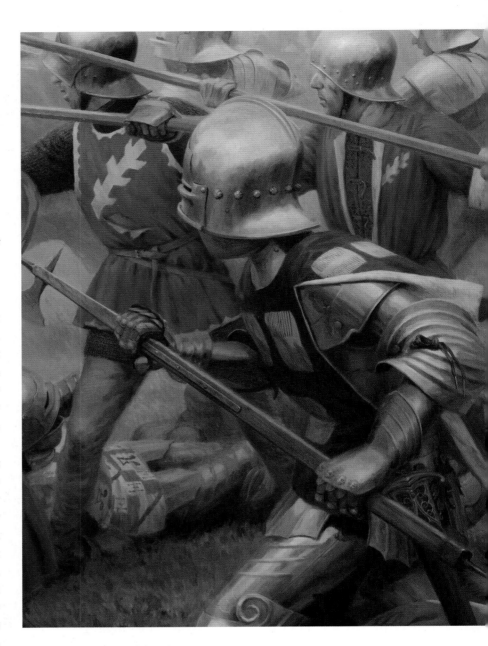

SIR RICHARD TUNSTALL

Sir Richard Tunstall was a staunch Lancastrian, who had fought at the battles of Wakefield, St Albans, Towton, Hedgeley Moor and Hexham, defended the Northumberland castles after Towton, and then participated in the long defence of Harlech, where he was finally captured and imprisoned in the Tower of London. When Warwick returned Henry VI to the throne in 1470/71, he was appointed to the prestigious role of chamberlain, before the wheel of fortune turned once more and he was attainted in the aftermath of Barnet. Once Lancastrian hopes were extinguished after the death of King Henry, Sir Richard did eventually make his peace with Edward IV and was pardoned by 1473, going on to serve both Edward IV and Richard III, becoming a Knight of the Garter, before probably going over to Henry Tudor at Bosworth.

(Detail from the painting of the Battle of Barnet reproduced on page 183.)

CHAPTER 16
RIGHTFUL INHERITANCE

Edward's small fleet made good time and arrived off the coast of Norfolk after just one day's sailing. They had successfully avoided their enemies, who had been otherwise engaged fighting Breton ships in the Channel, or waiting to escort Queen Margaret and Prince Edward to England. The plan had been to enlist the help of the dukes of Norfolk and Suffolk and other potential allies in East Anglia, but enquiries revealed that it was now Oxford who controlled the area, so, with it being unsafe to land, the fleet put to sea again and sailed north. Warwick had reacted to the threat of invasion by raising troops and restraining Norfolk and various other lords who he expected would support Edward – so far his preparations had proved effective.

That night and the following day 'great stormes, wynds and tempests' whipped up to batter the little ships, sinking one loaded with horses and scattering the rest of the fleet.[1] Emerging from this ordeal 'in great torment' on the afternoon of 14 March, Edward's *Antony* made landfall at the now lost port of Ravenspur on the Humber. When the storm finally abated the next morning, the duke of Gloucester and his company found themselves about four miles away, while Rivers was 14 miles from his king, but over the next day Edward's tired and bedraggled forces managed to reunite – 'from every landynge place the felowshipe came hoole towards hym.'[2]

Finding themselves in apparently hostile country and with limited options available, Edward decided to march towards York and adopted a rather disingenuous tactic. As he carefully made his way between large groups of armed men, he announced that he only wished to claim his father's inheritance of the duchy of York, and not the throne, ironically a ruse previously used by Henry of Bolingbroke after he had similarly landed at Ravenspur in 1399 to depose Richard II and become the first Lancastrian king, Henry IV. It apparently worked, for they passed Beverley and arrived at York unscathed. Edward's reputation as a warrior – his 'great curage and hardines' – plus the fact that he was surrounded by a small but elite group of soldiers no doubt also

helped dissuade would-be attackers. Some bribery of potential adversaries didn't do any harm either; 'certayne of theyre capitaines… were some whate enduced to be the more benivolent for money that the Kynge gave them.'[3]

Unsure of where York's loyalties lay, and warned that if he entered the city 'he was lost, and undone, and all his',[4] Edward left his army under the command of Gloucester and asked admittance for only himself and a small number of companions. Here he repeated his claim that he only sought the duchy of York, and one chronicler records that he even went so far with his act as to cry 'A Kyng Henry! A Kynge and Prynce Edward!'[5] and wear Prince Edward's livery of an ostrich feather. With Edward in such a precarious position, the earl of Northumberland could have destroyed his small force, yet chose to let them pass unmolested, doing 'the Kynge [Edward] right gode and notable service… For his sittynge still caused the citie of Yorke to do as they dyd, and no werse… and suffre the Kynge to passe as he dyd…'.[6] Restoring Henry Percy to the earldom of Northumberland the previous year had turned out to be a wise investment.

The next morning, they continued south, passing through Tadcaster, not far from the scene of the slaughter at Towton ten years before, and then on to another poignant location, Wakefield, where Edward and Richard's father and brother had perished back in 1460. All the while Edward's small army was in danger of attack by Marquess Montagu in Pontefract, but for reasons only known to himself, Montagu, like Northumberland, remained inactive: 'the Marqwes Montagwe that in no wyse trowbled hym, ne none of his fellowshipe, but sufferyd hym to passe in peasceable wyse, were it with good will, or noo, men may juge at theyr pleaswre.'[7] He was undoubtedly influenced by Percy's stance and the growing strength of Edward's army, but perhaps he also still found himself torn between his conflicting loyalties to his king and his brother, Warwick. John Neville comes across from the pages of history as a relatively straightforward and uncomplicated character, not cut out for the schemes and deceptions of his brother that would ultimately destroy them both.

'yonder man Edward, the kings oure soverain lord gret enemy rebelle and traitour' was 'commyng fast on southward accompanied by Flemynges, Esterlinges, and Danes'

Earl of Warwick to Henry Vernon, 25 March 1471

Warwick Castle, Richard Neville's centre of power in the Midlands.

It was only as Edward advanced further south that more significant numbers of men joined him, including a large contingent from Lord Hastings's estates. To meet this increasing danger, Warwick frantically tried to gather his supporters, writing to one that 'yonder man Edward, the kings oure soverain lord gret enemy rebelle and traitour' was 'commyng fast on southward accompanied by Flemynges, Esterlinges, and Danes'.[8] From Nottingham Edward heard that the duke of Exeter, now also returned from Burgundy, the earl of Oxford, and Viscount Beaumont were at Newark with 4,000 men, so he immediately marched towards them, prompting the Lancastrians to retire. Back on his route through Leicester, Edward's approach caused Warwick to withdraw his army within Coventry's walls and close the gates. Outside the city walls a now more confident Edward challenged the 'great Rebell, th'Erle of Warwicke' to 'come owte… to determyne his qwarell in playne fielde, which the same Earle refused to do at that tyme'.[9] He repeated the challenge to battle over the next three days, and Warwick steadfastly refused, probably because he was waiting for reinforcements from Montagu, now moving south, Clarence, advancing from the west, and Oxford's force that had been dispersed at Newark. Whatever his reasons, Warwick's refusal to fight at Coventry strengthened Edward at his expense.

Not wanting to linger any longer, Edward moved on to the town of Warwick, where he began to issue proclamations as king once again. Here he heard of the approach of his brother, the duke of Clarence, from the direction of Burford with more than 4,000 men, and Edward 'isswyd out of Warwicke, with all his felowshipe… into a fayre fylde towards Banbery.' Here he arrayed his army with banners displayed as if for battle; then, with only a few companions, including Gloucester, Rivers and Hastings, walked towards Clarence, who was approaching with just a small party, having likewise left his army behind him. 'And so they mett betwixt both hostes, where was right kynde and lovynge langwage betwixt them twoo' and 'hartyly lovynge chere and countenaunce, as might be betwixt two bretherne of so grete nobley and astate.'[10]

Following the reconciliation of the Yorkist brothers, the king renewed his challenges to Warwick to face him in battle, but Warwick steadfastly refused. Neither would he discuss terms of surrender, so, faced with the unrealistic option of besieging Coventry, on 5 April Edward chose to march to London. Warwick soon left Coventry and shadowed them as they passed through Daventry and Northampton – another battle-site of particular significance – and Dunstable, where King Edward sent 'comfortable' messages ahead to Queen Elizabeth in her sanctuary at Westminster. As they closed in, Edward and Warwick both wrote to their supporters and officials in the city, asking them for their support, their conflicting demands causing great consternation. The duke of Somerset, his brother the marquess of Dorset, and the earl of Devon had already departed to meet Queen Margaret, who was soon expected to land from France, and when news that Edward's army was at St Albans reached Warwick's most powerful ally in London – his brother, George Neville, Archbishop of York – the archbishop finally decided to submit, 'desyringe to be admittyd to his grace'.[11] Yorkists who had been detained in the Tower by Warwick now overpowered their guards, and the following day, 11 April, Edward marched unopposed through Bishopsgate at the head of his army.

Edward rode straight to St Paul's, and then on to the bishop's palace, where the archbishop of York presented himself and King Henry. The unfortunate Henry, clearly with no understanding of his predicament, shook Edward's hand and said, 'My

THE ARRIVALL

Edward IV enters London through Bishopsgate to reclaim the throne on 11 April 1471, to be greeted by Thomas Urswick, Recorder of the City, and other officials.

The story of Edward IV's return from exile and his victories at the battles of Barnet and Tewkesbury is told in a chronicle written soon after the tumultuous events of 1471, the *Historie of the arrivall of Edward IV. in England and the final recovererye of his kingdoms from Henry VI. A.D. M.CCCC.LXXI* – often referred to as simply *The Arrivall*.

Oil on canvas, 24" x 30" (61cm x 76cm), 2001.

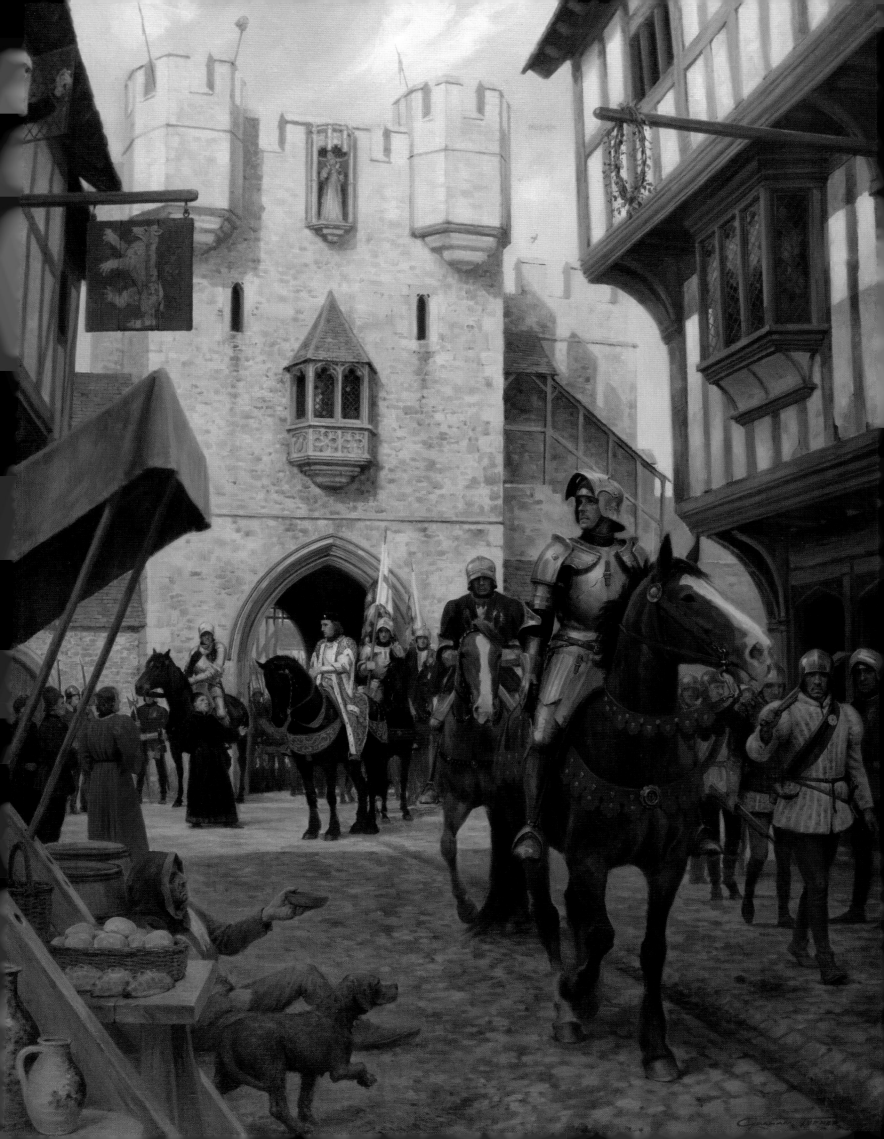

cousin of York, you are very welcome. I know that in your hands my life will not be in danger.'[12] Both Henry and the archbishop were taken to the Tower.

After greeting his supporters, now freed from their sanctuaries, King Edward hurried to Westminster for more prayers and a short crown-wearing ceremony, before he finally got to be reunited with his wife, Elizabeth, who had sheltered in her Westminster sanctuary since October, suffering 'right great trowble, sorow, and hevines, whiche she sustayned with all manar pacience that belonged to eny creature… to endure.' To 'the Kyngs greatyste joy'[13] she now presented him with his son and heir, another Edward, born in these difficult conditions on 2 November. The reunited family returned to within the safety of London's walls to spend the

night with his mother, Cecily, at her home of Baynard's Castle.

The next day, 12 April, was Good Friday, and the king took advice from his lords and council 'for the adventures that were lykely for to come'.[14] His supporters were arriving in large numbers, among them Humphrey Bourchier, Lord Cromwell, and Lord Howard and his son, Thomas, both of whom would have a large part to play over the coming years. With Warwick approaching, Edward lost no time; having lodged his family in the Tower for their safety, he mustered his army in St John's field, near Smithfield and, with his youngest brother Richard, Duke of Gloucester, leading the vanguard, marched north to Barnet.

OPPOSITE
CHALLENGE IN THE MIST

Nineteen-year-old Richard, Duke of Gloucester, strains to see the enemy through the thick fog that envelops the battlefield at Barnet on 14 April 1471. He would later have several of his retainers remembered in prayers, 'slayn in his service at the batalles of Bernett, Tukysbery or at any other feldes'.

Oil on canvas, 24" × 30" (61cm × 76cm), 2000.

THE BATTLE OF BARNET

When King Edward's army reached Barnet, Warwick's army was already in position, 'undre an hedge-syde'. The king's 'afore-riders' chased Warwick's back to their positions and, as night fell, he formed his army up to face them. It would transpire that he was much nearer Warwick's lines than anyone realised, and not quite opposite 'butt somewhat a-syden-hande'.[15] Both miscalculations would have a considerable bearing on the outcome of the following day's battle. While Warwick's gunners fired throughout the night, the closeness of the two armies meant their shot passed harmlessly overhead, and Edward kept his soldiers 'still, withowt any mannar langwage, or noyse,' and 'suffred no gonns to be shote on his syd'.[16]

A 'greate myste' greeted the tired soldiers as Easter Sunday dawned, with gun smoke from the night's barrage hanging in the air to further hamper visibility. Despite that, Edward immediately 'commytted his cawse and qwarell to Allmyghty

God, avancyd bannars, dyd blowe up trumpets, and set upon them, firste with shotte,' and then very soon 'they joyned and came to hand-strokes'.[17] In the centre the fighting was fierce, but on Edward's right, Gloucester's division found itself with no opposition,

LEFT Sir Walter Blount, Lord Mountjoy, was made a Knight of the Body by King Edward IV in 1463, having fled with him to Calais after the Yorkist disaster at Ludford Bridge, and fought alongside him at Mortimer's Cross and Towton in 1461. In 1464 he was appointed treasurer of England, before being raised to the peerage in 1465 as Lord Mountjoy of Thurveston. After Barnet (when he was in his fifties), he also fought with King Edward at the Battle of Tewkesbury, and was made a Knight of the Garter in 1472.

(Detail from the painting of the Battle of Barnet reproduced on the following page.)

'And on Ester day in the mornynge, the xiiij. day of Apryl, ryght erly, eche of them came uppone othere; and ther was suche a grete myste, that nether of them myght see othere perfitely'
Warkworth's Chronicle

'for the Kynge… mannly, vigorowsly, and valliantly assayled them, in the mydst and strongest of theyre battaile, where he, with great violence, bett and bare down afore hym all that stode in hys way'

The Arrivall

LEFT

THE BATTLE OF BARNET

14 April 1471

Edward IV leads his army through the fog and into the thick of the action, his banners flying above him and Knights of the Body beside him. Opposing the king are soldiers wearing the red livery of Richard Neville, Earl of Warwick, Edward's one-time great ally, and in the background can be made out the 'Kingmaker' himself, along with his brother, John Neville, Marquess Montagu.

Oil on canvas, 48" x 32" (122cm x 81cm), 2018.

the result of the previous night's misalignment. As Gloucester swung his division round he found the enemy and attacked, engaging what was probably the flank of Warwick's left, under the command of the earl of Exeter.

On the other wing the opposite had happened, and here the earl of Oxford's division outflanked and defeated the Yorkists of Lord Hastings, chasing them from the battlefield. It took some time for Oxford's captains to regroup his men, some of whom were busy pillaging in Barnet, and return to the battlefield, but when they did it would have a decisive effect.

In the centre, apparently largely unaware of the 'distrese' on the flank 'by cawse of [the] great myste that was, whiche wolde nat suffre no man to se but a litle from hym', the fighting was intense.[18] King Edward led from the front, where he 'mannly, vigorowsly, and valliantly assayled them, in the mydst and strongest of theyre battaile, where he, with great violence, bett and bare down afore hym all that stode in hys way'.[19]

As Oxford emerged from the mists to rejoin the battle, he should have found himself approaching the rear of the Yorkist lines. However, due to the misalignment, the battle lines had rotated and it was the flank of the division commanded by his ally, Montagu, that his men bore down upon. Oxford's men wore 'ther lordes lyvery, bothe before and behynde, which was a sterre withe stremys, whiche [was] myche lyke Kynge Edwardes lyvery, the sunne with stremys' [the sun in splendour], and in the thick fog the two badges were confused by Montagu's soldiers, who thought they were being attacked by King Edward. They fought back, and on realising that they were being attacked by their own side, Oxford's men 'cryed "treasoune! treasoune!" and fledde away from the felde'. With victory within his grasp, Warwick's forces collapsed. Montagu was killed, and Warwick made his bid to escape. The horses had been sent to the rear and that's where Warwick headed; 'he lepte one horse-backe, and flede to a wode by the felde of Barnet'. There, cornered, he was cut down and 'despolede hyme nakede'.[20]

> *'ther lordes lyvery, bothe before and behynde, which was a sterre withe stremys, whiche [was] myche lyke Kynge Edwardes lyvery, the sunne with stremys'*
>
> *Warkworth's Chronicle*

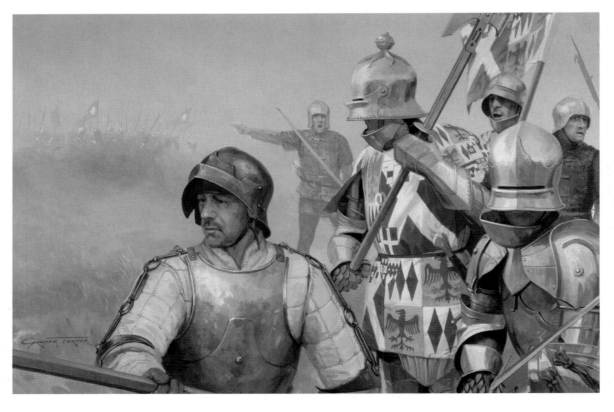

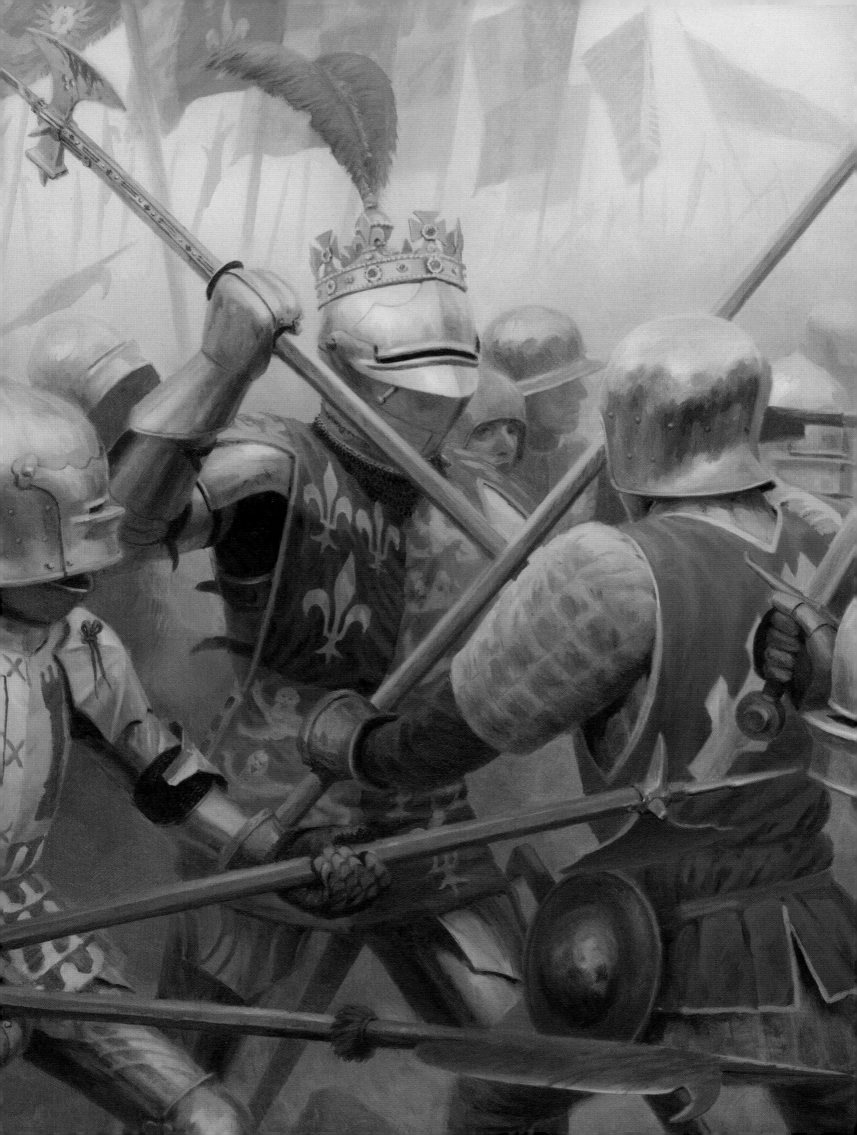

The battle wasn't particularly long, lasting either three hours or until 10am, according to two different sources. Alongside Montagu, the bodies of 'many othar knyghts, squiers, noble men, and othar' lay on the battlefield.[21] The chronicles often list the names of the notable casualties, but the majority of those killed are here simply acknowledged by the single word 'othar'. Elsewhere these nameless casualties are referred to as 'gode yemen, and many other meniall servaunts of the Kyngs'.[22] As with all the battles of the Wars of the Roses the numbers involved are extremely difficult to determine, with the accounts giving very different, often exaggerated, figures. At Barnet it has been suggested that King Edward fielded between 12,000 and 15,000 troops, Warwick slightly more, with 1,500 casualties being the more believable of the varying figures recorded by the chroniclers. Sir John Paston, who was present, wrote 'and other peple off bothe partyes to the nombre off mor then a m [thousand]'.[23] On the Yorkist side the battle had claimed the lives of Sir Humphrey Bourchier, Lord Cromwell (son of the earl of Essex) and his cousin, another Sir Humphrey (son of Lord Berners), Sir William Fiennes, Lord Saye (whose father had been beheaded by the rebels in 1450 during Cade's Rebellion), and Sir William Blount, son of Lord Mountjoy.

The duke of Gloucester's first experience of battle had left him slightly wounded, as was Earl Rivers. Gloucester would later have several of his followers remembered in prayers 'for the soules of Thomas Par, John Milewater, Christofre Wursley, Thomas Huddleston, John Harper and all other gentilmen and yomen servanders and lovers [friends and well-wishers] of the saide duke of Gloucetr, the wiche were slayn in his service at the battelles of Bernett, Tukysbery or at any other feldes'.[24]

In the piles of dead and dying scattered across the battlefield, the duke of Exeter lay seriously wounded and 'lafte for dead'.[25] He was found by a servant late in the afternoon and treated by a doctor, before being smuggled into sanctuary at Westminster. Seized from there, he would spend the next four years in the Tower. The earl of Oxford made good his escape, eventually reaching Scotland and from there getting to France, living to fight another day.

The victorious King Edward, after 'he had a little refreshed hym and his hoste',[26] returned to London and rode straight to St Paul's, where he was received by assorted ecclesiastical dignitaries, laid two badly torn banners at the altar 'and rendered to almightie

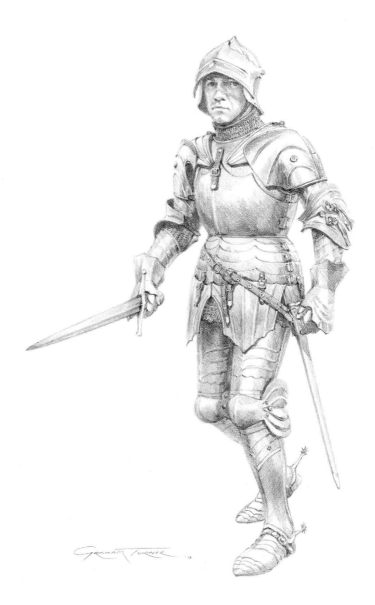

God, for his greate victory, moste hu[m]ble and hartie thankes',[27] before returning to his family at Westminster. It had been a busy day!

Henry VI, who had been taken to Barnet with the Yorkist army, was returned to the Tower, 'ther to be kept'.[28] A contemporary account of the returning army vividly illustrates the butchery of battle and the wounds sustained: 'Those who went out with good horses and sound bodies brought home sorry nags and bandaged faces without noses etc. and wounded bodies, God have mercy on the miserable spectacle'.[29] The bodies of Warwick and Montagu were brought to St Paul's, where they were laid on 'the pavement, that every manne myghte see them',[30] to try to quell any 'seditiows tales' that they still lived. [31] They lay there for three or four days before they were taken for burial alongside their father, the earl of Salisbury, in the family tomb at Bisham Abbey.

ABOVE **An armour of West European manufacture, based on the tomb effigy of Sir John Carent (*c.*1470) at St Gregory's, Marnhull, Dorset.**

Pencil, 12" x 16.5" (30cm x 42cm), 2019.

OPPOSITE **The letter Sir John Paston wrote to his mother four days after the Battle of Barnet.**
(The British Library, Add MS 43489 f.44r)

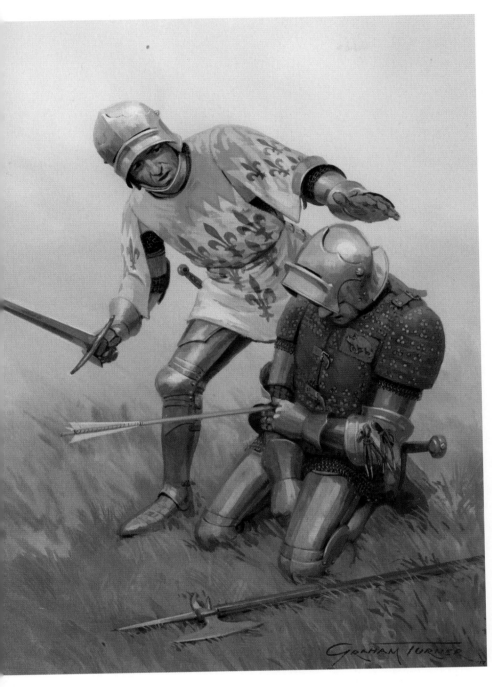

After they had sought his backing in their dispute over Caister Castle, the two John Pastons had been called upon to fight for the earl of Oxford at Barnet. They survived their undoubtedly traumatic experience, and on the Thursday after the battle Sir John wrote to their mother: 'Moodre [mother], I recomande me to yow, letyng yow wette [know] that, blyssed be God, my brother John is a lyffe [alive] and farethe well, and in no perell off dethe. Never the lesse he is hurt with an arow on hys ryght arme, be nethe [beneath] the elbow; and I have sent hym a serjon [surgeon], whyche hathe dressid hym, and he tellythe me that he trustythe that he schall be all holl [whole, i.e. healed] with in ryght schort tyme.'[32]

On 30 April, John III himself wrote to their mother, reassuring her that he was almost recovered: 'I thank God I am hole of my syknesse, and trust to be clene hole of all my hurttys within a sevennyght at the ferthest', but begging for funds because of the cost of his treatment; 'I beseche you, and ye may spare eny money… and send me some in as hasty wyse as is possybyll'.[33] He signed the letter John of Gelston, his birthplace, and gave no address as he was yet to be pardoned; he would secure his pardon in February 1472, just after his brother, who wrote to their mother in January saying 'I have my pardon… for comfort wheroffe I have been the marier thys Crystmesse'.[34]

LEFT

THE PASTONS AT BARNET

Gouache 10.6" × 13.25" (27cm × 34cm), 2017.

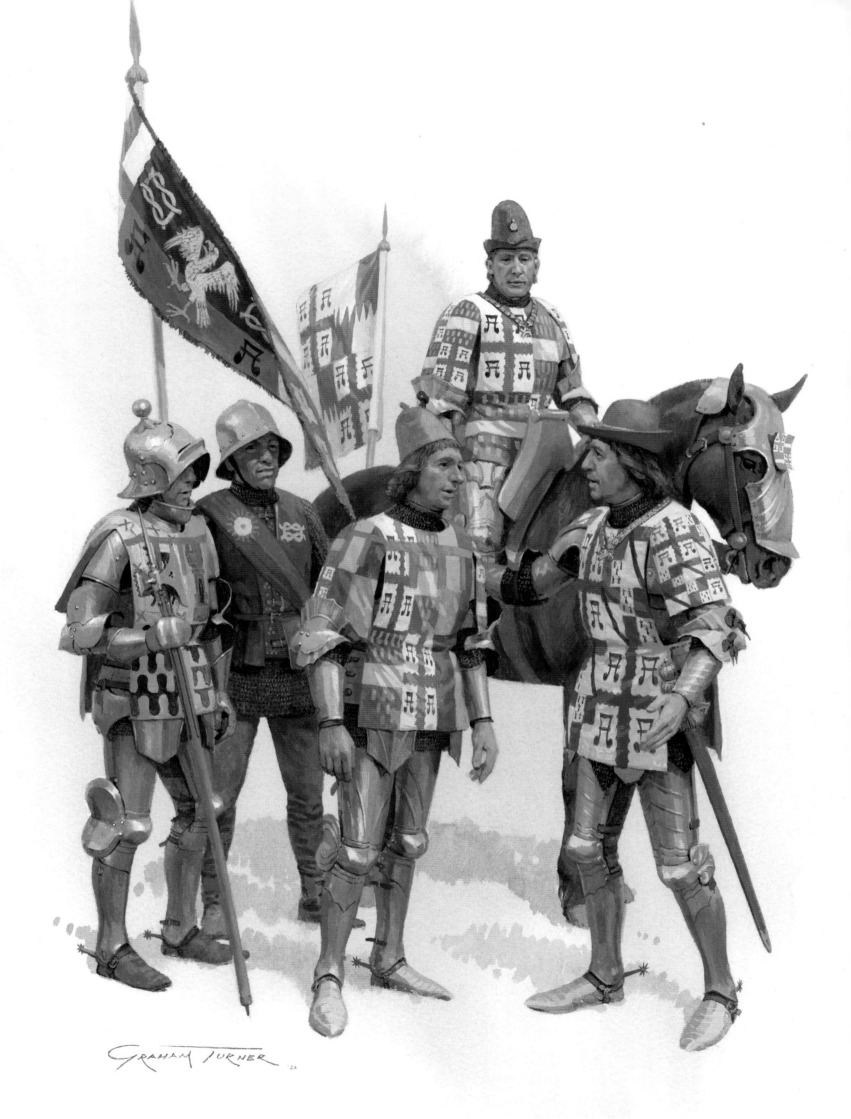

Graham Turner '22

BEHOLD THIS CHAMPION...
ACHILLES – TRUE, FAITHFUL
SERVANT OF THE KING

Like many noble dynasties, the Bourchier family reaped considerable rewards and suffered tragic losses as they navigated their way through the upheaval of the Wars of the Roses. A great grandson of Edward III and Knight of the Garter, Henry Bourchier (1404–83) married the sister of the duke of York, Isabel, and fought for the Yorkists at Northampton, Second St Albans and Towton, after which he was created earl of Essex by the new king, his nephew Edward IV, as a reward for his support.

Henry Bourchier managed to survive in England during Henry VI's brief Readeption of 1470–71, and was among those who emerged from captivity or sanctuary to welcome the returning Edward IV after he entered London on 11 April 1471.

Here, he watches from horseback as his son Humphrey, Lord Cromwell (right), greets his cousin, another Sir Humphrey (son of Essex's younger brother, Lord Berners: centre), prior to the Battle of Barnet, where both would lose their lives. (Cromwell gained his title through his marriage to Jane Stanhope, sister of Maud, whose marriage to Thomas Neville sparked the confrontation on Heworth Moor in 1453 – see painting on pages 38–39). Henry and Isabel had already lost a son at the Battle of Wakefield in 1460, dying alongside Isabel's brother, the duke of York. Another Yorkist to meet the same fate in the fog at Barnet would be Sir William Blount (left), the son and heir of Sir Walter Blount, Lord Mountjoy (see page 180).

The two Humphrey Bourchiers were buried in Westminster Abbey. Lord Cromwell has no surviving monument, but Sir Humphrey's epitaph beneath the now missing brass uniquely compares him to the classical hero Achilles:

Behold this champion lying here who, eager for the fierce fighting at Barnet, fights like Achilles.

The soldier receives wounds from all directions, He fell by force. Mars offers the wound. His [shield of] arms spattered by blood glows red in colour: Lo, the grief of the tearful hour. And indeed he falls on the day on which Christ rose from Death; Humphrey Bourgchier; sprung from the glorious line of King Edward, called the third, the son and first heir of John, Lord Barnes [Berners]. And Behold, Edward the Fourth holds the triumph in the battle, in which Humphrey dies as a true, faithful servant of the King. He was Chief Carver of the King's wife Elizabeth; thus is his virtue increased by the honour. He was formerly distinguished in arms and dear to Britons; ask in your prayers that he may live in Heaven.

The banner behind the earl of Essex belongs to another family member who would fight at Barnet, Sir Fulke Bourchier, Lord Fitzwarin, who had recently inherited his title from his late father, another of Essex's brothers. The arms worn by the various family members share many similarities, notably the Bourchier red engrailed cross with four black water-bougets (a highly stylised heraldic depiction of a water carrier), this being quartered with various combinations of arms inherited from parents or through marriage. Their individual identities are clear, as is their common ancestry and family connections.

The earl of Essex's long standard displays several of his badges, including the Bourchier knot and water-bougets. The knot badge is also worn on the livery of their standard-bearer, over which is a murrey and blue bend bearing the rose en soleil badge of Edward IV. Essex and Cromwell proudly wear their prestigious Yorkist livery collars around their necks.

Gouache, 11" x 15" (28cm x 38cm), 2022.

THE BATTLE OF TEWKESBURY

On the day that Edward and Warwick fought it out at Barnet, Queen Margaret, Prince Edward 'callyd Prince of Wales' and 'many othere knyghts, squiers, and othar of theyr party'[35] disembarked at Weymouth after an arduous Channel crossing. They had boarded their ships on 24 March but bad weather had delayed their departure by 20 days. The countess of Warwick landed on the same day at Portsmouth, but on hearing news of the death of her husband she took sanctuary at Beaulieu Abbey – now home to the current Lord Montagu and the National Motor Museum. On the following day Queen Margaret and Prince Edward were met by Edmund Beaufort, Duke of Somerset, his brother John, Marquess of Dorset, and John Courtenay, Earl of Devon, who 'welcomyd them into England' with the bad news from Barnet, at which the queen and prince were 'right hevy and sory'.[36]

Henry, Edmund and John Beaufort were sons of Edmund Beaufort, Duke of Somerset, who had been killed at the Battle of St Albans in 1455. As the oldest son, Henry had inherited the title and taken up their father's mantle as head of the family, and, apart from briefly pledging allegiance to Edward IV during the struggle in the north of England, he had remained a steadfast supporter of his kinsman, King Henry VI. After Henry Beaufort was executed at Hexham, his younger brothers managed to escape England to join the impoverished Lancastrian court in exile in France, before finding a protector in Charles, Count of Charolais, soon to become duke of Burgundy. Edmund and John were at the Burgundian court when Edward IV inconveniently washed up in 1470, and Edmund did what he could to encourage the duke to continue his support for 'his naturall kynsman' King Henry, to no avail.[37] By February 1471, Edmund and John had returned to an England ruled by Warwick, where they based themselves in London to pursue the return of their inheritance and titles, which had not been recognised by the Yorkists, before leaving for Weymouth on 6 April as Edward IV's army approached, to await Queen Margaret and Prince Edward's return.

Despite the loss at Barnet, Somerset, Dorset and Devon managed to remain optimistic, telling the queen that although 'they had lost one felde'[38] they could now assemble such a great army that King Edward would be unable to resist them. Messengers were sent out to supporters throughout the West Country, asking them to join them 'with all such fellowship as yowe canne make in your moste defensible aray' against 'Edwarde Earl of March the Kings greate Rebele our enemy'.[39] Over the next two weeks their supporters gathered at Exeter, before they marched 'with great people'[40] via Glastonbury to Wells, then on towards Bath. Queen Margaret's army had been faced with several choices: march to London, either via Salisbury or along the south coast, or aim northwards and join with Jasper Tudor in Wales, then into Lancashire and Cheshire. In January, Jasper had been despatched into Wales to raise troops for Henry VI, so had not been present at Barnet, and it was towards him and the crucial aid he could provide that Margaret headed.

In London King Edward 'purveyed for the relevynge of his sycke and hurt men, that had bene with hym at Barnet fielde, which were right many in nombar', and sent for 'freshe men… and ordinaunce, gonns, and other, for the filde gret plentye' to face the new threat in the west.[41] On Friday 19 April, less than a week after Barnet, he moved to Windsor for the feast of St George, and over the following five days gathered his army there, leaving on the 24th to head towards Abingdon and Cirencester.

Margaret had sent two advance parties in different directions to try to confuse Edward, but he received good intelligence from his 'espies' of her real intentions and marched to intercept her before her army had time to grow even larger.[42] When he reached Cirencester, he was told that the Lancastrian army was at Bath and preparing to meet him in battle, so he arrayed his army to face them. Here, Queen Margaret's misinformation appears to have worked, and while Edward's scouts looked for her army, she marched for Bristol, where she arrived on 1 May. At Bristol 'they were greatly refreshed and

ABOVE **The battlefield memorial at Barnet, erected in 1740.**

'Qwyen Margrett is verrely londyd and hyr sone in the west contre, and I trow that as to morow, or ellys the next daye, the Kynge Edwarde wyll depart ffrom hense to hyr warde, to dryve her owt ageyn.'

Sir John Paston to Margaret Paston, 18 April 1471

JOHN COURTENAY, EARL OF DEVON

Sir John Courtenay's family had long held power in the West Country as earls of Devon, and his father and brother had fought against Lord Bonville to retain this dominance during the 1440s and 50s. He fought at Wakefield, where he was knighted by his oldest brother Thomas, then the current earl, and again at Towton, where Thomas was captured and beheaded, and the title forfeited. John made good his escape, ending up in exile with Queen Margaret where he assumed the family title after another elder brother, Sir Henry Courtenay, was also executed by the Yorkists. However, Sir John's claim to the earldom wasn't recognised by the Yorkist regime, and in 1469 Edward IV awarded the title to Humphrey Stafford, who was himself killed shortly after the Battle of Edgcote. Sir John commanded the left wing of the Lancastrian army at Tewkesbury and was killed at the height of the battle. Several of his cousins also fought: Sir Hugh Courtenay took refuge in the abbey and was later executed, while three of Sir Philip Courtenay of Powderham's sons took to the field – one for King Henry and two for King Edward. These three survived.

Gouache, 12" x 18" (30cm x 46cm), 2020.

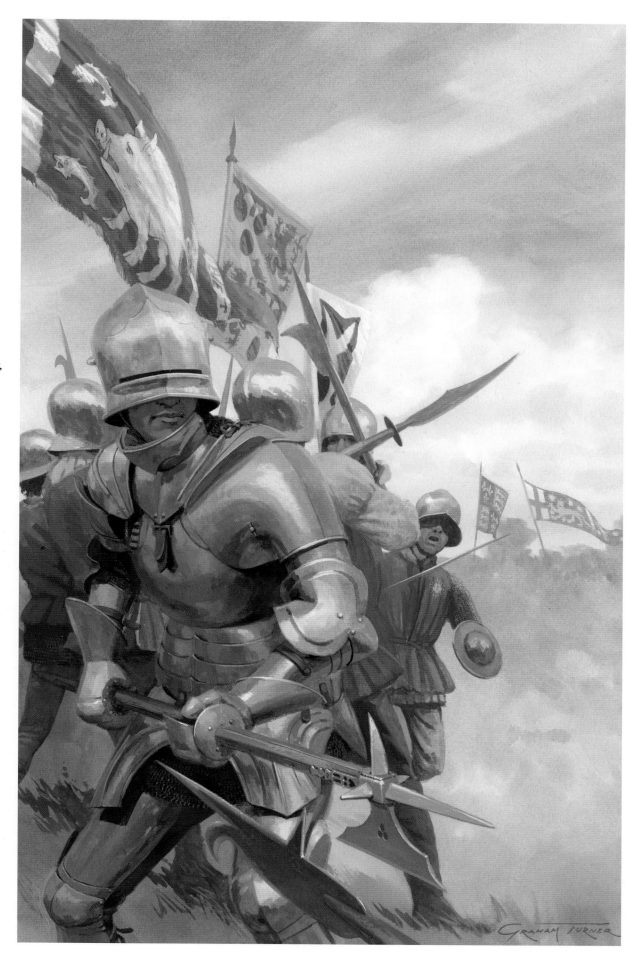

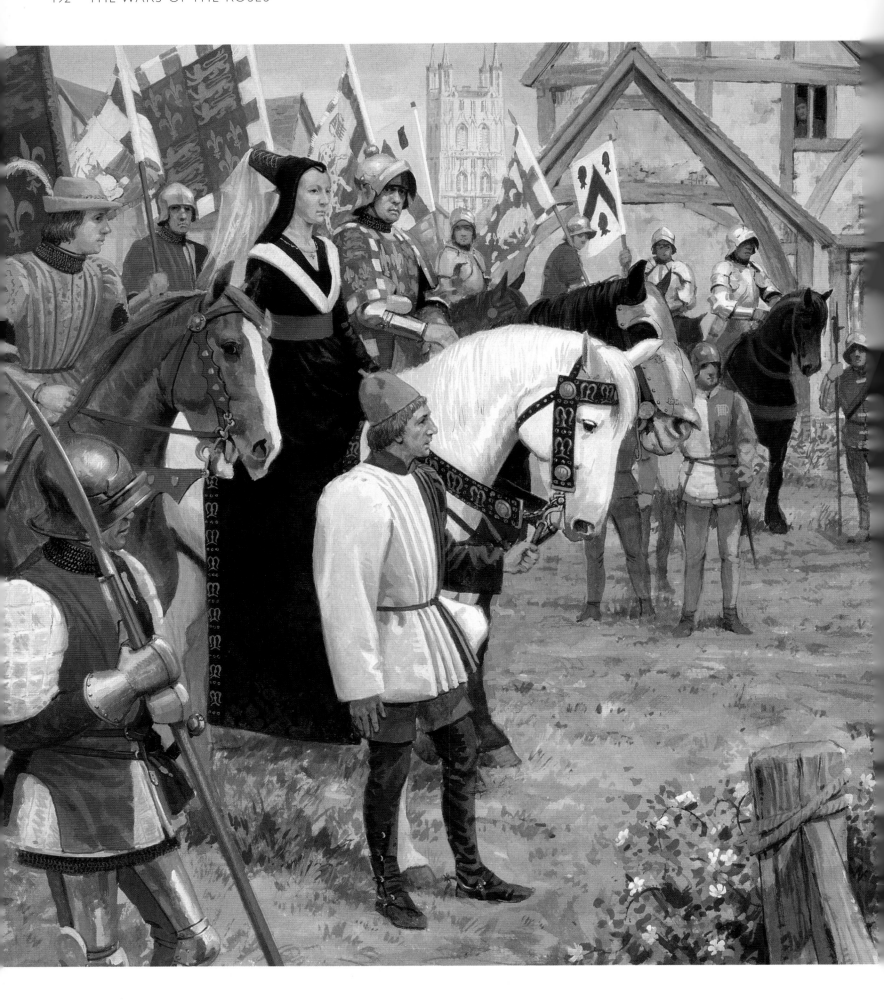

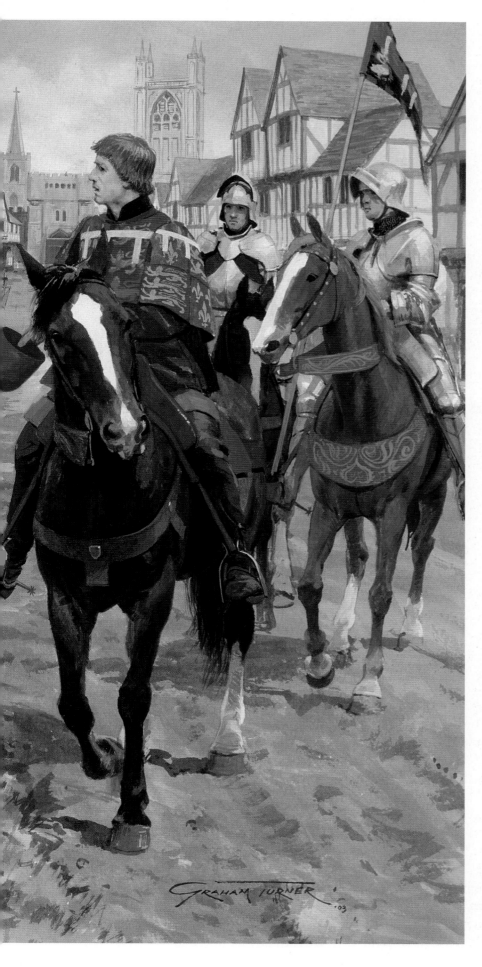

relevyd', and provided with 'money, men and artilarye',[43] and sent word that they would meet Edward in battle at Sodbury Hill on 2 May. A force of skirmishers was sent to Sodbury to add credence to the ruse, clashing with a small advance party from Edward's army, which arrived in force at Sodbury Hill around noon – and waited…

Margaret had left Bristol towards Sodbury, but immediately turned towards Gloucester and its crucial causeway and bridge across the river Severn and into Wales. In the early hours of the next morning 'the Kynge had certayne tydyngs that they had taken theyre way by Barklay toward Gloucestar' and he immediately sent messengers to the governor of the town, Richard Beauchamp, 'commaundynge hym to keep the towne and castle for the Kynge'.[44] When the Lancastrian army arrived outside the town at around 10am, having marched since around midnight, Gloucester's gates were closed, and entry 'was uttarly denyed them'.[45] They threatened to assault the town, but knowing that the Yorkist army wasn't far behind, decided to continue to Tewkesbury, the next crossing point on the Severn. As they marched away from Gloucester's walls, Richard Beauchamp emerged to harass the Lancastrian rearguard, managing to capture some of their guns.

As soon as he heard of Margaret's change of direction, Edward's army set off in pursuit but, rather than follow the same route as the Lancastrians 'in a fowle contrye, all in lanes and stonny wayes, betwyxt woodes, without any good refresshynge',[46] they took to the open countryside of the Cotswolds. It was 'right-an-hot day', and over the 30 miles they covered, the Yorkist army, at least those towards the rear of it, also struggled to find refreshment: 'whiche his people might nat finde, in all the way, horse-mete [horse feed], ne mans-meate, ne so moche as drynke for theyr horses, save in one little broke, where was full letle relefe, it was so sone trowbled with the cariages that had passed it.'[47] Their route would have taken them across the river Frome, a compelling

NOT WELCOME

Hotly pursued by Edward IV's army, Queen Margaret arrives at Gloucester to receive the news that the city has closed its gates and will not allow her army access to the bridge over the river Severn, prompting their march on to the next crossing point at Tewkesbury.

Gouache, 21.5" x 14.5" (55cm x 37cm), 2003.

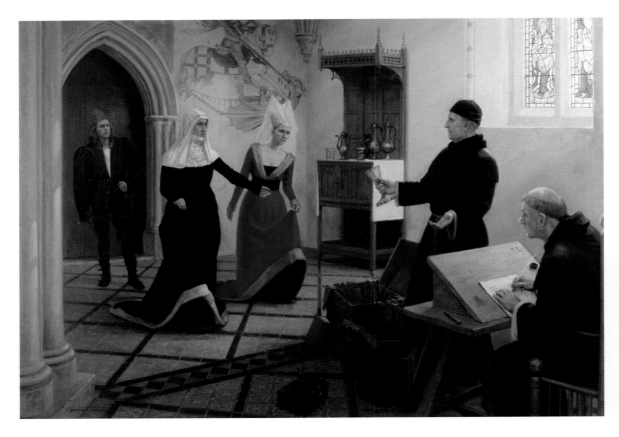

candidate for the 'little broke' the author complains was so churned up by the passage of the army that it was virtually undrinkable. From here their route would likely have taken them down off the Cotswold escarpment at Leckhampton Hill, and on to Cheltenham, where the king received intelligence that the Lancastrians had arrived at Tewkesbury and stopped: 'Whereupon the Kynge made no longar taryenge, but a litle confortyd hymselfe, and his people, with suche meate and drynke as he had done to be caried with hym…' and 'set forthe towards his enemyes, and toke the fielde, and lodgyd hym selfe, and all his hooste, within three myle of them.'[48]

Queen Margaret's exhausted army arrived at Tewkesbury at around four in the afternoon. They had 'so travaylled theyr hoaste that nyght and daye that they were right wery for travaylynge'; the footmen could go no further, and the horsemen too 'were ryght werye of that jorwney, as so were theyr horses.'[49] With the Yorkists closing in fast they turned and formed up with 'the towne, and the abbey, at theyr backs', the land around them comprising 'fowle lanes, and depe dikes, and many hedges, with hylls, and valleys, a ryght evill place to approche, as cowlde well have bene devysed.'[50]

'Upon the morow followynge, Saterday, the iiij. day of May, [the Kynge] apparailed hymselfe, and all his hoost set in good array; ordeined three wards;

IN SAFE HANDS

As the Lancastrian army passed Glastonbury Abbey, John, Lord Wenlock, decided to leave his valuables with Abbot Selwood for safekeeping. These included 'a coup [cup] of gold, a lytell salt saler of gold, a boke callyd a portous, and a kasked lokked stuffyd with such Juellys and other thynges.' On 20 May his wife, Agnes, retrieved them again, the agreement detailed in a deed drawn up between them. The abbot received 200 marks for his trouble.

Oil on canvas, 36" × 24" (91 cm × 61 cm), 2001.

displayed his bannars; dyd blowe up the trompets; commytted his caws and qwarell to Almyghty God… and avaunced, directly upon his enemyes; approchinge to theyr filde, whiche was strongly in a marvaylows strong grownd pyght, full difficult to be assayled.'[51] Edward's army was divided into three 'wards', or battles, as was conventional practice at the time, the 'vawarde', or vanguard, commanded by Richard, Duke of Gloucester, fresh from his successful initiation at Barnet. Edward commanded the middle ward himself, accompanied by his unreliable brother Clarence, with the rear ward once again under Lord Hastings. As they marched into position, Gloucester's division arrayed itself facing the Lancastrians of the duke of Somerset, in the centre the two Edwards faced one another, the

HARD ROAD TO TEWKESBURY

As Queen Margaret's Lancastrian army marched north past Bristol, Berkeley and Gloucester, looking for a crossing point over the river Severn and into Wales, Edward IV's army tracked them across the Cotswolds. The author of *The Arrivall* (Edward IV's official account of the events of 1471) complained there was 'ne so moche as drynke for theyr horses, save in one little broke, where was full letle relefe, it was so sone trowbled with the cariages that had passed it.'

Their route would have taken them across the river Frome, a possible candidate for the 'little broke' the author says was so churned up by the passage of the army. At Chalford the Frome was fordable, and although the river now shares its valley with a road, canal and railway, you can still appreciate the effort the Yorkist soldiers would have required to negotiate the steep approaches to the river crossing.

Gouache, 18.5" x 12.8" (47cm x 33cm), 2020.

17-year-old Lancastrian prince being supported by the experienced Lord Wenlock and Sir John Langstrother, Prior of St John, and Lord Hastings positioned his battle opposite the earl of Devon.

The Yorkist archers opened the battle 'with shott of arrows, that they gave them right-a-sharpe shwre', and gun fire, which the Lancastrians countered in similar fashion 'with shot of arrows and gonnes,' although they 'had not so great plenty as had the Kynge.' The guns lost outside Gloucester would have been sorely missed. Somerset's division bore the brunt of this barrage 'and his fellowshipe

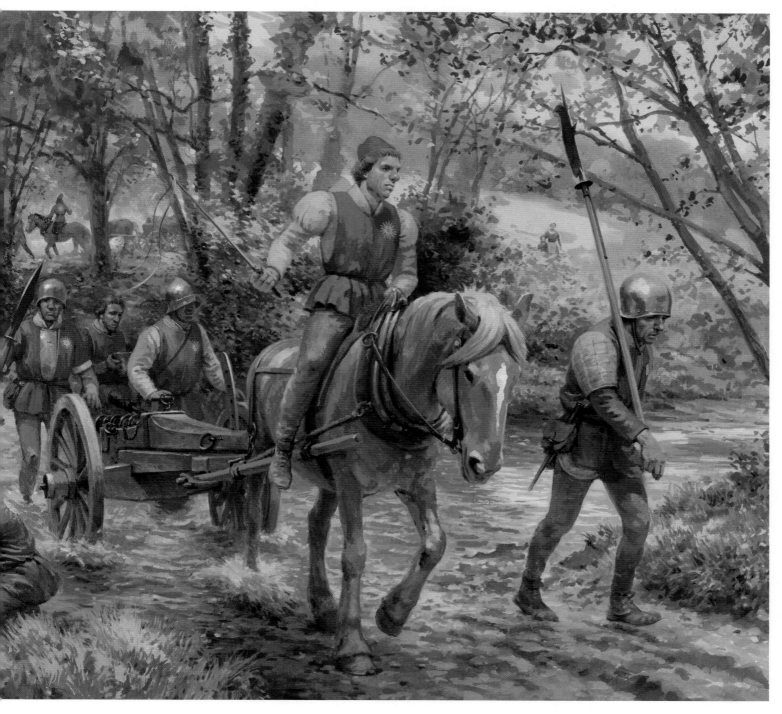

were sore annoyed... with gonnes-shott, as with shot of arrows' which they could not 'abyde', and the duke, 'of great harte and corage, knyghtly and manly' advanced. It seems that Somerset used the lie of the land to his advantage, possibly taking a pre-planned route 'by certayne pathes and ways therefore afore purveyed, and to the Kyngs party unknowne, he departyd out of the field, passyd a lane, and came into a fayre place, or cloos, even afore the Kynge where he was enbatteled, and, from the hill that was in that one of the closes, he set right fiercely upon th'end of the Kyngs battayle.' Faced with Somerset's onslaught, 'the Kynge, full manly, set forthe even upon them, enteryd and wann the dyke, and hedge, upon them, into the cloose, and, with great vyolence, put them upe towards the hyll, and, so also, the Kyng's vaward, being in the rule of the Duke of Gloucestar.'[52] The fighting here would have been at its most intense, with not just the king acting 'full manly'; the chronicle, written for him after the battle, describes Edward in glowing chivalric terms, but the exploits, experiences and emotions of the others involved in this bloody struggle were not recorded.

With Somerset's attack turned, Edward's earlier planning came into play, with devastating effect.

Before the battle he had sent a detachment to a nearby wood 'in caace his sayd enemyes had layed any bushement [ambush] in that wood', instructing them that 'yf they saw none suche... to employ themselfe in the best wyse as they cowlde'.[53] This they most certainly did, charging into the flank of the duke of Somerset's division as it reeled from its struggle with the Yorkist army's centre; 'cam and brake on, all at ones, upon the Duke of Somerset, and his vawarde, asyde-hand, unadvysed, whereof they, seinge the Kynge gave them ynoughe to doo afore them, were gretly dismaid and abasshed, and so toke them to flyght into the parke, and into the medowe that was nere, and into lanes, and dykes, where they best hopyd to escape the dangar; of whom, netheles, many were distressed, taken and slayne.'

King Edward now directed his attack on the Lancastrian centre 'w[h]ere was chefe Edward, called Prince, and, in short while, put hym to discomfiture and flight'. The broken Lancastrian army fled, 'and so fell in the chase of them that many of them were slayne... many rann towards the towne; many to the churche; to the abbey; and els where; as they best might'.[54] The field that today bears the evocative name 'Bloody Meadow' was already being referred to as 'Blody Furlong' in 1498.

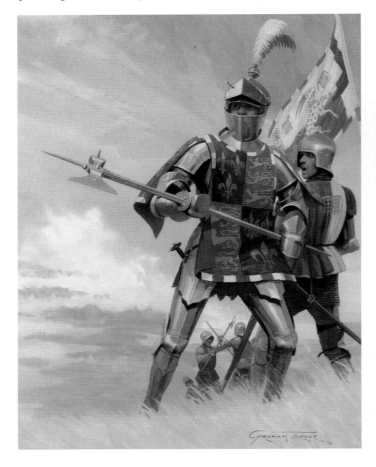

ABOVE **The view from the Cotswold escarpment at Leckhampton Hill, looking towards Cheltenham and Tewkesbury.**

EDMUND BEAUFORT, DUKE OF SOMERSET

Edmund succeeded his father and brother as duke of Somerset (respectively killed at St Albans in 1455 and executed after Hexham in 1464), returning from exile to command the Lancastrian army at Tewkesbury.

Gouache, 12" x 18" (30cm x 45cm), 2013.

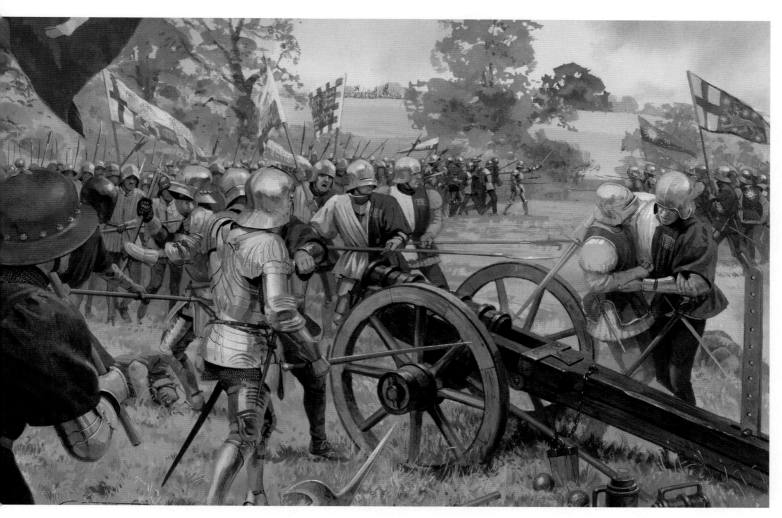

ABOVE
THE BATTLE OF TEWKESBURY

The duke of Somerset's division engages the Yorkist flank.

Gouache, 21.5" x 14.5" (55cm x 37cm), 2003.

LEFT
SIR LAURENCE RAYNFORD

Sir Laurence Raynford (or Rainsford) was captured at Formigny in 1450, later serving as sheriff in Essex, Hertfordshire and Wiltshire, and fighting for Edward IV at the battles of Towton, Barnet and Tewkesbury. In 1707 one of his descendants purchased Gupshill Manor, which still stands near the battlefield just outside Tewkesbury.

Gouache, 11.5" x 16" (29cm x 40cm), 2012.

NEXT PAGES
THE BATTLE OF TEWKESBURY

Lancastrian soldiers under the duke of Somerset's command desperately try to defend themselves against the advancing Yorkists, King Edward IV at their head.

This was one of my early Wars of the Roses canvases, painted in 1996 and unveiled at my first exhibition at the Tewkesbury Medieval Festival that year, beginning a long association with Tewkesbury that has continued ever since, and setting me on a path that would see the Wars of the Roses become a central theme in both my life and career.

Oil on canvas, 53" x 32" (135cm x 81cm), 1996.

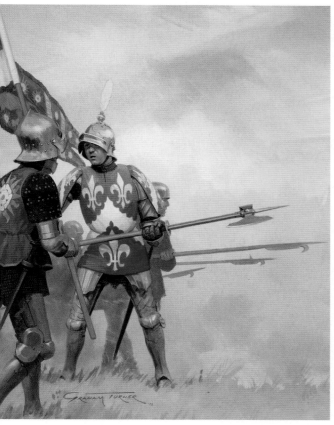

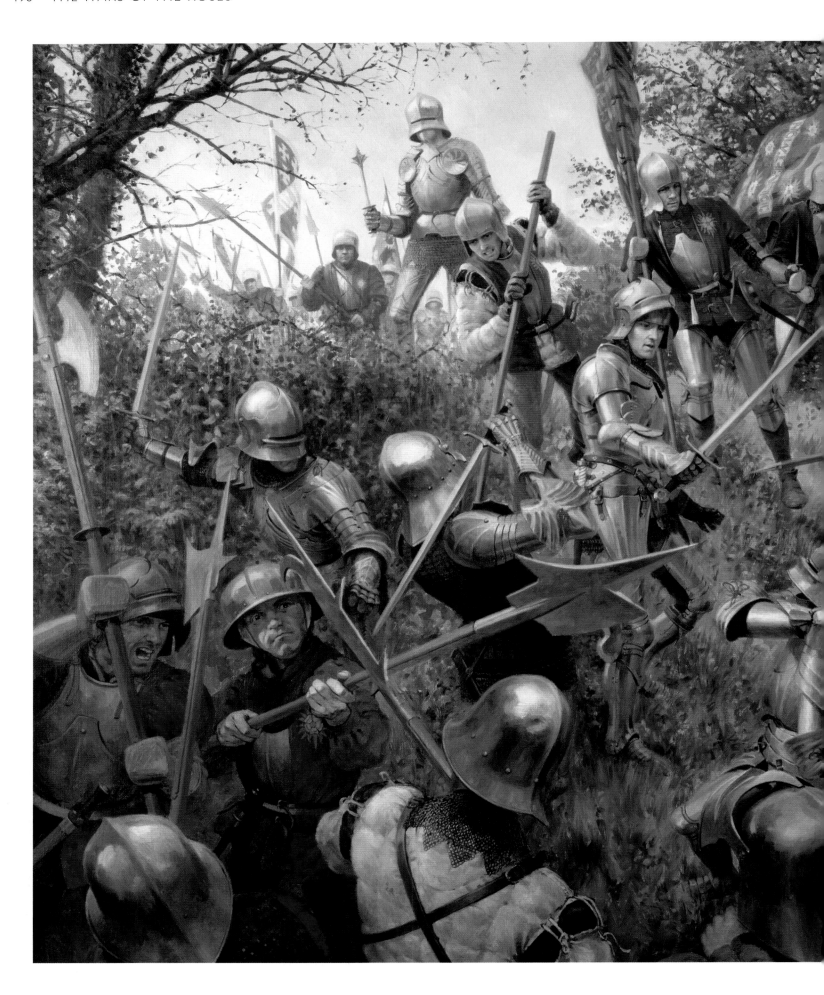

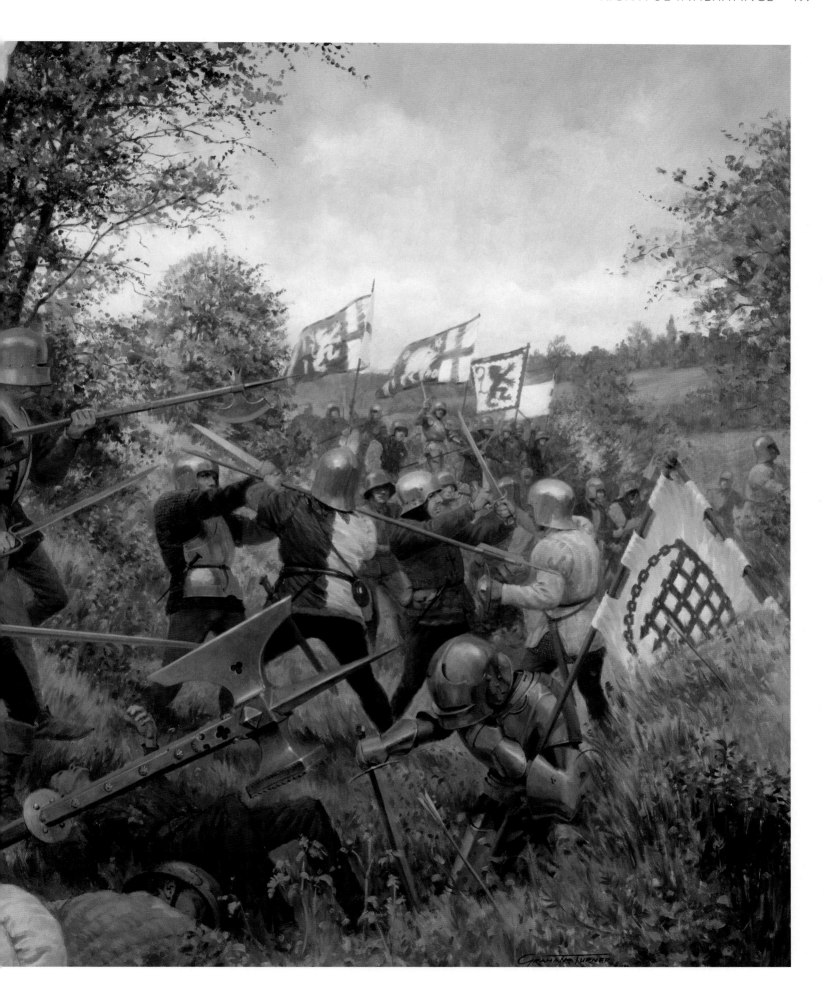

Among the dead on the field lay John Courtenay, Earl of Devon, John Beaufort, Marquess of Dorset, and Prince Edward, on whom had rested the future hopes of the House of Lancaster. A 16th-century account of the battle has the duke of Somerset managing to find his way back to the Lancastrian central division where, 'seyng the lord Wenloke standynge still… called him traytor, with his axe he strake y braynes out of his hedde'.[55] The suggestion is that Wenlock had failed to support Somerset's division in the attack, due perhaps to his old Yorkist loyalties – he was Warwick's man, thrust into the unnatural alliance forged between the earl and Queen Margaret, and as such, unlikely to have been trusted by ardent Lancastrians. This tale is not mentioned in any earlier account, though, where Wenlock is just listed among those killed.

An elated King Edward had achieved victory once again, and in his moment of glory he knighted more than 40 of his followers who had distinguished themselves in the battle, including Richard and Ralph Hastings, brothers of Lord Hastings.

Several Lancastrian fugitives, including the duke of Somerset, sought sanctuary in Tewkesbury Abbey, but this would fail to provide them with the protection they hoped for from a vengeful king. According to one account, 'Kynge Edwarde came with his swerde into the chirche' but was stopped by a priest, with the sacrament in his hands, and forced to pardon all within.[56] It only put off the inevitable, and two days later, Edmund Beaufort, Duke of Somerset, Sir John Langstrother, Prior of the Order of St John, Sir Hugh Courtenay, Sir Gervaise Clifton and several others were removed from the abbey and tried in front of the duke of Gloucester and the duke of Norfolk, as constable of England and marshal of England respectively. Convicted of treason, they were immediately executed on a scaffold in the centre

DECISIVE BLOW

Having been sent out to counter a potential ambush, instructed 'to employ themselfe in the best wyse as they cowlde', Yorkist horsemen do precisely that, falling on the duke of Somerset's soldiers as they are pushed back through a hedge by King Edward's main army. Trying to warn them of the danger is Somerset's 30-year-old brother, Sir John Beaufort, Marquess of Dorset, who would be killed in the battle.

Gouache, 22" x15.4" (56cm x 39cm), 2020.

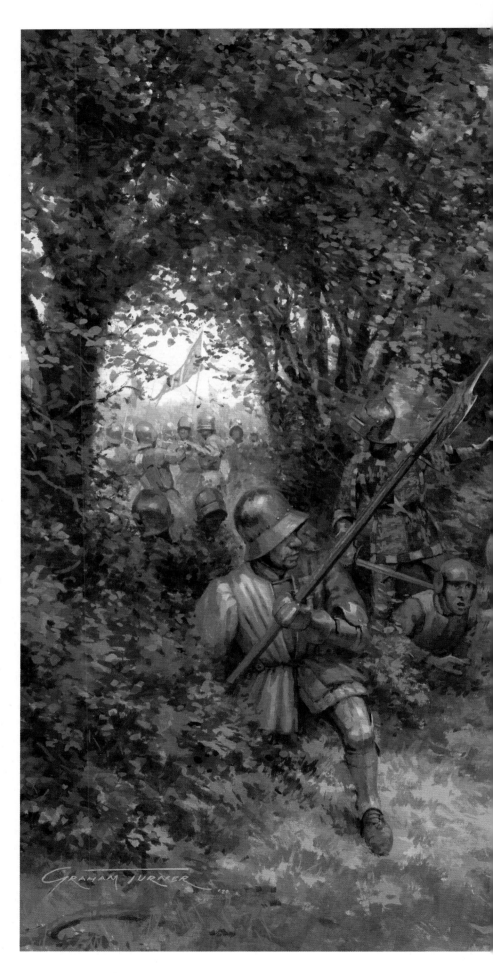

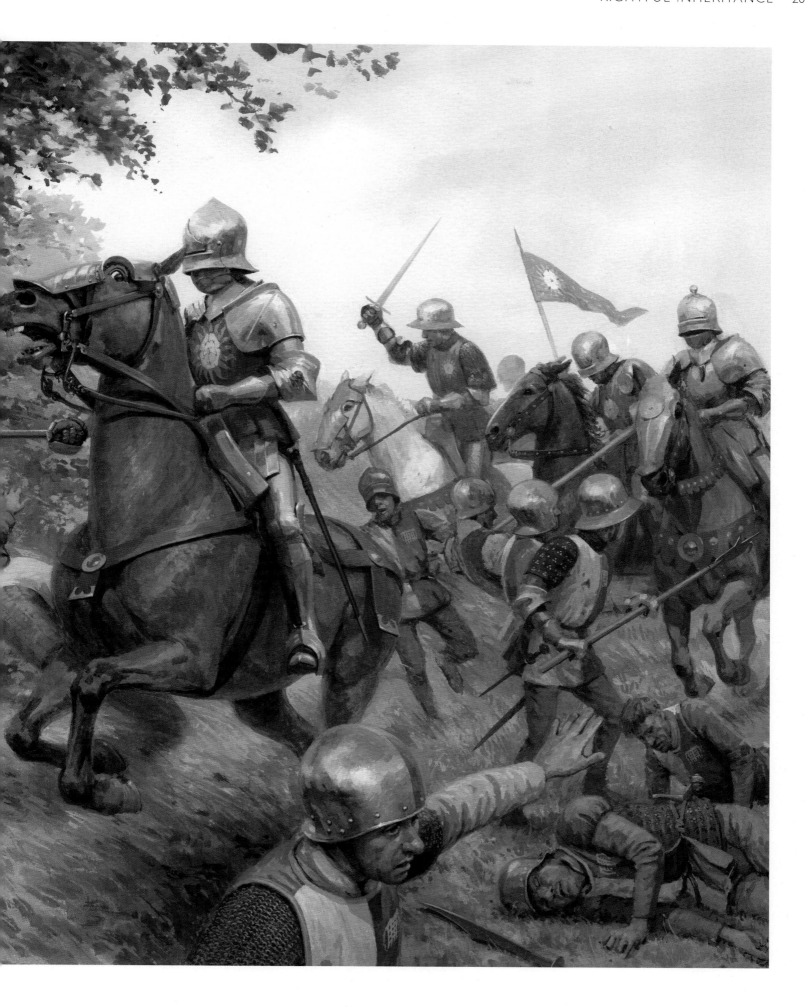

of town, 'behedyd evereche one, and without eny other dismembringe, or settynge up, licensyd to be buryed'.[57] Whatever had transpired within the sacred walls of the abbey, it was considered so violated that the building was later reconsecrated, and another local church at Didbrooke was eventually rebuilt because it had been 'notoriously polluted by violence and shedding of blood'.[58]

Edmund and John Beaufort joined their father, who had died at St Albans, and older brother, Henry, executed at Hexham, in the list of family members who had been consumed by the conflict. In March 1467 their mother, Eleanor, had passed away, like so many having suffered so much loss; it is perhaps merciful that she didn't see her two remaining sons perish too. Henry Beaufort left an illegitimate son Charles, who adopted the surname Somerset, fought for Henry Tudor at Bosworth, where he was knighted, and went on to climb to the title earl of Worcester in 1514. Their cousin, Margaret Beaufort, would see the family's fortunes revived and reach new heights when her son, Henry Tudor, claimed the throne of England in 1485.

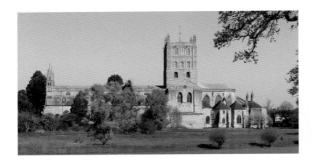

ABOVE Tewkesbury Abbey, started in the early 12th century, survived the Reformation by becoming the town's parish church.

RIGHT
SANCTUARY?

A Lancastrian knight considers his perilous situation, having sought sanctuary in Tewkesbury Abbey in an attempt to escape the slaughter outside.

I made the deliberate choice to paint the background as it appears today to make the connection between the ages – I am aware that although far from new in 1471, this tomb would have been in better condition than it is now, and most likely painted.

Gouache, 25.5" x 12.5" (32cm x 65cm), 2005.

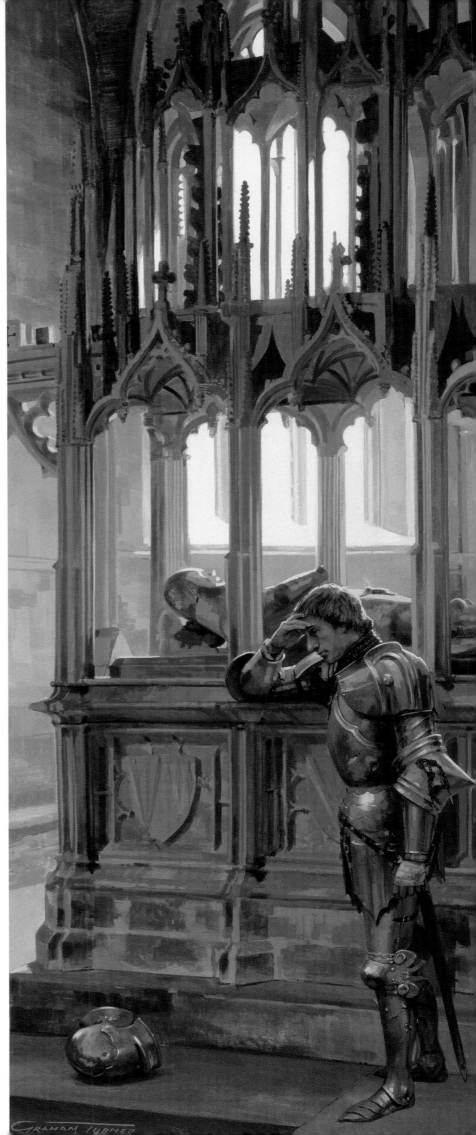

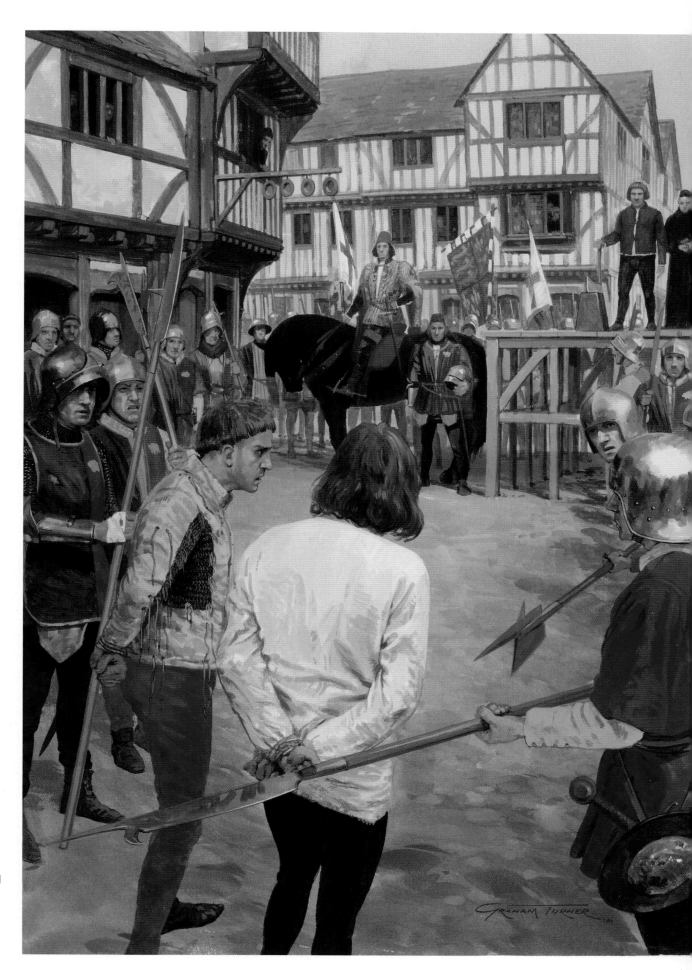

THE CONSEQUENCES OF DEFEAT

Having been dragged from their refuge in Tewkesbury Abbey, Lancastrian fugitives are led to the scaffold in the centre of the town to be beheaded. As the wheel of fortune turned during this turbulent period, one moment you might be a loyal subject, the next you could find yourself a traitor.

Gouache, 13" x 17" (33cm x 43cm), 2000.

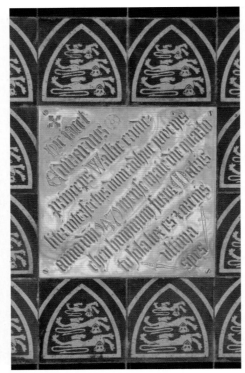
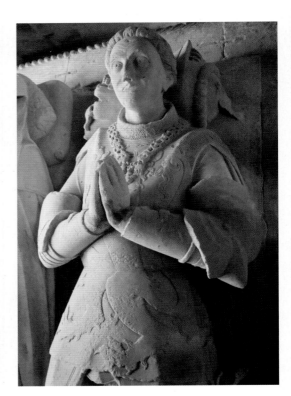

'and so were judged to deathe, in the midst of the towne, Edmond Duke of Somerset... with many other gentils that there were taken, and that of a longe tyme had provoked and continuyd the great rebellyon that so long had endured in the land agaynst the Kynge, and contrye to the wele of the Realme. The sayd Duke, and othar thus judged, wer executyd in the mydste of the towne, upon a scaffolde therefore made, behedyd evereche one, and without eny other dismembringe, or settynge up, licensyd to be buryd.'

The Arrivall

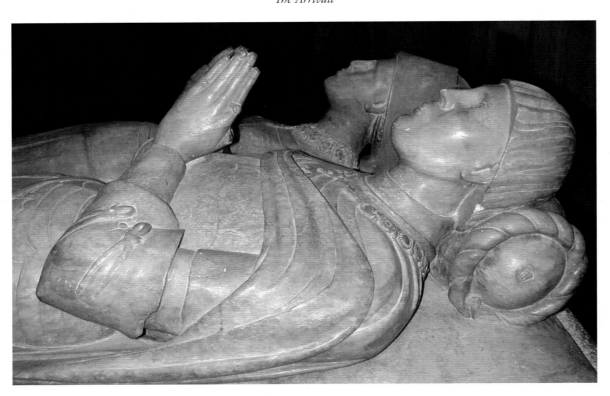

LEFT The tomb of Sir John
Crosby, merchant, alderman
and sheriff of London, and
one of those knighted by
Edward IV for resisting the
attack on London in 1471 –
'honoringe, and rewarding
them with the order, of his
good love and grace... as
they had ryght well and
trewly deservyd'. St Helen's,
Bishopsgate, London.
(Copyright Tobias Capwell)

'the bastarde of Fawconbrydge, that unto hym had gaderyd a riottous and evyll disposyd company of shypmen and other, with also the assystence of the comons bothe of Essex and Kent, came in great multytude unto the cytie of London'
Robert Fabyan, *The New Chronicles of England and France*

OPPOSITE **Tomb of Sir Robert Whittingham, Aldbury, Hertfordshire. Robert was part of Queen Margaret's household, marrying one of her ladies, Katherine Gatewyne, in 1448. He was knighted by Prince Edward after the Second Battle of St Albans, fought at Towton and afterwards fled to Scotland with the queen. He followed her into exile in France, returning to fight at Tewkesbury where he was killed. He is sculpted wearing a Milanese harness under his heraldic tabard, with a Lancastrian livery collar of esses round his neck.**

Queen Margaret was discovered in a 'powre religious place' not far from the battlefield, along with the newly widowed Anne Neville and the countess of Devon.[59]

The day after the executions at Tewkesbury, King Edward headed north to confront reports of another rising, and he arrived at Coventry on 11 May. Any troubles were soon extinguished, most rebels dispersing as word spread of Edward's victory, and the news that all was peaceful was brought to him in person by the earl of Northumberland.

The same could not be said about London though. Thomas Neville, Bastard of Fauconberg, had assisted Warwick after his flight from England the previous year and continued operating in the Channel. Accompanied by a force of men from the Calais garrison, he landed in Kent at the beginning of May and advanced to Canterbury, recruiting as he went, 'in great nombar, entendyng, by lyklyhode, to do some great myschevows dede.'[60] With his ships sailing up the Thames, Fauconberg demanded entry into London, with the undoubted intention of rescuing King Henry from the Tower. The city officials and citizens resolutely refused and when Fauconberg arrived at Southwark on 12 May he launched his first attack on the southern end of London Bridge.

Having been established by the Romans, London Bridge was first built in stone at the end of the 12th century. At its centre was a chapel dedicated to St Thomas the Martyr (Thomas Becket, murdered in 1170), which was rebuilt in the 14th century, and at the southern end were two fortified towers, Stonegate and the Drawbridge Gate. In 1437 ice caused Stonegate and two of the arches to collapse, and the repairs were only completed in 1467, so in 1471 this part of the bridge was still relatively new. As the gateway into London from the south, London Bridge had welcomed numerous kings and queens to the city with pageants and festivities, including the triumphant Black Prince with the captive French king after Poitiers in 1356, and Henry V after his victory at Agincourt in 1415. The young King Henry VI enjoyed a marvellous reception when he returned from his French coronation in 1432, and his bride, Margaret, was similarly received a few years later. Both towers were also used for the grislier display of

traitors' heads, spiked here as a warning to those crossing the bridge. After the 1450 rebellion the heads of Jack Cade and 23 of his followers ended up adorning the top of the Drawbridge Tower. The iconic bridge is chiefly remembered for the buildings that grew up on top of it. A writer in 1483 described it as 'a very famous bridge built partly of wood and partly of stone, on which there are houses crowded together with gates having portcullises: the dwellings belong to various types of craftsmen and have workplaces below'.[61]

When Fauconberg's forces attacked on 12 May 1471, they found the Drawbridge Gate closed against them, with three holes cut in the upright drawbridge for 'sending out gun shot',[62] and a group of determined defenders commanded by Ralph Josselyn, a former mayor. The northern banks of the Thames had been fortified and manned by men and guns, these and other defensive preparations being led by the current mayor, John Stokton, together with the earl of Essex and Anthony Woodville, Earl Rivers, whose retinues, added to the well-garrisoned and provisioned Tower, would strengthen the citizens' efforts to hold out until expected help from the king arrived.

Thwarted, Fauconberg headed west to Kingston. Here he found the crossing defended by Earl Rivers with soldiers he had ferried up the river by barge, and from his strong position Rivers was apparently able to persuade Fauconberg to return to his ships, still moored on the other side of London Bridge as the narrow gaps between the bridge's piers only permitted the passage of smaller craft, and then at considerable danger to the occupants due to the treacherous and fast flowing water. However, Fauconberg only returned as far as St George's Field, an open area between Lambeth and Southwark, where he reassembled his army and on the same day, 14 May, launched a full-scale attack on London.

Guns from the ships were set up along the south bank of the Thames and began to bombard the city. Another assault on the bridge was launched, in conjunction with attacks on Bishopsgate and Aldgate, by forces ferried across the river joined by additional men from Essex. The attackers succeeded in forcing the citizens to retreat back through Aldgate, dropping

the portcullis and killing several in the process. With fires burning around them and arrows and guns being shot at the gate 'which did more scathe to the portcolyous and to the stoon werk of the Gate then to any Enemyes on eythir syde', the Londoners launched a determined fightback.[63] Led by Robert Basset, alderman of the Aldgate ward, dressed in a 'blak jak', along with the mayor and other officials, they raised the portcullis and rushed out, managing to force the rebels back to St Botolph's church just outside the gate. At the same time Earl Rivers, with a 'felashipe right well chosen', issued out of a postern gate by the Tower and attacked the rebels' flank, driving them back further and then to 'flyght and discomfiture.'[64] While this was going on, the earl of Essex beat away the attackers at Bishopsgate, and the Londoners chased the defeated rebels as far as Stratford, five miles away, and Blackwall, where some tried to rejoin their ships. The rebels on the south bank had also been repulsed, their gunners being pushed back; unable to make headway across the bridge, they set fire to the Stonegate and nearby buildings, destroying around 14 houses (two carpenters were employed afterwards to construct wooden rails where these buildings had stood).

The remnants of Fauconberg's army retired to Blackheath, from where they dispersed, and his fleet sailed to Sandwich, where Fauconberg and the men from Calais rejoined their ships. Fauconberg himself would surrender later in May, at first somehow avoiding the traitor's death that claimed many others and left their heads adorning the gates of London, and yet more who were hanged along the road between London and Stratford. But in September, after another offence, he finally joined them, his head being spiked on London Bridge looking towards Kent.

On Tuesday 21 May King Edward arrived at the City, knighting the mayor and several other officials who had 'mannly and honorably acquit them selfe agaynst the bastard, and his crwell hooste',[65] before entering London in triumph. His victory was completed that same night when Henry VI died in the Tower, undoubtedly murdered, but recorded in King Edward's official account as having died of 'pure displeasure and melencoly'.[66] Another observer in Europe wrote 'King Edward has not chosen to have the custody of King Henry any longer… He has, in short, chosen to crush the seed'.[67]

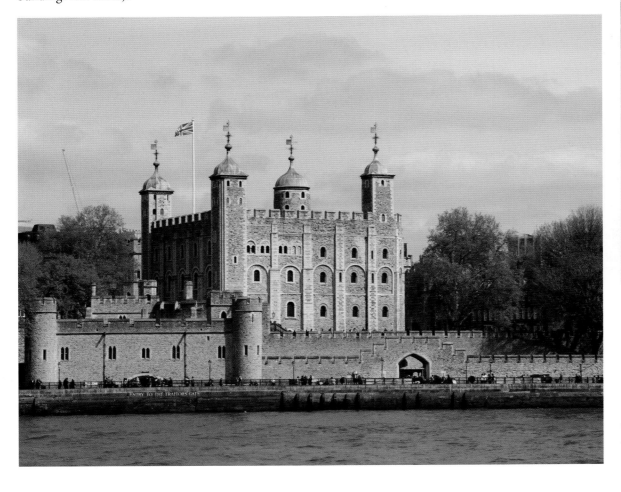

The Tower of London, viewed from the south bank of the river Thames.

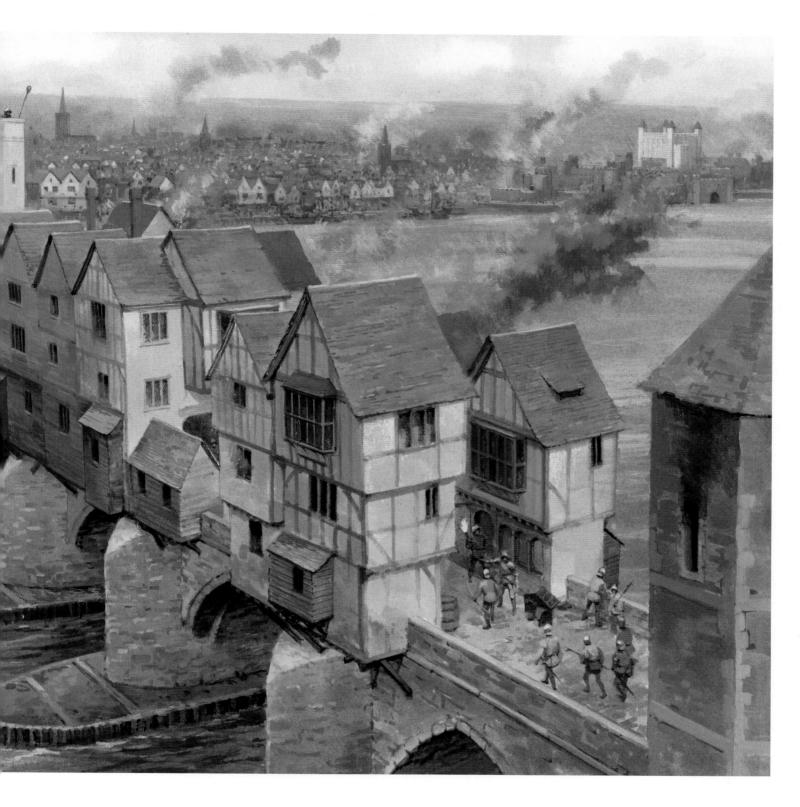

ABOVE

FAUCONBERG'S ATTACK ACROSS LONDON BRIDGE

As Thomas Neville's 'riottous and evyll disposyd company' launches an assault across London Bridge, smoke can be seen rising from the direction of Bishopsgate and Aldgate, which were subjected to simultaneous attacks. Faced with the citizens' determined defence, the attackers were driven away in 'flyght and discomfiture', leaving several buildings on the southern end of London Bridge in flames. Fauconberg's head would eventually end up spiked on London Bridge looking towards Kent.

Gouache, 15.2" x 10.75" (39cm x 27cm), 2022.

CHAPTER 17
RELATIVE PEACE

With Henry VI and his son Edward now dead, Edward IV would remain unchallenged on the throne for the rest of his life, and England would enjoy 12 years of relative peace.

Queen Margaret had lost her husband and son, and her part in the Wars of the Roses now ended. Having been brought captive to London and paraded as Edward's prisoner, she was imprisoned in the Tower until finally being returned to France in 1476. Here her father supported her until his death in 1480, upon which King Louis claimed his possessions, leaving Margaret on the verge of destitution. In August 1482 she died, aged 52.

The punishments meted out to those who had transgressed, often in the form of fines rather than the ultimate penalty, were balanced with clemency and a raft of pardons – amongst the hundreds accepting these being the John Pastons. Those who had helped Edward regain the throne were rewarded, chief amongst these being Richard, Duke of Gloucester, who received a large part of Warwick's estates and would go on to wield the king's power in the north of England. For sheltering him in his hour of need, Louis of Bruges, Lord of Gruuthuse, was rewarded with a title and a generous annuity, being created earl of Winchester amidst great ceremonies during his visit to England in 1472. Much lower down the scale but also recognized and rewarded were people such as Mark Symondson, master of 'le Antony of Camfeer in Zeland, in which the king was brought from those parts to England',[1] who received an annuity of £20, the abbot of Westminster, for aiding Queen Elizabeth in sanctuary, and the butcher who provided her with 'half a beef and ij motons' weekly while she sheltered there.[2]

In Wales, Jasper Tudor evaded capture and exacted revenge on the man who he believed had led his father Owen to the block after Mortimer's Cross, Roger Vaughan, by summarily executing him at Chepstow before retreating to within the walls of his castle at Pembroke. He finally left Welsh shores in September, sailing with his nephew Henry to Brittany, where they became political pawns as Edward IV and Louis XI fought to secure possession of them.

Another thorn to remain in King Edward's side was John de Vere, Earl of Oxford, who had managed to escape the battlefield at Barnet and remained at large. In 1462 his father and brother had been executed for treason but, fortunately for John, Edward's policy of reconciliation had allowed him to inherit his father's estates. However, in 1468 he was arrested for suspected treasonable plotting, a charge he managed to avoid, and then in 1469 he joined Warwick and Clarence in their schemes, enjoying a brief period of power under Henry VI's Readeption before it all collapsed with the defeat at Barnet. He succeeded in escaping to Scotland and from there to France, from where he harassed Calais and the Essex coast and engaged in piracy, capturing English and Burgundian ships and getting 'grete good and rychesse' by selling their cargoes.[3]

On 30 September 1473 Oxford sailed to St Michael's Mount, off the coast of Cornwall, and managed to take possession of the fortified abbey that perched on its rocky crag, cut off from the mainland for 20 hours a day and only accessible by a causeway at low tide. He was accompanied by his brothers, George, Thomas and Richard, along with William, Viscount Beaumont, and Sir Thomas Clifford – all of whom had been with Oxford at Barnet and escaped with him – and around 80 men.

King Edward's first response was to commission Sir John Arundell and local gangster Henry Bodrugan, along with John Fortescue, Sheriff of Cornwall, to besiege the Mount and expel Oxford's impudent force.

In one of the many skirmishes that took place as the defenders sallied out to try to secure supplies, Oxford was wounded in the face by an arrow, and in another Sir John Arundell was killed; he was buried in the abbey. These violent episodes were interspersed with occasional truces, sometimes lasting two or three days after 'thei hade welle y-foughte'.[4] It appears that the notorious Bodrugan identified an opportunity for personal profit and allowed provisions into the Mount, so in December, a frustrated King Edward replaced him in command with Fortescue, causing some division between them, and increased his efforts to dislodge Oxford by sending artillery from the Tower of London, together with four ships to blockade them in from the sea. Just before they were cut off, Oxford had sent his

JOHN DE VERE, EARL OF OXFORD

Following defeat at the Battle of Barnet and the death of King Henry VI, John de Vere's efforts to continue the fight against Edward IV – who had executed his father and brother in 1462 – finally led to a lengthy incarceration at Hammes Castle near Calais, from which he would eventually escape to be Henry Tudor's principal commander at Bosworth. He flourished under Henry VII and fought again for him at the Battle of Stoke. Oxford is pictured riding alongside his standard which bears his badges of the blue boar (a play on the Latin *verres* for boar) and mullet or molet (a five-pointed star).

John de Vere died peacefully at Hedingham Castle in 1513, and his will includes a number of items featuring the molet and blue boar; 'a testour and a Counterpoynt of Crymsen saten of Bridges [Bruges] enbrawdred with blew borys molette' and most interestingly 'iiij standers [standards], ij wᵗ angelles, and tother wᵗ the blue bore of sarcenet.' Amongst many items of great value in his inventory, his livery collar of esses stands out – 'A Colar of fine gold of xxvij S and ij Porteculeisse wt a diamount in a red Rose and a Lyon hanging upon the same Rose' with many more rubies, diamonds and 'ix greate perles'.

Gouache, 13" x 20" (33cm x 51cm), 2014.

ABOVE The earl of Oxford's seal, featuring the de Vere arms quartered with Howard (his mother's family) with a boar crest on his helm.

BELOW The earl of Oxford's signature.
(The British Library, Add MS 43489 f.33r)

brother Richard back to France to appeal to King Louis for assistance, without success.

Eventually, as the cost of the siege mounted with every day it continued, the king offered Oxford's men pardons, and when the earl found that most of them wanted to accept, he had little choice but to surrender. On 15 February 1474, Oxford, his two brothers, and Beaumont and Clifford were taken into custody. John de Vere would spend the next ten years of his life imprisoned in Hammes Castle in Calais. There he joined George Neville, Archbishop of York, the ambitious and untrustworthy youngest brother of the late Warwick and Montagu, who was arrested suddenly in April 1472 for suspected treasonable communications with Oxford. His treasure and possessions were taken by the king, who had his jewelled mitre broken up and remade into a crown, but charges were never brought, and he was released a broken man in November 1474, dying in England in June 1476 at only 44 years old.

Bodrugan's chequered career continued; he was attainted and his lands forfeited after failing to answer charges that included changing people's wills for his own benefit, yet he somehow managed to have this reversed before being knighted by the king in 1476. Subsequently he was outlawed and pardoned twice, yet still remained a power in Cornwall for the rest of Edward IV's reign.

Warkworth's *Chronicle*, which relates the events on St Michael's Mount, ends with the line 'and alle was donne by ther oune foly'[5] – a sentiment that could equally be applied to so many other events throughout history.

STANDOFF AT ST. MICHAEL'S MOUNT

Having taken St Michael's Mount in Cornwall on 30 September 1474, John de Vere, Earl of Oxford, proceeded to put to the test the idea that the 'stronge place and a mygty' was impregnable, for if well victualled 'xx. [20] menne may kepe it ageyne alle the world.' Obtaining victuals was the key, though, and their need for supplies saw them sally out regularly. On one occasion this resulted in the death of Sir John Arundell, one of the commanders of the besieging force, and his body is here seen lying on the beach at the feet of Oxford, Viscount Beaumont and their men, who are daring anyone else to step forward and risk the same fate while their comrades take the valuable provisions back along the causeway towards the fortress, before the tide cuts them off once more.

Gouache, 18" × 14" (45cm × 35cm), 2021.

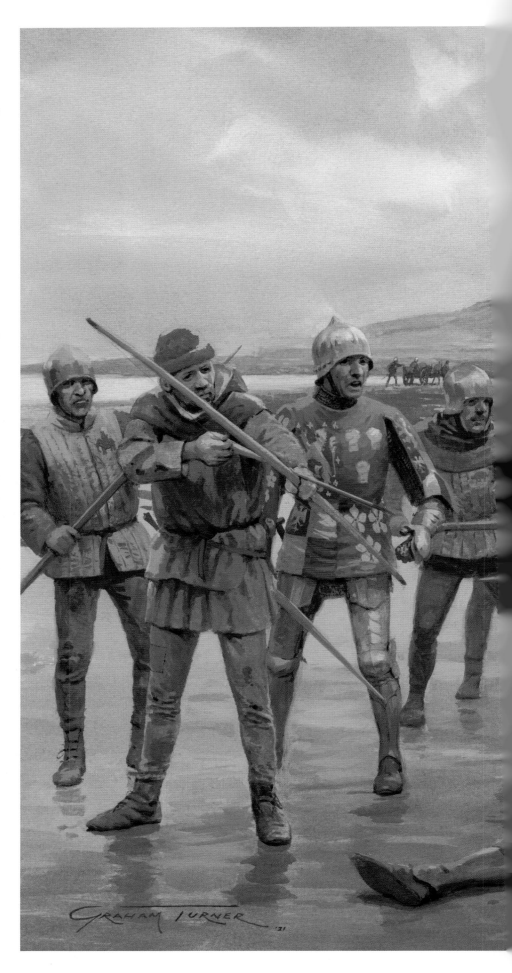

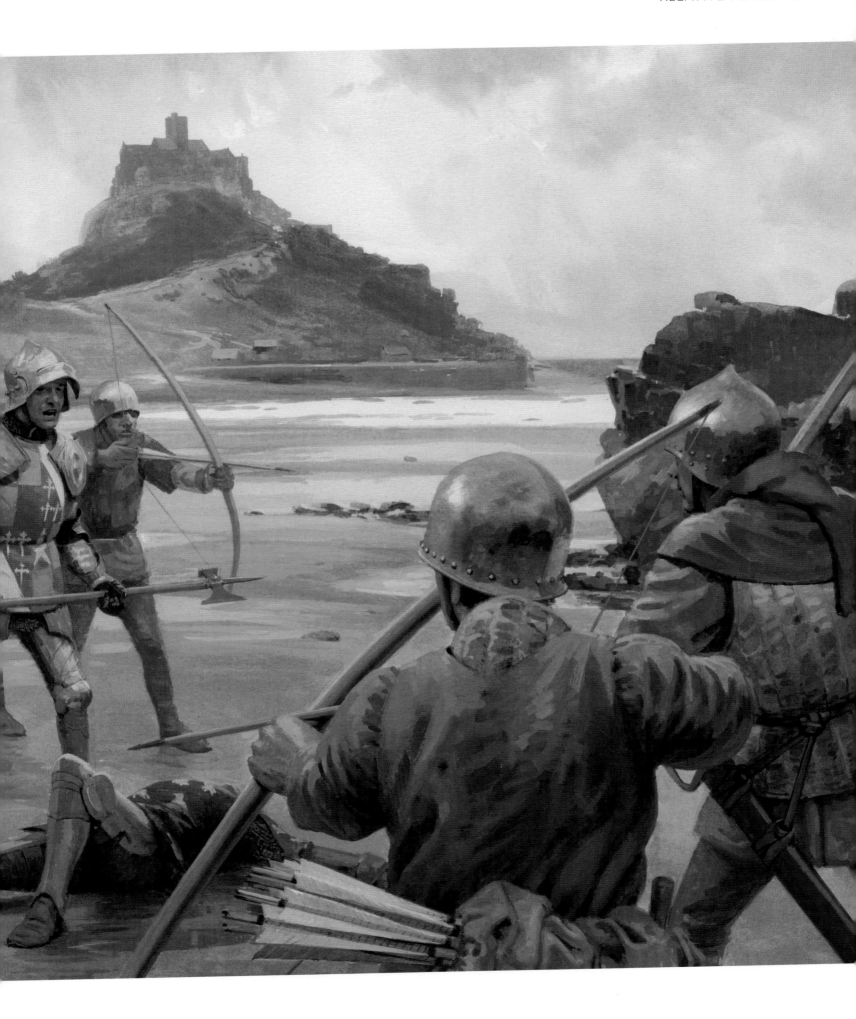

THE KING'S GREAT ENTERPRISE

The earl of Oxford's efforts in Cornwall did not distract King Edward unduly, and as he continued with the business of kingship, a major priority after his restoration in 1471 was England's relationship with her continental neighbours. Edward wanted revenge on Louis XI for his part in supporting Warwick's rebellion, while Louis's efforts remained focused on bringing Burgundy and Brittany under French rule. Overtures from the duke of Brittany in 1472 resulted in Earl Rivers and a thousand archers being sent to aid their defence, a force later re-enforced with further men. A treaty between England, Burgundy and Brittany included plans for an English invasion of France, and to obtain Parliament's approval King Edward used the argument that pursuing his 'right inheritance' to the throne of France would direct the martial energies of the population into a war with their traditional enemy, rather than against themselves. All came to nothing at this point after Brittany, followed by Burgundy, signed peace treaties with France, and Edward did likewise with a truce to last until 1 April 1474.

Further negotiations resulted in an agreement with Burgundy in July 1474 to wage war on France, and Edward explored every avenue to raise the huge amounts of money required. Ship masters recruited crews and prepared their vessels, including the old *Grace Dieu*, built around 1440, and the *Antony*, purchased by Edward after bringing him safely back to England from his exile in 1471. Bows and arrows were bought in huge quantities and guns were acquired, with all the tradesmen required to service, transport and operate them. Luxury items were purchased too; the king wanted to give the right impression in France.

In June 1475 the largest army to invade France up to that point assembled in Canterbury before shipping over to Calais – 'the most numerous, the best disciplined, the best mounted, and the best armed that ever any king of that nation invaded France with'.[6] This impressive force then kicked their heels in Calais for ten days waiting for their Burgundian allies, who had been occupied besieging the city of Neuss on the Rhine and fighting off French attacks elsewhere, so when Duke Charles eventually arrived it was with only a small retinue and not the mighty Burgundian army that the English expected. From Calais to St Omer they

marched, and on past the site of their ancestor's glorious victory at Agincourt, before arriving outside Péronne, where the Burgundians installed themselves behind the town walls. Brittany had made no move, the Burgundians kept the gates closed, the larger French army threatened, and a long winter campaign didn't appeal. When Duke Charles left Péronne in mid-August, the English began negotiations with the French, who agreed to pay a large sum and an annuity or pension to King Edward in exchange for the English army's return home, the deal cemented by the betrothal of the Dauphin to one of Edward's daughters. The duke of Burgundy was furious when he heard of the agreement. On 25 August, the English army marched to Amiens where King Louis played the generous host, providing large quantities of wine and food – with inevitable consequences. Ashamed of the drunken behaviour of his soldiers, Edward had them ejected from the town and guards placed on the gates. A few days later, on 29 August, at nearby Picquigny on the river Somme, the two kings met in great ceremony on a specially built bridge and the Treaty of Picquigny was concluded.

The English army retired to Calais and from there returned to England, although some enlisted with the Burgundian army for the fighting and plunder they thought they had signed up for. Their soldiers might have been disappointed, but many of the English dignitaries received generous pensions and gifts of money and plate, so, even though some were unhappy that the expedition's aims had been so readily abandoned, they returned home much richer men.

BELOW Part of the muster roll for Edward IV's French expedition of 1475, listing some of the leading captains with sketches of their badges. At the top is the duke of Clarence with his black bull; then Richard, Duke of Gloucester and his white boar; next the white lion of the duke of Norfolk; the duke of Suffolk's double-tailed lion; finally, the Stafford knot of the duke of Buckingham. (Redrawn from the College of Arms MS 21716)

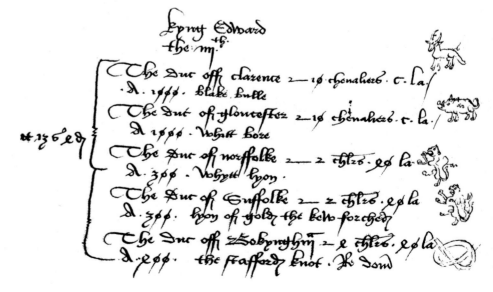

'the Kyng oure Soverayn Lord, is disposed by the grace of God in his owne persone to passe forth of this his seis Reame, with an Armee Roiall, for the saufegarde of the same Reame, the subduing of the auncien ennemyes of hym and of his seid Reame'

Rotuli Parliamentorum

Despite resentment about the huge cost and the hurt to English national pride, the ignominious result of the French expedition didn't result in quite as much trouble at home as was predicted by some, although the king was forced to come down hard on a rash of lawlessness caused primarily by the disbanding army. The lifting of commercial restrictions made some producers and merchants better off, and the French payment and pension also allowed the king to pay his debts and live largely independent of taxation for the remainder of his reign.

THE FALL OF THE DUKE OF CLARENCE

King Edward now had time and money to indulge, something he clearly enjoyed. At Picquigny an observer described him thus: 'He was a very good-looking, tall prince, but he was beginning to get fat and I had seen him on previous occasions looking more handsome.'[7] Edward had established himself as a military commander at Mortimer's Cross and Towton in 1461, cementing his reputation in 1471 with his decisive action and victories at Barnet and Tewkesbury, although some observers regarded the French expedition of 1475 to be a blemish on his otherwise outstanding military reputation. He would never lead an army into battle again, and as he enjoyed the peace he had earned, his enjoyment of the pleasures of life began to have an effect.

There was one problem that refused to go away, however, threatening to spoil these years of peace and prosperity for Edward, and that was his brother George, Duke of Clarence.

After Edward had forgiven him his treasonable behaviour of 1469–71, Clarence showed little appreciation of just how fortunate he had been to not only remain alive, but also retain his privileged position. The earl of Warwick's death at the Battle of Barnet had left his daughter, Anne, an extremely wealthy and eligible heiress, and as her very brief marriage to the Lancastrian Prince Edward had ended when he met the same fate at Tewkesbury, she was now available for marriage once again. When Richard, Duke of Gloucester, proposed to marry her, his brother Clarence – married to Anne's older sister Isabel – responded angrily; he wanted the entire inheritance himself. In Richard, Anne would have a husband powerful enough to protect her rightful share of her family inheritance; whether there was any other attachment between them at this stage is unsubstantiated, although they will have no doubt spent time together in her father's household, where Richard spent some of his formative years. Richard and Anne were married in 1472, but the dispute continued, and the king was forced to intervene to try to keep the peace between his brothers. Clarence was awarded the titles of earl of Warwick and Salisbury, along with a generous number of estates, but he was still not satisfied. A large proportion of the inheritance still belonged to Warwick's widow, Anne Beauchamp, who had taken shelter in Beaulieu Abbey. This was the Beauchamp inheritance that had helped split the warring factions before the First Battle of St Albans, and the squabbling brothers resorted to an act of a submissive Parliament to ride roughshod over her rights by effectively regarding her as 'nowe naturally dede'.[8] It was not their finest hour.

Clarence's wife Isabel died at Warwick Castle on 22 December 1476, two and a half months after the birth of a son, who would live for only a few days after his mother. Suggestions that Clarence might marry Mary, daughter and heir of the duke of Burgundy, or, alternatively, the sister of King James III of Scotland, were rejected by King Edward; either match, but especially the Burgundian option, could result in Clarence acquiring the resources to threaten his brother's throne (rumours that this is what he desired being fanned by the arch-schemer Louis XI). An aggrieved Clarence responded petulantly, avoiding the king and refusing to speak in council. He vented his anger on a former servant of his wife, dragging her into court and intimidating the jury into finding her guilty of poisoning the late duchess, then promptly had her hanged. In another episode, a member of Clarence's household was found guilty of colluding with 'a great sorcerer' to predict the king's death,[9] as well as

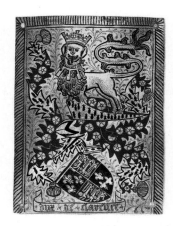

ABOVE **Garter stall plate of George, Duke of Clarence, at St George's Chapel, Windsor.**

'a moch higher, moch more malicious, more unnaturall and lothely Treason'

Rotuli Parliamentorum

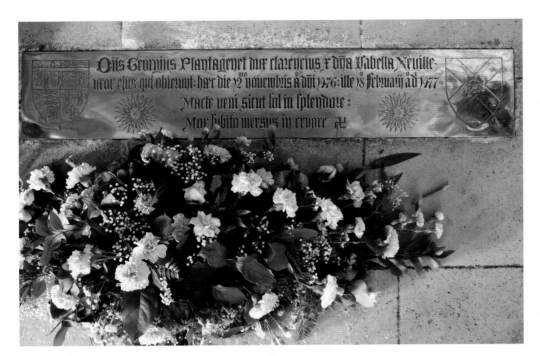

inciting rebellion, and in an outburst at a council meeting the duke had the defiant speech his man had made before execution read aloud. A despairing Edward had his brother arrested and detained in the Tower. On 19 January 1478 he was charged with treason, which Edward declared was a 'moch higher, moch more malicious, more unnaturall and lothely Treason' because it emanated from his own brother, despite his repeated forgiveness of past betrayals.[10] Parliament decided that 'George Duke of Clarence, be convicte and atteyntit of Heigh Treason',[11] but Edward hesitated for several days before the sentence of death was carried out privately in the Tower, popularly believed to be by drowning in a butt of malmsey wine at Clarence's own choice.

ABOVE LEFT **George, Duke of Clarence, was interred in Tewkesbury Abbey, alongside his wife Isabel.**

ABOVE **The Tower of London.**

ENSURING THE DYNASTY

By the close of 1475 Queen Elizabeth had provided Edward with two sons and five daughters, and would go on to give birth to three more. Each provided opportunities for their father's aggrandisement and the future prosperity of their dynasty through the arrangement of suitable marriages, and over the coming years negotiations would be conducted throughout Europe.

With their eldest daughter Elizabeth and third daughter Cecily betrothed to the heirs to the thrones of France and Scotland respectively, and a suitable bride for Edward, Prince of Wales, being sought in the courts of Spain, Austria and Milan, their second son Richard was the only one to be matched within the English nobility. When John Mowbray, Duke of Norfolk, died in January 1476, he left his infant daughter as his sole heir, making her an enticing prospective wife for the royal prince. Anne Mowbray's marriage to Richard, Duke of York, took place amidst all the spectacular pageantry and magnificence

of the Yorkist court at Westminster on 15 January 1478, when the bride and groom were around five years old. As she was paraded through the palace from the queen's chamber, Anne's tiny hands were held by Earl Rivers and the earl of Lincoln, and on entering the crowded St Stephen's Chapel, she was led to join her future husband Prince Richard, his parents the king and queen, and other family members, who waited for her under a canopy of cloth of gold. A papal dispensation was required because of the children's 'nearness of blood' (they were both descended from Edward I), and once this had been proclaimed the marriage ceremony itself took place, performed by the bishop of Norwich. As the wedding party prepared to move to the king's great chamber for spices and wine before the matrimonial feast, the duke of Gloucester cast gold and silver 'amongst the comone people'.[12]

The celebrations continued: on 18 January (the day before Clarence was accused of treason), King

'Oyes! Oyes! Be it understand to all men, that, upon knowledge had howe the moste highe, most excellent and most victorious prince, the Kinge our allers soveraigne and liege Lord, purposeth to solemnize the marriage betwixt his right deare sonne Richard Duke of Yorke, Marshall of England and Earl of Nottingham, and the right noble Lady Anne Mowbreye, daughter and sole heire unto the high and mighty prince, John, late Duke of Norff.;... and because the laudable and noble custome of this martiall and triumphant realme in tyme past hath bine, at such high days of honour, exercises and feates of the necessary discipline of Armes were shewed and done, to experience and enable nobles to the deserving of Chivalrie'

Proclamation and Articles of the Enterprise of Six Gentlemen Challengers, to Answer All Comers at the Justes Royal, the Tilt, and the Tournay, 10 December 1477

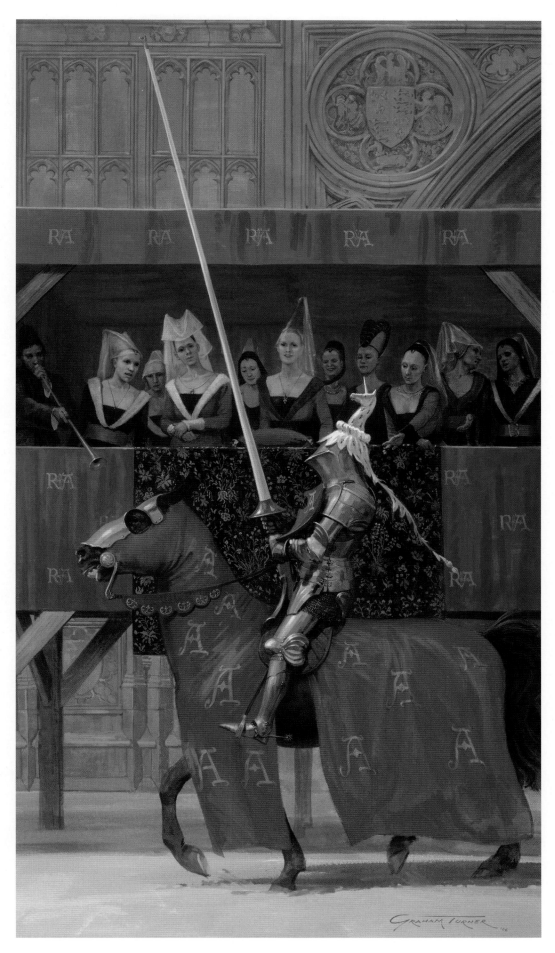

LADIES' FAVOURITE

'And there entered, first, my Lord Marquis of Dorsett, armed in great triumph'

Thomas Grey parades past a stand full of ladies at the jousts and tourney held at the Palace of Westminster to celebrate the marriage of Richard, Duke of York, and Anne Mowbray, on 22 January 1478.

Gouache, 12.5" × 23"
(32cm × 58cm), 2006.

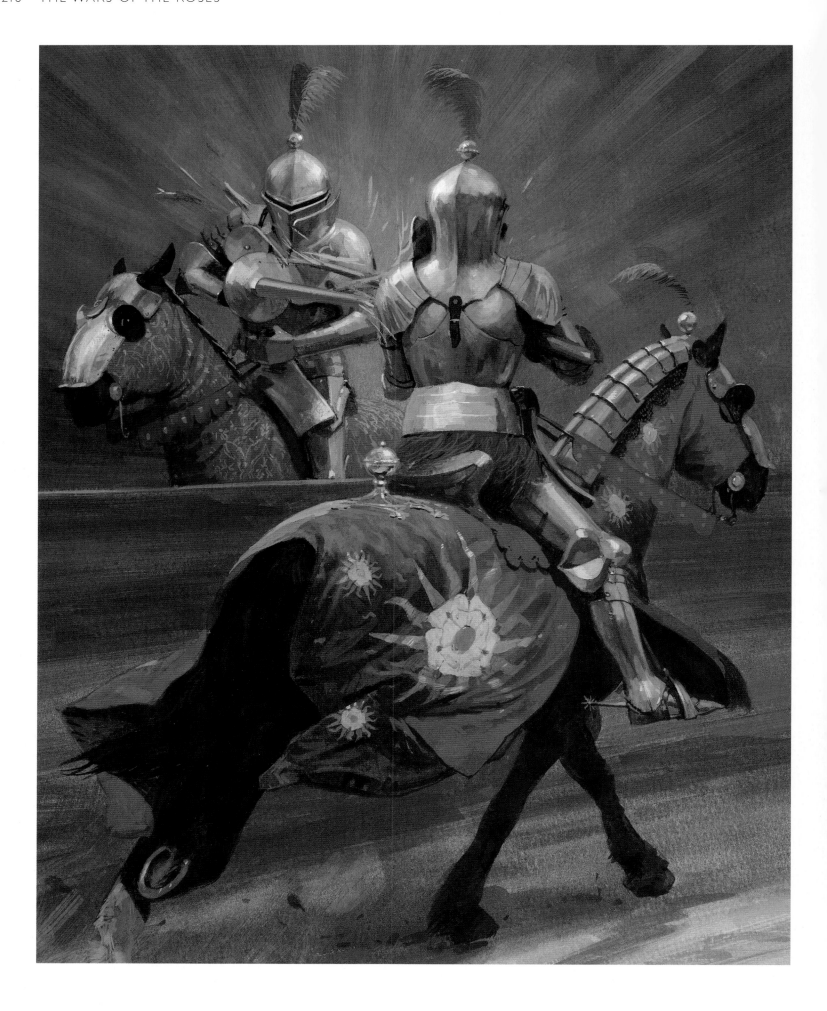

Edward created 24 knights of the Bath, and on the 22nd, jousts and tourneys were held at Westminster. The challenge had been proclaimed by heralds over a month before – six defenders would take on all comers in three disciplines: 'Justes royall, with helme and shield', 'Osting harneis, alonge a Tilt', and 'to strike certaine strokes with Swoardes, and guise of Torneye'.[13] The defenders' shields or guardbraces (re-enforcing plate for the left shoulder) would be painted blue and tawney, the livery colours of the duke of Norfolk, and decorated with a letter A, E or M, each with a precious stone (the A and M likely signifying the initials of Anne Mowbray, and the E Princess Elizabeth, the groom's eldest sister).

The first defender to enter the lists was Thomas Grey, Marquess of Dorset (Queen Elizabeth's son from her first marriage), 'armed in great triumph for the Justes Royall.' The duke of Buckingham bore his helm, with the knights and squires attending him clothed in his colours of white and murray. Five coursers followed, 'with rich trappers, cloth of gould, cloth of tissue, and crimson velvett' decorated with gold embroidered 'A's, a sixth horse led in hand for 'the accomplishment of his armes'.[14] He was followed by his brother Richard in a similar display of magnificence, with his companions clad in the Norfolk blue and tawney livery. With a theatrical flourish, the celebrated Anthony Woodville, Earl Rivers, emerged from 'the house of an Hermite, walled and covered with black velvett' dressed in the habit of a 'White Hermite', which his servants pulled from him to reveal him fully armoured for the tourney. Of the challengers, several sported the Yorkist blue and murrey colours, decorated with 'roses of silver in suns of gold'.[15]

The jousting and tourneying was well fought, with many 'speares, well and laudably broken' upon their opponents, and sword strokes exchanged 'with ardent courage'. All seemingly came away with enhanced reputations from their display before the king and queen, the royal family, 'other dukes and earles, ladyes and gentlewomen', and foreign ambassadors, and the festivities concluded with dancing and the presentation of awards by Princess Elizabeth.[16]

Anne Mowbray, the little girl at the centre of all these dynastic negotiations and bewildering ceremonies, would tragically not grow old enough to have any opportunity to enjoy her marriage. She died in 1481 just before her ninth birthday.

In an act not dissimilar to the disinheriting of the countess of Warwick, Anne's legal heirs were overlooked in favour of her young husband, Prince Richard. William, Viscount Berkeley – of Nibley Green notoriety – had previously surrendered his rights in exchange for his title and the cancelling of large debts, but John, Lord Howard, received no acknowledgement. He would, however, land on his feet in 1483 when he was granted the dukedom of Norfolk itself.

LEFT
JOUST

Lances shatter as two of the participants clash during the 1478 tournament at Westminster.

Gouache, 10" x 14" (25cm x 36cm), 2005.

RIGHT In 1191 the tomb of Arthur and Guinevere was claimed to have been discovered at Glastonbury, 'in former times called the Isle of Avalon'. The remains were subsequently moved to a new tomb in the centre of the church, where they remained until the dissolution of the abbey in 1539.

CHIVALRIC KNIGHTS AND FAIR LADIES

Our perception of the Middle Ages is intrinsically linked to tales of adventurous knights in shining armour and damsels in distress, specifically the tales of King Arthur and his knights of the Round Table. These stories were very much a part of the chivalric culture of the time and provided examples of the ideals a knight might aspire to emulate, along with dire warnings of pitfalls to be avoided, within the stirring tales of loyal heroes and their daring quests. How these ideals fitted with the brutal reality of war is another matter.

Arthur emerges from the oral traditions of the Dark Ages to be first mentioned in writing in the *Historia Brittonum* (*History of the Britons*), this 9th-century AD text forming a major source for Geoffrey of Monmouth's *Historia Regum Britanniae* (*The History of the Kings of Britain*), written in the 1130s. These early literary 'histories' blended the occasional grain of historical fact with huge amounts of poetic license, Geoffrey claiming to derive his from 'a very ancient book in the British tongue', but more likely drawing on many diverse sources, including his own *Prophetia Merlin* (*Prophecies of Merlin*), to create a narrative that begins with the Trojan War before moving onto Brutus's part in Britain's origins, Julius Caesar's invasion, and the rise of Arthur to defeat the Saxons. It is far removed from today's definition of history, but the popularity of Geoffrey of Monmouth's creation ensured that some still accepted it as essentially reliable until the 18th century. Most importantly, though, he established a literary tradition that would evolve to influence, and be influenced by, the chivalric culture of the age.

By 1155 *Historia Regum Britanniae* had been translated into the French *Roman de Brut*, and the stories evolved to incorporate elements such as the tale of Tristan and Iseult, the Round Table, and important new characters like Lancelot, Perceval and Galahad. The fashionable concept of courtly love was introduced into the stories, most poetically by Chrétien de Troyes writing later in the century. Courtly love, the idea that knights might be inspired to undertake great chivalrous quests for the love of a lady, was famously illustrated in his story of Lancelot and Guinevere, *Le Chevalier de la Charrette* (*The Knight of the Cart*). In Chrétien's final incomplete work, *Perceval* or *Le Conte du Graal* (*The History of the Grail*), he introduces the quest for the Holy Grail, a spiritual element which would become a central theme in the Arthurian romances that would evolve and grow over the coming centuries.

'It befel in the dayes of Uther pendragon when he was kynge of all Englond… Now make you redy said Merlyn this nyght ye shalle lye with Igrayne in the castel of Tyntigayll'
Sir Thomas Malory,
Le Morte d'Arthur

'Yet some men say in many parts of Inglonde that kynge Arthure ys nat dede, but had by the wyll of oure Lorde Jesu into another place; and men say that he shall com agayne, and he shall wynne the Holy Crosse. Yet I woll nat say that hit shall be so, but rather I wolde say: here in thys worlde he changed hys lyff. And many men say that there ys wrytten upon the tumbe thys: Hic iacet Arthurus, Rex quondam Rexque futurus. [Here lies Arthur, the once and future king].'
Sir Thomas Malory, Le Morte d'Arthur

In Germany the stories developed their own character, resulting most successfully in Wolfram von Eschenbach's *Parzival*, written in the early 13th century and the basis for Richard Wagner's famous opera six centuries later. The aristocracy in England were able to enjoy the French chivalric tales, with the first notable poem written in English being *Sir Gawain and the Green Knight* of the second half of the 14th century.

It was however during the Wars of the Roses that the most famous retelling of these legends was written by Sir Thomas Malory, and it is Malory's *Le Morte d'Arthur* that gives us the version of the stories most familiar today. There is still much debate about Thomas Malory's identity, but the strongest candidate belonged to a long-established gentry family of Newbold Revel, not far from Warwick Castle, making it natural that they should seek the good lordship of their powerful neighbours. In 1414 a Thomas Malory is recorded as being in the retinue of Richard Beauchamp, Earl of Warwick, when he took up his position as captain of Calais, and Thomas continued to serve in France for many years. In 1432 his uncle became prior of the English Knights Hospitaller, and two years later he responded to an urgent summons to help defend the order's base at Rhodes. Whether Thomas accompanied him is not recorded, but it would have been just the sort of pious undertaking to have appealed to the knights of the Round Table he would later write about. During the 1440s he was knighted and became a Member of Parliament, largely following the career path of a typical member of the gentry, but from 1450 he was accused of involvement in a succession of crimes that

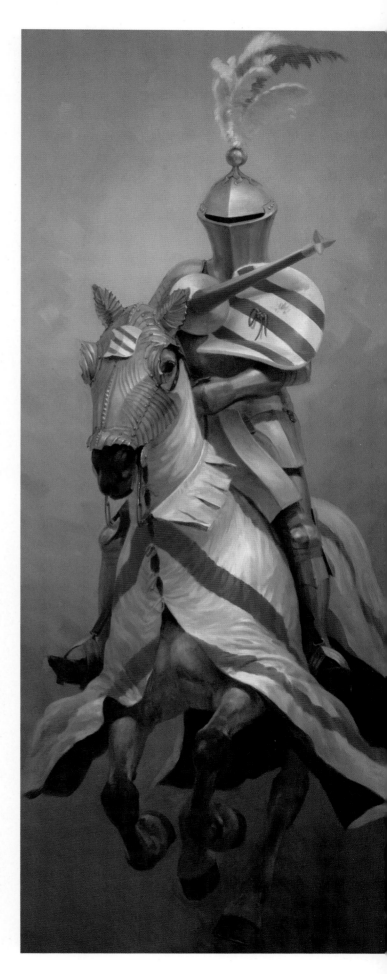

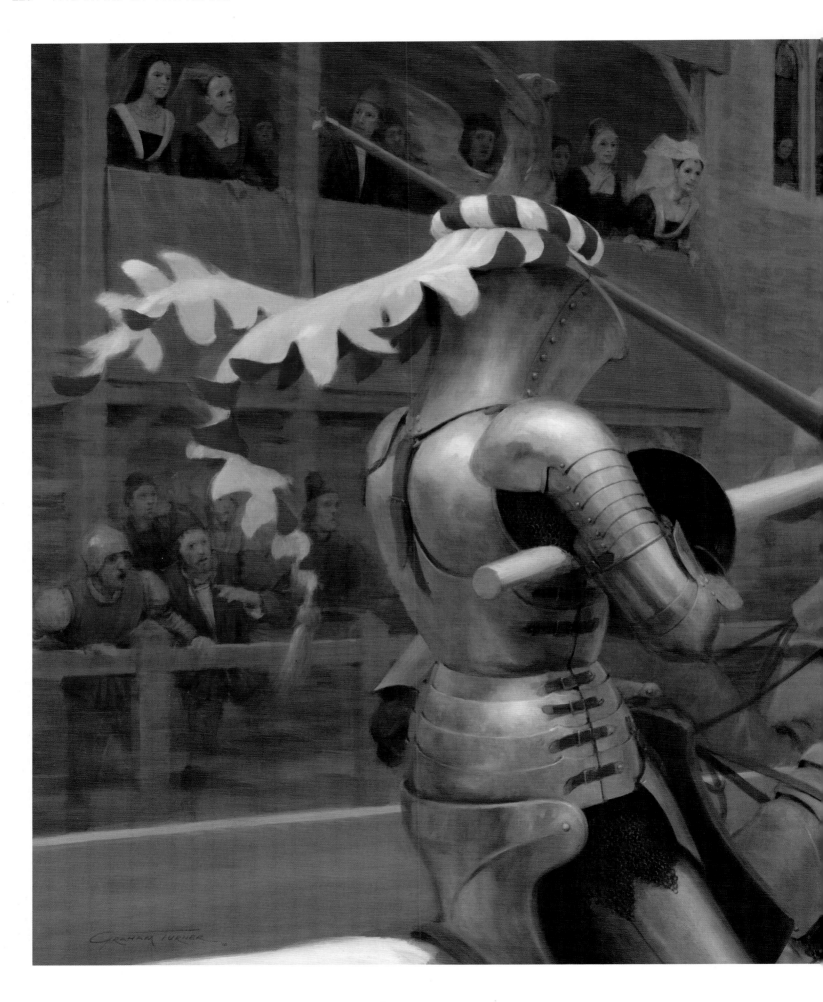

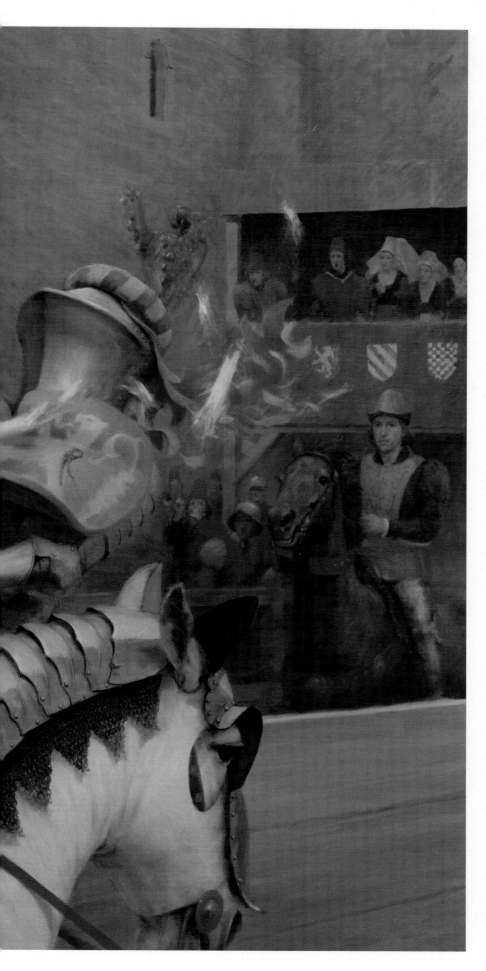

led to him spending several periods in jail, including the Tower of London. He was pardoned by Edward IV in 1462 and was in the north during the sieges of the 1460s, later writing that Lancelot's fortress of 'Joyous Garde' was either Alnwick or Bamburgh. Malory completed his monumental work while back in prison, describing himself as a 'knyght presenor', and he died in Newgate in 1471, a year after finishing his epic tale. Some lines within the book perhaps reflect his own suffering as he wrote them: 'But whanne sekenes toucheth a prysoners body, thenne may a prisoner say al welthe is hym berafte, and thenne he hath cause to wayle and to wepe'.[17]

'And thenne they dressid their sheldes and speres, and came to gyders [together] with alle their myghtes of their horses; and they met so fyersly that bothe their horses and Knyghtes fylle to the erthe, and as fast as they myghte avoyded theyre horses, and putte their sheldes afore them; and they strake to gyders with bryght swerdes as men that were of might, and eyther wounded other wonderly sore, that the blood ranne out vpon the grasse. And thus they fought the space of four hours, that never one wold speke to other one word, & of their harneis they had hewen of many pecys.

And there with syr launcelot kneled doune and yelded hym vp his swerd. And there with alle sir Tristram kneled adoune and yelded hym vp his suerd. "Retorne ageyne," said sir launcelot, "for your quest is done, for I haue mette with sir Tristram: loo here is his owne persone."'

Sir Thomas Malory, *Le Morte d'Arthur*

IMPACT

The moment of lance-shattering impact as 'Sir Lancelot' and 'Sir Tristan' clash in the lists at a late 15th century joust.

Oil on canvas, 40" x 30" (102cm x 76cm), 2010.

In 1344, Edward III held 'a most noble tournament' at Windsor Castle, his birthplace. After three days of jousting, where the king himself was 'held to be the best of the defenders', he announced his plans to 'begin a Round Table, in the same manner and condition as Arthur, formerly king of England, established it.' Building work on a circular hall to house this round table was begun but, when war with France overtook events, his plans were scaled down and replaced with a more exclusive fellowship, the Order of the Garter, in 1348, linked to the new college of St George at Windsor.

In addition to the king, the Order comprised 25 knights, and, as spaces became vacant, new members were appointed by the sovereign. When he took the throne in 1461, Edward IV had 13 vacancies to fill, with another seven in 1472, and he followed the usual protocol of appointing family – his brothers Clarence and Gloucester – and those whose support had earned such recognition, men like John Neville, John Tiptoft, William Herbert and William Hastings. When Richard III became king, his appointees included Francis Lovell, Thomas Howard, Richard Ratcliffe, Thomas Stanley and former staunch Lancastrian Richard Tunstall. Howard was degraded by Henry VII after Bosworth, but restored to the Order in 1489, joining the likes of Jasper Tudor, who had been a knight of the Garter under Henry VI, degraded by the Yorkist kings, then restored by his nephew Henry VII.

Although Henry VI attended many of the annual chapter ceremonies of the Order of the Garter, his queen probably had a far greater understanding and appreciation of the chivalric culture that underpinned it, given that she was the daughter of one of the most notable proponents of chivalry and the arts of the age, René d'Anjou. In 1446 he had organised a tournament with an Arthurian theme at Saumer, the 'Pas de la Joyeuse Garde', and he authored several books, including a popular treatise on the organising of tourneys and the allegorical *Le livre du cuer d'amours éspris* (*Book of the Love-Smitten Heart*).

Edward IV's reign would see a revival in the prestige of the Order of the Garter with his

FOCUS

A 15th-century jousting knight and his horse gallop towards their opponent, moments before impact, both totally focused on their target and what is to come.

Oil on canvas, 20" x 36" (50cm x 91cm), 2012.

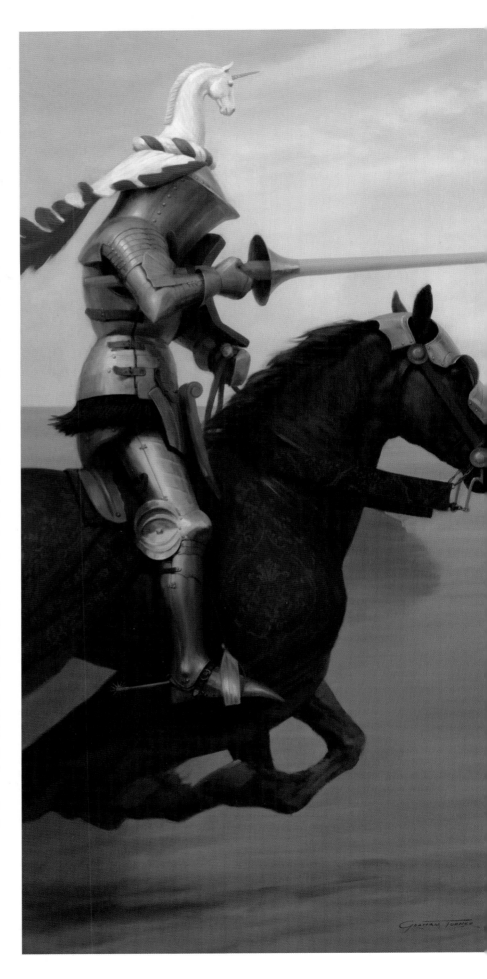

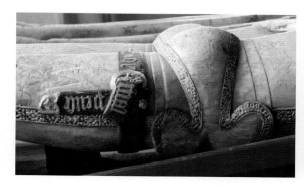

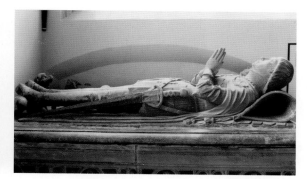

RIGHT The Garter worn by William Phelip, Lord Bardolph (d.1441) at St Mary's, Dennington, Suffolk. The motto reads 'Honi soit qui mal y pense' (Shame on him who thinks ill of it).

BELOW The Winchester Round Table, hanging in the great hall of Winchester Castle. Painted in the 16th century, the timber of the table itself dates from the 13th century. Caxton makes reference to 'At wynchester the rounde table' in his preface to Le Morte d'Arthur, using it, along with the tomb at Glastonbury, as evidence of Arthur's existence.

FAR RIGHT Sir Robert Harcourt, KG, wearing his Garter on his left leg and the Order's badge on his mantle. Sir Robert was one of those sent to escort Margaret of Anjou to England in 1445, a Member of Parliament and a Knight of the Garter from 1461. His feud with the neighbouring Staffords of Grafton would lead to his murder in 1470. Tomb at Stanton Harcourt, Oxfordshire.

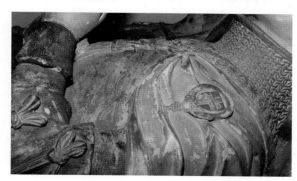

commissioning of the current St George's Chapel, begun in 1475, which would become his final resting place and lasting memorial. Henry VI's remains were moved to St George's in 1484, and Henry VII also originally planned to be buried there, beginning the construction of a new lady chapel for that purpose until he was persuaded that Westminster Abbey was a preferable location. Henry VII christened his oldest son Arthur, but he was never to become King Arthur, dying before his father in 1502 and leaving his brother to succeed to the throne as Henry VIII.

After his return from exile in 1471, Edward began to build up a library of expensive Flemish illuminated manuscripts, no doubt impressed by what he had seen in Burgundy, especially those belonging to his host, Louis de Gruuthuse, whose collection would become

exemplary. These beautiful volumes were the preserve of the very wealthy and were designed to be displayed as a sign of social status, but more modest books found their way into the possession of those with lesser means, men like Sir John Paston. A bill survives from William Ebesham, the scrivener Paston employed to copy 'dyvers and soondry maner of wrytings', detailing his charges for a selection of commissions including a medical 'litill booke of Pheesyk' costing 20 pence, and the 'Grete Booke', which contained a selection of texts such as 'wrytyng of the Coronacion, and other tretys of Knyghthode' and cost twopence a sheet. Amongst the assorted texts Paston selected for his great book are copies of the challenges from two famed feats of arms that took place at Smithfield: Sir John Astley's of 1442 and the 1467 combat between Lord Scales and the

ON TARGET

Keeping a lance steady and on target, while riding a charging horse and with sight limited by the narrow vision slit in the helmet, is a skill that requires considerable training.

Gouache, 21" × 10" (53cm × 25cm), 2010.

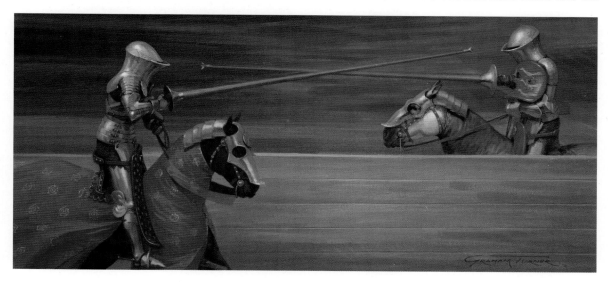

FAR LEFT One of the books commissioned by Edward IV was this chronicle of British history by Jean de Waurin. On this sumptuously decorated page, Edward, enthroned and wearing the Order of the Golden Fleece around his neck, is shown accepting the book from the author. The border includes the arms of England, supported by two lions of March and encircled by a Garter, while the banner held by a knight bears the motto of the Order of the Garter. (The British Library, Royal 15 EIV f.14r)

LEFT Detail from the margin of another of Edward IV's books, showing an angel holding a banner with the arms of England above a white rose. (The British Library, Royal 14 EIV f.10)

Bastard of Burgundy. Paston was slow in paying his scribe: Ebesham beseeches him 'most tendirly to see me sumwhat rewarded for my labour in the Grete Booke', desperately adding a request 'for almes oon of your olde gownes.'[18] A list of books in Paston's possession after 1475 includes copies of 'the Dethe off Arthr', 'the Greene Knyght', 'a Boke off nyw [new] Statuts from Edward iiij' (keeping up with the latest rules), and 'my Boke of Knyghthod and the man[er] off making off knights, off justs [jousts], off Tor[naments]', this last probably referring to his 'Grete Booke', which survives in the British Library.[19]

The hours of skilled labour that went into the creation of the handwritten text and painted illuminations in these books were reflected in their great value, but the invention of the printing press by Johannes Gutenberg would revolutionise this process. William Caxton initially set himself up in business as a printer in Bruges, and a copy of his 1475 book *The Game and Playe of Chesse* appears in John Paston's inventory, specified as 'a Boke in preente [print]'. In 1476 Caxton moved back to England and set up his press at Westminster, printing Anthony Woodville's translation of *Dictes or Sayengis of the Philosophres* the following year, making it one of the first English-language books to be printed in England.

Caxton dedicated his 1484 translation of Ramon Lull's *Ordre of Chyvalry or Knyghthode* to Richard III, this treatise about the virtues of knighthood joining the king's varied collection which included Chaucer's *Canterbury Tales*, Vegetius's *De re militari* (a widely owned textbook on the art of war), Monmouth's *Historia Regum Britanniae* (mentioned above), other assorted histories, treatises, chronicles, romances and religious texts. His collection is considered fairly typical for a man of high rank, but his surviving book of hours perhaps reveals a glimpse into the personal beliefs and feelings of Richard himself. This modest book was probably acquired by him after the death of his wife and son, and the prayers he chose to add may have provided him with some support through this time of sorrow; 'O most sweet lord Jesus Christ… deign to release me from the affliction, temptation, grief, sickness, need and danger in which I stand'.[20]

In 1485 Caxton printed Sir Thomas Malory's *Le Morte d'Arthur*, ensuring it would survive to become one of the best-known works of medieval literature, one that still inspires to this day. His preface contains the words: 'For herein may be seen noble chyvalrye, Curtosye, Humanyte, frendlynesse, hardynesse, love, frendshyp, Cowardyse, Murdre, hate, virtue, and synne. Doo after the good and leve the evyl, and it shal brynge you to good fame and renommee [renown].'[21]

ROYAL MAJESTY

'Item, it shall nede that the kyng have such tresour, as he mey make new bildynges whan he woll, ffor his pleasure and magnificence; and as he mey bie hym riche clothes, riche furres… rich stones… and other juels and ornamentes convenyent to his estate roiall. And often tymes he woll bie riche hangynges and other apparell ffor his howses; vessaill, vestmentes, and other ornamentes for his chapell; bie also horses off grete price, trappers, and do other suche nobell and grete costes, as bisitith is roiall mageste… Ffor yff a kyng did not so, nor myght do, he lyved then not like his estate, but rather in miserie. and in more subgeccion than doth a private person.'
Fortescue, *The Governance of England*

The conspicuous display of wealth was an expected part of the king and his lords' social standing, something that Edward IV fully understood and embraced. The established hierarchy provided order within society, and the king was expected to spend huge sums demonstrating his wealth and power to his subjects and foreign dignitaries. In 1471, when Henry VI was paraded through London in a last-ditch attempt to gain support in the face of the approaching Edward IV, his shabby appearance had the opposite effect, apparently pleasing 'the citezens as a fier paynted on the wall warmed the old woman'.[22] A king should look like a king, and this was something that came naturally to Edward. A complimentary overseas visitor remarked in 1466 that Edward IV 'had the most splendid court that could be found in all Christendom.'

Edward spent considerable amounts on his appearance: fine clothes, cloth of gold, silk and velvet damasks, furs and jewellery. His wardrobe accounts include lists of sumptuous clothing, such as: 'A longe gowne made of blue clothe of gold upon satyn grounde… lyned with grene satyne; a demy gowne made of tawny velvett lined with blac damask; a longe gowne of white damask furrid with fyne sables'.[23]

In all levels of society, men's basic garments were the doublet and hose, usually made of wool cloth. The king's accounts show 'doublettes of blak satyn' and 'purpull velvet', while the gentry Paston family, although they possessed some garments made of rich fabrics, for the most part appear to have been far more modestly clothed; a request for 'worsted for dobletts, to happe me thys cold wynter' shows practical considerations taking priority over display.[24] The separate legs of hose earlier in the century were now joined, and the waistline gradually rose as the century progressed. They were supported by laces, or 'points', tied through pairs of holes to the close-fitting doublet – in 1463 John Howard paid twopence 'ffor a doseyn poyntes',[25] but the king elevated such a basic item with the addition to his 'points of silk' of 'ageletts of silver and gilt' (the pointed metal tip at each end of the lace).[26] A linen shirt (sometimes silk for the wealthiest) and braies (underpants) were worn underneath. Over all was worn a gown, varying in length depending on the temperature, status, and fashion. The wealthier the individual, the better cut and more fashionable would be his garments, and the more expensive the fabrics. During the third quarter of the 15th century, fashionable men's doublets might have padded shoulders, which when worn with a gown that fell into vertical pleats helped achieve the desired wide-shouldered, narrow-waisted look. Everyone wore a hat; in 1469, John Paston wrote 'I pray yow send me an hat and a bonet by the same man,' and, clearly concerned it might get crushed, 'let hym bring the hat upon hys hed'. He added 'I have ned to bothe, for I may not ryd nor goo owt at the doorys with non that I have, they be so lewde [shabby]: a murry bonet and a blak or a tawny hat.'[27]

Surviving fragment of 15th century voided silk velvet.
(Metropolitan Museum of Art, New York, Rogers Fund, 1909, accession no. 09.50.1013)

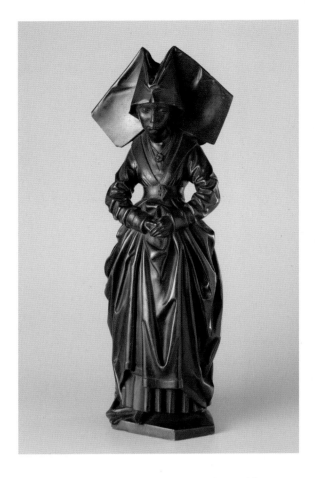

LEFT The memorial brass of one of the wives of Sir Thomas Peyton, *c.*1484, at St Andrew's church, Isleham, Cambridgeshire. She wears a truncated hennin on her head with attached veils, and the design on her gown suggests it is made of expensive silk damask.

FAR LEFT Weeper from the tomb of Isabella of Bourbon, wife of Charles the Bold, Duke of Burgundy (*c.*1475). After her death in 1465, the duke married Margaret of York, sister of Edward IV. (Rijksmuseum, object no. BK-AM-33-G)

The lady's equivalent to the doublet and hose was the kirtle, a full-length dress with a closely fitted body usually made from wool. Underneath would be a linen shift, and over would be the gown, again varying in cut and quality dependent on wealth, status and fashion. For the wealthy this might be fur lined, or just fur collared, and those designed for display at court might have long trains. Waistlines were high, and broad belts with decorative buckles and fittings often worn. Only girls were permitted to go bare-headed, and while poorer ladies and those who had work to do covered their hair with linen cloths, the wealthy wore hats that in some cases appear to defy the laws of physics with their carefully structured veils. The French fashion for exceedingly tall, pointed hats doesn't appear to have caught on in England, where the truncated hennin was popular.

It wasn't only the male Pastons who occasionally found themselves embarrassed by their appearance. After Queen Margaret visited Norfolk in 1453, Margaret Paston wrote to her husband asking 'that I may have somme thyng for my nekke. When the Quene was here, I borowd my coseyn Elysabeth Cleris devys [device], for I durst not for shame go with my be[a]ds among so many fresch [French] jantylwomen as here were at that tym.'[28]

Along with providing details of the dress and belongings of those towards the top of society, the few accounts and letters that survive also give us a glimpse into the lives of those who supplied and served them. In August 1460 'William Bury, serjeant of the poultry,' was commissioned 'to purvey capons, hens, chickens, geese' for Henry VI's court;[29] 20 years later Robert Boylet was paid for 'wasshing of ij pair of she[e]ts and ij pair of fustians that were occupied by Thambassiatours of Fraunce' and William Whyte supplied 'iij dosen… candell for to light whan the Kings highnesse and goode grace on a nyght come unto his said grete Warderobe'.[30] Amongst the vast number of recorded transactions in John Howard's accounts are sixpence paid to 'yonge Petman for his labour in payntenge of the pavyses' (large shields for the side of one of his ships, a 'kervelle'),[31] various sums 'paid to Willyam Cator fore a quartere beff… a pygge… saltfyshe and freshefyshe';[32] and in November 1469 several pairs of shoes were purchased from 'Gyles Clarke, Hanse the cordwaners man of Suthewerke' including 'a peyre of shoys for my master, viij.d. [8 pence]; for Thomas the chylde ij. Peyre shois,xij.d. [2 pairs for 12 pence]; to John of stabelle a paeyre of shoes, vij.d.'[33]

OPPOSITE
DEVOTION

A fashionably dressed 15th-century lady and her faithful deerhound relax near the roaring fire that keeps the cold outside their castle chamber.

Oil on canvas, 22" × 30" (56cm × 76cm), 2003.

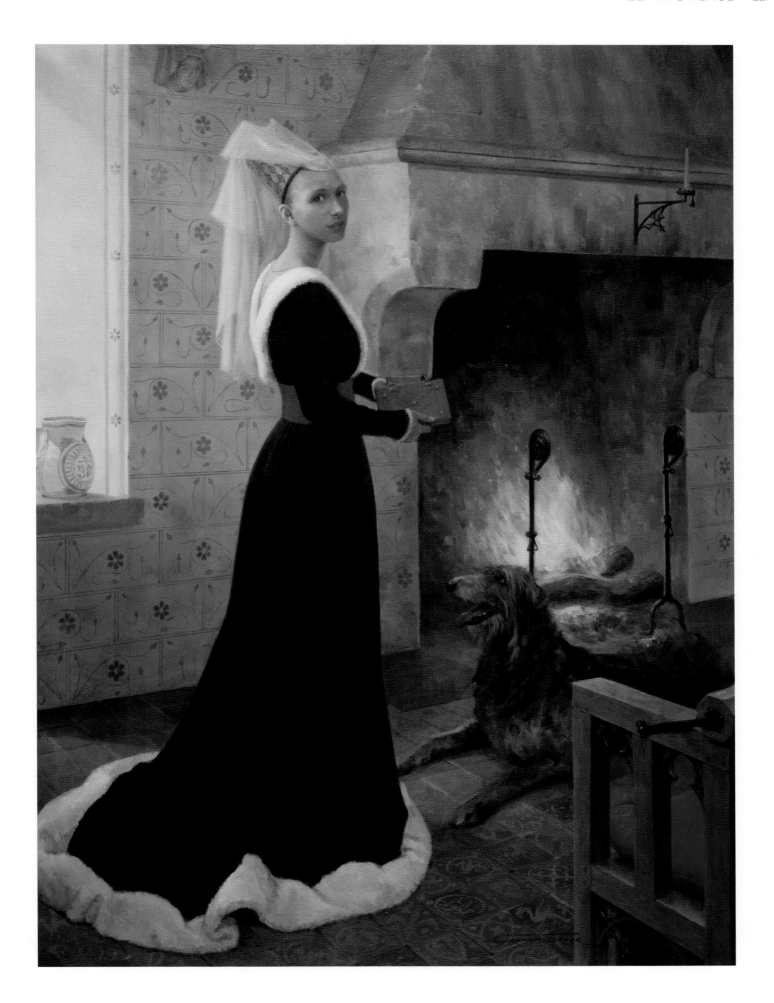

The Paston letters contain sometimes rather personal observations about those they did business with, such as John III's request for hose 'whyche be redy made for me at the hosers with the crokyd bak next to the Blak Freyrs gate, within Ludgate', adding, 'John Pampyng knowyth hym well jnow I suppose.'[34] They also hint at thrift; 'old peces of velvet, reed and roset, to make of jakettes',[35] and '… if ye have any old gownys for lynyngys and old schetys and old shertis'.[36] When looking for fabric to make clothing for her children, Margaret Paston recommended Hay's wife, for she 'have best chepe and best choyce… as it is told me.'[37] When she was shopping for cloth for her own gown, she wrote 'I can non gete in this town better than that I send yow an example of, whiche me thynkyth to simple bothe of colowr and of clothe… all the draperys shopis in this town and here is right febill cheys [choice].'[38]

During the Wars of the Roses, the majority of people probably got on with their lives as best they could, doing what they knew to make their way within the beliefs and framework of society – whether that be painting pavises, making shoes, farming, or any one of the myriad trades that kept society functioning – while hoping for good governance and law enforcement free of corruption. There were occasions when the lower orders decided they'd had enough, such as Cade's Rebellion in 1450, and in 1471, during Fauconberg's attack on London, when men of Essex demonstrated their resentment to the low prices paid for their dairy produce in London.

Unless directly affected by the sporadic outbreaks of warfare life probably went on as normal, albeit in the face of many challenges. As previously mentioned, outbreaks of plague erupted sporadically – 'For behold! on a sudden, the plague, or sweating sickness,

made great ravages'[39] – and the weather also added to the various difficulties the population faced. The freezing weather at the Battle of Towton is well known, but at the opposite extreme 'in xiij. yere of Kynge Edwarde, ther was a gret hote somere, bothe for manne and beste; by the whiche ther was gret dethe of menne and women, that in feld in harvist tyme men fylle downe sodanly, and unyversalle feveres, axes, and the blody flyx, in dyverse places of Englonde.'[40] Later the same year there was 'suche abundaunce of watere, that nevyr manne sawe it renne [rain] so moche afore this tyme'.[41]

In the generally peaceful Thames Valley, the Stonor family would have been concerned with the state of the weather as they tended their estates. Although they were involved in national events – Sir William joined the rebellion against Richard III and fought for Henry Tudor – for the most part their surviving correspondence rarely mentions the troubles outside their local sphere, in contrast with the Pastons' dramas in Norfolk. Their accounts, for example, include payments for 'a peyre of plough wheles', for 'shoyng of xj oxen', 'thetchyng on the berne', and 'for sheryng of xij^xx ix shepe'.[42] There were times when both families were sensitive to feelings of inferiority when they found themselves in the presence of their superiors: while Margaret Paston was embarrassed by her 'beads' (above), Elizabeth Stonor wrote of being with the duchess of Suffolk, who was 'dyspleysyd because that my Cystere Barantyne is no better arrayed [dressed], and leke wyse my Cyster Elysabeth.' She goes on to request that her husband send her 'blewe gowne of damaske', but not to send any more 'ryngis with stonys: ffore the ryng that you sent me by Hery Blakhall, the stone is ffallyn owght be the way and loste: wherffore I ame sorry.'[43]

WAR WITH SCOTLAND

As has already been seen, relations with England's neighbours played a crucial part in events at home, and this would remain the case following the treaty agreed with the French at Picquigny in 1475. Following Duke Charles of Burgundy's initial anger at the treaty, the relationship between Burgundy and England recovered, but the duke's death during the siege of Nancy in January 1477 created a sudden crisis. King Louis was quick to exploit the situation, launching attacks to try to finally crush the independence of the duchy and, in their moment of need, Margaret,

Charles's widow, appealed to her brother, King Edward, for help. While Edward considered the ramifications of siding against France, and therefore losing his valuable pension, Burgundy found help elsewhere, and in August 1477 Charles's daughter and heir, Mary, was married to Maximillian of Austria, son of the Hapsburg Emperor Frederick III.

While Burgundy continued to seek help from Edward, King Louis offered to share the conquered Burgundian lands if he assisted France. Potential marriage alliances were explored as Edward played both

'Appointment to the king's brother Richard, duke of Gloucester, as the king's lieutenant-general to fight against James, king of Scotland, who has violated the truce lately concluded with the king, and his adherents, with power to call out all the king's lieges in the marches towards Scotland and the adjacent counties.'
12 May 1480, Calendar of Patent Rolls

sides against each other throughout 1479, until, in the summer of 1480, a visit from Margaret resulted in a treaty between England and Burgundy, concluded with the betrothal of the recently born Burgundian heir Philip to Edward's daughter Anne. Unsurprisingly, Edward received no payment from France that year, and relations with Scotland deteriorated, stirred up by Louis to distract from the plight of Burgundy.

Since the treaty of 1474, consolidated by the betrothal of King James III's infant son and Cecily, Edward's youngest daughter, relations between England and Scotland had remained good, although anxiety was ever present on the borders, so used to centuries of conflict. A further marriage between King James's sister and Earl Rivers – a widower

since Elizabeth Scales died five years before – was set to take place in October 1479. All this was torn apart when the Scots began raiding along the border 'and molestyd the borders therof with suddaine incursions; wherefor king Edward, with great indignation, determynyd to make warre upon Scotland.'[44]

Richard, Duke of Gloucester, had become the king's power in the north following the destruction of the Nevilles of Middleham, and with Henry Percy, Earl of Northumberland, recognising Gloucester's dominant position with a formal agreement in which he 'promitts [promises] and grants unto the said Duc to be his faithful servant, the said Duc being his good and faithfull Lorde',[45] the two of them mobilised their

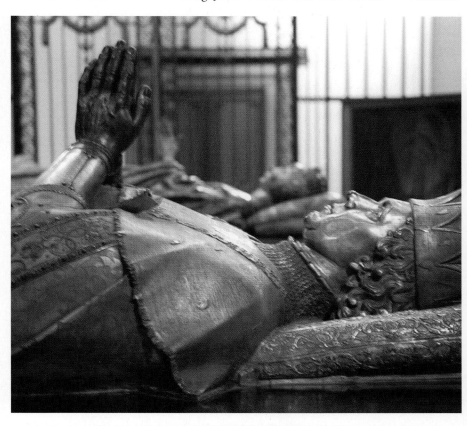

TOP LEFT The tomb of Charles the Bold, Duke of Burgundy, at the Church of Our Lady in Bruges.

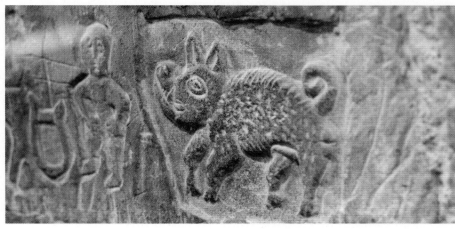

BELOW LEFT Graffiti at Carlisle Castle depicting a boar, the badge of Richard, Duke of Gloucester.

FAR RIGHT The empty shell of the great hall at Middleham Castle.

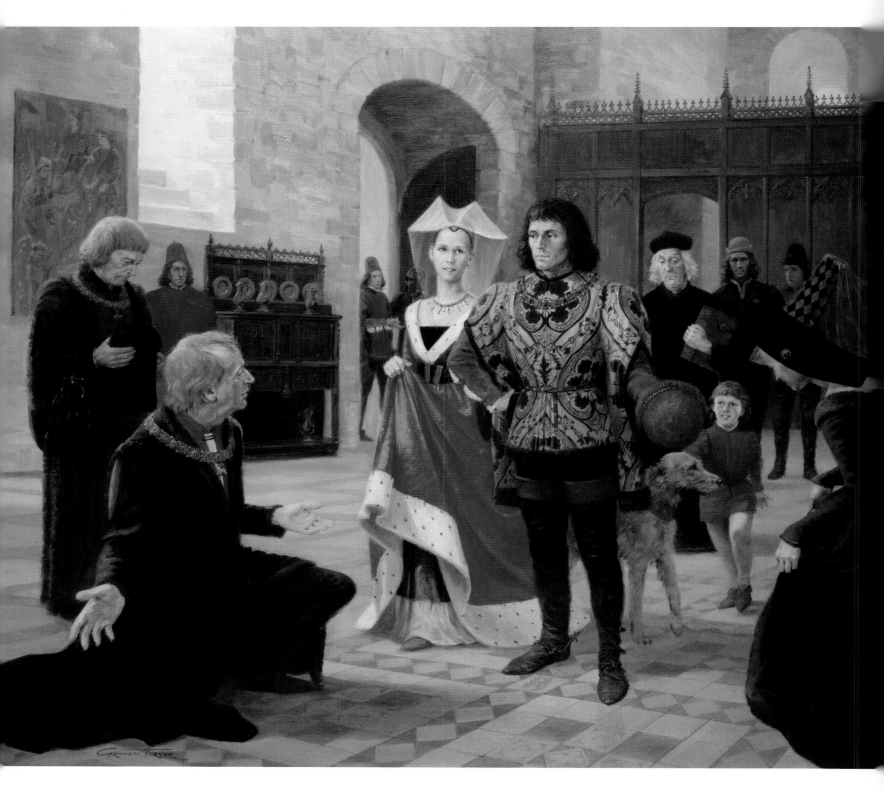

RICHARD, DUKE OF GLOUCESTER, AT MIDDLEHAM CASTLE

Richard, Duke of Gloucester, is greeted by his retainers as he enters the great hall at Middleham, accompanied by his wife and son, Anne and Edward.

Following the death of the earl of Warwick at the Battle of Barnet in 1471, Richard was granted the lordship of Middleham in Yorkshire. He had spent several formative years there as a boy, and it is generally accepted that he preferred Middleham to his other residences. In 1472 he married Warwick's youngest daughter Anne Neville, and their only son Edward was born at Middleham.

Oil on canvas, 30" x 24" (76cm x 61cm), 1997.

*'Grant to the king's brother Richard, duke of Gloucester, and the heirs male of his
body of the castles, manors and lordships of Midelham, Shiref-hoton and Penreth'*
29 June 1471, Calendar of Patent Rolls

forces to counter Scottish incursions that had reached as far as Bamburgh, which was burned.

Lord Howard was appointed to command the fledgling royal navy, which constituted 15 or 16 ships, and in the spring of 1481 the fleet raided along the Firth of Forth. A large land army was also assembled, but delays, possibly caused by the need to simultaneously juggle European diplomacy, resulted in King Edward turning back from Nottingham in October. While this left it too late to mount a full-scale campaign before winter, the English besieged Berwick, which had been in Scottish hands since being ceded by Queen Margaret in 1460, and skirmished across the border.

The fighting continued into 1482, causing 'grete byrnyng, hereschip [hardship] and distructioun' along the border,[46] Gloucester's raids reaching as far into Scotland as Dumfries. In June, an agreement was reached with Scotland's own 'Clarence', King James III's brother Alexander, Duke of Albany, providing him with English backing in his bid for the Scottish throne. By mid-July a large English army, perhaps 20,000 strong, assembled on the border. Berwick opened its gates, although the castle resolutely held out. The Scots advanced to meet the invaders, but division in their own court resulted in James III being seized and several of his courtiers hanged. James was returned to Edinburgh and imprisoned, allowing the English army to advance over a wide front, burning as they went, as the Scots withdrew. When Gloucester's army arrived at Edinburgh, they entered unopposed. It should have been a great triumph, but what followed left many observers critical. Albany renounced his claim to the Scottish throne in exchange for the restoration of his position and property, and with funds for their wages running out the English army returned to Berwick where it largely disbanded; the only success of this expensive enterprise appeared to be the eventual capitulation of Berwick Castle by 24 August.

'[And it was the French king who] encouraged the Scots to break the truce, and to show contempt for the match with our princess Cecily'.[47] King Louis

XI was unwell, though, suffering two strokes in 1481. Maximillian continued to press for English aid, but on 27 March 1482 Burgundy suffered another blow when Duchess Mary was killed in a riding accident. Negotiations were quickly opened between Burgundy and France, resulting in the treaty of Arras at the end of the year; Edward's French pension and the proposed marriage between his eldest daughter Elizabeth and the Dauphin of France were no more.

At the start of 1483 the duke of Albany decided to rebel once again and successfully negotiated English help, but in March he again backed down, came to terms with his brother King James III, and with that the northern front of Edward's foreign policy efforts finally fizzled out too. Albany apparently 'departyd into France, wher not long after he was killyd in running at tylt'.[48] Jousting was a dangerous sport.

At Christmas 1482 Edward had been showing off his new wardrobe of the latest fashions – 'clad in a great variety of most costly garments, of quite a different cut to those which had usually been seen hitherto in our kingdom' – but at Easter he fell ill and died at Westminster on 9 April 1483, three weeks before his 41st birthday.[49]

Louis XI of France would soon follow, dying on 30 August 1483.

A contemporary wrote that Edward was 'neither worn out with old age, nor yet seized with any known kind of malady',[50] but given his lifestyle it has been suggested that he quite possibly suffered a stroke. In his final year a visitor to the court wrote: 'In food and drink he was most immoderate: it was his habit, so I have learned, to take an emetic for the delight of gorging his stomach once more. …he had grown fat in the loins whereas, previously, he had been not only tall but rather lean and very active'.[51]

Edward IV's heir was his 12-year-old son Edward, currently residing at Ludlow under the care of his uncle, Anthony Woodville, Earl Rivers. Yet again a minor was set to inherit the English throne, and the Wars of the Roses was poised to enter its final act.

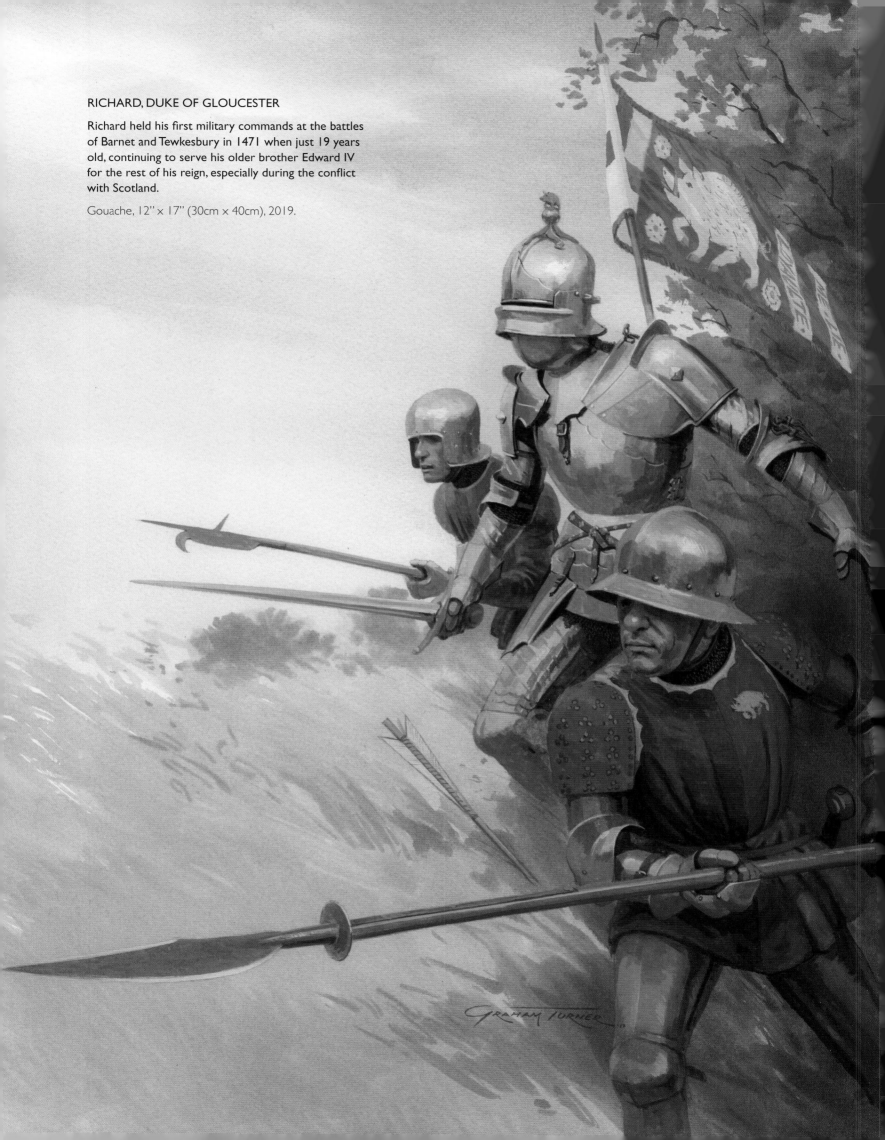

RICHARD, DUKE OF GLOUCESTER

Richard held his first military commands at the battles of Barnet and Tewkesbury in 1471 when just 19 years old, continuing to serve his older brother Edward IV for the rest of his reign, especially during the conflict with Scotland.

Gouache, 12" × 17" (30cm × 40cm), 2019.

CHAPTER 18
RICHARD III

'Still, the ground of these differences was the same in each case; it being the most ardent desire of all who were present that this prince should succeed his father in all his glory… In the meantime, the duke of Gloucester wrote the most soothing letters in order to console the queen, with promises that he would shortly arrive, and assurances of all duty, fealty, and due obedience to his king and lord Edward the Fifth, the eldest son of the deceased king, his brother, and of the queen.'
Croyland Chronicle

As arrangements were being made for King Edward's funeral, fractures and divisions began to appear. Several magnates were concerned about the Woodville side of the new king's family gaining dominance during his minority, and the Woodvilles in turn were against any suggestion that his uncle, Richard, Duke of Gloucester, take a leading role as protector or regent. Fearing what it could lead to, the late king's long-standing chamberlain and friend, Lord Hastings, objected to plans for young Edward V to be escorted from Ludlow to London by a large force of Woodville retainers, and he wrote to Gloucester in the north voicing his concerns. Gloucester had written to the queen and council assuring them of his loyalty to his nephew, and, in York, following a solemn funeral mass for his brother, he led those present to swear fealty to their new king, Edward V. As Gloucester headed south from York, Earl Rivers, with a still substantial retinue of 2,000 men, left Ludlow with young Edward V on 24 April, intending to be in London for his coronation, which was set to be held on Sunday 4 May.

The two parties had possibly arranged to rendezvous before entering London, and it appears that the young king's entourage camped near Stony Stratford in Buckinghamshire on 29 April, from where Rivers and Sir Richard Grey – Queen Elizabeth's younger son from her first marriage, so half-brother to the new king – rode to Northampton to meet Gloucester and the duke of Buckingham. Here the four men apparently enjoyed a sociable evening, but the following morning, Rivers and Grey were arrested, with others from their retinue, and sent north to be imprisoned in Gloucester's fortresses of Middleham, Sheriff Hutton and Pontefract.

Gloucester was appropriately reverent to his nephew the king and explained to him 'that his only care was for the protection of his own person, as he knew for certain that there were men in attendance upon the king who had conspired against both his own honour and his very existence.'[1]

On hearing the news, Queen Elizabeth fled into sanctuary at Westminster with her other children. Edward IV's patronage had provided the Woodvilles with almost all they had; with him gone, they were desperate to secure control over the new king to maintain their powerful positions, and now that young Edward was in the possession of his uncle Richard, and any schemes they may or may not have had to exclude him from power were seemingly undone, their situation was vulnerable.

King Edward V approached London on 4 May, the date originally set for his coronation, having passed through St. Albans and Barnet, the scene of Gloucester's first taste of battle 12 years before. As they entered the city they were greeted by the mayor, officials and large crowds of citizens. Preceding the royal procession were four carts of weapons and armour bearing Woodville badges, claimed to be part of a plot against Gloucester, which was countered by suggestions that it was just a ruse on his part to further alienate the queen's family.

At a meeting of council that began on 10 May, Edward V's coronation was rescheduled for 22 June and he was lodged in the Tower of London in readiness (then a royal palace and the traditional lodging for a monarch before their coronation). The terms of Gloucester's position and authority were agreed, and he was confirmed as protector of the kingdom, with the power to act 'just like another king'.[2] The wheels of Edward V's government turned,

Richard III's badge of the white boar at Fotheringhay.

'for tydynges I hold you happy that ye ar oute of the prese, for with huse is myche trobull, and every manne dowtes other. As on Fryday last was the lord Chamberleyn hedded sone apon noon. On Monday last was at Westm. gret plenty of harnest men: ther was the dylyeraunce of the Dewke of Yorke… my lord protectour recevynge hyme at the Starre Chamber Dore with many lovynge wordys… Yt is thought ther shalbe xx thousand of my lord protectour and my lord of Bukyngham men in London this weeke: to what intent I knowe note but to keep the peas.'

Simon Stalworth to Sir William Stonor, 21 June 1483

business was seen to, and plans for the coronation proceeded. By early June matters took another downward turn for the Woodvilles as their property began to be redistributed, but Richard, Duke of Gloucester, still feared them. On 10 June, he wrote to York and others he knew could be counted on asking the city to provide armed men 'to eide and assiste us ayanst the Quiene, hir blode adherents and affinitie, which have entended, and daly doith intend, to murder and utterly distroy us and our cousyn the duc of Bukkyngham, and the old royall blode of this realme…'.[3] Tensions would ramp up further in a sudden and bloody confrontation at the Tower of London three days later, Friday 13 June. During a meeting of some members of the council, Hastings and others were suddenly accused of treason, and he was dragged outside and immediately beheaded. William, Lord Hastings, had been one of Edward IV's closest and most trusted advisers and friends, and as such is seen as a steadfast protector of Edward's son. Having initially appeared to encourage Richard to take the course of action he had followed, had he now had a change of mind, did he have his own more selfish agenda, or was it a pre-emptive strike by Richard before he took the throne for himself? The mood of some members of the ruling class is perhaps suggested by Lord Mountjoy, who thought it unwise 'to be great about princes, for it is dangerous'. Having seen so many perish over the past three decades, maybe it was preferable to remain uninvolved in the latest succession crisis.

On 16 June, Edward V's younger brother Richard, Duke of York, left his mother's side in sanctuary to join his brother in the Tower, another event that is open to myriad interpretations. On the same day the coronation was postponed until November, and the forthcoming opening of Parliament was cancelled. On 22 June, a sermon was delivered proclaiming that Edward IV's sons could not inherit the throne. The claim had been made

'that the sons of king Edward were bastards, on the ground that he had contracted a marriage with one lady Eleanor Boteler, before his marriage to queen Elizabeth'.[4] In other words, Edward was accused of having been a bigamist and had no legitimate heir. He had certainly earned a reputation as a womaniser, and his controversial marriage to Queen Elizabeth had taken place in secret, so this idea would have been believable to many at the time. Similar rumours had already been spread by the duke of Clarence, along with allegations that Edward himself was illegitimate, charges that at the time had been strenuously denied.

Following the procedure that had led to Edward IV's accession in 1461, a delegation visited Richard at Baynard's Castle on 26 June 1483 and offered him the crown. Richard agreed and went to Westminster Hall, where, dressed in royal robes, he took his seat on the throne and began his reign as King Richard III.

The day before Richard's acceptance of the throne, Anthony Woodville, Earl Rivers, and Sir Richard Grey had been executed at Pontefract. Among the bequests detailed in his will, made a couple of days before his death, Rivers asked that some of his possessions be sold 'and with the money therof be bought shyrtes and smokes to pouer folkes'.[5] After his execution he was discovered to be wearing a hair shirt next to his skin, a sign of his religious devotion.

Richard was crowned on 6 July alongside Anne, his queen, 'accompanied by the entire nobility in royal splendour'.[6] Having processed in great estate through the streets of London the previous day, they entered Westminster Abbey where they were anointed, 'then both the King and the Queene changed them into Cloath of Gold and ascended to their seate where the Cardinall of Canterbury and other Bishopps them crowned according to the custome of the Realme, giving him the Scepter in the left hand, and the Ball with the Crosse in the right

BELOW William, Lord Hastings's Garter stall plate in St George's Chapel, Windsor.

MIDDLE William Hastings's castle at Kirby Muxloe was left unfinished after his death in 1483.

BOTTOM William Hastings's signature. (The British Library, Add MS 43490 f.10r)

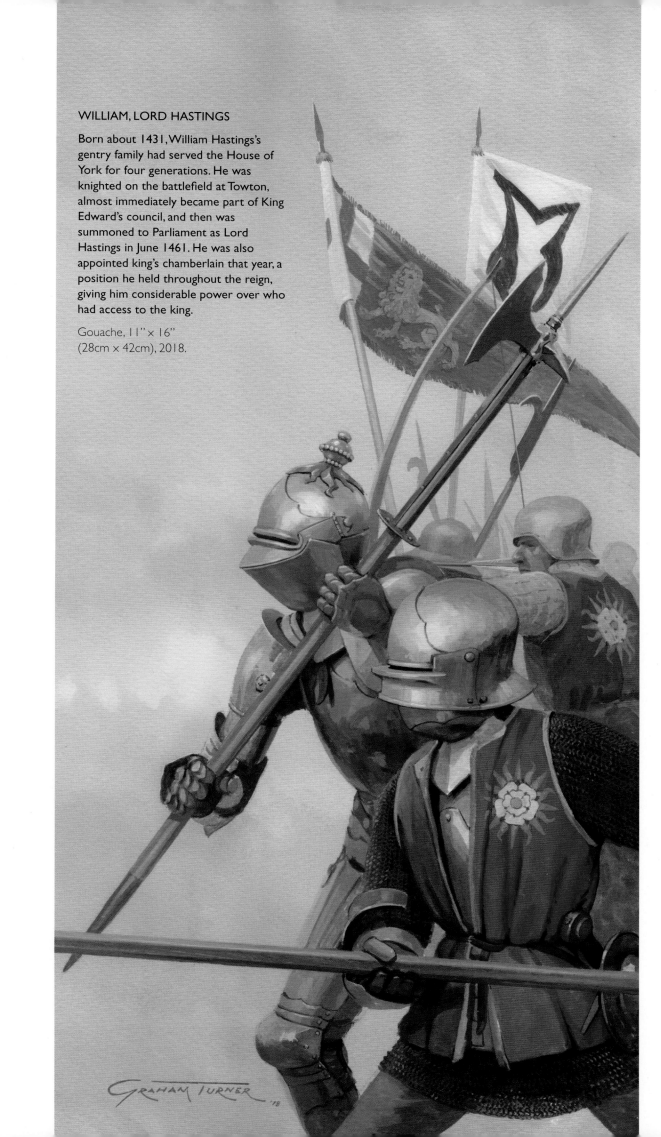

WILLIAM, LORD HASTINGS

Born about 1431, William Hastings's gentry family had served the House of York for four generations. He was knighted on the battlefield at Towton, almost immediately became part of King Edward's council, and then was summoned to Parliament as Lord Hastings in June 1461. He was also appointed king's chamberlain that year, a position he held throughout the reign, giving him considerable power over who had access to the king.

Gouache, 11" x 16"
(28cm x 42cm), 2018.

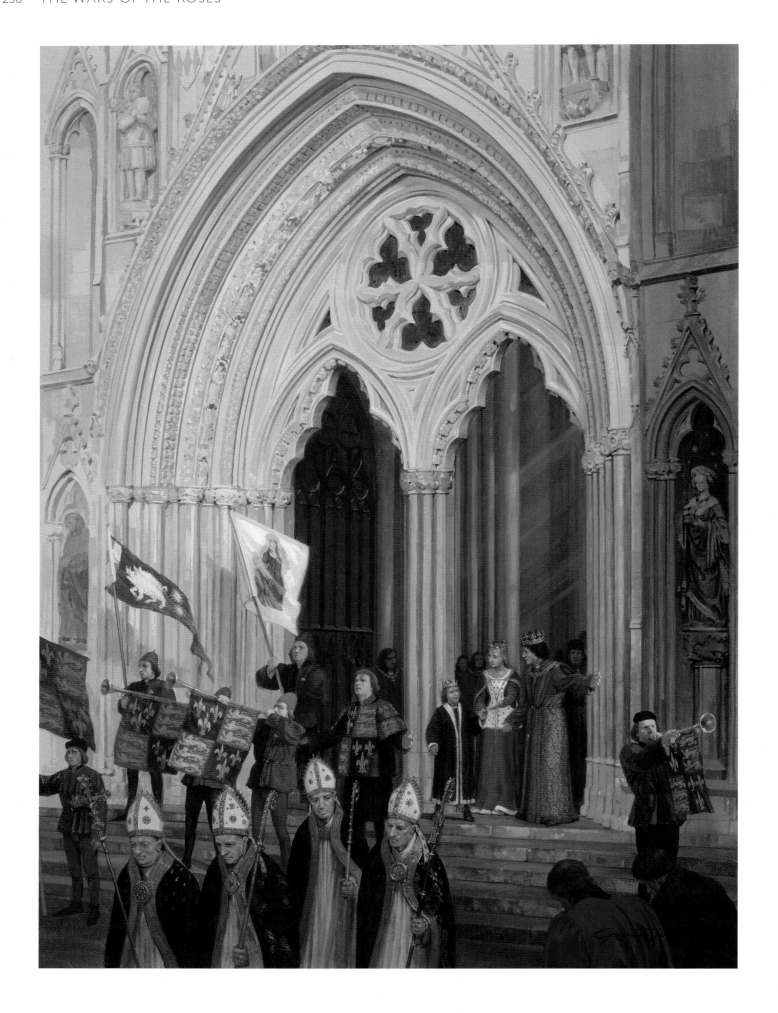

York Minster, where Edward, son of Richard III and Anne Neville, was invested as Prince of Wales in 1484. (Julian Humphrys)

INVESTITURE IN YORK

King Richard III, Queen Anne and their son, Edward, emerge from the gothic grandeur of York Minster on the occasion of Edward's investiture as Prince of Wales.

Gouache, 16" x 21" (41cm x 53cm), 2003.

hand. And the Queene had her Scepter in her right hand, and the rod with the Dove in her left hand.'[7] John, Lord Howard's legal claim to the title of duke of Norfolk had at last been recognized, and he took his place of honour alongside the dukes of Suffolk and Buckingham in the ceremonies, along with the earls of Northumberland, Arundel, Kent, Wiltshire, Huntingdon, Nottingham, Warwick, Lincoln and the new earl of Surrey, Howard's son Thomas.

Buckingham was handsomely rewarded for his support, and, revelling in his new-found position, 'distributed his livery of Stafford knots and boasted that he had as many of them as Richard Neville, Earl of Warwick had formerly had of... ragged staves. But they were greatly inferior in numbers, and it was not long before the underlying hatred between the king and duke began to grow.'[8]

Very soon after their coronation, King Richard and Queen Anne left London and began a progress through the country, stopping at Windsor, Reading and Oxford before arriving at Minster Lovell on 29 July. This was the ancestral seat of Francis, Viscount Lovell, who had first met Richard when they were boys in Warwick's household. The royal party's stately progress continued up the country and a month later they received a spectacular reception as they entered York. Here, on 8 September, the king and queen wore their crowns as their son, Edward, was ceremoniously invested as Prince of Wales at York Minster.

While Richard was in the north, stories of plots against him brewed in London and gossip spread about the fate of the king's nephews in the Tower of London. Had the two boys been murdered in cold blood or just spirited away, and if murdered, by whom, under whose orders, and with what aim? What became of the 'Princes in the Tower' was and remains shrouded in mystery, a mystery that continues to excite passionate debate over five centuries later, but which is unlikely to ever be solved. The seriousness of the plots against the new king became apparent to him in early October and, on hearing of risings in the southern counties, and another in Wales under his recent great supporter the duke of Buckingham, he hurried south and began assembling an army: 'the duc of Bukingham traiterously is turned upon us... and entendeth the utt[er] distruccion of us, you, and all other oure true subgiette... send unto us as many men defensibly arraied on horsbak as ye may godely make'.[9]

The king's supporters also tried to drum up support. Francis, Viscount Lovell, wrote to Sir William Stonor: 'the king hath commawndyd me to sende youe worde to make youe redy, and all our compeny, in all hast to be with his grace at Leyceter the Monday the xx day of Octobyr.'[10] Stonor would fail to comply, side with the rebels, and subsequently be among those attainted.

Richard marched his army towards the 'rebelle and traytour the Duc of Bukingham, to resiste and withstande his maliciouse purpose', but came upon little resistance.[11] Terrible weather had left the region flooded and, finding himself cornered and with his army melting away, Buckingham 'secretly left his people' but was 'discovered in the cottage of a poor man'.[12] Taken to the king at Salisbury, he was executed in the market place on 2 November 1483.

Although unsuccessful, this episode does introduce a new contender for the English throne, Henry Tudor. For 12 years he had been sheltering, or perhaps more accurately, under protective custody, in Brittany with his uncle Jasper, largely ignored but the target of occasional diplomatic attempts by Edward IV to have them returned and Louis XI who wanted them for his own political ends. Henry's claim to the throne was tenuous but he was championed as heir to the Lancastrian kings by his mother, Margaret Beaufort, a claim bolstered by the idea that he should marry Elizabeth, the eldest daughter of Edward IV. Henry's first invasion attempt was funded by the duke of Brittany, but his

little fleet was scattered by the same storms that had swamped Buckingham's attempted uprising in Wales. Finding landfall near Poole or Plymouth, he was suspicious of claims that Buckingham had been successful, so returned to Brittany without disembarking. Here he was joined by Elizabeth Woodville's son, Richard Grey, Marquess of Dorset, and others who had escaped the collapsed revolt. Also among Tudor's growing band of exiles was Sir Edward Woodville, who had been at sea when events took a turn against his family in May, prompting him to sail to Brittany with substantial funds.

'the seid rebelles and traitours have chosyn to be there capteyn one Henry Tydder, son of Edmond Tydder, son of Owen Tydder, whiche of his ambicioness and insociable covetise encrocheth and usurpid upon hym the name and title of royall astate of this Realme of Englond, where unto he hath no maner interest, right, title, or colour, as every man wele knowyth'

Richard III proclamation against Henry Tudor, 23 June 1485

With Henry Tudor evading him, King Richard headed into the West Country to stamp out another area of rebellion before slowly returning to London, which he entered on 25 November. Many of those turning against Richard had been strong supporters of Edward IV, and the oath Henry Tudor swore in Rennes Cathedral on Christmas morning 1483, to marry the late king's daughter Elizabeth as soon as he became king, skilfully drew these disaffected men to his side.

Among much other business conducted at the Parliament held in January and February 1484, Margaret Beaufort 'Countesse of Richmond, Mother to the Kyngs greate Rebell and Traytour, Herry Erle of Richemond' was accused of high treason, for 'sendyng messages, writyngs and tokens to the said Henry, desiryng, procuryng and stirryng hym by the same, to come into this Roialme, and make Werre ayenst oure said Soveraigne Lorde'. The punishment for men for such a crime was to be hanged, drawn and quartered; for women it was to be burned at the stake, but this unusual option for the time was avoided. The king showed mercy by sparing her life, but confiscated all her lands and gave them to her husband, 'remembryng the good and feithfull service that Thomas Lord Stanley hath doon, and entendeth to doo to oure said Soveraigne Lorde'.[13] King Richard was investing in Stanley's future loyalty; it was a gamble that would cost him dear.

Throughout all that had transpired over the past ten months, Elizabeth Woodville, 'late calling her self Quene of England',[14] remained in sanctuary at Westminster. On 1 March, however, for reasons that remain unclear, she allowed her daughters to leave and enter the care of the king, their uncle, after he had publicly declared that he would protect them

and provide for their futures. Elizabeth possibly emerged at the same time – she would later write to her son Dorset urging him to return from France, which he endeavoured to do but was stopped by Tudor's men.

Richard moved to Nottingham in mid-March 1484, a central location to oversee his preparations against possible invasion. It was here in early April that he and the queen received the devastating news of the sudden death of their only child, Edward, at Middleham Castle. Richard and Anne were heart-broken, 'in a state almost bordering on madness, by reason of their sudden grief'.[15] Not long after, Richard wrote to his mother, Cecily, in words that convey his sense of loss: 'Beseching you in my most humble and effectuouse wise of youre daly blissing to my Synguler comfort & defence in my need And madam I hertely beseche you that I may often here from you to my Comfort'.[16]

In June Richard reached an agreement with Brittany, promising to send 1,000 archers to defend their borders against France, in exchange for which Henry Tudor and his rebels would be returned to England. Henry became aware of these plans just before he was detained and managed to slip across the border into France. There, after an initial guarded reception, his presence was eventually recognized as a political opportunity to deter English involvement in France's own struggles. Henry's chances received a further boost following the arrival of John de Vere, Earl of Oxford, who had languished in Hammes Castle, Calais, since his escapade at St Michael's Mount ten years before. His escape, just before a warrant for his return to England arrived, provided Henry Tudor's fledgling court-in-exile with much needed military experience.

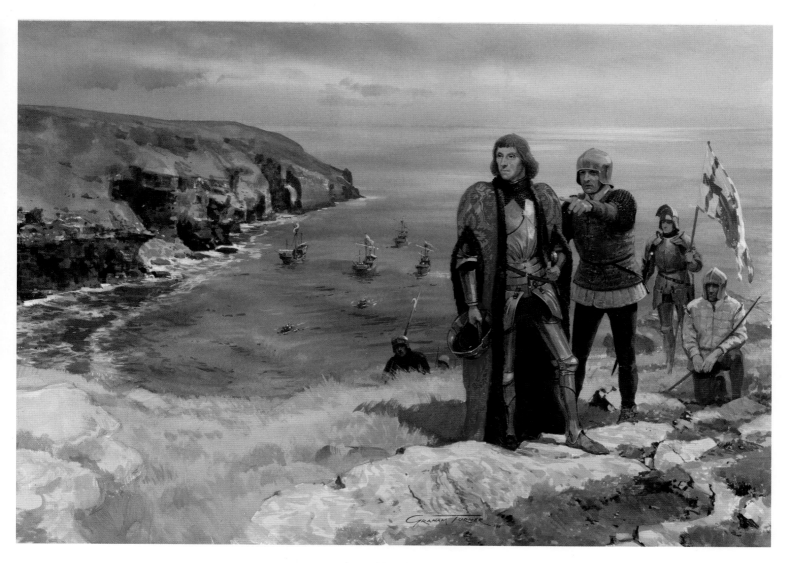

ABOVE
LANDING AT MILL BAY

With his small fleet anchored below him, Henry Tudor stands on the clifftop above Mill Bay.

Gouache, 21.5" x 14.5" (55cm x 37cm), 1999.

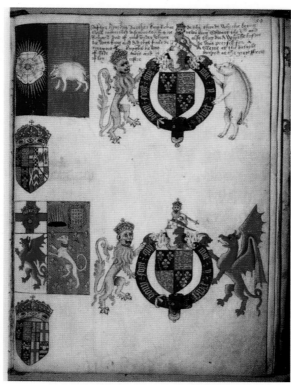

RIGHT
Richard III and Henry VII's arms are depicted in the early 16th century *Prince Arthur's Book*. Richard's white boar badge is shown with his brother's rose en soleil, while the selection of badges used by Henry include the red dragon, greyhound, Beaufort portcullis, sunburst and red rose. (College of Arms, Vincent MS.152)

As 1484 drew to a close and the threat of invasion receded with the approach of winter, Richard returned to London to celebrate Christmas. Not long after the festivities, tragedy struck once again; Queen Anne was taken ill and died on 16 March 1485, possibly from tuberculosis. She would be buried in Westminster Abbey. Rumours soon circulated that Richard had murdered his wife and planned to marry his niece, Elizabeth; where they originated is not known, but the king felt the damage the stories could inflict was serious enough to force him to publicly deny the accusations. Negotiations were begun to find a new wife for the recently widowed king, but not from within his own family. The intended bride was Joanna, sister of King John II of Portugal, and considered alongside this was a possible match between Elizabeth of York and the Portuguese king's cousin, Manuel, Duke of Beja, who would eventually succeed him. However, negotiations would be brought to a sudden halt by the outcome of events in England later that year.

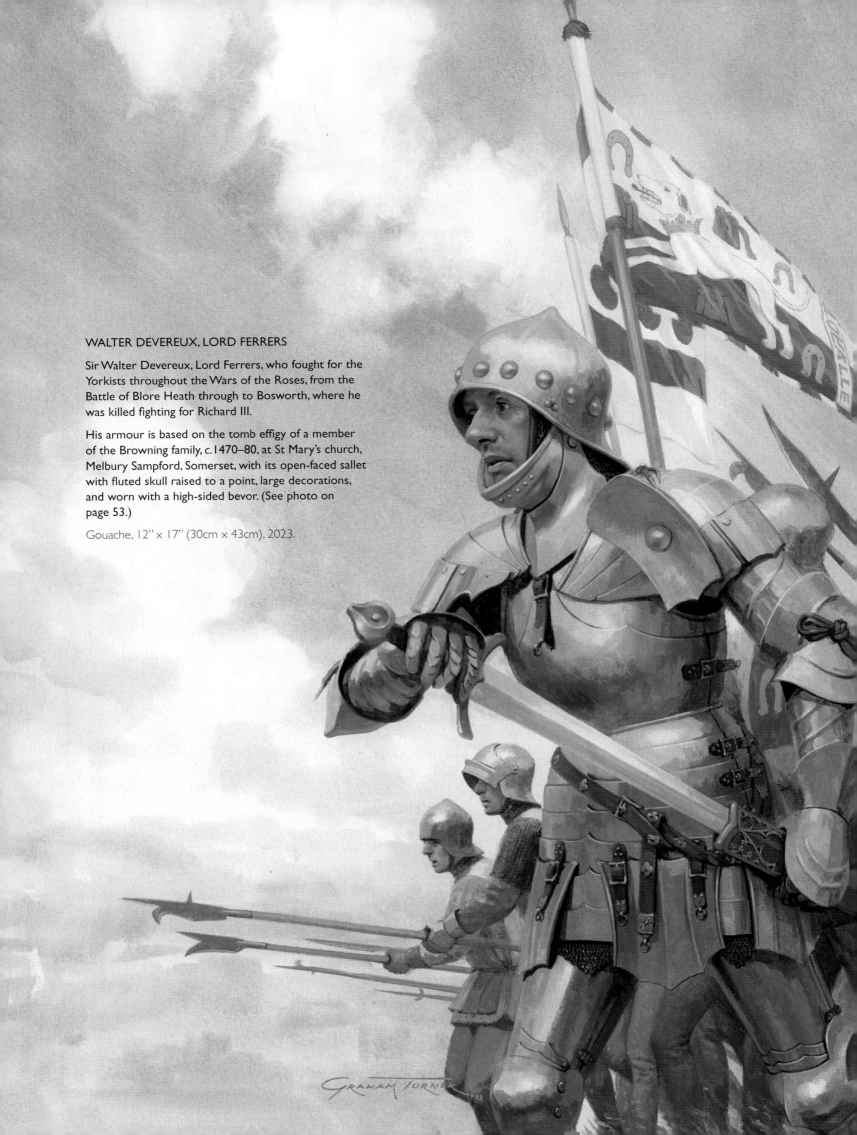

WALTER DEVEREUX, LORD FERRERS

Sir Walter Devereux, Lord Ferrers, who fought for the Yorkists throughout the Wars of the Roses, from the Battle of Blore Heath through to Bosworth, where he was killed fighting for Richard III.

His armour is based on the tomb effigy of a member of the Browning family, c.1470–80, at St Mary's church, Melbury Sampford, Somerset, with its open-faced sallet with fluted skull raised to a point, large decorations, and worn with a high-sided bevor. (See photo on page 53.)

Gouache, 12" × 17" (30cm × 43cm), 2023.

The letter from John Howard, Duke of Norfolk, to John Paston III, asking for him to provide 'seche company of tall men as ye may goodly make at my cost and charge, be seyd that ye have promysyd the Kyng; and I pray yow ordeyne them jakets of my levery'. (The British Library, Add MS 43490 f.53r)

Walter Devereux, Lord Ferrers, was made a Knight of the Garter in 1470. His arms can be seen in several of Graham Turner's paintings, including *The March from Leicester* overleaf.

With France now backing Henry Tudor's enterprise, he proceeded to fit out his ships at Harfleur and assemble his army. His small group of exiled Englishmen was strengthened by a force of mercenaries, mostly French, but also including a number of Scots who had been serving in France. As usual the sources don't agree on numbers, but between 2,500 and 3,000 men seems realistic. King Richard once again placed himself in Nottingham, from where he prepared to meet the attack. Commissions of array had already been issued, and checks made to make sure those previously pledged were still available. 'Furst that they on the kinges behalf thanke the people for theire true and lovyng disposicions shewed to his highnesse the last yere for the suertie and defense of his moost royal persone and of this his Royaulme ayemst his Rebelles and traytors exhorting theim soo to contynue... diligently enquere of alle baillieffes Constables and other Officers of Townes Towneships villages and hundredes within the procinct of theire Commission / the nombre of persones suffisauntly horsed harneysed and arrayed'.[17] As part of the defensive preparations, Francis Lovell was sent to Southampton, there to 'keep a strict watch upon all the harbours in those parts; that so, if the enemy should attempt to effect a landing there, he might unite all the forces in the neighbourhood, and not lose the opportunity of attacking them.'[18]

On 1 August, Henry Tudor's small fleet set sail and, avoiding interception, reached Milford Haven in south-west Wales after a six-day voyage to anchor in Mill Bay. As he stepped onto his home soil, Henry knelt and 'with meke countenaunce and pure devocion' recited the psalm: 'judica me Deus et decerne causam meam &c' ['Judge me, O God, and distinguish my cause'].[19]

The area was sparsely populated and nearby Dale Castle was soon under their control. On 8 August Henry moved from their remote landing site to Haverfordwest, where they were joined by their first local recruits and received some encouraging messages of support from those who remembered Jasper Tudor from the years before he was forced from his homeland. His old castle at Pembroke, where his nephew Henry had been born, was nearby on the opposite side of Milford Haven, and the earl clearly retained strong loyalties in the region. Nervousness over their fragile position was increased when rumours spread that a strong royal force was approaching, but it turned out to be more soldiers to bolster their ranks from Carmarthen. The small army continued north-east along the Welsh coast before turning inland to march 'through rugged and indirect tracts' through the mountains of central Wales towards Shrewsbury.[20] As he travelled, Henry sent out letters to potential supporters, wording them as if he was already king and stressing his

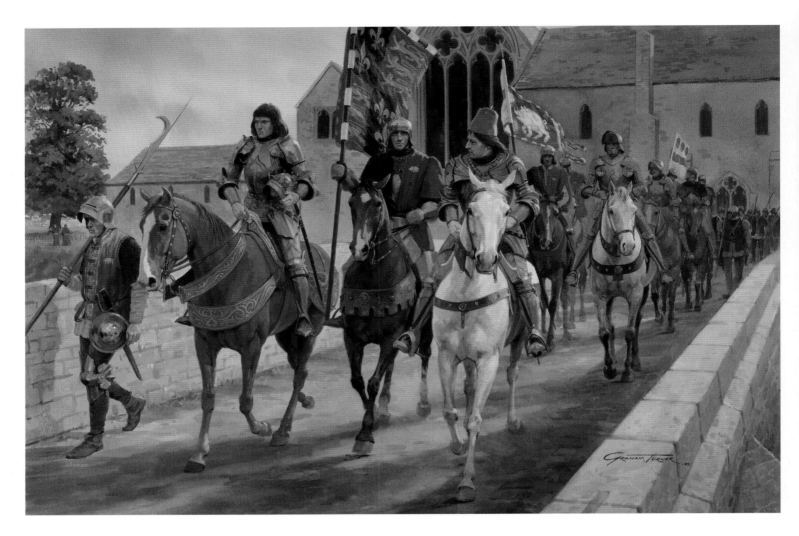

commitment to Wales. He also wrote to his mother and her husband, Lord Stanley, who was raising troops in the king's name. More men continued to join them as they advanced, but the approach of another significant force, raised by powerful local landowner Rhys ap Thomas, caused concern. When in France Henry had received word that Rhys was ready to assist, but since landing rumour was that he backed the king, who had promoted him after Buckingham's failed rebellion. As the two armies converged, Henry wasn't entirely sure where he stood, but, after some nervous negotiation, Rhys ap Thomas's soldiers joined his ranks to march alongside them as they crossed the border into England, arriving outside Shrewsbury on 17 August.

The town of Shrewsbury found itself in a difficult position and kept its gates firmly closed against the intimidating rebel force that approached from Wales. Recognising the important message that his entry – or otherwise – into the town would send out, Henry began negotiations, and after assurances were given, the gates were opened and his army marched through. More contingents of soldiers joined him as

they continued on to Stafford, where Henry met Sir William Stanley, his stepfather's brother. Here their route turned south-east towards Lichfield, where Lord Stanley waited with his army, but Sir William Stanley manoeuvred out of their path and kept a watching brief as he backed into Leicestershire ahead of them to join with his brother at Atherstone. On 20 August Henry Tudor's army arrived and camped nearby, possibly on land owned by Merevale Abbey; after the battle the abbot received compensation for 'going over his ground, to the destruccioun of his cornes and pastures.'[21] Atherstone and other villages in the area also received grants as recompense for damaged crops.

As soon as news of Henry Tudor's landing reached Nottingham, Richard had sent letters summoning more of his supporters to him: 'Trusty and wellbeloved we grete you wele. And forasmuche as our rebelles and traitours accompanyed with our auncient enemyes of Fraunce and othre straunge nacions departed out of the water of Sayn [Seine] the furst day of this present moneth... entending our uttre destruccion... Wherfor we wol and straitely

THE MARCH FROM LEICESTER

King Richard III leading his army out of Leicester, past Austin Friars and over Bow Bridge, en route to Bosworth and his fateful confrontation with the invading army of his adversary for the throne, Henry Tudor.

This is a subject I would love to have the opportunity to revisit, to incorporate what I've learned and how my ideas have evolved since painting it in 1999.

Gouache, 21.5'' x 14.5'' (55cm x 37cm), 1999.

charge you that in your persone and with suche nombre as ye have promised unto us sufficiently horssed and herneised be with us in all hast to you possible'. Suggesting that the king was unsure of who he could trust, the letter ends with the threat that attendance was expected 'upon peyne of forfaicture unto us of all that ye may forfeit and loose.' [22]

At the same time, John Howard, Duke of Norfolk, was mobilizing the men of East Anglia, and Sir John Paston received a letter from him with instructions to meet at Bury, and to 'brynge with yow seche company of tall men as ye may goodly make at my cost and charge, be seyd that ye have promysyd the Kyng; and I pray yow ordeyne them jakets of my levery'. [23]

While Lord Stanley supervised the recruitment of troops from his estates in Lancashire, his son and heir George, Lord Strange, was with the king in Nottingham. Realising the very real danger that Lord Stanley's wife, Margaret Beaufort, might influence him to support her son, Henry Tudor, the king urgently sent for Stanley, commanding him to return to Nottingham without delay. Lord Stanley pleaded illness – 'that he was suffering from an attack of the sweating sickness' – to excuse his non-compliance, but in doing so he placed his son in an extremely dangerous position. [24] The threat intensified after Strange was apprehended trying to escape, after which he wrote to his father to spell out the danger he was in if he failed to comply with the king's command. If he planned to throw in his lot with his stepson while also trying to preserve his son's life, Stanley would need to tread very carefully indeed. For the time being he kept his army separate from either of the protagonists.

Having heard that Rhys ap Thomas had not stopped the rebels but joined them, and that they had now crossed into England and were near Lichfield, on 19 or 20 August King Richard marched his army out of Nottingham and moved to Leicester to cut off their route to London. Here, Richard is traditionally believed to have stayed at the White Boar Inn, by coincidence his famous badge, a connection that caused the inn to be renamed the Blue Boar following the battle, after the earl of Oxford's similar but differently coloured badge. On Sunday 21 August, banners flying and crown on his head, King Richard led the royal army out of the city, past Austin Friars and over Bow Bridge. Marching towards their adversaries at Atherstone, they approached the village of Sutton Cheyney and set up camp in the surrounding area.

THE BATTLE OF BOSWORTH

King Richard had a troubled night, and in his nightmares 'had imagined himself surrounded by a multitude of dæmons'. [25] To add to the tired king's woes, when he asked for mass to be performed, preparations became rather chaotic; when his chaplains had 'one thing ready, evermore they wanted another, when they had wyne they lacked breade, and ever one thing was myssing.' [26] The delays in their devotions are reported to have caused them to miss breakfast, for by then they had more pressing matters to attend to.

Richard deployed his army, 'stretching yt furth of a woonderfull lenght, so full replenyshyd both with footemen and horsemen that to the beholders afar of yt gave a terror for the multitude, and in the front wer placyd his archers, lyke a most strong trenche and bulwark'. [27] He placed the vanguard under the command of the duke of Norfolk, and with him was Sir Robert Brackenbury, constable of the Tower of London, who had brought guns from the Tower and likely commanded the king's artillery.

Henry Tudor awoke early, and finding that Lord Stanley was still not by his side left him 'no lyttle vexyd, and began to be soomwhat appallyd'. [28] Having made their preparations, his army approached the battlefield, and for the first time saw the impressive force they would shortly face in combat arrayed in front of them beneath their banners. As the earl of Oxford's division came into range, the king's guns opened fire, and under their devastating impact Oxford changed direction to reposition his men and face the duke of Norfolk, perhaps slightly on his flank, 'in order to avoid the fire to mass their troops against the flank rather than the front of the king's battle'. [29]

As the distances closed, the soldiers gave 'great showtes' then 'assaultyd thennemy first with arrows… but whan they cam to hand strokes the matter than was delt with blades'. As the two sides came to blows, Oxford ordered that 'in every rang [rank] that no soldier should go above tenfoote from the standerds', and the tightly packed men pulled back, creating a momentary pause in the fighting before the grim

slaughter began again. Now Oxford, 'with the bandes of men closse one to an other, gave freshe charge uppon thenemy, and in array tryangle [a wedge] vehemently renewyd the conflict'.[30] Under this onslaught, Norfolk's line was slowly pushed back and began to give way.

With 'a choyce force of soldiers' around him,[31] including his knights of the body, King Richard watched developments from behind his lines, keeping a particular eye on Lord Stanley, who still apparently refused to commit. 'I see the banner of Lord Stanley he said, Fetch hither the Lord Strange to me, for doubtless he shall die this day.'[32] However, those tasked with carrying out the deed, 'seeing that the issue was doubtful in the extreme, and that matters of more importance than the destruction of one individual were about to be decided, delayed the

ABOVE **A selection of round shot excavated at Bosworth battlefield, with calibres ranging between 20.5 to 97mm.** (Bosworth Battlefield Heritage Centre/ Leicestershire County Council)

RIGHT
THE ARTILLERY OF RICHARD III

Royal gunners open fire at the start of the Battle of Bosworth from their position in front of the duke of Norfolk's division. Behind the guns and archers can be seen Norfolk himself, his banner and standard flying above him. Other banners include (from left to right) Norfolk's son, the earl of Surrey; Thomas, Lord D'Acre; John Touchet, Lord Audley; and Richard, Lord Fitzhugh, while to the right of Norfolk's banners are those of Ralph, Lord Greystoke; Walter Devereux, Lord Ferrers; and John de la Pole, Earl of Lincoln. Wearing the white tabard with black interlaced chevrons, Sir Robert Brackenbury – in charge of the artillery – gives a message to one of the king's retainers.

Gouache, 19" x 13" (49cm x 33cm), 2020.

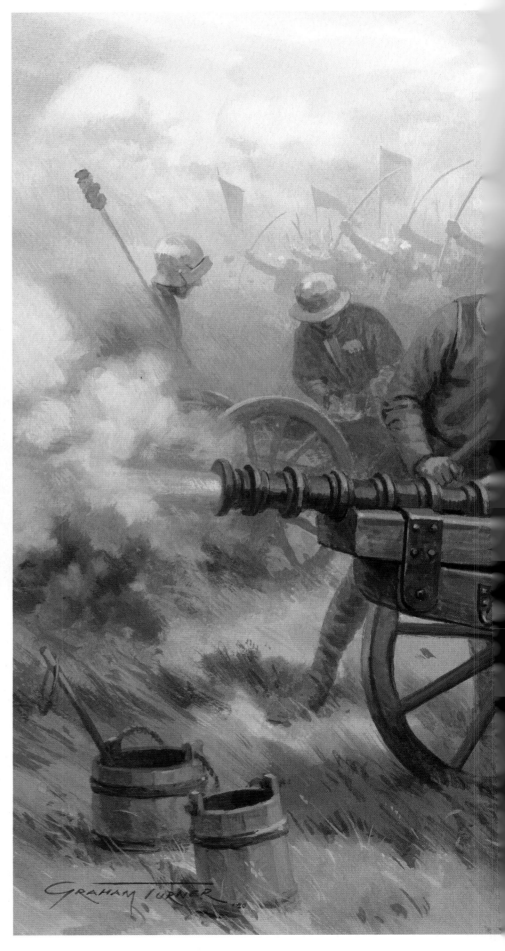

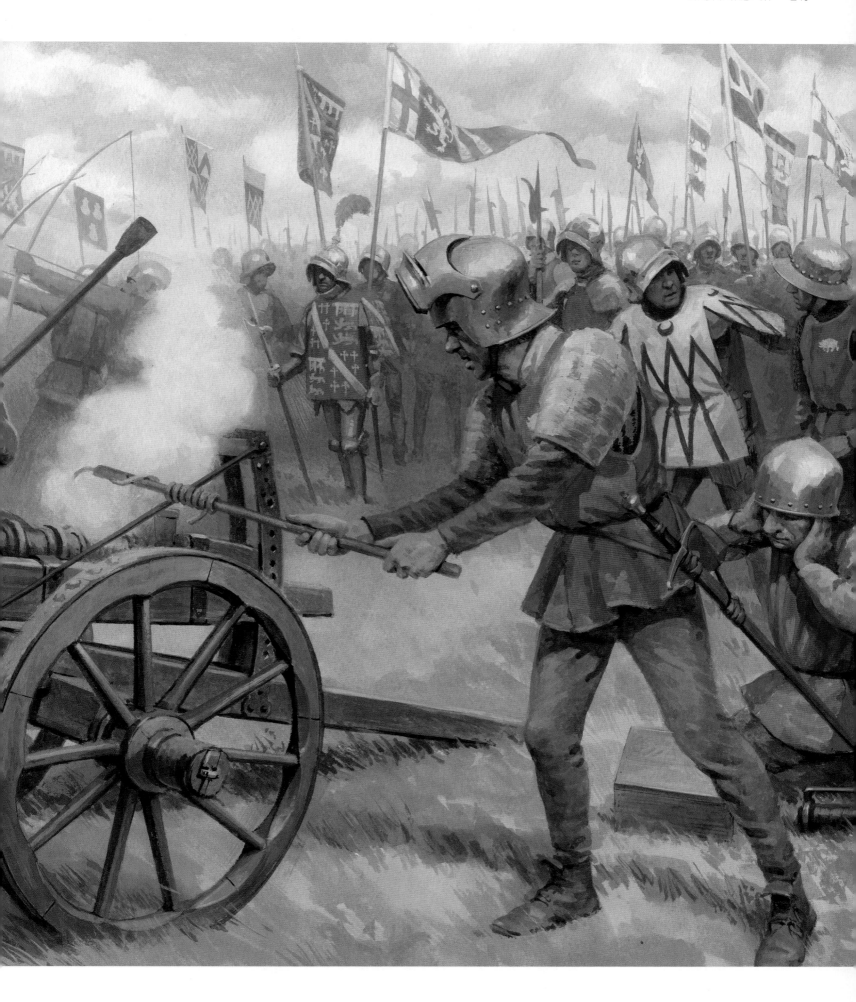

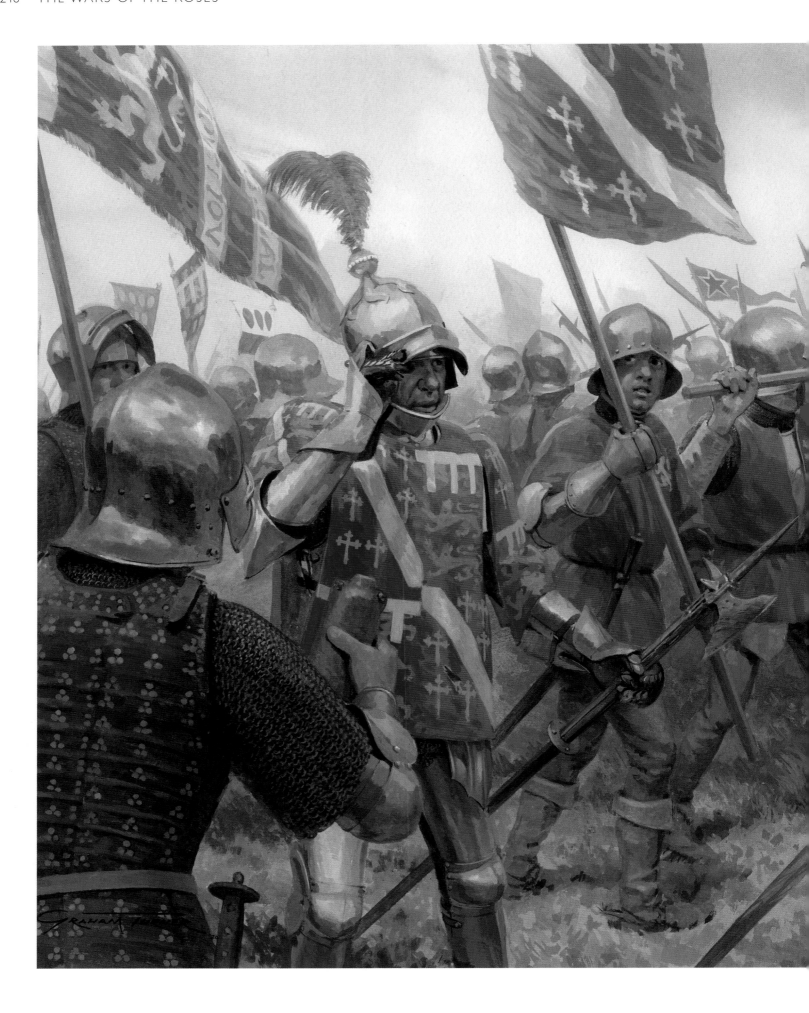

performance of this cruel order of the king, and, leaving the man to his own disposal, returned to the thickest of the fight'.[33]

As the battle looked to be swinging against him, some around the king apparently urged him to escape, to which he replied 'God forbid I yield one step. This day I will die as a king or win'.[34] Wearing his crowned helmet and surcoat or tabard bearing the royal arms, he was informed that 'erle Henry was a farre of with smaule force of soldiers abowt him'. Richard saw the opportunity to end the battle with one stroke, 'wherefor, all inflamyd with ire, he strick his horse with the spurres' and led his household knights and retainers in a thunderous charge, seeking out his adversary. As they crashed into Henry Tudor's bodyguard, Richard unhorsed and killed his standard-bearer Sir William Brandon, and then felled Sir John Cheyne, 'a man of muche fortitude, far exceeding the common sort'.[35] Rhys Fawr ap Maredudd retrieved Tudor's red dragon standard as Richard and his men struggled to get close to Henry, the king fighting 'with much vigour, putting heart into those that remained loyal, so that by his sole effort he upheld the battle for a long time'.[36] Richard is recorded as commenting 'These French traitors are today the cause of our realm's ruin', referring to the large proportion of soldiers facing him being French mercenaries.[37] Tudor for his part 'abode the brunt longer than ever his owne soldiers wold have wenyd [thought possible], who wer now almost owt of hope of victory'.[38] With the result on a knife-edge, the Stanleys finally committed themselves, Sir William's red-coated soldiers wading into battle to shore up Henry Tudor's embattled followers, and their arrival sealed King Richard's fate. The chroniclers, even those disposed against him, are almost unanimous in praising the way he met his end: 'For while fighting, and not in the act of flight, the said king Richard was

THE DUKE OF NORFOLK PAUSES FOR REST

John Howard, Duke of Norfolk, and his son Thomas, Earl of Surrey, take a moment away from their exertions in the thick of the press on the hot August day, as the royal vanguard fights against the onslaught from the earl of Oxford, his banner and blue boar standard waving menacingly close by.

From the left can also be seen the banners of John, Lord Zouche, John de la Pole, Earl of Lincoln and Walter Devereux, Lord Ferrers.

Gouache, 19" x 13" (49cm x 33cm), 2020.

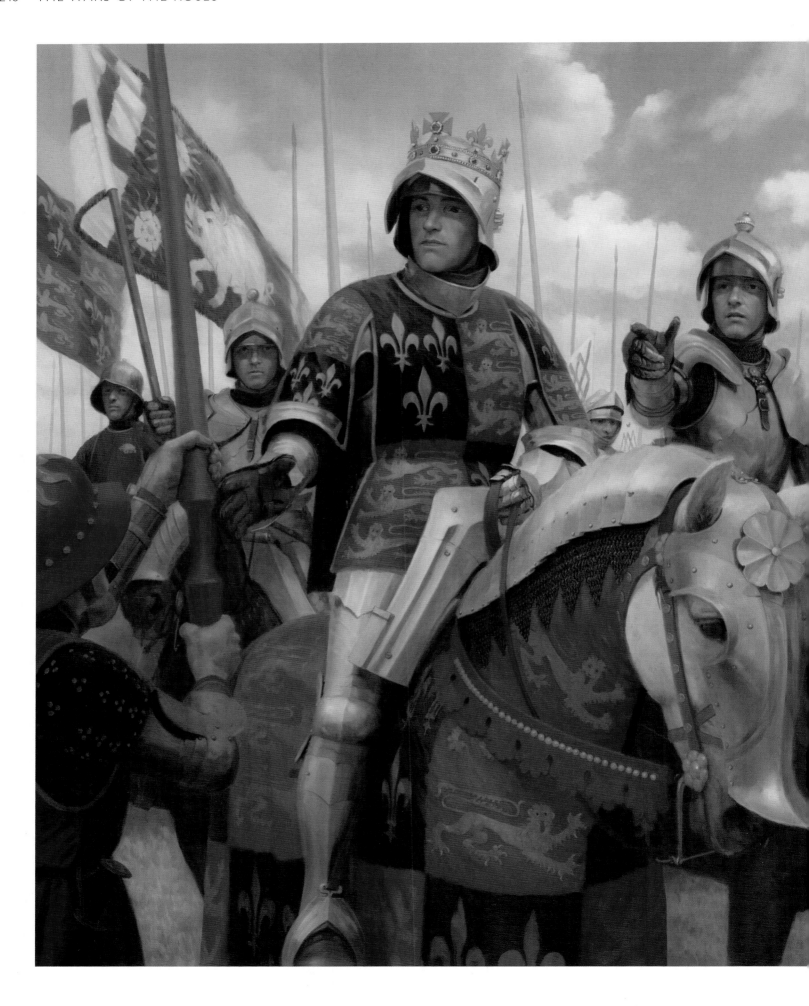

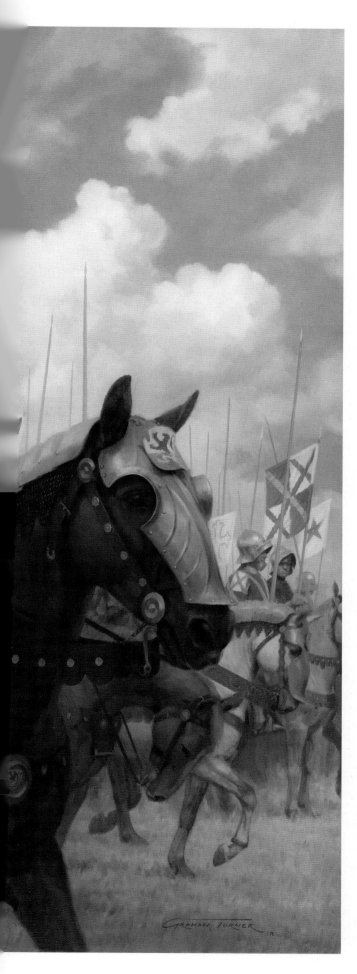

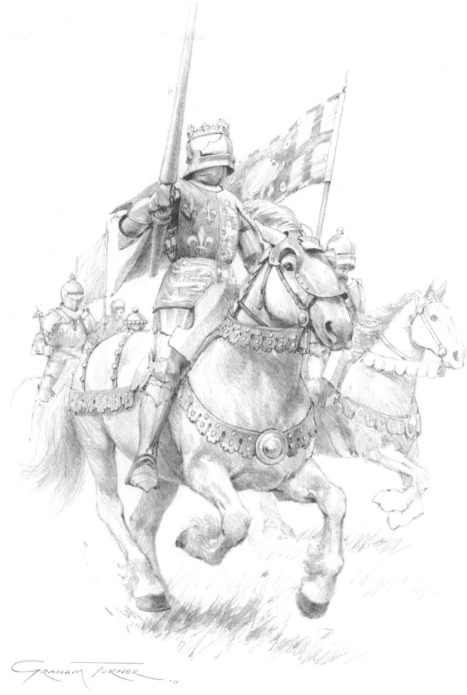

LEFT

RICHARD III AT BOSWORTH

King Richard III reaches for his lance as Sir Robert Percy points out Henry Tudor amongst the enemy host, prompting the king to lead his 'choyce force of soldiers' in their thundering charge towards the challenger for his throne and try to win the battle with one decisive stroke. (More details about this painting can be found on page 255.)

Oil on canvas, 38" x 30" (102cm x 76cm), 2012.

ABOVE

RICHARD III'S CHARGE

Pencil, 12" x 16.5" (30cm x 42cm), 2011.

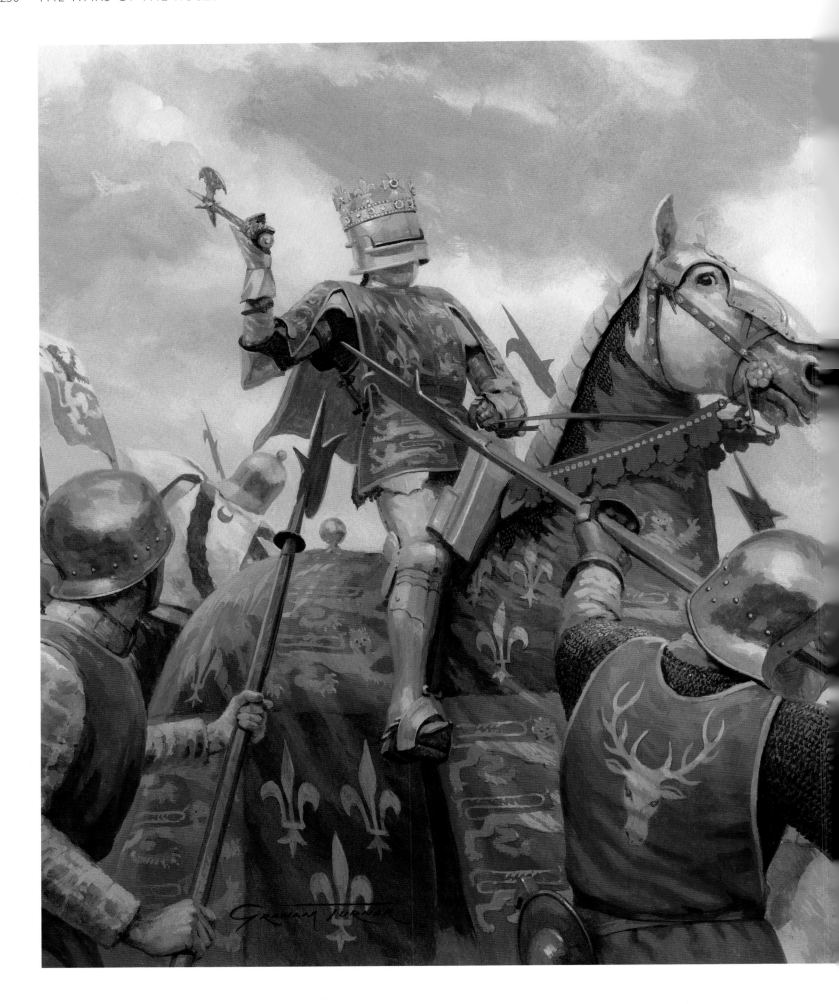

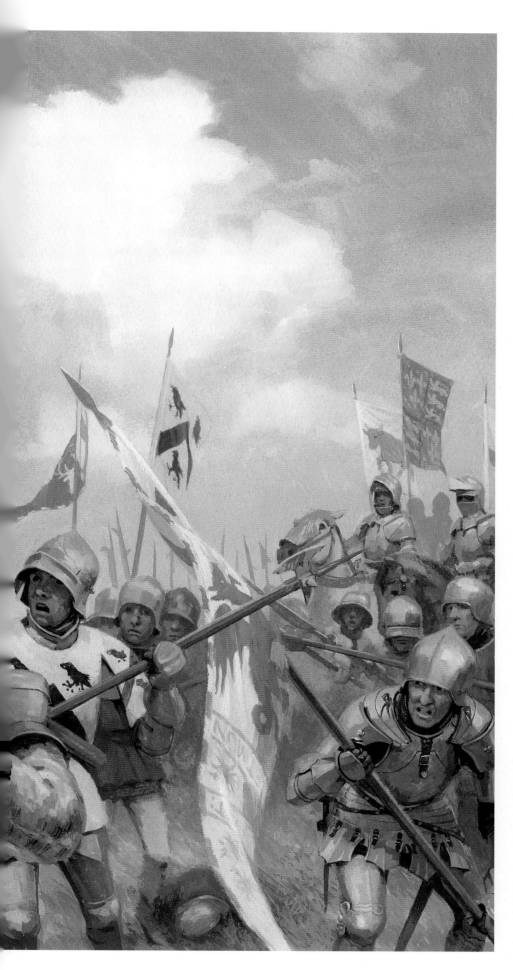

pierced with numerous deadly wounds and fell in the field like a brave and most valiant prince'.[39] 'For all that, let me say the truth to his credit: that he bore himself like a gallant knight and, despite his little body and feeble strength, honourably defended himself to his last breath, shouting again and again that he was betrayed, and crying "Treason! Treason!"';[40] 'king Richerd alone was killyd fyghting manfully in the thickkest presse of his enemyes.'[41]

With the king's death, the royal army broke and fled. The duke of Norfolk was also killed, either at the height of the battle or as his men made a fighting retreat. The earl of Northumberland appears not to have engaged his division: 'In the part where the earl of Northumberland was posted, with a large and well provided body of troops, there was no opposition made, as not a blow was given or received during the battle.'[42]

With the final slaughter still under way, Henry thanked God for his victory, then, 'replenysshyd with joy incredible' he went to 'the next hill' – traditionally Crown Hill – where he commended his soldiers amidst cheers of 'God save king Henry, God save king Henry!'[43] He knighted several of his followers, including Rhys ap Thomas, and commanded that the wounded be treated and the dead buried. Richard's crown was discovered on the battlefield – a later tradition says it was found under a thornbush – and it was brought to Lord Stanley, possibly by his brother Sir William, and placed on the new king's head.

RICHARD III FIGHTS FOR HIS CROWN

Having killed Henry Tudor's standard bearer and felled Sir John Cheyney, King Richard III wields his battle-axe against some of Sir William Stanley's red-jacketed retainers. Behind the king, knights of his household who charged into the fray alongside him struggle to get near Henry Tudor. The banner of Sir Robert Percy can be identified, and Sir Richard Ratcliffe is seen being pulled from his horse. To the right Rhys ap Thomas approaches, while Rhys Fawr ap Maredudd picks up the fallen red dragon standard, and behind them Henry Tudor himself can be seen, surrounded by his bodyguard and provocatively displaying the royal arms.

Gouache, 19" x 13" (49cm x 33cm), 2020.

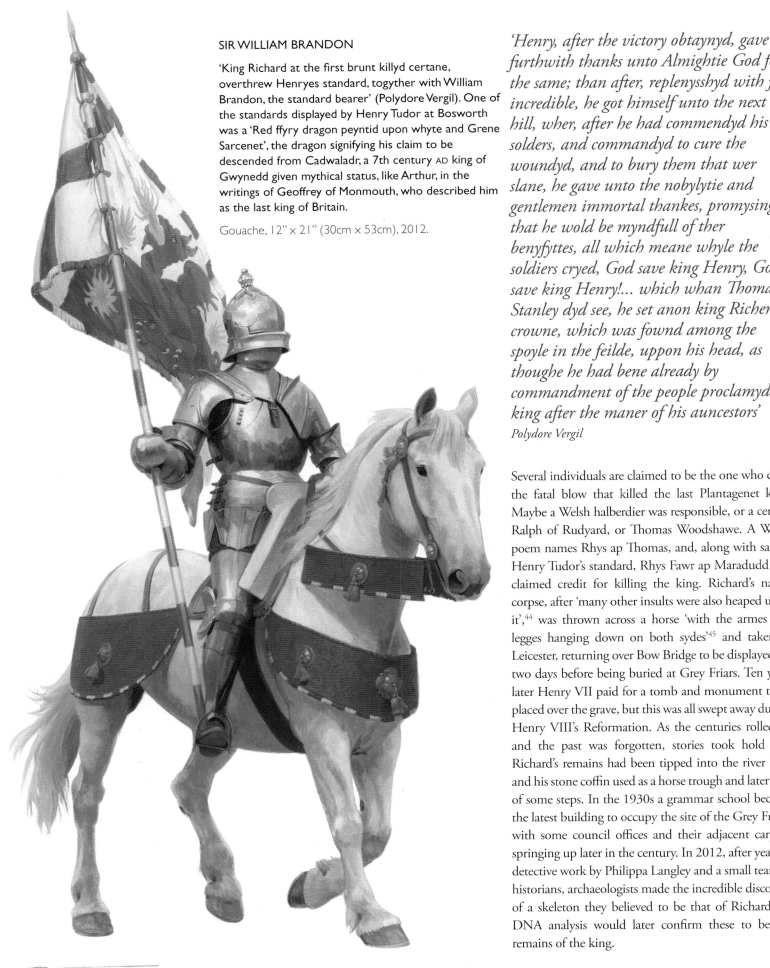

SIR WILLIAM BRANDON

'King Richard at the first brunt killyd certane, overthrew Henryes standard, togyther with William Brandon, the standard bearer' (Polydore Vergil). One of the standards displayed by Henry Tudor at Bosworth was a 'Red ffyry dragon peyntid upon whyte and Grene Sarcenet', the dragon signifying his claim to be descended from Cadwaladr, a 7th century AD king of Gwynedd given mythical status, like Arthur, in the writings of Geoffrey of Monmouth, who described him as the last king of Britain.

Gouache, 12" x 21" (30cm x 53cm), 2012.

'Henry, after the victory obtaynyd, gave furthwith thanks unto Almightie God for the same; than after, replenysshyd with joy incredible, he got himself unto the next hill, wher, after he had commendyd his solders, and commandyd to cure the woundyd, and to bury them that wer slane, he gave unto the nobylytie and gentlemen immortal thankes, promysing that he wold be myndfull of ther benyfyttes, all which meane whyle the soldiers cryed, God save king Henry, God save king Henry!... which whan Thomas Stanley dyd see, he set anon king Richerds crowne, which was fownd among the spoyle in the feilde, uppon his head, as thoughe he had bene already by commandment of the people proclamyd king after the maner of his auncestors'
Polydore Vergil

Several individuals are claimed to be the one who dealt the fatal blow that killed the last Plantagenet king. Maybe a Welsh halberdier was responsible, or a certain Ralph of Rudyard, or Thomas Woodshawe. A Welsh poem names Rhys ap Thomas, and, along with saving Henry Tudor's standard, Rhys Fawr ap Maradudd also claimed credit for killing the king. Richard's naked corpse, after 'many other insults were also heaped upon it',[44] was thrown across a horse 'with the armes and legges hanging down on both sydes'[45] and taken to Leicester, returning over Bow Bridge to be displayed for two days before being buried at Grey Friars. Ten years later Henry VII paid for a tomb and monument to be placed over the grave, but this was all swept away during Henry VIII's Reformation. As the centuries rolled by and the past was forgotten, stories took hold that Richard's remains had been tipped into the river Soar and his stone coffin used as a horse trough and later part of some steps. In the 1930s a grammar school became the latest building to occupy the site of the Grey Friars, with some council offices and their adjacent carpark springing up later in the century. In 2012, after years of detective work by Philippa Langley and a small team of historians, archaeologists made the incredible discovery of a skeleton they believed to be that of Richard III; DNA analysis would later confirm these to be the remains of the king.

The Garter stall plate of
Thomas, Lord Stanley, his
arms including the three
armoured legs of the Isle of
Man, granted to his great-
grandfather by Henry IV.

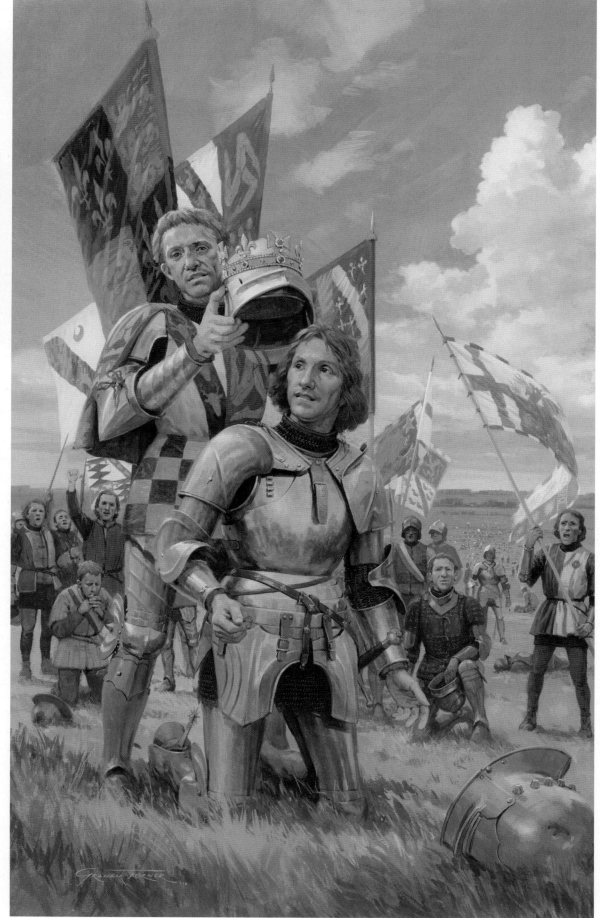

HENRY TUDOR IS CROWNED

With the crown taken from
Richard III's helmet, Lord
Stanley crowns Henry Tudor
after his victory at Bosworth.

Gouache, 15.5" x 21"
(39cm x 53cm), 2014.

Before being reinterred with great ceremony in Leicester Cathedral, study of the king's skeleton revealed much about his life and death. Most significant was the confirmation that he had scoliosis, a condition in which the spinal column bends to the side, rather than the rounded back caused by kyphosis; he was not the 'Deform'd, unfinish'd, sent before my time... scarce half made up' creature of Shakespeare's imagination. A visitor to his court in 1484 wrote 'Richard was three fingers taller than himself, but a little slimmer and not so solid, also far leaner; he had delicate arms and legs, and also a great heart'. While his bones tell us nothing about his character, they do remind us that he was a man, and that any assessment of his personality and actions should not be influenced by the theatrical monster. Richard's remains also vividly convey the horror of his violent death. Of the 11 injuries he received that had been of sufficient violence to leave their marks on his bones, nine were to his skull, a combination of slicing wounds and punctures, the most severe being a huge hole made by a sword or staff weapon and another that had passed through his brain and marked the skull wall on the opposite side.

On 19 August the city of York had agreed to send a force of men to the king's aid, but they arrived at Bosworth too late. The city's records for 23 August, when word reached them of Richard III's death, note 'that King Richard, late meifully reigning upon us was, through grete treason... with many other lord and nobilt... was piteously slane and murdred, to the grete hevynesse of this Citie'.[46]

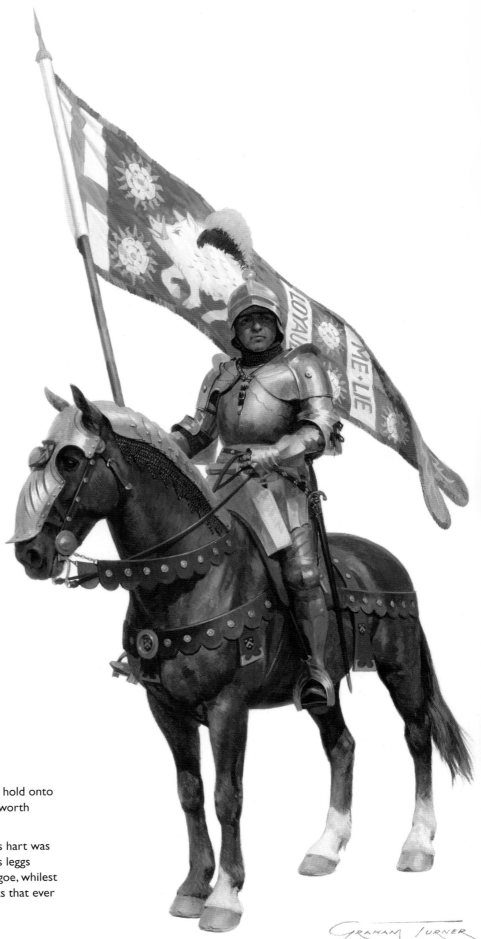

SIR PERCIVAL THIRLWALL

Richard III's standard bearer Sir Percival Thirlwall. He would hold onto the standard until the last, as described in the 'Ballad of Bosworth Fielde':

'Sir Percivall Thriball, the other hight, & noble knight, & in his hart was true; King Richard's standard hee kept upright untill both his leggs were hewen him froe; to the ground he wold neuer lett itt goe, whilest the breath his brest ws within; yett men pray ffor the knights that ever was soe true to their King.'

Gouache, 12" x 20" (30cm x 51cm), 2012.

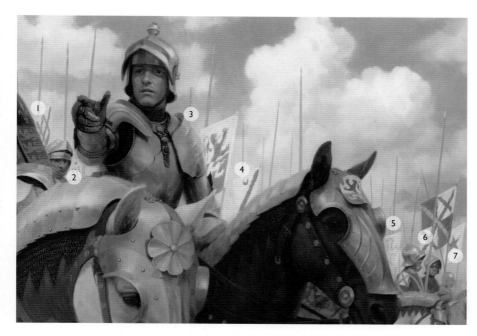

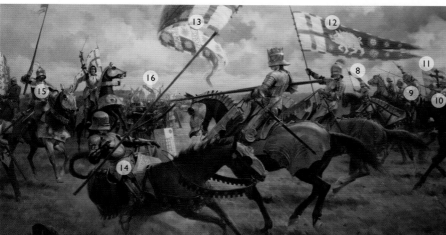

KEY TO PAINTINGS OF THE BATTLE OF
BOSWORTH ON PAGES 248–249 AND 9–10.

1	Banner of Sir James Harrington
2 & 10	Sir Robert Brackenbury, constable of the Tower of London.
3	Sir Robert Percy, and his banner. Sir Robert served with Richard in Scotland in 1482, was knighted in 1483, and appointed controller of the King's Household.
4 & 8	Banner of Sir Richard Ratcliffe, knighted after Tewkesbury and created Knight of the Garter in 1484.
5	Banner of Sir Thomas Pilkington, who was knighted by Richard in Scotland, survived Bosworth but killed at Stoke two years later.
6	Lord Scrope of Bolton and his banner. Fought at Northampton, Towton, Hexham, was made a Knight of the Garter in 1463 and pardoned by Edward IV after siding with Warwick in 1470.
7	Banner of Sir Ralph Ashton
9	Sir Richard Charlton
11	Banner of Sir Thomas Gower
12	Standard of Richard III
13	Standard of Henry Tudor
14	Sir William Brandon
15	Sir John Cheyne
16	Standard of Sir William Stanley

PAINTING RICHARD III AT BOSWORTH

King Richard III's charge at Bosworth inspired my first Wars of the Roses painting in 1995 (pages 10–11), and while I was happy with the way that turned out, in 2012 I began a new painting that reflected how my knowledge and understanding had evolved during the intervening years. Not long after I had started to put paint on canvas, the stunning news broke that human remains had been discovered under a car park in Leicester, remains that might possibly be those of King Richard himself. I stopped work immediately and like the rest of the world waited for the DNA test results, and the day after the momentous announcement that confirmed the bones were indeed those of the king, I was honoured to be asked to speak at the press conference at the Society of Antiquaries when the facial reconstruction was revealed. It was incredible to be one of the first to see the likeness of Richard III in over five centuries, and I'll never forget that moment.

Picking up my brushes once again, I was able to incorporate the initial information the discovery had revealed, and the resulting painting was unveiled at an exhibition of my work at a most appropriate location; Bosworth Battlefield, where my first painting had been unveiled in 1995. It subsequently formed the centrepiece of a year-long exhibition at the newly opened King Richard III Visitor Centre in Leicester, during which time the King's remains were ceremonially reinterred in the cathedral.

The decision to depict Richard in gilded armour was reached after much research and consideration. We do not know what he wore at Bosworth, but 15th century kings are often depicted in manuscript illuminations wearing gilded armour, and fully gilded armour from the early 16th century survives. Here was the king of England facing a challenge to his throne, demonstrating his right to wear the crown as God's anointed ruler, at a time when visual display played a crucial role in conveying an individual's importance. This painting can be seen on pages 248–249.

HENRY VII

CHALLENGES TO THE NEW TUDOR DYNASTY

'At the beginning of the new reign, the sweating sickness…
prevailed to great extent'
Croyland Chronicle

The death at Bosworth of the last Plantagenet king, and accession of Henry VII as the first of the Tudor dynasty, is the convenient date traditionally used to mark the point when the Middle Ages ended, and England dragged itself into the Renaissance. As the above quote makes very clear, for the vast majority the sometimes harsh challenges facing them remained, and they didn't wake up on 23 August 1485 and decide they were no longer medieval.

The Wars of the Roses wasn't over quite yet either – there were several aftershocks still to come before the story of our ancestors moved on to another dramatic chapter.

The new king spent two days in Leicester 'for refreshing of his soldiers from ther travaile and panes, and to prepare for going to London',[1] where he arrived on 3 September. It was an unfamiliar land where he was largely unknown, 'without any reputation but what his person and deportment obtained for him'.[2] He had lived a large proportion of his life in exile, had little experience of administering an estate, let alone a country, and had no knowledge of the people at the heart of government or the royal household he would now have to rely on.

His first proclamation as king demanded 'upon pain of death, that no manner of man rob or spoil no manner of commons coming from the field [Bosworth]; but suffer them to pass home to their countries and dwelling-places, with their horses and harness'.[3] Henry's policy appears to have been one of clemency, one notable exception being William Catesby, a central figure in Richard's administration as chancellor, who was captured at the battle and executed three days later.

The earls of Surrey and Northumberland were taken into custody, and the late duke of Clarence's ten-year-old son Edward, Earl of Warwick – who possessed his own claim to the throne – was escorted to the Tower of London, where he would live out the rest of his life. Northumberland was released and restored to his position in December, while Surrey languished in the Tower for the next four years. However, once released and restored to his position, he would provide sterling service to the Tudor dynasty, most notably with his defeat of the Scots at the Battle of Flodden in 1513.

The king's uncle, Jasper Tudor, was made duke of Bedford as reward for his unstinting support, his stepfather Thomas Stanley became earl of Derby, and Edward Courtenay was restored to his family title as earl of Devon. After his years of struggle, John de Vere, Earl of Oxford, regained his title and position to become an important part of the new regime.

Henry was crowned with considerable pomp and pageantry at Westminster Abbey on 30 October. At the Parliament summoned a week later, an act of attainder was passed against Richard III and a list of his supporters, dated to the day before Bosworth so that those who had answered the call to arms from the then reigning king could now be declared traitors. It was a move that left some uneasy: 'what assurance, from this time forth, are our kings to have, that, in the day of battle, they will not be deprived of the assistance of even their own subjects, when summoned by the dread mandate of their sovereign?'[4] The act that had declared the children of Edward IV illegitimate was reversed, and on 18 January 1486, Elizabeth of York, Edward's eldest daughter, was married to King Henry VII, fulfilling a promise he had made to his supporters in Rennes Cathedral on Christmas Day 1483.

As his predecessors had done soon after their own coronations, King Henry began a royal progress in March to meet his subjects, and it was while celebrating Easter in Lincoln that word reached him that Viscount Lovell and Humphrey and Thomas Stafford had come out of hiding and were planning rebellion, Lovell in Yorkshire and the Staffords in the west. All three had been faithful followers of Richard

TOP **Tudor rose at Ely Cathedral.**

ABOVE **A Tudor rose on the livery collar of Sir Edward Redman, d.1510, at Harewood, Yorkshire.**

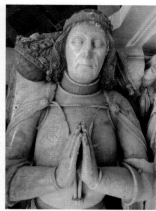

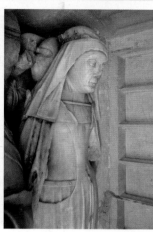

ABOVE The parents of John de la Pole, Earl of Lincoln – John and Elizabeth de la Pole, Duke and Duchess of Suffolk (Elizabeth was the daughter of Richard, Duke of York and Cecily Neville, so sister to Edward IV and Richard III). Tomb at Wingfield, Suffolk.

III, Lovell in particular remembered for his friendship with the late king, and they had been stripped of their titles and estates by the act of attainder for 'traiterously intendinge, imagininge and conspireinge' against the new monarch.'[5] Seemingly unconcerned by these initial reports, Henry continued to York, entering through Micklegate Bar to be greeted by several spectacular pageants, the first including a symbolic reference to the union of the royal houses of Lancaster and York, the intention behind his marriage: '… a rioall, rich, rede rose… unto the which rose shall appeyre an othre rich white rose…'.[6] This symbolic amalgamation of the red and white roses would evolve into the famous Tudor rose.

Finally appreciating the gravity of the threat that the rebels posed, and 'struck by great fear since he had no army, no weaponry… in a city which was hostile, in whose mind the memory of Richard's name remained fresh',[7] Henry despatched the limited force he had available against Lovell's camp. A promise of pardon to those who threw down their weapons proved sufficient to diffuse the situation, and Lovell slipped away, eventually finding his way across the sea to Flanders. Desperate attempts by the Stafford brothers to recruit significant support themselves ultimately proved fruitless and, faced with the rapidly approaching forces of the king, they fled into sanctuary near Abingdon in Oxfordshire. This failed to protect them; dragged from the church and convicted of high treason, Humphrey lost his head at Tyburn, but Thomas was granted a last-minute pardon, deemed to be acting under his brother's 'evell counsaill'.[8]

Henry was soon able to enjoy a decidedly more uplifting event with the prompt arrival of an heir to his fledgling Tudor dynasty. Prince Arthur was born on 20 September 1486 in Winchester – identified by Malory as Camelot – which provided a further link to the popular Arthurian tradition. Having taken the crown in battle, Henry recognised the considerable difficulties he faced in establishing his rule, but he now had an heir named after a legendary hero with parents from both royal houses, who would hopefully help heal any lingering divisions and herald an age of peace and prosperity under the rule of the Tudors.

Trouble continued to fester, though, and it wouldn't be long before Henry's fragile grasp on power was put to a more serious test.

Francis Lovell's escape to Flanders allowed him to make contact with Margaret of York, dowager duchess of Burgundy and sister to the late Yorkist kings Edward IV and Richard III. She would prove a valuable ally, and a prime mover in further schemes as she 'pursued Henry with insatiable hatred'.[9] In March 1487, John de la Pole, Earl of Lincoln, joined Lovell at Margaret's court. A grandson of Richard, Duke of York, and William de la Pole, Duke of Suffolk, he had been given his title by Edward IV and supported his uncle Richard III, under whom he had received recognition and reward. Like other Yorkists who pragmatically endeavoured to seek acceptance under the new king, Lincoln had begun to re-establish himself, but for reasons that are unclear – perhaps he nurtured ambitions to wear the crown himself – he had a change of heart.

Rumours had been spreading that the young earl of Warwick had escaped from the Tower and was in Ireland, his father's birthplace, and it was this that would provide the focus for the plot. With a force of 2,000 German and Swiss mercenaries recruited by Margaret and commanded by Martin Schwartz, Lincoln and Lovell arrived in Dublin on 5 May 1487, and on 24 May 'Warwick' was crowned as Edward VI. It would transpire that the 'Warwick' crowned in Dublin was actually a young 'Lambert Symnell, a child of x [ten] yere of age, sonne to Thomas Symnell, late of Oxford Joynonre [joiner]',[10] extensively trained to carry out the deception at the centre of this complex web of conspiracy.

Aware of the plots brewing against him, Henry VII made efforts to make it clear that the real Warwick was still in his hands. Also suspecting the involvement of his Woodville in-laws, he had his queen's mother, Elizabeth Woodville, removed to Bermondsey Abbey, where she would spend the last five years of her life, and the Marquess of Dorset joined young Warwick in the Tower. With ships patrolling the seas, commanded by Thomas Brandon, brother of his fallen Bosworth standard bearer, and commissions of array issued, Henry settled at Kenilworth Castle to watch developments.

Avoiding moves against them in Ireland, the rebels set sail for England at the end of May, their army now bolstered by a contingent of Irish troops commanded by Thomas Fitzgerald, brother of the earl of Kildare.

THE BATTLE OF STOKE

The pretender to the throne of England landed on the Lancashire coast on 4 June 1487, and his disparate force made their way inland towards Yorkshire, where they hoped to gain support. Joined by Lord Scrope of Bolton and his kinsman Lord Scrope of Masham, they approached York, to find the city had been reinforced and prepared to hold out against them. Despite being concerned about the 'gretely decayed' state of their walls,[11] the city's leaders declared that 'they wold kep this citie with ther bodies and goodes to thuttermast of ther powerz… ayenst his [King Henry's] rebelles'.[12]

Despatched to attack the 'Kinges ennemyes lyng upon Bramham More', Henry Clifford – whose father had been killed at Towton – was beaten in a skirmish near Tadcaster, the survivors retreating back within York's walls and leaving many of their number 'slayne and maymed'.[13] As Lincoln's army marched past the city, the lords Scrope launched a determined attack on Bootham Bar, the main gate from the north-west, but they were put 'to flitht' by the stout defence put up by 'the Comons being watchmen there well and manly defendid tham'.[14]

Lincoln continued south, determined to 'march directly against the king',[15] but his hopes that supporters would rally to them proved optimistic, leaving him to gamble all on 'the fortunes of war', while taking some little encouragement from the thought that Henry had conquered Richard III two years before, despite similarly overwhelming odds.

King Henry had not been idly waiting. John de Vere, Earl of Oxford – 'the noble and coraygious Knyght'[16] – was called on to lead the vanguard of Henry's army once again, and they marched from Kenilworth, passing not far from where he had won

THE BATTLE OF STOKE
16 June 1487

John de la Pole, Earl of Lincoln, fights for his life as his army is cut down around him; the Irish contingent in their distinctive yellow clothing, and the Swiss wielding their long pikes. Francis Lovell's banner can be seen behind him in the thick of the action, while advancing against them as part of Henry VII's vanguard, commanded by the earl of Oxford, can be seen John Paston III, who would be amongst those knighted by a grateful king after their victory.

Gouache, 21.8" x 17" (55cm x 43cm), 2023.

his crown at Bosworth, to be joined at Nottingham by his stepbrother George Stanley, Lord Strange, George Talbot, Earl of Shrewsbury, and Sir John Cheyne – all three 'distinguished commanders' 'accompanied by a great number of armed men'. Many others are listed. 'In this way the king's army was hourly augmented in wonderful fashion.'[17]

'Understanding that his Enemyes and Rebelles drew towards Newarke', the king marched his army towards them 'and logged that Nyght beside a Village called Ratcliff, 9 Miles oute of Newarke'. Despite losing some 'Cowards' and 'Raskells' overnight, 'no Man of Worship… fledde', and an impressive force lined up for Henry on 16 June 1487.[18]

The two armies met near the village of East Stoke, with the king's vanguard under the earl of Oxford being the only division to engage. The Germans in the front line proved a formidable foe; they were 'experienced in war' and 'yielded little to the English in valour', their leader Martin Schwartz being complimented for being 'not inferior to many in his spirit and strength.' In contrast, the Irish recruits proved ill-equipped, lacking body armour, and despite fighting 'most spiritedly, were nonetheless slain before the others.'[19]

After much vigorous fighting, a final determined push by Oxford's troops would prove too much for the rebels, and seeing their leaders cut down they broke. The earl of Lincoln, Martin Schwartz and Thomas Fitzgerald were among the dead left lying on the battlefield, but Francis Lovell was 'disconfotid and fled'. The 'Lad that his Rebells called King Edwarde, whos Name was indeed Lambert'[20] was taken 'and broght unto the Kinges grace'.[21] Deeming him an 'innocent lad' who was 'too young to have given offence', Simnel was put to work in the royal kitchens before being promoted to train the king's hawks.[22]

On the day of his victory, King Henry knighted 52 men in recognition of their valour, including John Paston III. He also promoted ten more to knight banneret to join Sir Gilbert Talbot, Sir John Cheyne and Sir William Stonor, who had been similarly rewarded before the battle. Celebrations appear to have been washed down with copious quantities of wine; Henry later paid the substantial sum of £42 to 'our wel-beloved William Bele, of our countie of Lincoln', for 'certaine wyne of him bought to oure use and spent in owre last victorious feld'.[23]

Punishment was meted out to captives 'in grete number which was juged to deth at Lincolne and other places theraboute'[24] before Henry regrouped at Kenilworth, then headed north again to establish his

TOP LEFT **The ruins of Minster Lovell Hall, Oxfordshire.**

LEFT **Bootham Bar, York.**

BOTTOM LEFT **Sir John Cheyne's tomb in Salisbury Cathedral. Having served Edward IV as one of his squires of the body and fought for him at Barnet and Tewkesbury, John Cheyne turned against Richard III and was one of the leaders of Buckingham's rebellion. He subsequently joined Henry Tudor in exile and was knighted by him when they landed in Wales. At Bosworth he was famously unhorsed by Richard III, despite being described as 'a man of muche fortitude, far exceeding the common sort' – an 18th-century measurement of a thighbone in his tomb suggests he was six feet eight inches tall. After the Battle of Stoke he was made a knight banneret, a Knight of the Garter, and raised to the peerage as Lord Cheyne. He died in 1499. (Julian Humphrys)**

SIR FRANCIS LOVELL, 1st VISCOUNT LOVELL

Sir Francis Lovell was a staunch supporter, and likely a friend, of Richard, Duke of Gloucester, having spent some of their formative years together in the care of the earl of Warwick. Lovell was knighted by Gloucester after their expedition to Scotland in 1481, made viscount in 1483, and after Richard acceded to the throne, he became lord chamberlain and a Knight of the Garter. Following the Battle of Bosworth he escaped to fight for the Yorkist cause for the last time at the Battle of Stoke in 1487, after which he vanished, his end shrouded in mystery. He wears armour based primarily on memorial brasses of the 1480s, his helmet being notable as an early close helm.

Gouache, 9" x 14" (24cm x 35cm), 2019.

BELOW **The Garter stall plate of Francis, Viscount Lovell.**

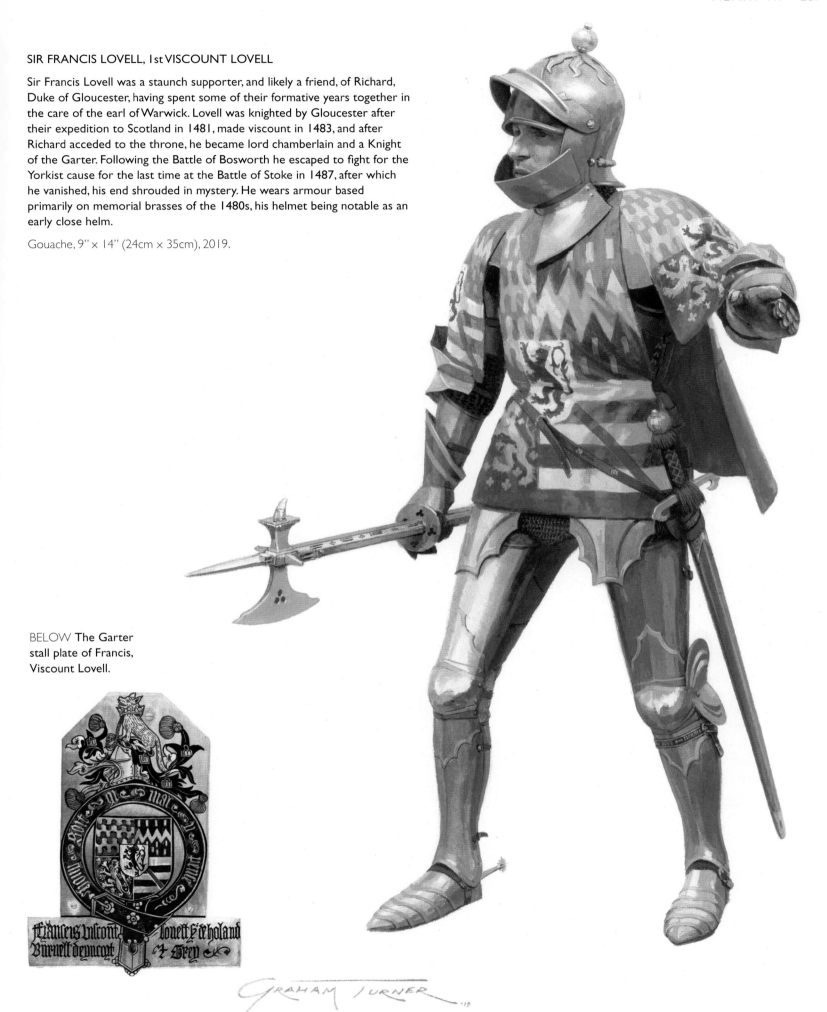

rule and 'wede oute, and purge his land of all sedicyous seede'.[25] The two lords Scrope were treated far more leniently than they might have expected, being pardoned in 1489, but Francis Lovell remained at large. His fate remains a mystery, a mystery fuelled by an early 18th-century claim that a skeleton had been discovered in a secret chamber at Minster Lovell Hall, only for it to immediately crumble to dust. It seems most unlikely that Francis would have hidden in such an obvious place as his old ancestral home, especially given that it was now in the possession of the king's uncle, Jasper Tudor, but the legend persists.

Despite his conclusive victory at Stoke, four years later another pretender would emerge in Ireland to become the focus of a further plot against Henry's reign. The young man who claimed to be Prince Richard, son of Edward IV – the younger of the so-called Princes in the Tower – is known to history as Perkin Warbeck. He would become embroiled in international intrigues, firstly in France as a pawn during hostile Anglo-French relations, then in 1492, no longer welcome there, he was welcomed by Margaret of York in Flanders where he provided her with another opportunity to channel her hatred of Henry VII. With Margaret claiming he was indeed her nephew, interest and support increased, leading to growing tensions between England and Burgundy, while at home, conspiracies against King Henry would cost several men their heads early in 1495, including most shockingly the king's step-uncle Sir William Stanley.

Although deprived of his supporters in England, Warbeck launched a Burgundian-backed invasion attempt in June 1495, landing at Deal in Kent to determined resistance from local forces who comprehensively defeated them. Warbeck remained at sea while many of his men were slaughtered to next appear off the Irish coast, where the remains of his force became involved in Ireland's own troubles by joining a siege of Waterford, leading to more disastrous losses. Warbeck's adventures continued, and he was now drawn into the schemes of James IV of Scotland. An invasion of England in September 1496 failed to attract support to the banner of 'King Richard IV' and became nothing more than a short, bloody raid, deemed a success by the Scottish king but a complete failure for Warbeck's ambitions. An uprising in Cornwall in 1497 would distract Henry VII from his planned war of reprisal against Scotland, heavy taxation for which had caused the unrest; the rebellion would grow and get close to London before being crushed in battle by a vast royal army at Blackheath on 17 June. The elusive and tenacious Warbeck emerged once again in Ireland before landing near Land's End in Cornwall in September 1497 for a final throw of the dice. Here he tried to exploit the resentment and anger that had led to the rebellion a few months prior. Attracting some local support 'with fayre words and large promises', Warbeck marched to Exeter, held by Edward Courtenay, Earl of Devon, but his attacks on the walled town were repulsed. Moving on to Taunton, and finding his poorly equipped army caught between Devon's forces from Exeter and a large royal army, Warbeck fled. He got as far as Beaulieu Abbey, in the New Forest, where he claimed sanctuary.

On 5 October King Henry finally met the pretender, who gave a detailed confession of his life and the deception that had been such a persistent thorn in Henry's side. He was paraded through London, mocked and humiliated, but Henry's prize was allowed to live. This all changed after a failed escape attempt in June 1498; sent to the Tower, in 1499 he was convicted and hanged for supposedly conspiring with the earl of Warwick, who had been the focus of the 1487 Lambert Simnel rebellion. Warwick himself, an 'unhappy boy'[26] who had been incarcerated in the Tower for the past 14 years because of his Yorkist blood, was beheaded on 28 November. Unlike Warbeck, whose head was spiked on London Bridge, Warwick was buried alongside his 'Kingmaker' grandfather and other illustrious forebears at Bisham Abbey.

The tragic story of the duke of York's family wasn't yet over. In 1541, 42 years after Edward, Earl of Warwick lost his head because of his ancestry, his 67-year-old sister, Margaret Pole, also fell victim to the axe during Henry VIII's blood-soaked reign.

As time passed, the upheavals of the Wars of the Roses receded into distant memory and the descendants of those who had lived their lives through those turbulent times added their own chapters to the often-bloody patchwork of history, through the reigns of the Tudor monarchs, then the Stuarts… to the present day. If we look and reflect, we can see the imprint of their lives all around us.

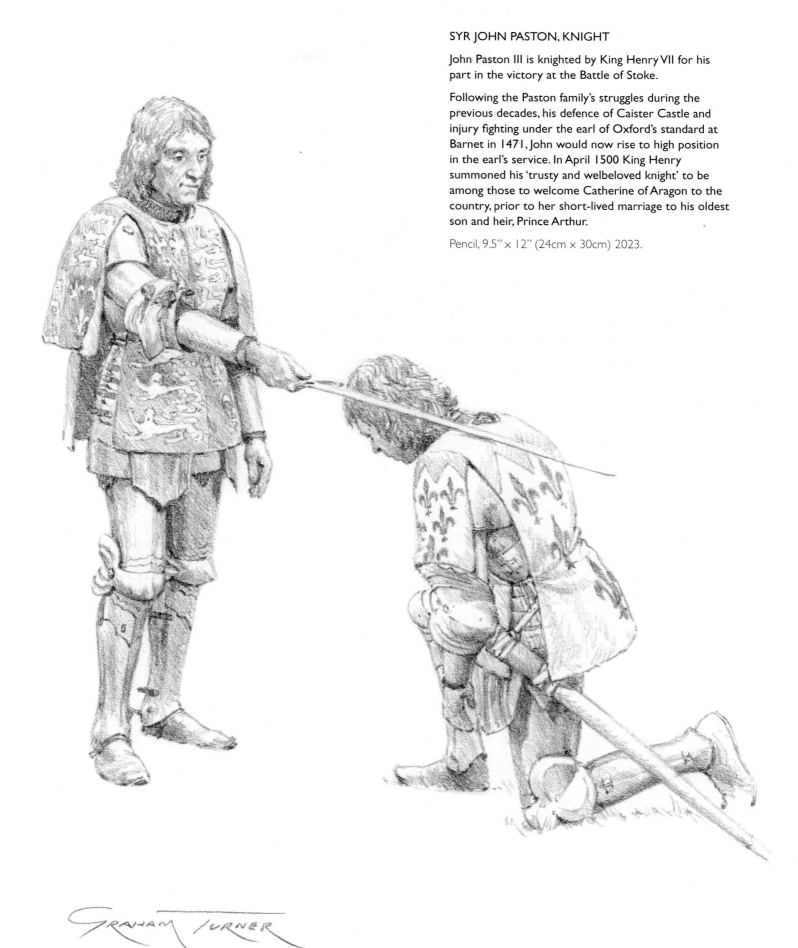

SYR JOHN PASTON, KNIGHT

John Paston III is knighted by King Henry VII for his part in the victory at the Battle of Stoke.

Following the Paston family's struggles during the previous decades, his defence of Caister Castle and injury fighting under the earl of Oxford's standard at Barnet in 1471, John would now rise to high position in the earl's service. In April 1500 King Henry summoned his 'trusty and welbeloved knight' to be among those to welcome Catherine of Aragon to the country, prior to her short-lived marriage to his oldest son and heir, Prince Arthur.

Pencil, 9.5" x 12" (24cm x 30cm) 2023.

PAINTING DIARY

I am often asked how long a painting takes, along with how I go about it – both far from simple questions to answer. I have been painting full time for 40 years, and over that time my approach and techniques have evolved, alongside an increased understanding of my subject matter and the research that underpins my work, so the paintings I am creating now are the result of not only the days, weeks and months of painting time, but also a considerable amount of practice! The time spent on each painting depends on many factors, not least size, medium and complexity, and then there are the countless hours spent on research and observation: people, landscapes, skies, buildings, all things that can be observed around us and which are crucial to creating a convincing image of a real past.

I work in either gouache – a water-based paint – or the very traditional medium of oil. Gouache is similar to watercolour in many respects but has more body to it, making it opaque rather than transparent and allowing light tones to be applied over dark to some degree. It can be used to achieve soft watercolour washes, but also crisp detail, and when used slightly thicker can be blended with a wet brush – which can be a mixed blessing if the paint is allowed to build up too much and become a grey dirge. For me,

watercolour requires too much disciplined planning to ensure that light areas are left clear, gouache allowing me a greater freedom to let the painting evolve, but that is very much a personal preference and I greatly admire others who can skilfully use watercolour and the results that can be achieved with it.

For larger paintings I work in oils on canvas, which is a very different experience from gouache, standing at an easel rather than sitting at an angled desk, and taking considerably longer, not just because of the larger scale, but also the way that oils can be built up in layers to increase the depth of colour and tone, along with the drying time needed as the painting progresses. I did briefly try working in acrylic paint many years ago but found the drying time way too fast, and although slower-drying acrylics are now available, I've stuck to oils – albeit using a medium that speeds up the time they take to dry.

In 1999 I followed the creation of my oil painting 'The Arrivall' with a Painting Diary, in which I posted weekly updates on my website with stage-by-stage photos and commentary. This proved popular so it's something I've repeated several times since, most recently with my painting of the Battle of Barnet. Over the following pages you can see

how this large oil on canvas painting took shape, from a blank canvas to the finished painting, along with some additional background into the events and people depicted, and I hope this provides some insight into how I work and the research behind each painting.

A. The first stage is to decide exactly what to portray, what I want to convey, and what is the most important focal point. Immersing myself in research while scribbling away on little thumbnail sketches (that are often only intelligible to me!) usually helps focus my ideas, which I then develop with slightly larger preliminary sketches. A large scene like this provides the opportunity to include many different stories within the overall narrative, but it's important that these don't distract from the overall impression, the aim being to arrive at a composition that guides the eye around the canvas, leading it into the focal point.

The moment I wanted to capture in this painting is the struggle at the height of the battle, men fighting for their lives and being cut down in the brutality of medieval warfare. Central to the composition is Edward, wearing the royal arms on his tabard and a crown on his head, his banner and personal standard flying behind him. He is in the thick of the fighting, about to strike down one of Warwick's billmen, while others jostle for position to strike at their enemies, trying not to stumble over their fallen comrades. In my preliminary sketch I indicated a couple of figures on the right in the middle distance; as the painting evolves these will become the earl of Warwick and his brother John, Marquess Montagu, both of whom would lose their lives at Barnet, and in the central background, just visible through the fog, I will indicate the banners of the earl of Oxford overrunning those of William, Lord Hastings, commander of Edward's left, an important part of the Battle of Barnet story.

B & C. Firstly I draw the composition I developed in my preliminary sketch onto the canvas to make sure all the elements are in the right places. This isn't set in stone, and I will make constant adjustments as the painting progresses – it's not just a matter of drawing an outline and colouring it in.

D. I then very broadly cover the whole canvas with paint, which allows me to build up my tones in relation to one another without the distraction of all that very white canvas. It also obliterates a lot of my initial drawing out but enough remains visible to guide me – ultimately, I don't want to be governed by outlines, but rather paint three-dimensional objects.

E. As I start to establish some of the main figures you can see how it is easier to lift these out of the mid-tone I've covered the canvas in. I work fairly loosely for as long as I can to try to preserve a sense of atmosphere and movement, leaving the working up of specific details until much later in the creation of the painting.

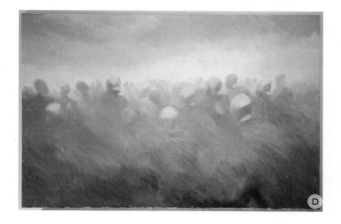

F. As I put in more figures, what initially appeared to be quite a strong overall background tone now starts to look really quite pale in places, showing how tonal values are relative to one another. My figures usually start in my head, drawing the pose I think fits the action and composition, sometimes aided by some quick photos taken in the garden to prove that my ideas are physically possible and also to help visualise the foreshortening of limbs, twist of a head, positioning of hands, etc., all the little touches that hopefully make the people in my paintings look real. The armour and clothing I construct on the basic figures using the

huge amount of reference material and information I've gathered over the years. With such a complicated painting it can get rather chaotic in my studio, with references all over the place, and be very frustrating when I can't lay my hands on a particular picture of a certain tomb effigy I'm basing one of the armours on!

G. Establishing the banners in the painting makes a huge difference to the overall appearance. I've added colour to the important ones in the foreground, while the others will be painted in various degrees of fogginess to convey the atmosphere that is so important. At the moment some of these are a bit strong, but that can be adjusted as I progress.

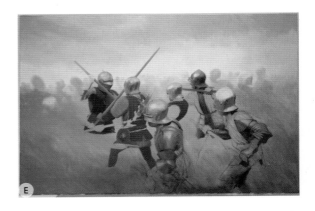

H. In my preliminary sketch I indicated bodies of the dead and wounded without being that specific, so it takes quite a lot of thought and work to decide exactly how they should be placed within the composition. Their struggle and fate is as much a part of the story I'm trying to convey as those still standing – it's the end they are desperately trying to avoid with all the effort they can muster. As with every element in the painting, these will evolve – as you can see with the figure clutching his face, who I have altered from the initial drawing out.

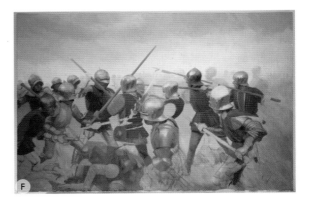

I. After several weeks of painting I am now able to start putting in a few details that make it feel like I'm finally getting somewhere. Indicating the heraldry on Edward IV's tabard and putting the beginning of a crown on his helmet starts to give him some interest. They are only a few brushstrokes and need refining, but it is definite progress.

J. Another busy week has seen me concentrating on the right-hand side of the painting. I have done some more work to the billman grappling with Edward IV, but I've primarily focused on two rather important figures in the background: John Neville, Marquess Montagu, conferring with his brother Richard, Earl of Warwick.

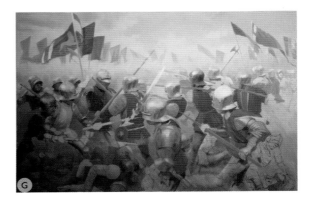

I hadn't initially thought I'd be able to include the commanders of both sides in the same painting, with the composition centred on King Edward, but what I had just indicated with a few pencil marks in the preliminary sketch shouted out to me to be Warwick and Montagu when I looked at the space on the full-sized painting.

They will remain relatively indistinct in the fog, but I will do some more work to them both, and the figures and banners around them. Montagu wears a tabard bearing his coat of arms, while Warwick is dressed in the famous armour depicted on the tomb effigy of his father-in-law Richard Beauchamp, made a couple of decades after his death, so actually very appropriate for Richard Neville.

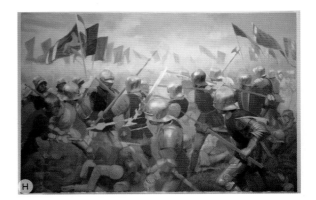

This is a stage in the evolution of a painting where everything appears to slow down, as the relatively quick early progress with broad brushstrokes changes to adding some of the finer detailed work. However, I am still working fairly loosely on some areas, still grappling with the placement and posing of some of the figures so that they all inhabit the same space and interact convincingly. Sometimes this can be very frustrating and it is easy to get bogged down with something that just won't look right. After wiping the paint off the canvas for the umpteenth time, sometimes I need to tell myself to walk away and come back to that area later!

K. I tend to work from the right to the left, as being a left-hander, this means my mahl stick (the stick with a padded end used to rest the brush hand on) rests on dry paint. This also allows the previous few days' painting to hopefully dry before I move

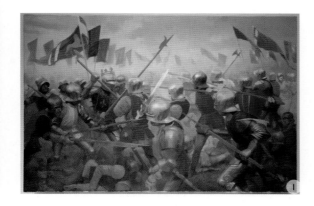

back to it. So while last week I concentrated on the right side of the painting, this week I've moved my attention across the centre to the left, and this weekend I should be able to focus on to the banners of Edward and his Yorkist supporters, which now look like they've been left behind by progress on the rest of the painting. I feel that it's important to keep the painting evolving evenly.

The central foreground figure is wearing the earl of Warwick's livery over a Milanese harness (much like the main figure in my painting 'Concealed Attack' on page 58). He is facing a Yorkist billman, brandishing his bill directly at him. Will his armour protect him or is there perhaps a vulnerable gap for the bill to find and exploit? Either way, it will be over for one of them in moments...

Just as it's probably all over for the figure on the ground between them, who is now starting to take shape. I intentionally posed him so the angle of his head looks slightly awkward; if he's fallen dead or grievously wounded, he wouldn't have the opportunity to make himself comfortable.

L. At first glance you'd think the painting was finished at this point, but there's still a lot of work to do. The early days with a big brush see fast progress, but now that I'm working on the details, a whole day can be spent on one figure.

The foreground figure on the right threw a last-minute headache into the mix. Originally, I intended to make him Sir John Conyers, a member of a prominent Yorkshire family with a long history as retainers of the earl of Warwick and before him his father, the earl of Salisbury. Sir John played a major part in Warwick's uprising of 1469, resulting in the Battle of Edgcote, where Conyers fought. However, he made his peace with King Edward IV soon after, and went on to become a faithful Yorkist, so without any conclusive evidence of his presence at Barnet, despite his long association with Warwick, I became nervous of including him in the painting. Mind you, that was after I'd painted the tabard blue and added his heraldry! I then considered other potential candidates, but for various reasons had to discount them, either because I could find no evidence of their being at Barnet, or because their allegiances would have put them with the earl of Oxford on the right wing, far in the background of my painting. Finally, following many hours of frustration, I narrowed it down to just one possibility – Sir Richard Tunstall.

Contemporary evidence identifying those who fought at the Battle of Barnet, apart from the major commanders, is scarce, but the little snippet that backs my inclusion of Sir Richard in my painting was written in a letter from the duke of Burgundy's secretary, passing on the latest news from England and including Sir Richard's name amongst a list of those who fought at Barnet.

The finished painting can be seen reproduced on pages 182–183, and there are some details on pages 167, 176, 180 and 185.

Warfare is brutal and I am very conscious that I should be careful not to glamorise it in my work. Often, the suggestion of violence and a nasty outcome is sufficient, but with a painting set in the midst of battle like this, I had to be more obvious. Accounts mention the propensity of wounds to the face and limbs, and this can easily be imagined when you look at the vicious sharp hooks and spikes on a bill or poleaxe, and then see the lack of much armour on the majority of those involved in the fighting, particularly the open-faced helmets and unprotected legs and arms. Seeing these more lightly armed figures and the weapons they're brandishing, and some of those who have been struck down, does, I think, make it clear the medieval battlefield was not a nice place to be.

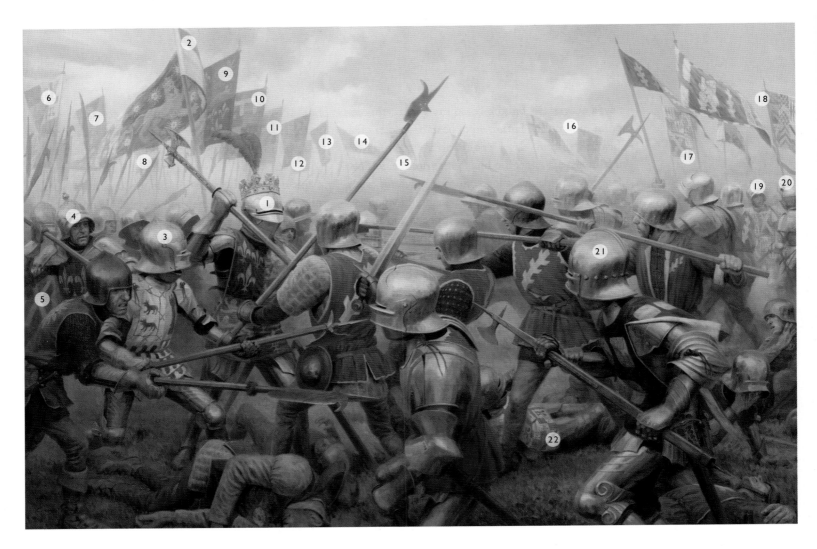

1 King Edward IV

2 Edward IV's Standard

3 Sir Walter Blount, Lord Mountjoy

4 Sir Thomas de Burgh

5 Sir James Harrington

6 Banner of Henry Bourchier, Earl of Essex

7 Banner of Sir John Howard, Lord Howard

8 Banner of Sir Henry Grey, Lord Grey of Codnor

9 Royal banner

10 Banner of George, Duke of Clarence

11 Banner of Sir Walter Devereux, Lord Ferrers

12 Banner of William Fiennes, Lord Saye

13 Banner of Edmund Grey, Earl of Kent

14 The earl of Oxford's Standard

15 Banner of Sir William Hastings, Lord Hastings

16 Standard and Banner of Viscount Beaumont

17 Banner of John Neville, Marquess Montagu

18 Banner and Standard of Richard Neville, Earl of
 Warwick

19 John Neville, Marquess Montagu

20 Richard Neville, Earl of Warwick

21 Sir Richard Tunstall

22 Sir Humphrey Bourchier, Lord Cromwell

The Battle of Barnet Painting Diary, along
with several others, can be seen on my website
www.studio88.co.uk

The banners in the painting
are carefully chosen to show
not only some of the other
notable lords present, but to
help tell the story of the
battle. In the background you
can make out the banner of
Sir William, Lord Hastings,
commander of the Yorkist
left, who was outflanked and
overrun by the Lancastrians
under the command of John
de Vere, Earl of Oxford,
because the two armies had
misaligned in the fog.
Oxford's standard can be
seen passing Hastings's
wavering banner – both
deliberately placed to add
another layer to the
narrative included in the
painting.

BIBLIOGRAPHY

PRIMARY SOURCES

Contemporary sources of information for the period of the Wars of the Roses are sparse, but those that do exist help us piece together the twists and turns of events during this turbulent time.

Although monastic chronicles written in Latin were in decline, the *Croyland* (or Crowland) *Chronicle* and Abbot Whethamstede continued the tradition, Whethamstede's remarks about the Battle of St Albans in particular providing a valuable eyewitness record.

Among the secular chronicles that survive, written in what is now described as Middle English, are several narratives originating in London such as *Gregory's Chronicle*, named after the suggested author, William Gregory, a skinner who rose to become mayor of London. However, this attribution is far from certain. The events recorded in these chronicles are often based on information circulating at the time, with some clearly based on or copied from other similar works, but they also contain passages that give the impression that they were witnessed first-hand or are based on eyewitness accounts.

Letters provide a much more personal view of events, along with snippets of everyday life, with the correspondence of the Paston family being the best known. These letters, like the chronicles, inevitably contain a good helping of bias and rumour, while proclamations and manifestos are more obvious propaganda. However, although this has sometimes coloured the popular history of the Wars of the Roses, so long as the viewpoint or agenda of the author is borne in mind all these sources provide valuable information and contemporary opinion of the events the writers were living through. A comprehensive account of Edward IV's exile and return in 1471 is provided by the *Historie of the Arrivall of Edward IV in England and the Finall Recoverye of his Kingdomes from Henry VI* (usually referred to more simply as *The Arrivall*), and while this was an official account, written for the government and very obviously biased in favour of the 'full manly' king, it does constitute an important and detailed source for this crucial period.

Continental observers have also left us their view of events, either as reports sent to their masters at home, or in the form of histories or memoirs. The writings of Burgundians Jean de Waurin and Philippe de Commyns, for example, contain much of value, especially regarding Anglo-Burgundian and French diplomacy with which they were involved, but they are less reliable when writing about events in England, so they too need to be treated with some caution.

Government and civic records contain copious amounts of information, and amongst the more mundane items are illuminating nuggets covering royal patronage, commissions, grants, appointments, petitions, legal proceedings, acts of attainder and much more.

Surviving account books such as those of John Howard, Duke of Norfolk, provide details of purchases of all manner of items, including arms and armour, and wages, along with much more than the bald records of expenditure would suggest: for example, in 1465 it is noted that the duke of Clarence owed Howard 20 shillings, which he lent him to give to the 'Kyngys menstralys [minstrels] att the meyrys [mayor's] howse'.

We are fortunate that many of these chronicles and records were transcribed and published in the 19th and early 20th centuries, with others subsequently joining them, and even more so that some of these resources are now available online.

The Acts of the Parliaments of Scotland, vol. II, Thomson, T. and Innes, C. (eds), London: Record Commission, 1814

Bentley, Samuel (ed.), *Excerpta Historica*, London: Samuel Bentley, 1831

Black, W.H. (ed.), *Illustrations of Ancient State and Chivalry from Manuscripts Preserved in the Ashmolean Museum*, London: Roxburgh Club, 1840

Brie, Freidrich W.D. (ed.), *The Brut, or the Chronicles of England*, London: Early English Text Society, 1906

Brown, R. (ed.), *Calendar of State Papers and Manuscripts Relating the English Affairs, Existing in the Archives and collections of Venice*, vol. I, London: Longman, Roberts, and Green, 1864

Bruce, John (ed.), *Historie of the Arrivall of Edward IV in England and the Finall Recoverye of his Kingdomes from Henry VI*, London: Camden Society, 1838

Calendar of Close Rolls: Henry VI, vol. VI *1454–61* (1967); *Edward IV*, vols. I–II, *1461–68, 1468–76* (1949, 1953); *Edward IV, Edward V, Richard III, 1476–85* (1954), London: HMSO

Calendar of Patent Rolls: Henry VI, vol. VI *1452–61* (1910); *Edward IV 1461–7* (1897); *Edward IV, Henry VI 1467–77* (1900); *Edward IV, Edward V, Richard III, 1476–85* (1901), London: HMSO

Campbell, William (ed.), *Materials for a History of the Reign of Henry VII*, 2 vols., London: Longman and Co., 1873 & 1877

Carpenter, Christine (ed.), *Kingsford's Stonor Letters and Papers 1290–1483*, Cambridge: Cambridge University Press, 1996

Carsen, Annette, *Domenico Mancini: de occupatione regni Anglie*, Horstead: Imprimis Imprimatur, 2021

Davis, Norman (ed.), *Paston Letters and Papers of the Fifteenth Century* (2 vols.), Oxford: Oxford University Press for The Early English Text Society, 2004

Davies, John Sylvester (ed.), *An English Chronicle of the Reigns of Richard II, Henry IV, Henry V, and Henry VI*, London: Camden Society, 1856

Dockray, Keith, *Edward IV: A Source Book*, Stroud: Sutton Publishing, 1999

Dockray, Keith, *Henry VI, Margaret of Anjou and the Wars of the Roses: A Source Book*, Stroud: Sutton Publishing, 2000

Dockray, Keith, *Richard III: A Source Book*, Stroud: Sutton Publishing, 1997

Ellis, Henry (ed.), *Original Letters Illustrative of English History*, Second Series, vol. I, London: Harding and Lepard, 1827

Fabyan, Robert, *The New Chronicles of England and France*, ed. Henry Ellis, London: F.C. and J. Rivington; T. Payne; Wilkie and Robinson; Longman, Hurst, Rees, Orme and Co.; Cadell and Davies; J. Mawman; and J. Johnson and Co., 1811

Flenley, Ralph (ed.), *Six Town Chronicles of England*, Oxford: Clarendon Press, 1911

Fortescue, John, *The Governance of England*, ed. Charles Plummer, Oxford: Oxford University Press, 1926

Gairdner, James (ed.), 'William Gregory's Chronicle of London', *The Historical Collections of a Citizen of London in the Fifteenth Century*, London: Camden Society, 1876

Gairdner, James (ed.), *Three Fifteenth-Century Chronicles with Historical Memoranda by John Stowe*, London: Camden Society, 1880

Gairdner, James (ed.), *The Paston Letters* (6 volumes), London: Chatto & Windus, 1904

Hall, Edward, *Hall's Chronicle*, London: J. Johnson; F.C. and J. Rivington; T. Payne; Wilkie and Robinson; Longman, Hurst, Rees and Orme; Cadell and Davies; and J. Mawman, 1809

Halliwell, James Orchard (ed.), *Letters of the Kings of England*, vol. I, London: Henry Colburn, 1848

Harris, Mary Dormer (ed.), *The Coventry Leet Book or Mayor's Register*, London: Early English Text Society, 1907

Hearne's Fragment, *Thomae Sprotti Chronica*, vol.11, 1719, pp.283–306

Hinds, Allen B. (ed.), *Calendar of State Papers and Manuscripts Existing in the Archives and Collections of Milan*, vol. I, London: HMSO, 1912

Horrox, R. and Hammond, P.W. (eds), *British Library Harleian Manuscript 433*, 4 vols., Upminster: Richard III Society, 1979

The Household Books of John Howard, Duke of Norfolk, 1462–71, 1481–83, introd. Anne Crawford, Stroud: Alan Sutton for Richard III and Yorkist History Trust, 1992

Kingsford, C.L. (ed.), *The First English life of King Henry the Fifth… by an anonymous author known commonly as the translator of Livius*, Oxford: Clarendon Press, 1911

Kingsford, C.L. (ed.), *Chronicles of London*, Oxford: Clarendon Press, 1905

Kirby, Joan (ed.), *The Plumpton Letters and Papers*, Cambridge: Cambridge University Press, 1996

Legg, L.G.W. (ed.), *English Coronation Records*, Westminster: Archibald Constable & Co., 1901

Leland, J., *Joannis Lelandi Antiquarii de Rebus Britannicis Collectanea*, vol. IV, ed. T. Hearn, London: Apud Benj. White, 1774

Lyte, H.C. Maxwell (ed.), *The Manuscripts of His Grace the Duke of Rutland Preserved at Belvoir Castle*, vol. I, HMSO, 1888

Madden, Frederick, *Political Poems Written in the Reigns of Henry VI and Edward IV*, London: J.B. Nichols & Son, 1842

Malden, Henry Elliot, *The Cely Papers: Selections from the Correspondence and Memoranda of the Cely Family, Merchants of the Staple, AD 1475–1488*, London: Longmans, Green and Co, 1900

Maurer, Helen and Cron, B.M. (eds), *The Letters of Margaret of Anjou*, Woodbridge: The Boydell Press, 2021

Nichols, John Gough (ed.), *Chronicle of the Rebellion in Lincolnshire, 1470*, London: Camden Society, 1847

Nicolas, Nicholas Harris (ed.), *Privy Purse Expenses of Elizabeth of York: Wardrobe Accounts of Edward the Fourth*, London: William Pickering, 1830

Nicolas, Nicholas Harris (ed.), *Proceedings and Ordinances of the Privy Council of England*, vol. VI, London: Record Commission, 1831

Nicolas, Nicholas Harris and Tyrrell, Edward (eds), *A Chronicle of London from 1089–1483*, London: Longman, Rees, Orme, Brown and Green, 1827

de Pizan, Christine, *The Book of the City of Ladies*, translated by Rosalind Brown Grant, London: Penguin Books, 1999

de Pizan, Christine, *The Treasure of the City of Ladies*, translated by Sarah Lawson, London: Penguin Books, 2003

Raine, Angelo (ed.), *York Civic Records*, 2 vols., The Yorkshire Archaeological Society, 1939 & 1941

Raine, James (ed.), *A Volume of English Miscellanies Illustrating the History and Language of the Northern Counties of England*, Durham: The Surtees Society, 1890

Records of the Borough of Nottingham, vol. II, *King Henry IV to King Richard III, 1399–1485*, London: Bernard Quaritch, Nottingham: Thomas Forman & Sons, 1883

Richardson, T., 'The Bridport Muster Roll 1457', *Royal Armouries Yearbook* 2, 1997, pp.46–52

Riley, H.T. (ed.), *Ingulph's Chronicle of the Abbey of Croyland*, London: Henry G. Bohn, 1854

Riley, H.T. (ed.), *Registrum Abbatiae Johannis Whethamstede*, 2 vols., London: Longman & Co., 1872–73

Rotuli Parliamentorum, vols. V & VI, J. Strachey and R. Blyke (eds), 1767

Rymer, T. (ed.), *Foedera, Conventiones, Litterae…* (20 volumes), London: J. Tonson, 1727–35

Scoble, Andrew R. (ed.), *The Memoirs of Philip de Commines*, vol. II, London: Henry G. Bohn, 1856

Sinclair, Alexandra, *The Beauchamp Pageant*, Richard III and Yorkist History Trust, 2003

Spencer, Dan, 'Italian Arms and Armour for the Royal Household of Edward IV', *Arms and Armour* vol. 17, issue 2, 2020, pp.111–121

Thomas, A.H. and Thornley, I.D. (eds), *The Great Chronicle of London*, London, 1938. Facsimile edition, Stroud: Sutton Publishing, 1983

Vergil, Polydore, *Three Books of Polydore Vergil's English History, Comprising* the Reigns of Henry VI, Edward IV and Richard III, ed. Henry Ellis, London: Camden Society, 1844

Warkworth, John, *A Chronicle of the First Thirteen Years of the Reign of King Edward the Fourth*, ed. J. O. Halliwell, London: Camden Society, 1839

Waurin, Jehan de, *Recueil des Cronicques et Anchiennes istories de la Grant Bretaigne*, vol. V, ed. William Hardy and Edward Hardy, London: HMSO, 1891

Worcester, William, 'Annales Rerum Anglicarum', in *Letters and Papers Illustrative of the Wars of the English in France*, vol. II pt.II, ed. Joseph Stevenson, London: Longman, Green, Longman, Roberts and Green, 1864

SECONDARY SOURCES

Amin, Nathen, *Henry VII and the Tudor Pretenders*, Stroud: Amberley Publishing, 2020

Amin, Nathen, *The House of Beaufort*, Stroud: Amberley Publishing, 2017

Baldwin, David, *Elizabeth Woodville: Mother of the Princes in the Tower*, Stroud: Sutton Publishing, 2002

Barber, Richard, *King Arthur: Hero and Legend*, Woodbridge: The Boydell Press, 2004

Barnard, Francis Pierrepont, *Edward IV's French Expedition of 1475: The Leaders and their Badges*, Dursley: Gloucester Reprints, 1975

Barnes, H.D. and Simpson, D.S., 'Caister Castle', *The Antiquaries Journal*, vol.32, issue 1–2, April 1952, pp.35–51

Bennett, Michael, *Lambert Simnell and the Battle of Stoke*, Stroud: Sutton Publishing, 1993

Bennett, Nicholas, 'The Road to Losecoat Field: The Story of the first Lincolnshire Rising', *The Ricardian*, vol. XXX, 2020, pp.137–49

Blacker, B.H. (ed.), *Gloucestershire Notes and Queries*, vol. III, London: W.M. Kent & Co., 1887

Boardman, Andrew, *The First Battle of St Albans 1455*, Stroud: Tempus Publishing, 2006

Boardman, A.W., *The Battle of Towton*, Stroud: Sutton Publishing, 1996

Breverton, Terry, *Owen Tudor: Founding Father of the Tudor Dynasty*, Stroud: Amberley Publishing, 2017

Buri, Anna Rapp and Stucky-Schürer, Monica, *Burgundische Tapisserien*, Munich: Hirmer Verlag, 2001

Burley, P., Elliott, M., Watson, H., *The Battles of St Albans*, Barnsley: Pen and Sword, 2007

Capwell, Tobias, *Armour of the English Knight 1400–1450*, Thomas Del Mar, 2015

Capwell, Tobias, *Armour of the English Knight 1450–1500*, Thomas Del Mar, 2021

Capwell, Tobias, *Armour of the English Knight: Continental Armour in England, 1435–1500*, Thomas Del Mar, 2022

Castor, Helen, *Blood & Roses: The Paston Family in the Fifteenth Century*, London: Faber and Faber, 2004

Clark, K.L., *The Nevills of Middleham: England's Most Powerful Family in the Wars of the Roses*, Stroud: The History Press, 2016

Crawford, Anne, *Yorkist Lord: John Howard, Duke of Norfolk, c.1425–1485*, London: Continuum, 2010

Cron, B.M., *Margaret of Anjou and the Men Around Her*, History and Heritage Publishing, 2021

Evans, Graham, *The Battle of Edgcote 1469: Re-evaluating the evidence*, Northamptonshire Battlefield Society, 2019

Evans, H.T., *Wales and the Wars of the Roses*, Stroud: Sutton Publishing, 1995

Fiorato, Veronica, Boylston, Anthea, and Knüsel, Christopher (eds), *Blood Red Roses: The Archaeology of a Mass Grave from the Battle of Towton AD 1461*, Oxford: Oxbow Books, 2000

Fleming, Peter and Wood, Michael, *Gloucestershire's Forgotten Battle: Nibley Green 1470*, Stroud: Tempus Publishing, 2003

Foard, Glenn and Curry, Anne, *Bosworth 1485: A Battlefield Rediscovered*, Oxford: Oxbow Books, 2013

Friel, Ian, *The Good Ship: Ships, Shipbuilding and Technology in England 1200–1520*, London: British Museum Press, 1995

Goodchild, Steven, *Tewkesbury: The Eclipse of the House of Lancaster – 1471*, Barnsley: Pen & Sword, 2005

Gravett, Christopher, *English Medieval Knight 1400–1500*, Oxford: Osprey Publishing, 2001

Gravett, Christopher, *Tewkesbury 1471: The Last Yorkist Victory*, Oxford: Osprey Publishing, 2003

Gravett, Christopher, *Towton 1461: England's Bloodiest Battle*, Oxford: Osprey Publishing, 2003

Gravett, Christopher, *Bosworth 1485: The Downfall of Richard III*, Oxford: Osprey Publishing, 2021

Griffiths, R.A., *The Reign of King Henry VI*, Stroud: Sutton Publishing, 1998

Griffiths, Ralph A. and Thomas, Roger S., *The Making of the Tudor Dynasty*, Stroud: Sutton Publishing, 1993

Haigh, Philip A., *The Battle of Wakefield 1460*, Stroud: Sutton Publishing, 1996

Haigh, Philip A., '… Where Both the Hosts Fought…': The Rebellions of 1469–1470*, Heckmondwike: Battlefields Press, 1997

Hammond, P.W., *The Battles of Barnet and Tewkesbury*, Stroud: Sutton Publishing, 1990

Hammond, Peter, *Richard III and the Bosworth Campaign*, Barnsley: Pen & Sword, 2010

Hardyment, Christina, *Malory: The Life and Times of King Arthur's Chronicler*, London: Harper Collins, 2005

Hicks, Michael, *Warwick the Kingmaker*, Oxford: Blackwell Publishing, 2002

Higginbotham, Susan, *The Woodvilles: The Wars of the Roses and England's Most Infamous Family*, Stroud: The History Press, 2013

Hodges, Geoffrey, *Ludford Bridge & Mortimer's Cross*, Logaston Press, 2001

Hope, W.H. St. John, *The Stall Plates of the Knights of the Order of the Garter, 1348–1485*, Westminster: Constable, 1901

Ingram, Mike, *The Battle of Northampton 1460*, Northampton Battlefield Society, 2015

Jones, Michael K., *Bosworth 1485: Psychology of a Battle*, Stroud: Tempus Publishing, 2002

Judde, David, *John Judde: Merchant of London and Master of the King's Ordnance*, www.medievalsoldier.org/about/soldier-profiles/john-judde-merchant-of-london-and-master-of-the-kings-ordnance/

Key, David, 'Whythe bendys a-bove hyr harnys: An Investigation into the "Bend" as a Part of Fifteenth-Century Military Clothing', *Costume: The Journal of the Costume Society*, no.37, London, 2003, pp.17–23

Kleineke, Hannes, 'Gerhard von Wesel's Newsletter from England, 17 April 1471', *The Ricardian*, vol. XVI, 2006, pp.66–83

Lander, J.R., *The Wars of the Roses*, London: Grange Books, 1997

Laynesmith, J.L., *Cecily Duchess of York*, London: Bloomsbury Academic, 2017

Lewis, Matthew, *Richard III: Loyalty Binds Me*, Stroud: Amberley, 2018

Lewis, Matthew, *Richard, Duke of York: King by Right*, Stroud: Amberley, 2016

Maurer, Helen E., *Margaret of Anjou*, Woodbridge: The Boydell Press, 2003

Nicolle, David, *The Fall of English France 1449–53*, Oxford: Osprey Publishing, 2012

Nicolle, David, *Orléans 1429: France Turns the Tide*, Oxford: Osprey Publishing, 2001

Radford, G.H., 'Nicholas Radford 1385–1455', in *Reports and Transactions of the Devonshire Association*, vol. XXXV, 1903, pp.251–78

Radford, G.H., 'The Fight at Clyst in 1455', in *Reports and Transactions of the Devonshire Association*, vol. XLIV, 1912, pp.252–65

Reeves, A. Compton, 'Some of Humphrey Stafford's Military Indentures', in *Nottingham Medieval Studies*, vol.16, 1972, pp.80–91

Richmond, Colin F., 'The Earl of Warwick's Domination of the Channel and the Naval Dimension to the Wars of the Roses, 1456–1460', in *Southern History*, vol. 20–21, 1998–99, pp.1–19

Roberts, Sara Elin, *Jasper: The Tudor Kingmaker*, Fonthill Media, 2015

Ross, Charles, *Edward IV*, London: Eyre Methuen, 1974

Ross, Charles, 'Some "Servants and Lovers" of Richard in his Youth', *The Ricardian*, vol. IV, no.55, December 1976, pp.2–4

Ross, James, *The Foremost Man in England: John de Vere, Thirteenth Earl of Oxford (1442–1513)*, Woodbridge: The Boydell Press, 2011

Ross, James, *Henry VI*, London: Penguin Books, 2019

Schofield, C.L., *The Life and Reign of Edward the Fourth*, 2 vols., London: Longmans, Green and Co., 1923

Siddons, Michael Powell, *Heraldic Badges in England and Wales*, 4 volumes, Woodbridge: The Boydell Press for The Society of Antiquaries of London, 2009

Sommer, H.O. (ed.), *Le Morte D'Arthur by Syr Thomas Malory*, London: David Nutt, 1889

Steer, Christian, 'The Death of Achilles: The Funerary Brass of Sir Humphrey Bourchier', *Transactions of the Monumental Brass Society*, vol. XIX/5, 2018, pp.425–44

Storey, R.L., *The End of the House of Lancaster*, Stroud: Sutton Publishing, 1999

Strickland, Matthew and Hardy, Robert, *The Great Warbow: From Hastings to the Mary Rose*, Stroud: Sutton Publishing, 2005

Sutherland, T.L., 'Killing Time: Challenging the Common Perceptions of Three Medieval Conflicts – Ferrybridge, Dintingdale and Towton – "The Largest Battle on British Soil"', *Journal of Conflict Archaeology*, 5, No.1, 2010, pp.1–25

Sutton, Anne F. and Visser-Fuchs, Livia, *The Hours of Richard III*, Stroud: Sutton Publishing, 1996

Sutton, Anne F. and Visser-Fuchs, Livia, *Richard III's Books: Ideals and Reality in the Life and Library of a Medieval Prince*, Stroud: Sutton Publishing, 1997

The Tewkesbury Battlefield Society, *The Street Banners of Tewkesbury*, Tewkesbury, 2022

Thornley, Isobel D., *England Under the Yorkists*, London: Longmans, Green and Co., 1920

Warnicke, R.M., 'Sir Ralph Bigod: A Loyal Servant to King Richard III', *The Ricardian*, vol. VI, no.84, March 1984, pp.299–303

Watson, B., Brigham, T. and Dyson, T., *London Bridge: 2000 Years of a River Crossing*, London: Museum of London Archaeology Service, 2001

Weightman, Christine, *Margaret of York: Duchess of Burgundy 1446–1503*, Stroud: Sutton Publishing, 1993

Whitewood, Dickon, *Shrewsbury 1403*, Oxford: Osprey Publishing, 2017

Woolley, Linda, *Medieval Life and Leisure in the Devonshire Hunting Tapestries*, London: V&A Publications, 2002

ENDNOTES

INTRODUCTION

1 William Shakespeare, *Henry VI: Part I*, II.iv.951–55, 985–86. [ADD edition]
2 William Shakespeare, *Henry V*, IV.iii.60.

CHAPTER 1: HENRY V – A FORMIDABLE LEGACY

1 *The Chronica Maiora of Thomas Walsingham*, quoted in Dickon Whitewood, *Shrewsbury 1403*, Osprey Publishing: Oxford, 2017, p.68.

CHAPTER 2: HENRY VI – KING OF ENGLAND AND FRANCE

1 James Ross, *Henry VI*, London: Penguin Books, 2019, p.3.
2 Ibid., p.11, original Latin in T. Rymer (ed), *Foedera, Conventiones, Litterae…*, vol. X, London, 1727, p.399.
3 *Calendar of Patent Rolls, Henry VI*, vol. VI *1452–61*, HMSO, 1910, p.247.
4 N.H. Nicolas and E. Tyrrell (eds), *A Chronicle of London from 1089–1483*, London, 1827, p.123.
5 Translated from the Eton foundation charter of 11 October 1440, in R.A. Griffiths, *The Reign of King Henry VI*, Stroud: Sutton Publishing, 1998, p.243.

6 Letter from Henry VI to the Lord Chancellor, 16 April 1445, in N.H. Nicolas (ed.), *Proceedings and Ordinances of the Privy Council of England*, vol. VI, Record Commission, 1837, preface, p.xvi.
7 Helen E. Maurer, *Margaret of Anjou*, Woodbridge: The Boydell Press, 2003, p.21.
8 Christine de Pizan, *The Book of the City of Ladies*, trans. Rosalind Brown Grant, London: Penguin Books, 1999, p.32.
9 Christine de Pizan, *The Treasure of the City of Ladies*, trans. Sarah Lawson, London: Penguin Books, 2003, p.24.
10 David Baldwin, *Elizabeth Woodville*, Stroud: Sutton Publishing, 2002, p.31.

CHAPTER 3: DESCENT TOWARDS CIVIL WAR

1 Letter from William Lomner to John Paston, 5 May 1450, in James Gairdner (ed.), *The Paston Letters*, vol. II, London, 1904, p.147.
2 Robert Fabyan, *The New Chronicles of England and France*, ed. Henry Ellis, London, 1811, p.622.
3 'A proclamation made by Jacke Cade, Capytayne of ye Rebelles in Kent', in James Gairdner (ed.), *Three Fifteenth-Century Chronicles with Historical Memoranda by John Stowe*, London: Camden Society, 1880, pp.94–99.
4 James Gairdner (ed.), *William Gregory's Chronicle of London*, in *The Historical Collections of a Citizen of London in the Fifteenth Century*, London: Camden Society, 1876, p.193.
5 *Gregory's Chronicle*, p.195.
6 *Bale's Chronicle*, in Ralph Flenley (ed.), *Six Town Chronicles of England*, Oxford: Clarendon Press, 1911, p.134.
7 *Gregory's Chronicle*, p.196.
8 Ibid., p.196.
9 Ibid., p.197.

10 *Benet's Chronicle*, in Keith Dockray, *Henry VI, Margaret of Anjou and the Wars of the Roses: A Source Book*, Stroud: Sutton Publishing, 2000, p.55.
11 *Paston Letters*, vol. I, p.101.
12 *Rotuli Parliamentorum*, 1767, vol. V, p.318.
13 Excerpts from a letter to Queen Margaret from Cecily, Duchess of York, May 1453, in Helen Maurer and B.L. Cron (eds), *The Letters of Margaret of Anjou*, Woodbridge: The Boydell Press, 2021, p.195.
14 *Bale's Chronicle*, p.140.
15 Newsletter of John Stodeley, in *Paston Letters*, vol. II, p.296.
16 From a letter written while their father was quelling a Yorkshire uprising, in *Paston Letters*, vol. I, pp.148–49.
17 Edmund Clere to John Paston, 9 January 1455, in *Paston Letters*, vol. III, p.13.
18 T. Rymer (ed), *Foedera, Conventiones, Litterae…*, vol. XI, 1727, p.362.

CHAPTER 4: THE ARMIES

1 *Rotuli Parliamentorum*, vol. V, pp.487–88.
2 Sir John Paston to John Paston III, 5 August 1470, in *Paston Letters*, vol. V, p.80.

3 *Gregory's Chronicle*, p.212.
4 *The Household Books of John Howard, Duke of Norfolk, 1462–71, 1481–83*, introd. Anne Crawford, Stroud: Sutton Publishing for Richard III and Yorkist History Trust, 1992, II, p.480.

5 John Warkworth, *A Chronicle of the First Thirteen Years of the Reign of King Edward the Fourth*, ed. J.O. Halliwell, London: Camden Society, 1839, p.12.

6 Letter from the earl of Oxford, 19 March 1471, in *Paston Letters*, vol. V, pp.95–96.

7 Letter from Richard, Duke of Gloucester to Lord Neville, 11 June 1483, in *Paston Letters*, vol. VI, pp.71–72.

8 Letter from Henry VII to Sir Robert Plumpton, 13 October 1489, in Joan Kirby (ed.), *The Plumpton Letters and Papers*, Cambridge: Cambridge University Press, 1996, p.87.

9 *Gregory's Chronicle*, p.212.

10 John Paston III to John Paston II, 11 December 1464, in *Paston Letters*, vol. IV, p.60.

11 *Gregory's Chronicle*, p.226.

12 *Historie of the Arrivall of Edward IV in England and the Finall Recoverye of his Kingdomes from Henry VI*, ed. John Bruce, London: Camden Society, 1838, p.24.

13 *Arrivall*, p.32.

14 *Warkworth's Chronicle*, p.13.

15 *Gregory's Chronicle*, p.212.

16 Michael Powell Siddons, *Heraldic Badges in England and Wales*, Woodbridge: The Boydell Press for The Society of Antiquaries of London, 2009, vol. I, p.97.

17 *Gregory's Chronicle*, p.208.

18 N.H. Nicolas (ed.), *Privy Purse Expenses of Elizabeth of York: Wardrobe Accounts of Edward the Fourth*, London, 1830, p.165.

19 Mary Dormer Harris (ed.), *The Coventry Leet Book or Mayor's Register*, London, 1907, pp.282–83.

20 David Key, 'Whythe bendys a-bove hyr harnys: An Investigation into the "Bend" as a Part of Fifteenth-Century Military Clothing', *Costume: The Journal of the Costume Society*, no.37, London, 2003, pp.17–23.

21 *Gregory's Chronicle*, p.212.

22 *Records of the Borough of Nottingham*, vol. II, *King Henry IV to King Richard III, 1399–1485*, Nottingham, 1883, p.53.

23 Christine Carpenter (ed.), *Kingsford's Stonor Letters and Papers 1290–1483*, Cambridge: Cambridge University Press, 1996, p.96.

24 *The Household Books of John Howard, Duke of Norfolk*, vol. I, p.195.

25 *Wardrobe Accounts of Edward the Fourth*, p.162.

26 *The Household Books of John Howard, Duke of Norfolk*, vol. I, p.195 and p.215.

27 Translated from original Latin in Annette Carsen, *Domenico Mancini: de occupatione regni Anglie*, Horstead: Imprimis Imprimatur, 2021, p.69.

28 Philippe de Commynes, *Mémoires*, in J.R. Lander, *The Wars of the Roses*, London: Grange Books, 1997, p.155.

29 *Gregory's Chronicle*, p.205.

30 Dan Spencer, 'Italian Arms and Armour for the Royal Household of Edward IV', *Arms and Armour*, vol. 17, issue 2, 2020, p.119.

31 H.E. Malden, *The Cely Papers: Selections from the Correspondence and Memoranda of the Cely Family, Merchants of the Staple, AD 1475–1488*, London: Longmans, Green and Co, 1900, p.56.

32 T. Richardson, 'The Bridport Muster Roll 1457', *Royal Armouries Yearbook 2*, 1997, pp.46–52.

CHAPTER 5: FIRST BLOOD

1 *Paston Letters*, vol. III, p.28.

2 Ibid.

3 Translated from the 'Dijon relation' in Armstrong, BIHR, XXXIII, 1960; quoted in Griffiths, *Henry VI*, p.745.

4 Abbot Whethamstede, *Registrum Abbatiae…*, translated from Latin by Lesley Boatwright in Boardman, *The Battle of St Albans 1455*, Stroud: Tempus Publishing, 2006, p.167.

5 *Paston Letters*, vol. III, pp.28–29.

6 *The Coventry Leet Book*, p.283.

CHAPTER 6: UNEASY PEACE

1 Petition to the king made by John Radford, seeking justice for his murdered cousin Nicholas, in G.H. Radford, 'Nicholas Radford 1385–1455', *Reports and Transactions of the Devonshire Association*, vol. XXXV, 1903, p.267.

2 Exeter Mayor's Roll, in G.H. Radford, 'The Fight at Clyst in 1455', *Reports and Transactions of the Devonshire Association*, vol. XLIV, 1912, p.261.

3 Ibid.

4 Nicholas Harris Nicolas (ed.), *Proceedings and Ordinances of the Privy Council of England, Vol. VI*, London: Record Commission, 1831, p.268.

5 Warrant of Prince Edward, 19 November 1458, in Helen E. Maurer, *Margaret of Anjou*, p.134, and Griffiths, *Henry VI*, p.781.

6 F.W.D. Brie (ed.), *The Brut, or the Chronicles of England*, London: Early English Text Society, 1906, p.527.

7 *Hall's Chronicle*, London, 1809, p.249.

8 William Shakespeare, *Henry VI: Part III*, I.iv.112–19, 142–43.

9 *Calendar of Patent Rolls*, 4 March 1457, vol. VI, p.348.

10 *Calendar of Patent Rolls*, 27 December 1457, vol. VI, p.413.

11 John Jernyngan to Margaret Paston, 1 June 1458, in *Paston Letters*, vol. III, p.130.

12 J.S. Davies (ed.), *An English Chronicle of the Reigns of Richard II, Henry IV, Henry V, and Henry VI*, London: Camden Society, 1856, pp.83–84.

13 *Calendar of Patent Rolls, Edward IV, 1461–1467*, HMSO, 1897, p.61.

14 Robert Fabyan, *The New Chronicles of England and France*, p.633.

15 Davies, *An English Chronicle…* p.77.

16 Fabyan, *The New Chronicles of England and France*, p.633.

17 Letter from Henry VI to the earl of Arundel, 14 February 1458. *Proceedings and Ordinances of the Privy Council of England*, vol. VI, p.293.

CHAPTER 7: OPEN WAR RETURNS

1 Ibid., p.634.
2 Davies, *An English Chronicle...* p.78.
3 Ibid., p.79.
4 Margaret Paston to John Paston, 29 April 1459, in
 Paston Letters, vol. III, p.139.
5 *Calendar of Patent Rolls*, 26 April 1460, vol. VI, p.582.
6 H.T. Riley (ed.), *Registrum Abbatiae Johannis Whethamstede*, 2 vols.,
 London, 1872–73, pp. 339–41, translation from
 Keith Dockray, *Henry VI, Margaret of Anjou*

and the Wars of the Roses: A Source Book, Stroud:
 Sutton Publishing, 2000, p.82.
7 *Rotuli Parliamentorum*, vol. V, p.348.
8 *Gregory's Chronicle*, p.205.
9 *Rotuli Parliamentorum*, vol. V, p.348.
10 *The Brut, or the Chronicles of England*, p.527.
11 *Rotuli Parliamentorum* vol. V, p.349.
12 *Gregory's Chronicle*, p.207.
13 Ibid., p.206.

CHAPTER 8: THE WHEEL OF FORTUNE TURNS

1 *Rotuli Parliamentorum*, vol. V, p.349.
2 William Paston to John Paston, 28 January 1460, in *Paston Letters*,
 vol. III, p.204.
3 Davies, *An English Chronicle...* p.90.
4 Thomas, A.H. and I.D. Thornley (eds), *The Great Chronicle of
 London*, London, 1938, p.192, quoted in Colin F. Richmond, 'The
 Earl of Warwick's Domination of the Channel and the Naval
 Dimension to the Wars of the Roses, 1456–1460', in *Southern
 History*, vol. 20–21, 1998–99, p.12.
5 Davies, *An English Chronicle...* p.96.
6 Ibid., p.97.
7 *Whethamstede*, pp.373–74, translation from Mike Ingram, *The Battle
 of Northampton 1460*, Northampton Battlefield Society, 2015,
 p.95.
8 Davies, *An English Chronicle...* pp.97–98.
9 Pope Pius II after reports from Francesco Coppini, R.A. Griffiths,
 The Reign of King Henry VI, Stroud: Sutton Publishing, 1998,
 p.864.
10 Ibid., p.96.
11 Ibid., p.98.
12 Gairdner (ed.), *Three Fifteenth-Century Chronicles*, p.75.
13 *Gregory's Chronicle*, p.209.
14 *Whethamstede*, pp.376–78, translation from J.R. Lander, *The Wars
 of the Roses*, London: Grange Books, 1997, p.78.
15 Davies, *An English Chronicle...* p.100.

16 Worcester, *Annales*, p.775, translation from Philip A. Haigh, *The
 Battle of Wakefield 1460*, Stroud: Sutton Publishing, 1996, p.18.
17 *Hall's Chronicle*, p.251.
18 Davies, *An English Chronicle...* p.107.
19 Ibid., p.110.
20 *Gregory's Chronicle*, p.211.
21 H.T. Riley (ed.), *Ingulph's Chronicle of the Abbey of Croyland*,
 London, 1854, p.422.
22 *Whethamstede*, pp.388–92, translation from Keith Dockray, *Henry
 VI, Margaret of Anjou and the Wars of the Roses: A Source Book*,
 p.107.
23 *Gregory's Chronicle*, p.213.
24 Ibid.
25 Ibid.
26 *Whethamstede*, translated from Latin by Lesley Boatright on Susan
 Higginbotham blog, https://www.susanhigginbotham.com/posts/
 the-singing-laughing-henry-vi-at-st-albans/.
27 *Gregory's Chronicle*, p.214.
28 Davies, *An English Chronicle...* p.97.
29 *Gregory's Chronicle*, p.212.
30 Davies, *An English Chronicle...* p.109.
31 Worcester, *Annales*, p.776, translation from Keith Dockray, *Henry
 VI, Margaret of Anjou and the Wars of the Roses: A Source Book*,
 p.111.
32 *Gregory's Chronicle*, p.212.

CHAPTER 9: TWO KINGS OF ENGLAND

1 *The Great Chronicle of London*, p.195.
2 Ibid.
3 Ibid., p.196.
4 Lander, *The Wars of the Roses*, p.91.
5 *Calendar of Close Rolls*, 1461–68, pp.54–55.
6 Henry VI to Sir William Plumpton, 13 March 1460, in Kirby,
 Plumpton Letters and Papers, p.26.
7 Pardon from Edward IV, 5 February 1462, in *Plumpton Letters*,
 p.255.
8 Angelo Raine (ed.), *York Civic Records*, vol. I, The Yorkshire
 Archaeological Society, 1939, p.135.
9 *Coventry Leet Book*, p.315.
10 George Neville to Francesco Coppini, in A.W. Boardman, *The

Battle of Towton, Stroud: Sutton Publishing, 1996, p.92.
11 *Gregory's Chronicle*, p.216.
12 *Hall's Chronicle*, p.255.
13 T.L. Sutherland, 'Killing Time: Challenging the Common
 Perceptions of Three Medieval Conflicts – Ferrybridge, Dintingdale
 and Towton –"The Largest Battle on British Soil"', *Journal of
 Conflict Archaeology*, 5 No.1, 2010, pp.1–25.
14 *Hall's Chronicle*, p.255.
15 *Gregory's Chronicle*, p.216.
16 Jean de Waurin, *Recueil des Croniques d'Engleterre*, vol. V, ed. W.
 Hardy and E. Hardy, London, 1891, p.339; translation from
 Boardman, *The Battle of Towton*, p.98.
17 *Hall's Chronicle*, p.255.

18 Waurin, translation from Sutherland, 'Killing Time', p.15.
19 *Hall's Chronicle*, pp.255–56.
20 Waurin, p.240, translation from Boardman, *Battle of Towton*, p.119.
21 Henry Ellis (ed.), *Three Books of Polydore Vergil's English History*, London: Camden Society, 1844, p.111.
22 Bishop of Salisbury to Francesco Coppini, 7 April 1461, in R. Brown (ed.), *Calendar of State Papers and Manuscripts Relating the English Affairs, Existing in the Archives and collections of Venice*, vol. I, London, 1864, p.102.
23 *Hall's Chronicle*, p.256.
24 Hearne's Fragment, *Thomae Sprotti Chronica*, vol.11, 1719, p.287.

25 *Vergil's English History*, p.111.
26 *Hall's Chronicle*, p.256.
27 *Croyland Chronicle*, in Keith Dockray, *Edward IV: A Source Book*, Stroud: Sutton Publishing, 1999, p.425.
28 Hearne's Fragment, *Thomae Sprotti Chronica*, vol.11, 1719, p.287.
29 *Gregory's Chronicle*, pp.217–18.
30 *Croyland Chronicle*, p.426.
31 George Neville to Francesco Coppini, 7 April 1461, in *Calendar of State Papers and Manuscripts… Venice*, p.100.
32 *Croyland Chronicle*, p.425.

CHAPTER 10: EDWARD IV – CONSOLIDATING HIS CROWN

1 *The Great Chronicle of London*, p.197.
2 *Hearne's Fragment*, p.288.
3 *Warkworth's Chronicle*, pp.2–3.
4 *Gregory's Chronicle*, p.219.
5 Ibid., p.223.
6 *Hall's Chronicle*, p.260.
7 *The Great Chronicle of London*, pp.199–202.
8 *Warkworth's Chronicle*, p.5.
9 Ibid., pp.37–38.

10 Ibid.
11 *Calendar of Patent Rolls*, 1 December 1459, vol. VI, 1452–61, p.527.
12 *Rotuli Parliamentorum* vol. V, p.348.
13 David Judde, *John Judde: Merchant of London and Master of the King's Ordnance*, www.medievalsoldier.org/about/soldier-profiles/john-judde-merchant-of-london-and-master-of-the-kings-ordnance/.
14 *Bale's Chronicle*, p.149.

CHAPTER 11: A NEW QUEEN

1 *Croyland Chronicle*, p.424.
2 Ibid., p.484.
3 *Gregory's Chronicle*, p.226.
4 Newsletter from Bruges, 5 October 1464, in *Calendar of State Papers and Manuscripts… Venice*, p.114.
5 *Croyland Chronicle*, p.440.
6 William Paston to John Paston, 28 January 1460, in *Paston Letters*, vol. III, p.204.

7 Sir John Paston to John Paston III, April 1467, in *Paston Letters*, vol. IV, p.275.
8 Samuel Bentley (ed.), 'Tournament between Lord Scales and the Bastard of Burgundy, A.D. 1467', *Excerpta Historica*, London, 1831, pp.178–84.
9 Ibid., pp.203–12.
10 John Paston III to Margaret Paston, 8 July 1468, in *Paston Letters*, vol. IV, p.298.
11 Ibid.

CHAPTER 12: THE OVERMIGHTY SUBJECT

1 Public Records Office National Archives, E404/74/2; David Key, 'Whythe bendys a-bove hyr harnys', p.21.
2 *The Coventry Leet Book*, p.342.
3 Edward IV to the earl of Warwick, 9 July 1469, in *Paston Letters*, vol. V, p.35.
4 *Warkworth's Chronicle*, p.46.
5 Ibid., p.47.
6 Ibid., p.6.
7 *Hall's Chronicle*, p.274.
8 Ibid.
9 Graham Evans, *The Battle of Edgcote 1469: Re-evaluating the evidence*, Northamptonshire Battlefield Society, 2019.

10 *Hall's Chronicle*, p.274.
11 Ibid.
12 Ibid.
13 'Marwnad Wiliam Herbert o Raglan, iarll cyntaf Penfro' – 'Elegy for William Herbert of Raglan, first earl of Pembroke', by Guto'r Glyn, edited by Barry J. Lewis. Quoted in Graham Evans, *The Battle of Edgcote 1469*, p.101, from www.gutorglyn.net.
14 *Warkworth's Chronicle*, p.7.
15 *Croyland Chronicle*, p.447.
16 Waurin, translated by Livia Visser-Fuchs in Evans, *The Battle of Edgcote 1469*, p.116.
17 *The Coventry Leet Book*, p.346.

CHAPTER 13: GREAT TROUBLES

1 Will of Sir John Fastolf, in *Paston Letters*, vol. III, p.162.

2 John Paston III to Sir John Paston, late November 1472, in *Paston Letters*, vol. V, p.169.

3 Margaret Paston to John Paston I, in *Paston Letters*, vol. II, p.101.

4 John Paston's Petition, 1450, in *Paston Letters*, vol. II, p.128.

5 Margaret Paston to John Paston, 21 February 1450, in *Paston Letters*, vol. II, p.133.

6 John Paston I to James Gresham, 4 September 1450, in *Paston Letters*, vol. II, p.170.

7 Margery Brews to John Paston III, February 1477, in *Paston Letters*, vol. V, p.268.

8 Margery Paston to John Paston III, 18 December 1477, in *Paston Letters*, vol. V, pp.307–08.

9 William Paston to John Paston I, 2 May 1460, in *Paston Letters*, vol. III, p.218.

10 Richard Calle to John Paston I, 10 July 1465, in *Paston Letters*, vol. IV, p.160.

11 Margaret Paston to John Paston I, 27 October 1465, in *Paston Letters*, vol. IV, pp.206–07.

12 Sir John Paston to John Paston III, April 1467, in *Paston Letters*, vol. IV, p.275.

13 John Paston III to Sir John Paston, April 1467, in *Paston Letters*, vol. IV, p.276.

14 John Paston III to Margaret Paston, 8 July 1468, in *Paston Letters*, vol. IV, p.298.

15 Sir John Paston to John Paston III, 9 November 1468, in *Paston Letters*, vol. IV, p.306.

16 Inventory of household goods at Caister, 6 June 1462 from The British Library Add. MS 39848 ff.50–53, transcribed in Norman Davis (ed.), *Paston Letters and Papers of the Fifteenth Century*, vol. I, Oxford: The Early English Text Society, 2004, pp.107–14.

17 H.D. Barnes and D.S. Simpson, 'Caister Castle', *The Antiquaries Journal*, vol.32, issue 1–2, April 1952, p.36.

18 Inventory of household goods at Caister, 6 June 1462 in Davis (ed.), *Paston Letters and Papers of the Fifteenth Century*, vol. I, pp.107–14.

19 Inventory taken after surrender of Caister, 1470 from The British Library Add MS. 39848 f.54, in Davis (ed.), *Paston Letters and Papers of the Fifteenth Century*, vol. I, pp.434–36.

20 *Itineraries of William Worcester*, ed. J.H. Harvey, Oxford: Clarendon Press, 1969, p.187; quoted in Helen Castor, *Blood & Roses*, London: Faber & Faber, 2004, p.205.

21 Margaret Paston to Sir John Paston, 12 September 1469, in *Paston Letters*, vol. V, p.45.

22 Sir John Paston to Margaret Paston, 15 September 1469, in *Paston Letters*, vol. V, p.47.

23 Duke of Norfolk to John Paston III, 26 September 1469, in *Paston Letters*, vol. V, p.55.

24 John Paston III to Sir John Paston, September 1469, in *Paston Letters*, vol. V, p.57.

25 John Paston III to Sir John Paston, December 1469, in *Paston Letters*, vol. V, p.69.

26 John Paston III to Sir John Paston, 23 January 1470, in Davis (ed.), *Paston Letters*, vol. I, p.553.

CHAPTER 14: RETURN OF THE KING

1 Warwick to the chancellor, 4 September 1469, Writs of Privy Seal, in C.L. Schofield, *Edward IV*, vol.1, London, 1923, p.502.

2 Sir John Paston to Margaret Paston, October 1469, in *Paston Letters*, vol. V, p.63.

3 *Croyland Chronicle*, p.74.

4 *Warkworth's Chronicle*, p.8.

5 John Gough Nichols (ed.), *Chronicle of the Rebellion in Lincolnshire, 1470*, London: Camden Society, 1847, p.6.

6 Ibid., p.7.

7 Ibid., p.10.

8 Nicholas Bennett, 'The Road to Losecoat Field: The Story of the First Lincolnshire Rising', *The Ricardian*, vol. XXX, 2020, p.146.

9 Letter to John Paston, 27 March 1470, in *Paston Letters*, vol. V, p.70.

10 *Chronicle of the Rebellion in Lincolnshire*, p.11.

11 Ibid., p.13.

12 Edward IV to Thomas Stonor, 3 April 1470, in Carpenter (ed.), *Kingsford's Stonor Letters and Papers 1290–1483*, vol.1, p.115.

13 Letter to John Paston, 27 March 1470, in *Paston Letters*, vol. V, p.71.

14 *Warkworth's Chronicle*, p.9.

CHAPTER 15: OUR SOVEREIGN LORD KING HARRY THE SIXTH

1 Milanese ambassador in France to duke of Milan, 24 July 1470, in Allen B. Hinds (ed.), *Calendar of State Papers and Manuscripts Existing in the Archives and Collections of Milan*, vol. I, HMSO, 1912, p.141.

2 'The Maner and Gwidynge of the Erle of Warwick at Aungiers…', in Henry Ellis (ed.), *Original Letters Illustrative of English History*, Second Series, vol. I, London, 1827, p.133.

3 Milanese ambassador in France to duke of Milan, 14 February 1467, *Calendar of State Papers and Manuscripts Existing in the Archives and Collections of Milan*, p.117.

4 *Warkworth's Chronicle*, p.10.

5 Sir John Paston to John Paston III, 5 August 1470, in *Paston Letters*, vol. V, p.80.

6 *Hearne's Fragment*, p.306.

7 *The Great Chronicle of London*, p.211.

8 *Warkworth's Chronicle*, p.11.

9 John Paston III to Margaret Paston, 12 October 1470, in *Paston Letters*, vol. V, p.84.

10 *Arrivall*, p.10.

11 P.W. Hammond, *The Battles of Barnet and Tewkesbury*, Stroud: Sutton Publishing, 1990, p.54.

12 *The Great Chronicle of London*, p.216.

CHAPTER 16: RIGHTFUL INHERITANCE

1 *Arrivall*, p.2.
2 Ibid., p.3.
3 Ibid., p.5.
4 Ibid.
5 *Warkworth's Chronicle*, p.14.
6 *Arrivall*, p.7.
7 Ibid., p.6.
8 Earl of Warwick to Henry Vernon, 25 March 1471, in H.C. Maxwell Lyte (ed.), *The Manuscripts of His Grace the Duke of Rutland Preserved at Belvoir Castle*, vol. I, HMSO, 1888, p.3.
9 *Arrivall*, pp.8–9.
10 Ibid., p.11.
11 Ibid., p.16.
12 Letter from Margaret of York, Duchess of Burgundy, to Isabel of Portugal, April 1471, in Jehan de Waurin, *Anchiennes Croniques D'Angleterre*, vol. III, Paris, 1863, p.211, translation in Hammond, *The Battles of Barnet and Tewkesbury*, p.70.
13 *Arrivall*, p.17.
14 Ibid.
15 Ibid., p.18.
16 Ibid.
17 Ibid., p.19.
18 Ibid.
19 Ibid., p.20.
20 *Warkworth's Chronicle*, p.16.
21 *Arrivall*, p.20.
22 Ibid.
23 Sir John Paston to Margaret Paston, 18 April 1471, in *Paston Letters*, vol. V, p.100.
24 Indenture between duke of Gloucester and Queens' College, Cambridge, July 1477, in Charles Ross, 'Some "Servants and Lovers" of Richard in his Youth', *The Ricardian*, vol. IV, no.55, December 1976, p.2.
25 *Arrivall*, p.20.
26 Ibid., p.21.
27 *Hall's Chronicle*, p.297.
28 *Warkworth's Chronicle*, p.17.
29 Hannes Kleineke, 'Gerhard von Wesel's Newsletter from England, 17 April 1471', *The Ricardian*, vol. XVI, 2006, p.82.
30 *Warkworth's Chronicle*, p.17.
31 *Arrivall*, p.21.
32 Sir John Paston to Margaret Paston, 18 April 1471, in *Paston Letters*, vol. V, p.99.
33 John Paston III to Margaret Paston, 30 April 1471, in *Paston Letters*, vol. V, p.102.
34 Sir John Paston to Margaret Paston, 8 January 1472, in *Paston Letters*, vol. V, p.130.
35 *Arrivall*, p.22.
36 Ibid., p.23.
37 *Hall's Chronicle*, p.289.
38 *Arrivall*, p.23.
39 Letter from Prince of Wales to John Daunt of Wotton-Under-Edge in P.W. Hammond, *The Battles of Barnet and Tewkesbury*, p.81.
40 *Arrivall*, p.23.
41 Ibid., p.24.
42 Ibid.
43 Ibid., p.25.
44 Ibid., p.26.
45 Ibid., p.27.
46 Ibid.
47 Ibid., p.28.
48 Ibid.
49 Ibid., p.27.
50 Ibid., p.28.
51 Ibid., pp.28–29.
52 Ibid., p.29.
53 Ibid.
54 Ibid., p.30.
55 *Hall's Chronicle*, p.300.
56 *Warkworth's Chronicle*, p.18.
57 *Arrivall*, p.31.
58 B.H. Blacker (ed.), *Gloucestershire Notes and Queries*, vol. III, London, 1887, p.505.
59 *Arrivall*, p.31.
60 Ibid., p.33.
61 Carsen, *Domenico Mancini: de occupatione regni Anglie*, p.71.
62 B. Watson, T. Brigham, and T. Dyson, *London Bridge: 2000 Years of a River Crossing*, London: Museum of London Archaeology Service, 2001, p.108, quoting from CoLRO, BHR 5, f.182v. [City of London Records Office]
63 *The Great Chronicle of London*, p.219.
64 *Arrivall*, p.37.
65 Ibid., p.38.
66 Ibid.
67 Milanese ambassador in France to duke of Milan, 17 June 1471, *Calendar of State Papers and Manuscripts Existing in the Archives and Collections of Milan*, p.157.

CHAPTER 17: RELATIVE PEACE

1 22 November 1471, *Calendar of Patent Rolls* 1467–77, p.303.
2 Hammond, *The Battles of Barnet and Tewkesbury*, p.117.
3 *Warkworth's Chronicle*, p.24.
4 Ibid., p.27.
5 Ibid.
6 Philippe de Commynes, *Mémoires*, in Lander, *The Wars of the Roses*, p.155.
7 Commynes; Ross, *Edward IV*, p.232.
8 *Rotuli Parliamentorum*, vol. VI, p.100.
9 *Croyland Chronicle*, p.478.
10 *Rotuli Parliamentorum*, vol. VI, p.193.

11 Ibid., p.194.

12 W.H. Black (ed.), *Illustrations of Ancient State and Chivalry from Manuscripts Preserved in the Ashmolean Museum*, London: Roxburgh Club, 1840, p.30.

13 Ibid., p.ix.

14 Ibid., p.32.

15 Ibid., p.33.

16 Ibid., pp.36–38.

17 H.O. Sommer (ed.), *Le Morte Darthur by Syr Thomas Malory*, London, 1889, p.400.

18 William Ebesham to Sir John Paston, in *Paston Letters*, vol. V, pp.1–4.

19 *Paston Letters*, vol. VI, pp.65–67. Paston's 'Grete Booke' is British Library, MS Lansdowne 285.

20 Anne F. Sutton and Livia Visser-Fuchs, *Richard III's Books: Ideals and Reality in the Life and Library of a Medieval Prince*, Stroud: Sutton Publishing, 1997, p.54.

21 Caxton's preface from *Le Morte Darthur by Syr Thomas Malory*, p.3.

22 *Hall's Chronicle*, p.294.

23 *Wardrobe Accounts of Edward the Fourth*, pp.146–48.

24 John Paston to Margaret Paston, 21 September 1465, in *Paston Letters*, vol. IV, p.188.

25 *The Household Books of John Howard*, vol. I, p.216.

26 *Wardrobe Accounts of Edward the Fourth*, p.119.

27 John Paston III to Sir John Paston, 7 April 1469, in *Paston Letters*, vol. V, p.17.

28 Margaret Paston to John Paston I, 20 April 1453, in *Paston Letters*, vol. II, p.285.

29 *Calendar of Patent Rolls*, 24 April 1460, p.599.

30 *Wardrobe Accounts of Edward the Fourth*, p.121.

31 *The Household Books of John Howard*, vol. I, p.212.

32 *The Household Books of John Howard*, vol. I, p.544.

33 *The Household Books of John Howard*, vol. I, p.540.

34 John Paston III to Margaret Paston, 14 September 1465, in *Paston Letters*, vol. IV, p.185.

35 Inventory of household goods at Caister, 6 June 1462, in Davis (ed.), *Paston Letters and Papers of the Fifteenth Century*, vol. I, pp.107–14.

36 Margaret Paston to John Paston I, 1449, in Davis (ed.), *Paston Letters and Papers of the Fifteenth Century*, vol. I, p.234.

37 Margaret Paston to John Paston I, in *Paston Letters*, vol. II, p.102.

38 Margaret Paston to John Paston I, in *Paston Letters*, vol. IV, p.210.

39 *Croyland Chronicle*, p.495.

40 *Warkworth's Chronicle*, p.23.

41 Ibid., p.24.

42 Carpenter, *Kingsford's Stonor Letters and Papers 1290–1483*, vol. I, p.106.

43 Elizabeth Stonor to William Stonor, 22 October 1476, in Carpenter, *Kingsford's Stonor Letters and Papers 1290–1483*, vol. II, p.14.

44 *Vergil's English History*, p.169.

45 Indenture made between duke of Gloucester and earl of Northumberland, in Isobel D. Thornley, *England Under the Yorkists*, London, 1920, p.147.

46 *The Acts of the Parliaments of Scotland*, vol. II, 1814, p.138.

47 *Croyland Chronicle*, p.482.

48 *Vergil's English History*, p.171.

49 *Croyland Chronicle*, p.481.

50 Ibid., p.483.

51 Carsen, *Dominic Mancini*, p.47.

CHAPTER 18: RICHARD III

1 *Croyland Chronicle*, p.487.

2 Ibid., p.488.

3 Raine (ed.), *York Civic Records*, vol. I, p.73.

4 *Croyland Chronicle*, p.489.

5 Samuel Bentley (ed.), 'The Will of Anthony, Earl Rivers, 1483', *Excerpta Historica*, London, 1831, p.247.

6 Carsen, *Dominic Mancini*, p.71.

7 L.G.W. Legg (ed.), *English Coronation Records*, Westminster, 1901, p.196.

8 John Rous, quoted in Keith Dockray, *Richard III: A Source Book*, Stroud: Sutton Publishing, 1997, p.69.

9 Raine (ed.), *York Civic Records*, vol. I, p.83.

10 Viscount Lovell to Sir William Stonor, 11 October 1483, in Carpenter, *Kingsford's Stonor Letters and Papers 1290–1483*, vol. II, p.163.

11 Richard III to bishop of Lincoln, in Ellis, *Original Letters Illustrative of English History*, p.159.

12 *Croyland Chronicle*, p.492.

13 *Rotuli Parliamentorum*, vol. VI, p.250.

14 R. Horrox and P.W. Hammond (eds), *British Library Harleian Manuscript 433*, Upminster: Richard III Society, 1979, vol. III, p.190.

15 *Croyland Chronicle*, p.497.

16 *Harleian Manuscript 433*, vol. I, p.3.

17 *Harleian Manuscript 433*, vol. III, p.125.

18 *Croyland Chronicle*, p.500.

19 Fabyan, *The New Chronicles of England and France*, p.672.

20 *Croyland Chronicle*, p.501.

21 William Campbell (ed.), *Materials for a History of the Reign of Henry VII*, London, 1873, vol. I, p.201.

22 Richard III to Henry Vernon, 11 August 1485, in Maxwell Lyte (ed.), *The Manuscripts of His Grace the Duke of Rutland Preserved at Belvoir Castle*, vol. I, pp.7–8.

23 Duke of Norfolk to John Paston III, August 1485, in *Paston Letters*, vol. VI, p.85.

24 *Croyland Chronicle*, p.501.

25 Ibid., p.503.

26 R.M. Warnicke, 'Sir Ralph Bigod: A Loyal Servant to King Richard III', *The Ricardian*, vol. VI, no.84, March 1984, p.299.

27 *Vergil's English History*, p.222.

28 Ibid., p.223.

29 French chronicler Molinet, in Peter Hammond, *Richard III and the Bosworth Campaign*, Barnsley: Pen & Sword, 2010, p.98.

30 *Vergil's English History*, pp.223–24.

31 Ibid., p.222.
32 'Ballad of Bosworth Field', in Hammond, *Richard III and the Bosworth Campaign*, p.98.
33 *Croyland Chronicle*, p.503.
34 Diego de Valera, in Christopher Gravett, *Bosworth 1485: The Downfall of Richard III*, Oxford: Osprey Publishing, 2021, p.72.
35 *Vergil's English History*, p.224.
36 Diego de Valera, in Dockray, *Richard III: A Source Book*, p.130.
37 Michael K. Jones, *Bosworth 1485: Psychology of a Battle*, Stroud: Tempus Publishing 2002, pp.193–95.

38 *Vergil's English History*, p.224.
39 *Croyland Chronicle*, p.504.
40 John Rous, in Dockray, *Richard III: A Source Book*, p.123.
41 *Vergil's English History*, p.224.
42 *Croyland Chronicle*, p.503.
43 *Vergil's English History*, p.226.
44 *Croyland Chronicle*, p.504.
45 *Vergil's English History*, p.226.
46 Raine (ed.), *York Civic Records*, vol. I, p.119.

CHAPTER 19: HENRY VII

1 *Vergil's English History*, p.226.
2 Andrew R. Scoble (ed.), *The Memoirs of Philip de Commines*, vol. II, London, 1856, p.64.
3 J.O. Halliwell (ed.), *Letters of the Kings of England*, vol. I, London, 1848, pp.169–70.
4 *Croyland Chronicle*, pp.511–12.
5 *Rotuli Parliamentorum*, vol. VI, p.276.
6 James Raine (ed.), *A Volume of English Miscellanies Illustrating the History and Language of the Northern Counties of England*, The Surtees Society, 1890, p.54.
7 Polydore Vergil, *The Anglica Historia, A.D. 1485-1537*, Dana F. Sutton, The University of California, Irvine, https://philological.cal.bham.ac.uk/polverg.
8 *Hall's Chronicle*, p.428.
9 Polydore Vergil, *The Anglica Historia, A.D. 1485–1537*, in Nathen Amin, *Henry VII and the Tudor Pretenders*, Stroud: Amberley Publishing, 2020, p.62.
10 *Rotuli Parliamentorum*, vol. VI, p.397.
11 Raine (ed.), *York Civic Records*, vol. II, The Yorkshire Archaeological Society, 1941, p.9.
12 Ibid., p.20.
13 Ibid., p.22.
14 Ibid.

15 Vergil, *The Anglica Historia*, in Michael Bennett, *Lambert Simnell and the Battle of Stoke*, Stroud: Sutton Publishing, 1993, p.137.
16 J. Leland, *Joannis Lelandi Antiquarii de Rebus Britannicis Collectanea*, vol. IV, ed. T. Hearn, London, 1774, p.210.
17 Vergil, *The Anglica Historia*, in Bennett, *Lambert Simnell and the Battle of Stoke*, p.136.
18 Leland, *Joannis Lelandi Antiquarii de Rebus Britannicis Collectanea*, p.213.
19 Vergil, *The Anglica Historia*, in Bennett, *Lambert Simnell and the Battle of Stoke*, p.137.
20 Leland, *Joannis Lelandi Antiquarii de Rebus Britannicis Collectanea*, p.214.
21 Raine (ed.), *York Civic Records*, vol. II, p.23.
22 Vergil, *The Anglica Historia*, in Bennett, *Lambert Simnell and the Battle of Stoke*, p.137
23 Campbell, *Materials for a History of the Reign of Henry VII*, vol. II, p.158.
24 Raine (ed.), *York Civic Records*, vol. II, p.23.
25 *Hall's Chronicle*, p.435.
26 Vergil, *The Anglica Historia*, in Amin, *Henry VII and the Tudor Pretenders*, p.307.

INDEX

ORIGINAL PAINTINGS, PRINTS & CARDS BY

Graham Turner

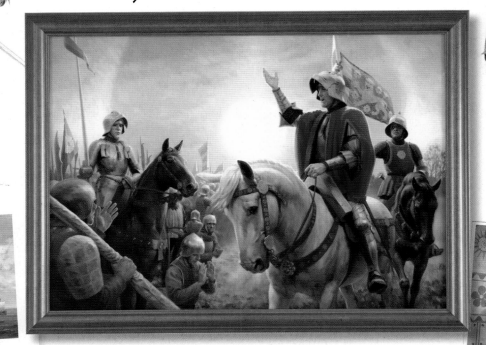

Visit Graham Turner's website for details of his extensive range of prints, greeting cards and original paintings.

Most of the paintings reproduced in this book are available as prints, part of a large selection of open and limited editions or individually produced, artist-signed giclée prints. Several are also available as special canvas editions.

Full details at www.studio88.co.uk

Graham Turner also paints other periods of history, along with aviation, motorsports and wildlife subjects. Details of these can be seen on his website, together with more of his Painting Diaries, news about forthcoming exhibitions and other items of interest.

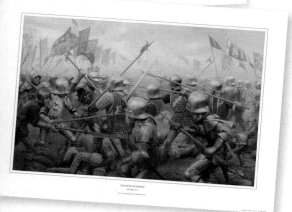

Examples from Graham Turner's large range of prints

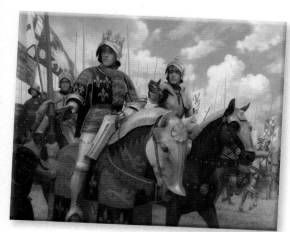

One of a selection of prints also available on canvas

A small sample of the Greeting Cards available